everyday genius

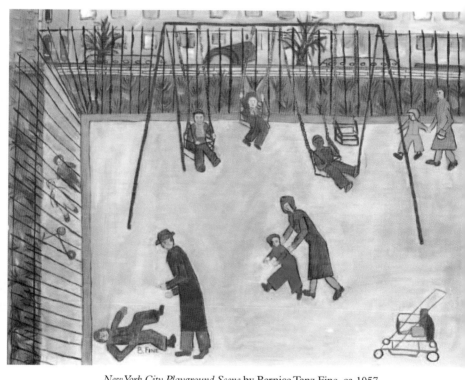

New York City Playground Scene by Bernice Tanz Fine, ca 1957.

Gary Alan Fine

everyday
genius

Self-Taught Art
and the Culture
of Authenticity

The University of Chicago Press
Chicago and London

Gary Alan Fine is professor of sociology at Northwestern University.
He is the author of nineteen books, including *Shared Fantasy: Role-Playing
Games as Social Worlds* (1983), *With the Boys: Little League Baseball
and Preadolescent Culture* (1987), and *Difficult Reputations:
Collective Memories of the Evil, Inept, and Controversial*
(2001), all published by the University of Chicago Press.

The University of Chicago Press, Chicago 60637
The University of Chicago Press, Ltd., London
© 2004 by The University of Chicago
All rights reserved. Published 2004
Printed in the United States of America

13 12 11 10 09 08 07 06 05 04 1 2 3 4 5

ISBN: 0-226-24950-6 (cloth)

Library of Congress Cataloging-in-Publication Data

Fine, Gary Alan.
 Everyday genius : self-taught art and the culture of authenticity / Gary Alan Fine.
 p. cm.
 ISBN: 0-226-24950-6 (cloth : alk. paper)
 1. Outsider art—United States. 2. Art—Marketing. 3. Art—Expertising.
I. Title.

N7432.5.A78F56 2004
709'.04'07—dc22

2003023042

This book is printed on acid-free paper.

To

Bernice Estelle Tanz Fine

1918–1980

An
unappreciated
self-taught
artist

Contents

Illustrations

Preface

Behind each dedication is a story. My mother, Bernice Estelle Tanz Fine, fancied herself an artist. More precisely, she enjoyed oil painting. As a "housewife"—more frustrated than devoted to that craft—participation in public realms was limited. Her talents as a student of science and medicine, evidenced by collegiate success, produced only dreams, occasionally fanciful, sometimes bitter. Painting was an avocation appropriate for the wife of a successful psychiatrist. And so, when on vacation or on playground outings, she would bring her hopes and her palette.

Her oldest son—an adolescent at the time—knew what art should be, and he knew that these canvases did not qualify. These canvases lacked perspective, feeling, aesthetic theory. With the spiked tongue of youth, he expressed his assessment with vigor. He shared the view of art critics who might have privately muttered the same—without the familial drama—had the work ever risen to their attention. In the end, she left a few canvases and a musty home.

Irony is God's soft justice. After her death, that oldest son acquired two of the canvases. He viewed them with new eyes, amazed by their genius, shaken by his obtuse confidence, stirred by what might have been. Beyond adolescent conceit, the question remains: What should we make of her art? Put more generally, how should we interpret artistic productions, particularly when created by those who lack institutional credentials in an increasingly credentialized society. Does authenticity trump training?

In time this son's academic peregrinations led him to the University of Georgia, where, as a sociologist of culture and an academic folklorist, he discovered a vigorous community interested in folk art. In time, he came to know some of those who participated in this field—as artists, collectors, dealers, curators, and critics—and collected this "stuff" himself. The act of collecting was gratifying and the prices were what an academic could afford. His house began to fill.

During a sabbatical at the Center for Advanced Study in the Behavioral Sciences in Palo Alto, he recognized that self-taught art provided an opportunity to utilize his training in folklore and the sociology of culture. He could examine the creation and the dynamics of a market in which—contrary to most markets, artistic and otherwise—the absence of credentials, and the lack of cultural and social capital, contributes to the value of the work. The research began in 1995 and data were collected until 2000. The early part of this research was supported by National Science Foundation grant SBR-9022192 to the Center for Advanced Study in the Behavioral Sciences. The final writing took place at the Swedish Collegium for Advanced Study in the Social Sciences in Uppsala.

This volume is about a realm of art—two-dimensional and three-dimensional objects—created by individuals who have not attended art school. This "style" of art has variously been labeled "folk art," "outsider art," and "self-taught" art. A market has been created in which collectors and dealers pay good money—sometimes very good money—for these objects. Some have been incorporated into museum collections.

Yet, as I shall discuss, this paragraph raises more questions than it solves. I refer to the concept of art, a realm of art, the nature of objects, the characteristics of artists, the label of the field, the creation of a market, the idea of value, all bolstered by individuals with social roles and institutional support. These issues are problematic. Were it not for the power, the meaning, and the beauty of the objects, one might wonder whether this "field" was a grand jest on the art world.

The perspective of the sociologist deserves comment. I presented

a corner of this material at a symposium at the John Michael Kohler Arts Center in Sheboygan, Wisconsin. The Kohler is an excellent small museum whose collection centers on crafts and self-taught art. My presentation, focusing on the connection among the multiple roles in the "field," proved to be controversial with some prominent figures frustrated by my address. One announced that I should be focusing on the "what," not the "who": the art, not the market.

This criticism is fair, but aesthetic analysis is not what sociologists do, or at least not what they do well. We leave aesthetic judgments to others. Readers may feel that I do not sufficiently "appreciate" the art that I describe, and there is some justice in this complaint, at least as far as this piece of writing is concerned. I suggest that my critics are far more able at the tasks that they chide me for not attempting. Sociologists examine the social conditions in which judgments occur and those who make these judgments. Where I do discuss aesthetics, I do not discuss them as "absolute" but rather as judgments of individuals in particular social locations. The art world is a community, and sociologists know how to examine communities. In doing so, I follow in the tradition of Julia Ardery's study of self-taught art, *The Temptation: Edgar Tolson and the Genesis of Twentieth-Century Folk Art.* Through interviews and documentary evidence, Ardery, an art critic, an art historian, a popular journalist, and a sociologist, presents a case study of the recognition given to Edgar Tolson, a Kentucky carver, a master of contemporary self-taught art. She provides a historically grounded account of a particular moment, and, as a result, it is important for her to get the facts right and the names correct.

While I draw upon Ardery's analysis and research at many points, our goals differ. This is not the analysis of the reputation of any particular artist. In contrast, I attempt to understand something about the structure of this art world, and how it relates to other worlds. The information that I have gleaned from participant observation fieldwork and in-depth interviews is anonymous. I do not reveal the names of my informants, following the standard practice of qualitative research. I joke that I trade in gossip. What makes this frustrating for those knowledgeable of the field is that I deny them the pleasure of gossip in that I eliminate who said what about whom.

Many individuals helped during this research: academics, collectors, dealers, curators, and artists. Among those who provided support or advice at various stages of this project include: Julia Ardery, Ben Apfelbaum, Barbara Archer, William Arnett, Howard S. Becker, Simon Bronner, Lynne Browne, Jeff Cory, Brenda Danet, Steven Dubin, John

Foster, Baron and Ellin Gordon, Wendy Griswold, Bonnie Grossman, Lynda Hartigan, Bert Hemphill, Rebecca Hoffberger, Liza Kirwin, Lee Kogan, Marianne Lambert, Eugene Metcalf, Judith McWillie, Randall Morris, Richard Peterson, Anton Rajer, Robert Roth, Judy Saslow, Barry Schwartz, Myron Shure, Mike Smith, John Vlach, David Wise, and Vera Zolberg. In a study that may prove to be contentious, it is wise to underline that the interpretations are my own, and some of those thanked might well take issue with my claims. It is difficult to draw the boundary lines for acknowledgments, but I deeply appreciate the literally hundreds of artists, collectors, dealers, curators, and others who have spent time with me over the years. Two art historians helped transcribe interviews, Deborah Nelson and Jane Friedman, and I thank them for making sense of my tape recordings. Vanessa Gomez translated Raymonde Moulin's "La Genèse de la Rareté Artisque"; I am grateful to her and to Howard Becker for insisting that it be done. I wish to thank Dawn Hall, my copy editor; Leslie Keros, my production editor, and Douglas Mitchell, my editor, dining companion, and friend.

Finally I thank my wife, Susan, and my sons, Todd and Peter, who have put up with the time I spent collecting data, and the costs of my collecting objects. My older son, Todd, traveled with me on several collecting trips, and over the years learned to appreciate the creativity of some very special people. He also prepared the index.

By the frontispiece I honor my mother, a woman of unappreciated—and everyday—artistic genius.

<div style="text-align: right">

Uppsala, Sweden
January 2003

</div>

Introduction

Art is elusive. The more we conceptualize it, the more it slips from our grasp. Artists, with their desire to test boundaries, are often no help in the matter. It is common to think of "Art" as connected to beauty and visual pleasure. Most art lovers recognize that their infatuation began with the appreciation of particular objects. Whether a Monet landscape, Rembrandt portrait, Michelangelo sculpture, or a Redon floral, we marveled at a material object that we found "pleasing" in color, design, or content. The fact that many art critics, and some artists, dismiss this entry point as esteeming works that are merely "decorative," reveals how artistic appreciation has become subcultural—specialized and requiring acquired values distinct from those that come naturally. David Halle in *Inside Culture*,[1] his astute analysis of what people place on their walls, discovered that even elite Manhattan art collectors select abstract art because of the appeal of its color combinations—how it looks over the couch.

1

Yet brutal, uncomfortable, ugly art abounds. That a Richard Serra rusted steel slab, a Marcel Duchamp ready-made urinal, a Robert Mapplethorpe homoerotic photograph, a Damien Hirst cow in formaldehyde, or graffiti by Jean-Michel Basquiat can be considered profound and moving—and valuable—reflects the triumph of aesthetic education and the status-conferring power of art-world judgments. The art world is a community (or several communities) with norms, values, and standards. Value is created through collective interest and action. Communities determine what is beautiful and what is powerful.

As artists push the boundaries of art, some have moved beyond the object to create works that are evanescent, performed, or conceptual. Some suggest that art is whatever artists *do*. Appropriately the products of this domain are referred to as work, as when describing an "artwork" or a "body of work."

Art is an occupation. This view has some appeal in that we know what doctoring is through the work of doctors, plumbing through the work of plumbers, and so forth. Yet, we are uncomfortable. This view excises aesthetic principles—or, more precisely, leaves them in the hands of practitioners and their associates.

This perspective raises a series of questions, each troubling in its way. Who is an artist? How does one gain the "credentials" by which one can participate within this occupational world? How does a community develop that provides for the legitimation of art objects? How does a market develop that validates (or denies) the claims of artists? Can we separate aesthetic merit from material value? How do institutions provide for legitimation? Responses to these questions represent the intellectual core of this manuscript.

As a sociologist I am interested in the organization of social worlds—occupational and leisure worlds. In his influential writings Howard Becker refers to the concept of art worlds—communities with conventions of practice, expressed ideologies, and a division of labor.[2] My approach builds on Becker's, relying on the detailed examination of an artistic domain. I am interested in the development of value, examining how an integrated community produces a hierarchical ranking of objects.[3] This connects with my research into reputations.[4] Not just objects, but persons associated with them receive collective esteem or contempt, and so it is with artists; only a few enter into the canon, a shared political system of positive reputation. Dealers and collectors are linked to this reputational system through the artists with whom they are associated.

Reputations are linked to markets, and so I attempt to understand an economic world—a world that sometimes does not choose to believe that it is an economic world. While many associated with the arts have an antimarket mentality, such a perspective diverts us from the reality that artworks are commodities, and that their evaluation is linked to (although not fully determined by) what people are willing to pay. The commodification of art suggests that it is impossible to separate an aesthetic perspective from an economic one.[5] To appreciate art, the contours of this market must be understood in light of how it is based upon aesthetic claims and in light of how it attempts to separate aesthetic and economic claims. Further, this is not a world of disconnected or anonymous buyers or sellers—as at a supermarket—but a world in which relationships of trust, friendship, or enmity abound. Such a market is characterized by embedded relationships.

This is an ethnographic case study of an embedded market in which value is inseparable from the moral appreciation of objects and from the relationships in which they are embedded. It is often assumed that individuals fill a single role in such a system, but as this analysis indicates, there is considerable role overlap, as individuals alter their roles, sometimes playing several roles simultaneously, and sometimes switching roles sequentially. As a result "conflicts of interest" are endemic and have become accepted as how the market should properly operate. Roles are more negotiated than what is often assumed in the analyses of economic worlds. Seeing the art world as an economic marketplace deepens, not weakens, our appreciation for its complexity and aesthetic concern.

Identity Art

To understand value and reputation within an art market, I focus on a closely observed community: that of self-taught artists and their associates. Markets need boundaries to determine which objects are included and which excluded, and boundaries presume labels, and so I begin by analyzing the spirited controversies concerning the proper designation for this field—self-taught art, folk art, or outsider art. I select the first label, self-taught art, because, even though it is as flawed and inadequate as the others, it is the most general and least political and over the past decade has become the standard—although not universal—designation. Needless to say the art is not self-taught, the artist is.

In most occupational domains, a strong correlation exists between

one's knowledge (one's cultural or social capital[6]) and the estimation of one's competence. The more training and the more credentials, the more ability. What makes self-taught art so significant is that this correlation is broken—indeed, is inverted. By definition, artists in this domain lack formal training and this is considered their defining quality.[7] The identity of the artist is how the field is labeled; thus, this art world constitutes an example of *identity art*. Whether this is desirable, I leave to others, but it reflects how the field is conceptualized and how boundaries are drawn. It is for this reason that I title this volume *Everyday Genius*, to emphasize that there is "nothing special" in their training that permits us to characterize these artists, but their genius—if such it be—is inherent in who they are.

The importance of identity is not limited to self-taught art, but also involves other marginal art worlds based on demographic characteristics. Examples include African American art or Women's art—both of which have shows, dealers, and specialized collectors.[8]

An art world grounded in identity contrasts two alternate forms of organization: art worlds designated by genre, such as portraiture, history painting, still life, or landscape, and by style, such as impressionism, minimalism, or abstract expressionism. Stylistic designations have higher status: in contrast to genre or identity designations, stylistic groups often represent an integrated, intense network of practitioners[9] who collectively construct their careers through reputation building and alliances with other art-world personnel, notably dealers and curators.[10] These artists work on a shared intellectual project, often with a developed theory, a phenomenon one does not find in art worlds that are labeled by outsiders to the community of artists, such as self-taught art.

Self-Taught Art as an Art World

Self-taught art is defined through the characteristics of the creators—they are often uneducated, elderly, black, poor, mentally ill, criminal, and/or rural. As far as the art market is concerned, they lack social capital, ties to the larger community, aesthetic theory, and are not fully integrated professionals in the mainstream art world.[11] Mainstream art is labeled contemporary art, and even though self-taught artists are working today, they are not defined as contemporary artists.[12] A few self-taught artists, such as Thornton Dial, are able to reside, uneasily perhaps, in both worlds, although appreciated from somewhat different aesthetic or social perspectives.[13]

Sociologist Howard Becker defines an art world as "the network of people whose cooperative activity, organized via their joint knowledge of conventional means of doing things, produces the kind of artworks that the art world is noted for."[14] While Becker's definition is deliberately tautological, linking the reputation of the art world to its practices, an art world—indeed, any social world—consists of an interconnected group of actors who perceive common interests and who are embedded in a network of social relations.[15]

While Becker focuses on the artists, I expand the idea of an art world to incorporate not only a network of producers, but also all those *invested* in the productions that come to characterize the domain. The concept of production includes the production of reputations and markets. Self-taught artists do not form an art world by themselves, being defined by the absence of linkages and conventions. Yet when the network is expanded to include those skilled professionals who surround them, the concept of a self-taught art world is useful, referring to a group with a self-conscious focus and set of practices. The participants in the social world typically recognize a boundary between those within the world and those outside. The art world is a *social system,* and because it depends upon routinized exchange relations, it is also a market.

In the case of art worlds, this system as it has developed throughout the western world consists of artists, collectors, dealers, critics, academics, and curators. Artists produce valued objects, and collectors consume them. Dealers link producers and consumers, sellers and buyers. Art markets are entrepreneurial organizational systems in which individual producers contract with mediating organizations to get their products to their public. The art market can be understood through an appreciation of the recording industry in which private contractors (bands) provide product for corporations to distribute.[16] The art world operates in a similar way, although, unlike the recording industry, most artworks cannot be duplicated (even high quality prints are numbered[17]) and most dealers sell few products, although with a higher profit margin than the cost of a CD. Critics, academics, and curators validate objects and producers, providing ostensibly unbiased and informed judgments, even if we recognize that these judgments may be political and self-interested.

The domain of self-taught art has several features that differentiate it from other art worlds, and by virtue of these differences highlights features of other art worlds. First, these artists are typically not directly involved in the art market. Most self-taught artists do not attend gallery openings, and are not involved in pricing or in shaping their careers.

Often they do not perceive themselves as having artistic "careers." Obviously one must take care in generalizing about this diverse group of workers, but typically, self-taught artists stand further outside the market than do their trained colleagues. Most self-taught artists are passive in establishing their reputations.

A second feature of this domain is its continued low status in the art world. Again, this is a generalization, but it is demonstrably true that higher-status museums and universities pay this realm little attention. As a result, the critical and curatorial infrastructure that characterizes other artistic arenas is relatively absent. Despite valiant attempts to claim that these works should be seen as "art" or as "contemporary art," and not as falling into a specialized, trivialized, ghettoized category, the attempts have not yet been entirely successful.

As a result, rather than the reputation of artists being shaped by curators, academics, and critics in their formal institutional capacities, self-taught art is a world in which status is tied to choices of dealers, auction houses, and collectors. Dealers, auction houses, and collectors through their pricing and purchases determine how objects are to be valued. While this applies to all artistic domains, the relative absence of critical assessments does little to muffle the voice of the market.

Given its low status and the lack of training of the producers, one might ask why would anyone collect this "stuff." Of course, we all purchase stuff, but why this? While the low cost of many of these objects is appealing for collectors with more cultural than financial capital, that alone cannot explain the phenomenon. One does not place just anything on one's walls. For this to become a recognized artistic market, participants must define these works as being self-enhancing. The meaning of the work is not embedded in the object, but in the relationship between object and collector. As a collector, I do not display things that I don't like, but liking is connected to my self-image and how I wish to display myself to others through my possessions.

Part of the value of these works is linked to the characteristics of the artists and the stories that the objects call forth. The works are authentic because of the biographical contours of their creators—life stories of *difference* that infuse the content of the work. The purity—the unmediated quality—of the vision gives a work by an elderly black sharecropper a greater value than the "same" work by a wealthy white stockbroker. The work might be identical, but for many the meaning changes. A formal analysis, in any domain, but particularly when one is considering identity art, does not fully explain value.

The History and Position of Self-Taught Art

Art history has a long and distinguished pedigree, but the same cannot be said of the history of self-taught art. For much of the history of western art (primitive or ethnographic art is another, highly charged, political matter[18]) producers of "art" had a recognizable social position, that of the artist, often linked to elites through patronage or through a market, and often involved in shaping their own public image. While some self-taught artists, such as the naive painter Henri Rousseau, were embraced by artistic avant-gardes, perhaps as a mascot, most were ignored. His nickname, the Douanier, the Customs Officer, testifies to the fact that Rousseau did not truly belong; his identity as an outsider defined him.

Although there is a need for a comprehensive history of the development of interest in American self-taught art, this is only the briefest of overviews, merely what I need to make my argument.[19] I ignore the development of European interest in "Art Brut," a term coined in 1945 by artist Jean Dubuffet,[20] or "Outsider Art" coined in 1972 by British academic Roger Cardinal at the insistence of his publisher who felt that the term Art Brut was too French.[21]

In the United States, interest in contemporary self-taught art can be traced to the interest of avant-garde artists, such as Elie Nadelman in the 1920s, although early American antiques ("folk art") had been collected since the nation's centennial.[22] This period also reflected increased interest in American Indian crafts and southwestern art. Just as their European compatriots, such as the cubists, "discovered" African and Oceanic arts in the previous decades, American artists discovered arts hidden in plain sight. As Robert Bishop and Jacqueline Atkins note in their magisterial *Folk Art in American Life,* by discovering American folk art, artists were seeking "a paradigm for a new American art." Artists discovered "the American spirit in its essentials—a simple, almost austere directness, an engagingly straightforward honesty."[23] Through the artworks these artists were able to limn national character and use it to legitimate their own art. Nationalism and aesthetic politics were linked. Artists had discovered their own "home-grown primitives, the equivalent of tribal arts."[24]

The 1924 exhibition *Early American Art,* held at the Whitney Studio Club, is pivotal in the discovery of American folk art. Artists active in the American avant-garde (the Ogunquit School, named after their summer colony in Maine), such as Robert Laurent, Charles Sheeler, William Zorach, and Yasuo Kuniyoshi, contributed works from their collections.

This linkage between folk art and the modernist (and later postmodern) avant-garde is often repeated.

Because of the interest by these modernist artists, some galleries developed interest in self-taught art. Edith Halpert, affiliated with the artists who contributed to the Whitney Studio Club exhibit, recognized the market potential of folk art and opened her influential Downtown Gallery in New York in 1929 and her American Folk Art Gallery in 1931.[25]

At the time, Holger Cahill, surely the most prominent curatorial proponent of folk art during the 1930s, opened an influential show of traditional American folk art *(American Primitives: An Exhibit of the Paintings of Nineteenth-Century Folk Arts)* at the Newark Museum in December 1930, and subsequently a related show at the Museum of Modern Art in 1932, drawing from the collection of Abby Aldrich Rockefeller.[26] If Cahill's ideology could not be said to be modernist in thrust, nationalism remained central. In 1938 the Museum of Modern Art in New York organized a show, *Masters of Popular Painting,* of contemporary folk artists, including thirteen American self-taught artists. Among the now well-known artists that MOMA exhibited at this time—either in the 1938 show or in others of the period—were John Kane, Morris Hirshfield, Horace Pippin, "Grandma" Moses, and William Edmondson.

By the 1930s the interest in folk or primitive art served another function: it was enshrined as the art of the people, and thus was linked to the Left's interest in establishing a popular front.[27] Although many discoveries were linked to craft traditions,[28] the boundaries between art and craft were vague. Yet, the MOMA show in 1938 and the publication of elite New York art dealer and curator Sidney Janis's *They Taught Themselves* constituted the beginnings of a canon of contemporary self-taught artists.[29]

The founding in 1961 of the Museum of American Folk Art provided an institutional venue for folk art. It was symbolic that until 1966 the museum was named the Museum of *Early* American Folk Art (and since 2001 has been named the American Folk Art Museum). Under the curatorship of Bert Hemphill, the museum presented a diverse array of exhibits including tattoos and occult objects. However, the original name of the museum presaged tensions between those whose interests were in traditional American folk art and antiques and those who were more interested in contemporary—and often more challenging, political, and sexual—works. Over the forty years of the museum's existence, the divisions have been real, even though some supporters, like Hemphill, crossed boundaries.

By the late 1960s interest in "folk" artists expanded again, notably with the influx of young people (including young artists) into the Appalachian region, often through community activism or through working in the reformist government-supported VISTA program.[30] Issues of class and race helped to animate the discovery and acceptance of self-taught art. The discovery and promotion of Kentucky carver Edgar Tolson by University of Kentucky sculptor Michael Hall was part of this phenomenon, as was the discovery of self-taught Chicago artist Joseph Yoakum by painter Roger Brown and his artistic circle, the Chicago Imagists.

The American Bicentennial, like the Centennial before it, provided an impetus to examine American arts and crafts. Much attention— including museum shows and books[31] —were devoted to self-taught art, even though at the time only two elite galleries, both located outside of New York—the Phyllis Kind Gallery (then in Chicago) and the Janet Fleisher Gallery (in Philadelphia) were regularly displaying such work. The most influential show of the period was the 1982 "Corcoran Show" (officially titled *Black Folk Art in America, 1930–1980*),[32] curated by John Beardsley and Jane Livingston, the associate director of the Corcoran Gallery of Art in Washington. The show, with nearly four hundred objects by twenty "untrained" African American artists, proved to be enormously influential, and in the words of one informant, "a defining moment." *Black Folk Art,* which later traveled to museums across the country, introduced many subsequently prominent collectors to the field and almost single-handedly established an artistic canon. While the Corcoran show was not the only show of the period, its location in the nation's capital proved influential in legitimating the work. The seventeen men and three women, largely southern, still provide a Who's Who of black folk artists. In alphabetical order, the artists included were Jesse Aaron, Steve Ashby, David Butler, Ulysses Davis, William Dawson, Sam Doyle, William Edmondson, James Hampton, Sister Gertrude Morgan, Inez Nathaniel-Walker, Leslie Payne, Elijah Pierce, Nellie Mae Rowe, James "Son Ford" Thomas, Mose Tolliver, Bill Traylor, George White, George Williams, Luster Willis, and Joseph Yoakum. With a few exceptions, these are the major black self-taught artists whose works are displayed by museums and which bring the highest prices. The 1982 Corcoran Show, like the 1924 Whitney Studio show and the 1938 MOMA show, provided a charter for this domain. Some museum shows truly shape art history and art markets.

The fact that the Corcoran Show displayed the works of primarily southern artists helped to focus the attention of dealers and collectors

on the (rural) South—until recently, in the eyes of cultural elites, America's backward and exotic internal colony.[33] Of the twenty Corcoran artists, fifteen lived in states of the former Confederacy, and another four were born in the region. This is not surprising given the demography of this cohort of African Americans (seventeen were born between 1886 and 1914), prior to the Great Migration. Yet regional stereotypes surely directed the curators' eyes southwards. The perception of region, admittedly a social construction,[34] has a real effect on the search for and appreciation of artworks.[35] Whether a function of differential creativity or simply the amount of effort to discover art, regional differences exist,[36] creating what one dealer labeled "the current Southern fad" (Field notes).

Much has happened in the past two decades: numerous shows, an explosion of galleries, prominent discoveries, and refined ideological justifications. A remarkable growth in interest in self-taught art over the past half-century defines the field, an increase in interest that is matched with an increase in institutional support and an increase in value. Even when proponents of this field complain—as they often do—about the lack of interest in their favored works and artists, when examined in light of a historical trajectory, the newfound interest is remarkable, although whether this interest will continue or will fade remains to be seen.

Uncovering the Field

To appreciate a community is a never-ending process. In this ethnographic study I spent five years (1995–2000) examining the world of American self-taught art through participant observation, in-depth interviews, and document analysis. Following the precepts of "Grounded Theory," as promulgated by sociologists Barney Glaser and Anselm Strauss,[37] my goal was avoid preconceptions, and attempt—inductively —to develop a theoretical understanding from the actions and collective meanings of participants.

In previous research I referred in jest to *Fine's Law of Shared Madness* in which members of *every* group feel that any visitor who observes them will define them, because of their enthusiasms and esoteric cultural traditions, to be "mad." One informant told me, "You're studying crazy collectors" and on another occasion in which, after an artist was described by a collector as "not the most stable guy here," I was told jokingly that his collectors were not stable either (Field notes).

These were good years for the field, as prices, particularly during the first years, were growing steadily. New galleries opened, auctions

expanded, museums were established and grew, and shows were more common. By the end of the period some sensed that the rapid growth had leveled off, but there seemed to be no significant downturn. While many of the best-known, canonized artists had died before or during the research, and there was concern about whether there would be new discoveries, the field of self-taught art is generally acknowledged to be vibrant and healthy. This sense of confidence, leavened with some frustration at not being taken seriously by the finest museums and critics, provides the backdrop for this research.

Unlike many ethnographic investigations, there was no place in which members of the community routinely congregated—no workplace, clubhouse, or street corner. This diffuseness proved a challenge for observation. In contrast to my past ethnographic research—on high school debaters, mushroom collectors, restaurant cooks, fantasy gamers, and Little League baseball players—I was not examining a locality-based group, but an ever changing, migrating social network. As a result, I appeared wherever members of the art world were likely to be. Over the years, I attended annual meetings of the Folk Art Society of America four times, the Outsider Art Fair in New York five years, Collect-O-Rama in Chicago three times, Folk Fest in Atlanta twice, and a large number of art openings, smaller shows (such as the widely respected Kentuck Festival of the Arts in Northport, Alabama; and others in Gainesville, Georgia; Columbus, Georgia; and Harbert, Michigan), auctions, tours, and symposia, writing extensive field notes after each event. Sometimes I attended as a member of the public and sometimes my role as sociologist was clear. At times I helped organize shows or served as a guide. As I developed relationships with artists, dealers, and collectors, I informed them of my research and, in many cases, received their enthusiastic support. My major informants knew of the research and, in general terms, of my objectives. At least three of these self-taught artists had strong interests in sociology, one majored in sociology in college, and each claimed that they enjoyed the subject. For some artists, less educated, my explanations may not have been fully comprehended, but even the least sophisticated, were aware how I might use them for my ends.

Bolstering my observations, I conducted taped in-depth interviews with seventy-four persons, including artists, dealers, collectors, academics, and curators. Most interviews were over an hour in length with several running longer than three hours. While these interviews were not formally structured, I attempted to cover a comparable set of topics in each.

In addition to observations and interviews, for two years I was a

member of a lively, and occasionally contentious, e-mail discussion group, organized and moderated by Randall Morris, a prominent New York dealer.[38] Topics on this list varied from philosophical discussions of aesthetics to evaluation of particular artists and exhibits to the pragmatics and ethics of the dealer-collector relationship. Participants included dealers, collectors, critics, and even the more technologically sophisticated self-taught artists.

I spent a month during the summer of 1999 as a guest researcher at the National Museum of American Art at the Smithsonian Institution. While there, I read widely in the Archives of American Art, including interviews of artists, dealers, and collectors and the papers of important figures such as collectors Jan and Chuck Rosenak and Bert Hemphill, dealer Jeff Camp, and artist Reverend Howard Finster. I also read reams of published material, including the run of relevant periodicals including *Clarion/Folk Art*, *Folk Art Finder*, *Folk Art Messenger*, *Raw Vision*, and *Spaces*, as well as catalogs, art periodical articles, and newspaper accounts.

My informants cover the social class structure, from some very poor individuals with barely a grade school education or with considerable cognitive confusion to highly educated and articulate Ph.D.s to some very wealthy and influential Americans. Largely absent in this research were the American middle class. Few groups are easier for a researcher to study than the American middle class—God bless them! These citizens respect education and respect professors. They are articulate, but feel that they have no right to comment on the doings of their "intellectual betters." Such was not always the case with the informants in this research project. Some artists—mentally confused or uneducated—proved to be a challenge to talk to *on my terms*. On their own terms was another matter, and on those terms I was the one who failed. The issues that I wished to discuss (pricing, socialization to art, strategies of self-presentation, community values) were not those that some artists would or could discuss with me. Surely some of the difficulty is a function of my own background and awkward limitations—what sociologists refer to as *habitus*. Yet, others, even those without much education, were quite articulate.

Elites proved to be a different problem. Some interviews were quite challenging as informants wished to control the agenda. On some occasions (once with a widely admired dealer), I found myself turning the tape recorder on and off repeatedly as my informant wished certain remarks off tape, but couldn't quite decide which ones. Further, as this was a tight-knit world with friendships and animosities, informants

could be quite pungent in their assessments. Some figures—notably dealers—generate powerful emotions, positive and negative, and informants wanted to learn whether I shared their views of these devils or angels. Bitterness, while not frequent, was not absent, as was the occasional deception. These were individuals who were accustomed to control, and on occasion our visions of the important issues conflicted. In contrast to other research projects in which my sociological thoughts received benign neglect, I have no doubt—and treasure, ruefully—that this manuscript will receive a microscopic reading from friends and associates, who will not be reluctant to express their opinions.

Some informants—rich and poor—were remarkably generous, giving me books in which their collections were displayed, objects produced by their companies, food from impoverished kitchens, and even, on occasion, artworks. To reject these gifts might have been construed as an insult. I appreciated the gifts, attempted to avoid a sense of intellectual obligation, and felt awkward about breaching the typically dispassionate relationship between researcher and informant.

A note about the naming of sources. It is standard practice in ethnographic research that authors use pseudonyms. In this research I hold tight to this rule with an important exception. All information provided by informants through observations, interviews, or e-mail postings, is referred to by the individual's role (dealer, collector, artist), unless that individual has specially given me permission to quote them by name. However, I will on occasion use the names of individuals referred to when I feel that this information is necessary for readers. It made little sense to create a set of pseudonyms for artists, influential collectors, and major dealers. As a result, unless noted, the names of individuals referred to are their real names. The material gained from the Smithsonian archives, lectures, and published material belong to the public domain and proper names and references will be used unless I feel that the names are unnecessary and would be unduly embarrassing.

On some occasions, with some discomfort, I use racial designations when I refer to folk artists. This art world, with the significant exception of the artists, is almost entirely white. Indeed, I can think of only a few African American art historians who have written on self-taught art. However, many artists are black or Hispanic, and, on occasion, I feel that a racial designation will help the reader understand important issues, so I include that information.

Regarding other terminological issues, I have chosen to use the term "self-taught art" to refer to this art world, not because the term is ideal, but because at this historical moment, it is least controversial. I also use

dealer, rather than gallery owner, as a term of convenience; many sellers do not have public spaces.

Finally, an apology. There are many names, places, and dates in these pages. Some of them are surely wrong. In a review of my book on mushroom collecting, *Morel Tales,* a reviewer, properly, took me to task for misstating the color of the spore print for Agrocybe mushrooms (I said it was white, and it was black, or was it the reverse?). Within these pages, there will be similar errors for which I ask indulgence.

One last plea. My style in this academic tome may strike some as flippant, although hopefully gently so. We have an obligation to treat the art with great seriousness, but I believe that we don't have the same obligation to treat ourselves with that same gravitas. I strive to puncture my own pomposity with as much gusto as I do for others.

Plan of the Book

In this volume I analyze how objects gain value and how creators gain reputations. My focus is not on making personal aesthetic or comparative judgments of objects, but in seeing how these objects and their makers are treated and processed. (Some might say I am interested in everything *but* the art. I wouldn't agree, but I see why they might say it.) I explore these issues in light of how the process of interpretation occurs through a community and a market. While my case study involves an art world, I attempt to generalize beyond art worlds in the substantive chapters and then more explicitly in the conclusion. Writing within the constructionist and interactionist traditions in sociology, I focus on the collective creation of meaning.

In chapter 1, "Creating Boundaries," I address the process by which artistic boundaries are defined. Some proponents of self-taught art suggest that we should ignore all labels and proudly—defiantly—refer to these works as "art"—eschewing adjectival limits. Such a strategy, linking this art world to elite art worlds, has appeal, but would, if taken seriously, destroy this domain as a community of interest by erasing its cultural, cognitive, and social boundaries. Yet, if boundaries are to exist, what are they to be? This is the question addressed in the first chapter. I focus on the creation of boundaries by examining the vigorous controversies over the *naming* of this approach. We respond to things by the labels given them: names allow for categorization, essential for human cognition. I then address the implication of these labels for the moral order of the field. A name sends a message about the kinds of things that we should value. These choices are not objective, but are made by

communities. Finally, I explore the roles of the keepers of these bound-aries: academics and critics. These men and women are supposed to be objective and analytic, but in defense of their beliefs are as passionate as any.

The second chapter, "Creating Biography" recognizes that this artis-tic domain depends, as a matter of definition, on the social and psycho-logical characteristics of the artists. I examine how biographical "stories" are created. Even if we admit that the content of the work matters, it is interpreted and situated within the context of the life experiences of the artist. The biography of the artist establishes the *authenticity* of the work. The lack of training of the artists is trumped by their experiences and the legitimating qualities of those experiences. These artists' experiences, in conjunction with their creative talents, establish the value of the work.

In the third chapter, "Creating Artists," I consider the work of artists. How is art done as a matter of practice? What does art work mean as a mundane task? However, I explore more than the creation of their works. I address how artists engage in strategies of self-presentation. In identity art, one's identity is a part of the product. Through their dealings, these artists—like all workers—are shaped by and shape those with whom they come into contact. I address the effects of race, class, and gender on the production of art, as well as examining the otherness that such designations typically imply.

Chapter 4, "Creating Collections," turns attention from the artists to the works and how works are organized and valued as commodities. Contemporary art markets depend, crucially, upon the interests of those who wish to display the products: museums and collectors. Why do people place this on their walls? Why and how do educated Americans find work by their uneducated neighbors to be worthy of exhibition and purchase? This is not a trivial matter. Collections are linked to cultural capital, as are the relationships that collectors develop with artists—relationships that are sometimes sincere and deep and are sometimes also patronizing and problematic. In each case, the collectors use both the art and the artist to establish their own aesthetic and social identity.

While artists and collectors sometimes have direct relationships, deal-ers often mediate these relationships, the topic of chapter 5, "Creating Community." The world of self-taught art, like other art worlds, con-sists of various bundles of tasks that must be filled by someone. Dealers, because of their positions as network nodes, connecting those in other roles, become particularly central in functioning art worlds. Because of the requirement to sell and to set prices, dealers must be attuned to the establishment of value, sometimes creating it themselves through

marketing strategies, testing and prodding others in this art world to discover "what the market will bear." Being a dealer requires that one knits a group of diverse others into a social system. Dealers through their bridging function create community. The existence of a mediator emphasizes the importance of a division of labor within art markets. Yet these "roles" are not as pure as they sometimes seem. In fact, perhaps more often than not, individuals adopt several roles and in some instances self-interest is involved in these multiple roles, just as self-interest affects friendship ties.

Discussing dealers leads to the consideration of markets, the topic of chapter 6, "Creating Markets." No matter how urgently we proclaim that artworks are ethereal, sacred objects, they are also commodities in a society that some define as having fetishized commodities. Even if we do not treat them as such, artworks are investment instruments— they increase or decrease in value, and should we sell as well as buy, we reap these changes in value. Even if we do not conceptualize works as investments, they are bought and sold through a variety of venues. Markets do not just exist, but rather they are created through embedded, socially meaningful relationships. I examine the process of their creation, both as financial markets and as social venues. In this, art is similar to other products and services, but in this market the original producers lack the credentials upon which our credentialized society usually insists.

Chapter 7, "Creating Institutions," examines the position of governments and museums in allowing these objects and their creators to enter collective memory. The position of the State in the art world is not entirely incidental. States can subsidize or burden artistic production, display, and transactions. The investment of a state in an art world can be benign or malign, but it reflects interests of state officials in maintaining their legitimacy. Museums, often linked to the state by ownership or subsidy, have a related role. Museums make claims through their displays about what it is citizens should remember and venerate. Of course, museums belong to the community. Curators have their tasks, and operate within an occupational division of labor. Within museums, curators operate in a political world in which other curators (and directors) have ideas for what their museum should be purchasing and displaying. The fact that relatively few American museums have substantial collections of self-taught art limits this social world. It is these limits that the collector/dealer system attempts to overcome through patronage and through the artistic equivalent of social activism.

Chapter 8, "Creating Art Worlds," brings these themes together: boundaries, biography, art, collections, community, markets, and insti-

tutions, focusing on how a demand for authenticity and identity structures this art world, but suggesting parallels to other domains. I analyze the world of self-taught art as it is, not as it should be. Sociologists distinguish between writing that is idiographic (grounded in description of a case) and that is nomothetic (grounded in what should be). My analysis is of the former type. What is, is not necessarily what must be.

1

creating

boundaries

A sticky Georgia afternoon in August can feel like Hell.[1] Yet on the third weekend of that torrid month hordes of collectors and dealers of self-taught art gather in a modest exhibit hall in the Atlanta suburbs to buy, sell, and socialize. A smattering of "folk artists" joins them. As the dominant city in the Southeast, Atlanta feels a proprietary relationship to all things southern. "Hotlanta" mediates New York style with that of its red clay hamlets. The explosion of interest in self-taught art—often called simply folk art or more formally southern contemporary folk art—has been a boon for collectors. Dealers have established themselves, sometimes precariously, in metropolitan Atlanta and in the mountains of north Georgia, where many Atlantans escape from the heat.

The growth of a market in self-taught art led a former Cliff Notes salesman, Steve Slotin, to organize a gathering of dealers in 1994 for what he labeled Folk Fest. The show has

grown in popularity over the years, attracting many Atlantans and collectors from other parts of the nation. While the show lacks the cachet of the Outsider Art Fair, held in New York's SoHo at the end of January, some seventy dealers and some ten thousand collectors attend. The success of the show has led a Johnson City, Tennessee, auctioneer, Kimball Sterling, to organize his own show in a nearby hotel. The Folkee Showee he calls it, and he sponsors an auction that same weekend of works both fine and whimsical, dear and cheap. While Atlantans flock to Folk Fest, it is the Kimball Sterling auction that attracts out-of-town collectors from Louisiana, Chicago, and New York. (In recent years the show and auction have not been held.)

Friday afternoon is a still, steaming southern day, drenched in humidity. Many of the more active collectors attend Slotin's opening cocktail party prior to the Sterling auction. No one attends for the modest hors d'oeuvres and cheap wine, but to see what dealers are offering and to meet old friends, including those self-taught artists who accepted Slotin's invitation. This year eight artists attend, including R. A. Miller, the elderly, friendly, white Gainesville, Georgia, creator of whirligigs and metal cutouts.

Miller is known for his prices; he doesn't sell his work for over $25 and, thus, a trip to Gainesville is one of the first visits of novice collectors. His pricing has implications for dealers, the better of whom stay away from Miller's work because of the lack of profits (and, some argue, the lack of sophistication in the work). His work is as likely to be displayed in gift shops as in art galleries. Many collectors are fond of Miller and pay court at his folding chair, though as usual he has little to say about his artistic style, talking instead about his political complaints. However, many collectors are more interested in accounts of his disorganized home life, demonstrating that this southerner is "real." Miller is an "authentic outsider."

Also present is the African American Miami artist Purvis Young, driven to Atlanta by his white friend and dealer Jimmy Hedges of Chattanooga. Young has created some profoundly beautiful, powerful, and political works, depicting the gritty, if colorful, poverty of minority communities in Miami. Some of his works sell for several thousand dollars. At this show, he spends his time rapidly drawing on a sketchpad, occasionally filling the requests of collectors; these drawings take minutes, and sell for $100. Although friendly, Young doesn't have much to say, leading some critics to contend that he has no place being placed on "display" at the event. Do "real" artists draw squiggles on request? Some

find such comments racist, but his presence seems racist to others. In this white-dominated world, with many uneducated black artists, the claim of racial insensitivity is never far from the surface.

As collectors greet artists, they are also catching up with dealers and fellow enthusiasts, trading gossip, and sharing, perhaps competitively, what they have recently added to their collections and at what price. Given that many of the artists are elderly, the gossip often turns to necrology. Each year several prominent artists die, and some wonder whether artists of comparable promise and ability will replace them. What will be the effects of advances in psychopharmacology on the "art of the insane"? Will increased education, especially art education, decimate the field? Some even joke that they need to be thankful for cutbacks in arts education! Excitement at new "discoveries" is matched by a concern for the future. Along with discussions of artists, these men and women discuss prices. Auction results are assessed with great care, even by those who claim that their collections are not investments, as an increase in price validates their aesthetic judgment while at the same time may place works out of their price range. Much speculation occurs about the prices at tonight's auction.

As usual, the quality of the 249 auctioned lots varies. Many of the "more serious" (better) works are sold at Sotheby's Folk Art auction in January in New York, but agreement exists that there are some desirable works from a prominent collector who has decided to change his collecting focus, and other important works from a couple who have recently retired. The value of the items is indicated by the presence of a few dealers who hope to purchase work to resell.

As always, Kimball Sterling provides a nice spread, feeling that his culinary hospitality puts people into a "bidding mood." Fried chicken, barbecue, corn, and peach cobbler make this seem like a Georgia picnic. Much joking and anticipation is evident. Phones and computers have been set up for bidders who are not present, perhaps valuing their privacy.

Kimball is a big, bluff, entertaining man who understands his audience and teases them about their interests. If he can make the auction a party, he will increase his revenues. As the auction begins, Kimball brims with jokes and the audience occasionally jokes back. As usual, the best work is in the middle of the auction. The audience "warms up" by bidding on minor and unknown work, and some pieces actually receive no bids. At first, most lots sell for under their lowest estimate, the price that Kimball provides to guide novices that is supposed to represent the "reasonable" range for the work, although there is doubt about some

of his claims. The bidding seems anemic, and Kimball seems nervous. Perhaps this auction will be a loss, both financial and to his reputation.

However, about an hour into the four-hour auction, bidding picks up. Several paintings on corrugated tin by the late artist Sam Doyle from St. Helena, one of the sea islands of South Carolina, bring strong bidding from the audience and several phone bidders. Several pieces sell for well over $10,000 and indicate that Doyle's work is "hot." Bids are also strong on the work of Clementine Hunter, who, as an elderly black women living on a plantation in Louisiana painted colorful pictures of plantation life, and bids are good for the earlier, larger work of the Reverend Howard Finster, an elderly white preacher from Summerville, Georgia, who claims to have been instructed by God to paint. Finster became something of a national celebrity, painting a rock album cover for the Talking Heads and appearing on the *Tonight Show* to spread his message. These collectors scorn Finster's later, smaller works—painted wooden cutouts—and these sell for little more than for what Finster had originally sold them. The auction validates collectors' interests, although given the fact that the auction is held in Atlanta, interest in southern work predominates.

On Saturday, a beautiful late summer day, Folk Fest is packed. The *Atlanta Constitution* printed a large feature story on the event, and many Atlantans attend because it is the place to be. Some are amused by the "sloppiness" of the work and exotic stories of the artists, commenting that they or their children could do as well, while others seem genuinely moved by the work; perhaps some serious collectors will result from this exposure. Seventy dealers attend, each paying fees for the privilege. The $5 admission fee from ten thousand visitors also makes Folk Fest profitable. As usual, most of the major dealers do not have booths; only one gallery from New York is present, although some dealers show up to see what is selling, to buy for resale in New York, and to cement relations with clients. Several dealers are marginal, causing some collectors to grouse that Slotin should have turned down the applications of those whose booths are filled with cheap objects, more cute than artistic. Unlike the New York Outsider Art Fair, Folk Fest has few criteria for inclusion, and powerful, expensive work is displayed next to tchotchkes. Of course, this can be a virtue in that there is something for everyone at all price ranges: something cheap to place on a coffee table or to match one's sofa.

The highlight of the day is the arrival of the Reverend Howard Finster, now deceased, but at that point infirm yet still gregarious. Finster's family sells his smaller works through a toll-free number (1–800-FINSTER),

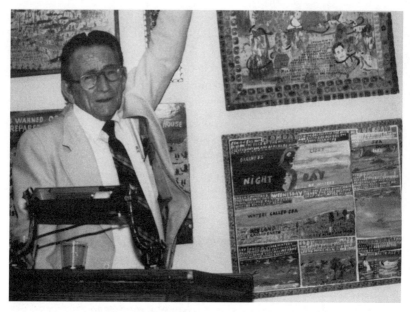

Howard Finster (1916–2001). Archives of the American Folk Art Museum, New York. Courtesy of Chuck and Jan Rosenak. Photo by Chuck Rosenak.

leading many to scorn his lack of authenticity. Some suggest that most of the labor on his pieces is being done by family members. But still, until his death, Reverend Finster was a true celebrity, perhaps the only real celebrity artist in this field. Finster sits at his booth signing autographs for a long line of buyers, many of whom have purchased his books or prints. To each he has a remark, often about the power of Jesus. The wilder his comments, the more satisfied his audience. While no one can deny the power of his beliefs, his faith is not that of most of his artistic audience.

Sales are good, and most dealers leave happy, even if the better ones feel exhausted by answering naive questions, but hope that new and profitable relationships were developed with long-term clients.

Sunday, in contrast, is clammy and stormy, and attendance is down. Most out-of-town collectors have left or are at brunches held by local friends. The excitement of Saturday is over, as dealers break down their exhibits and prepare to return home. Still, given that mid-August is traditionally a slow period in the art business, the success of this weekend helps dealers who are living, as always, on a precarious edge.

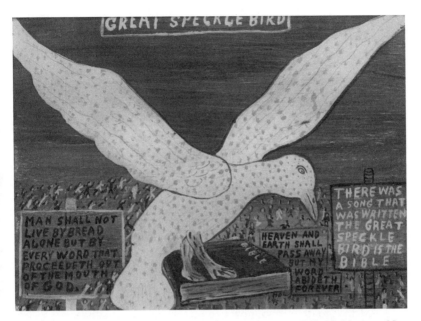

Great Speckle Bird by Howard Finster. Archives of the American Folk Art Museum, New York. Courtesy of Chuck and Jan Rosenak.

Defining a Field

Every community of interest requires a collective identity to create a sense of focus. This identity is used to display to insiders and outsiders the characteristics of participants. Boundaries are drawn and these boundaries, often vague, distinguish between inside and outside. Participants may have strong interests in how these lines should be drawn. At times, subcommunities may attempt to coexist in uneasy tension under a single rubric, but unless some measure of consensus comes to exist or unless such an arrangement is seen as benefiting both groups, the system will be unstable.

"Boundary work" is essential for social and economic groups, but often it requires considerable debate and may cause tension among those with different perspectives. Whether it be birders who argue as to what species to count and how the watching is to be done as a matter of environmental ethics, or stamp collectors who debate what constitutes a collectible postage mark, interest groups limit what it is they do—and what they don't do. Meaning creation is crucial to group affiliation.

Central to the development of community is naming: Who are these people? How to refer to them? This is particularly salient when the activity lacks a clear, consensual, public label. In such contexts, labeling is likely to be controversial, particularly if different values are emphasized in the alternative labels. For instance, the debate between animal welfare advocates and animal rights advocates can be quite intense, as the two groups—similar from the outside—see themselves as having different perspectives.

Determining the boundaries of art—much less artistic subfields—is no easy matter. "Art" consists of sets of unique objects that by virtue of their uniqueness lack precise boundaries. How can unique objects be categorized? Folklorist Gerald Pocius asserts that "perhaps of all the words that surround us in our daily life, *art* is one of the most contentious, most controversial."[2]

What *is* art? Some, despairing, suggest art is simply what artists do or what museums hang on their walls. As Larry Shiner suggests, the boundaries of art have continually shifted over the centuries.[3] If the broad term is so resistant to definition, how can one distinguish a subcategory? Is a portrait simply an image of a person? Can one distinguish between landscapes and backgrounds for other genres? How minimal must a minimalist work be? How African American—genetically or culturally—does one have to be to produce African American art? The labeling problems are endless, even while they determine how markets, museums, magazines, collections, and art schools are structured. Definitional choices come to affect organizations and the structure of markets.

The British journal *Raw Vision,* in a playful advertisement in the *New Art Examiner* in 1991, listed a set of 147 terms that "described" their field.[4] Some of these terms were humorous (Bonkers Art, Potty Art, Real Art), others were esoteric (Superphrenia, Autodidact Art, Dream Spaces), more were specialized (Prisoner Art, Art of the Mentally Handicapped, Visionary Art), and still others were politically incorrect (Primitive Art, Naive Art). Many were legitimate terms that have been seriously proposed, if not widely accepted (Grassroots Art, Folk Bricolage Landscapes, Obsessive Art). A few were in wide, if contentious, usage: Folk Art, Outsider Art, and Self-Taught Art. These latter terms do not only reflect individual preferences, but are claims of how the field should properly be conceptualized.

What constitutes an adequate label? A label must be simultaneously descriptive, political, and aesthetic. First, there needs to be a perceived correspondence between the term and the works that the community recognizes as part of the field. The works come first, and the label is

supposed to cover those objects without much slippage. As *Washington Post* art critic Paul Richard noted, " 'folk art,' like pornography, is easier to recognize than it is to define."[5] The label should make sense in light of the body of objects that participants "know" belong together. The meaningful character of the word should correspond to the content of the object and the position of the creators.

Beyond this, the term should be politically acceptable. Terms such as "primitive" or "naive" art, once acceptable to define those who are unsophisticated in light of the cultural capital of art-world participants, are now inappropriate, no longer politically correct, revealing class bias or, worse, racism. A poorly chosen term can marginalize artists.[6] This is a problem especially with the labels "folk art" and "outsider art." Labeling a poor, black, uneducated, or elderly person as "folk" or "outsider" strikes some—including some artists—as unseemly.

Third, the term should have an aesthetic appeal. It should charm its audience. The label should be "good to think" and "good to say." Two terms in the *Raw Vision* ad have potential as labels, Art Brut and Vernacular Art, but neither has caught on, perhaps for reasons of terminological poetry.

Art brut was coined by Jean Dubuffet in 1945 to describe works created by those outside the art world and that were interpreted by critics, notably Dubuffet himself, as rejecting the mainstream aesthetic. Art brut—raw or brutal art—served the French well as the label for a type of untaught art by those outside of the social system of art. Perhaps because of its foreignness or perhaps because art brut suggests that the artists were "brutal," the term has not been widely accepted among English speakers. As noted, when British academic Roger Cardinal[7] published his pioneering volume in 1972, the publisher insisted that he select an English term, and so outsider art was selected as an English synonym for art brut.

Vernacular art mirrors the more common "Vernacular Language" or "Vernacular Architecture." The monumental volume, *Souls Grown Deep,* edited by Paul and William Arnett, is subtitled "African American Vernacular Art of the South." Paul Arnett in his introduction notes, "We acknowledge a certain planned obsolescence to our imperfect and imprecise label 'vernacular,' and we await the moment when its practitioners name the phenomenon, if it is reducible to one name. 'Vernacular,' the term chosen here, means 'using a language or dialect native to a region or country, rather than a literary, cultured, or foreign language; . . . of, relating to, or characteristic of a period, place, or group.' 'Vernacular' denotes a language *in use* that differs from the official languages of power

and reflects complex intercultural relationships charged with issues of race, class, region, and education. In a way that the terms 'folk,' 'outsider,' and even the supposedly neutral 'self-taught' do not, 'vernacular' puts the terms of selfhood squarely and self-consciously with the art's creators."[8] Focusing on art *in use* suggests that these creations are a matter of everyday genius.

While one might quarrel that the term still separates the artist from elites and focuses on the identity of the artist and not the content of the work, the argument is plausible, but, at this writing, vernacular art has not been widely accepted. Perhaps in practice the term has been too tied to southern African American art,[9] or perhaps it lacks the poetry needed for wide usage outside of academic and critical discourse. Critic Michael Kimmelman speculates that, " 'Vernacular' may not catch on because it lacks the ring of avant-garde rebellion." An academic who prefers the term notes that "it's a term that doesn't seem to be loaded with the cleverness and charm normally associated with folk art" (Interview). It lacks resonance for its audience. Perhaps "vernacular" nicely fits the art, but not the art world.

Term Warfare

Examining the range of labels that have been proposed for this creative domain, some suggest that agreement on a label is impossible. From this perspective the ongoing term warfare seems silly.[10] These objects do not constitute a neat category and never will. The field, like so many domains, is an uneasy coalition among those with different interests. Every so often the board of New York's American Folk Art Museum discusses whether to change their name. The name has been changed twice—first to permit the inclusion of contemporary folk art (the first name was the Museum of Early American Folk Art), then to incorporate global folk art (the second name was the Museum of American Folk Art), but the label folk art has remained, lacking a consensus for change (Field notes).[11] Roger Cardinal, musing on the controversy surrounding his term "Outsider Art," speculates that term warfare "may be symptomatic of an obscure complex of feelings, including the embarrassment at being seen to define and display a passion which a majority may perceive as unusual, even illicit. Perhaps what all the competing labels reveal is not so much the intrinsic quality of the art itself as the disarray of its partisans. . . . At yet another level, it might be thought that such bickering over terms betrays a basic fear of genuine critical

dialogue, which can only really flourish where there is agreement on a fixed nomenclature."[12] Cardinal speaks not about the art, but about the divided community that promotes it. He suggests that term warfare mirrors the psychological and social disarray of the art's supporters.

Some suggest that a label is unnecessary. Wandering into a booth of a prominent dealer at Chicago's elite Art Fair, I commented how impressive their selection of folk art was, adding, thoughtlessly, "or whatever you call it." The dealer responded, tartly, "we call it art" (Field notes). Randall Morris, a prominent New York dealer and critic, asserted on his e-mail discussion list, "No one will ever win the name game. . . . The work itself will direct its own future curating. Please stop trying to define it. A description (self-taught for example) is not a definition."[13] Bert Hemphill, the influential collector, is said to have reached the same conclusion: "[Hemphill] now believes that applying only the word 'art' to many of these objects would be a therapeutic release from endless efforts to assign just the right qualifier or modifier."[14] One speaker received sustained applause at a symposium by remarking, "It's art *period*. . . . It's all one big, happy family, but there are a few people who haven't realized it yet" (Field notes). Just as contemporary art galleries vary in the styles of art they display (no one would confuse a gallery that specialized in minimalism with one that emphasized hyper-realism), some "contemporary art galleries" could specialize in work now known as "self-taught," "outsider," or "folk."

As appealing as this perspective is—and as a strategic matter might raise the stature of this work,[15] moving it to the center from the periphery—a problem exists. Labels serve the interests of individuals and institutions. To erase labels, forcing this work into the mainstream (where it might or might not thrive), would erase the community. Cognitively, socially, and organizationally labels have power.

COGNITIVE JUSTIFICATIONS. People depend on categorical systems to organize their "buzzing, booming" environment.[16] Everything may be different, but there are, in the words of philosopher Ludwig Wittgenstein, "family resemblances."[17] One dealer suggested that she would prefer to discuss the work as "art," "but collectors need handles, writers need handles, and this is one of the reasons why Outsider has been such a great success is because it allows . . . so many pundits [to recognize it]" (Interview). At a symposium, Roger Cardinal claimed that, "We give our name when we meet someone. . . . We need some term to refer to it, even if it is 'Wow Art'" (Field notes). A dealer, asserting that "art" is preferable, notes, "Unfortunately or otherwise,

our modern brains demand that all things great and small be classified. Birdwatchers would discard their binoculars if every feathered creature were only known as 'bird.' "[18]

SOCIAL JUSTIFICATIONS. A label justifies a group. Collectors, faced with innumerable potentially appealing works, need a system through which their choices can be limited and through which their interest and expertise can be shared. As is often the case in leisure worlds, people need focus. In the forest, one hiker will see mushrooms, another will hear birds, and a third will recognize animal tracks. One enthusiast explained, "As a collector, I want to have focus . . . and whether it's just called art, that's fine, but I will know that my collection consists of art that is by untrained artists" (Interview). Not only that, but he wants to affiliate with friends who share his enthusiasm. Another suggests that labels communicate: "If we can't decide on a vocabulary, how are we *ever* going to express what's going on here to other people? I mean, sooner or later we've got to decide on calling these things *something*" (Interview). We need a "something" to share our appreciation of the artistic genre that a particular piece represents. Creating a group of artists creates a community of admirers.

ORGANIZATIONAL JUSTIFICATIONS. Not only do individuals need labels, so do institutions. If this body of work were only *art,* what would happen to the mission of the American Museum of Folk Art, the American Visionary Art Museum, and the Outsider Art Fair? The High Museum of Art would not need a Curator of Folk Art. The institutionalization of cultural practices depends on terminology, however imperfect.[19] As one museum director argued against those who suggest "Let's just call it all art!": "A museum, as an educational institution, has a responsibility to give its audience some insight into the historical circumstances and cultural conditioning of artistic production as well as the individual creative leaps made by artists. Thus the museum's responsibility is to define for its audience how one approach to making art might differ from another."[20] One might speculate whether objects of "self-taught art" (by whatever name) are more similar to each other than to those artistic objects that are placed outside of the boundary. Whether the particular claims are justified, museums claim the obligation to carve up the world of art in manageable chunks that audiences can easily digest.

What is true for this field applies to all domains in which boundaries are needed. These limits serve functions that are cognitive, giving actors a sense of order; social, providing the basis for communal interaction; and organizational, justifying institutional involvement and control. For

these reasons the identity labels that ethnic and political groups (Asian Americans, Hispanics) give themselves are so important, the labels of social movements (Greenpeace, Operation Rescue) affect the likelihood of success, and the self-definitions of restaurants (fusion, Pacific Rim) create a market niche.

If a label is necessary, which should it be? Folk art? Outsider art? Self-Taught art? Each has a distinct history and set of defenders, and the terms are not precisely synonymous. Although each refers to the identity of the artist (a member of a folk group, an outsider, or a person without formal artistic training), their implications differ.

Folk Art

Folk art has the longest pedigree and the richest associations in the popular imagination. Many institutions, such as the American Folk Art Museum, chose that label—although their name relates as much to nineteenth-century self-taught material. Atlanta's High Museum of Art has a folk art curator, and the leading organization for collectors of contemporary self-taught art is the Folk Art Society of America. Indeed, the label for the organization is apt as many collectors treasure the fact that they are collecting the creative output of the "folk," part of the cultural project of American nationalism. The term, which often implies rural life, community, simplicity, tradition, and authenticity, provides a powerful image on which to build community. While this oversimplifies what is categorized as "folk art," the image remains potent. Jules Laffal, the editor of *Folk Art Finder*, remarked, "Nobody's going to give up the term 'folk art.' It's just too juicy."[21]

However, the pedigree and associations are problematic. Some see the term as owned by "folklorists," that beleaguered band of academics.[22] In the words of folklorist Robert Teske, "Folk art must be defined in terms of: first, its acceptance of and dependence upon a communal aesthetic shared by a group of artists and their audience and shaped and reshaped by them over time; second, its traditional nature, with its conservative emphasis upon perfecting old forms instead of creating entirely new ones; and third, its transmission via apparently informal, yet often highly structured and systematic, means."[23] Teske's criteria are that folk art is communal, traditional, transmitted outside a formal market, and based on a communal aesthetic.

While some self-taught artists fit this model adequately, if imperfectly—notably southern African Americans working in rural communities and some elderly memory painters—this model does not fit those

who are idiosyncratic, mentally ill, or transient.[24] In this view creativity is tightly circumscribed, as folklorist John Vlach notes, rejecting the claim that acclaimed Kentucky carver Edgar Tolson is a folk artist: "Folk artists, *by definition,* submit to or are at least very aware of the demands and needs of their audience. . . . Should they deviate markedly from the usual criteria they run the risk of rejection, that is, a social death. . . . The carvings of Edgar Tolson cannot . . . be accepted as folk sculpture . . . his work is unprecedented."[25] For this master of "folk art" and subject of Julia Ardery's *The Temptation: Edgar Tolson and the Genesis of Twentieth-Century Folk Art* to be denied his place in the canon suggests the battle lines that academic definitions can provoke. Tolson is not alone in the decertification of "folk artists" by academic folklorists through their emphasis on community as opposed to personal creativity.

Others also object to the appropriation of "folk" discourse. For some, folk art seems too rustic. One Atlanta artist asserts, "I don't know [if I like] people saying I'm a folk artist. You don't see a bunch of chickens hanging out in my front yard, and, you know, I don't live out in the middle of the woods, and that to me is what I think people are thinking of when they think of folk art" (Interview). A collector notes, "I hate the word 'folk art,' . . . because it depicts to me the wooden cut-out craft work that we see at a craft show" (Interview). Put another way, "Folk art is, in fact, everything that everybody always thought was *not* art before the modernist revolution at the turn of the century."[26] Despite its cultural resonance, the term folk art may be too loaded with alternative meanings to be useful. And, yet, terms and ideas do change meanings over time. Perhaps "folk" could be given a broader definition, assuming there was a motivation for definitional change.

Outsider Art

Outsider art has a different set of problems, more political than aesthetic. Coined by a British professor, Roger Cardinal, to designate artists who operate outside of the mainstream of society (the mentally ill, the visionary, and the odd), many find the term exclusionary. Some artists, surely, are outsiders, and Cardinal differentiated his term from folk art. Despite his scholarly caution, the catchy term has an elastic life of its own, and in the process has been linked to corners of the market for which outsider status invested the art and the artist with authenticity.

In part, the debate consists of whether being an insider is desirable. If not, who would object to being an outsider? Reaction to the term, in some measure, falls along a political divide with some hearing a "radical-chic ring"[27] or a marketing strategy to appeal to those who desire the

morality of the exotic. Some definitions of outsider art, such as that of Chicago art dealer Judy Saslow, capture this: "work produced by people immune to artistic culture in which there is little or no trace of mimicry; so that such creators owe everything—their subject matter, their choice of materials, their modes of transcription, their rhythms and styles of drawing, and so on—to their own resources rather than to the stereotypes of artistic tradition or fashion." [28] Is immunity to culture possible?

One collector was more explicit: "I'm not sure I find it offensive. I can see where some of these guys mean they're outcasts, but I think it means outside the snotty art world, and I find that to be a positive, rather than a negative" (Interview). Randall Morris, the New York dealer and critic who has since changed his view, noted that, "We were the first gallery in this country to call the work of non-Europeans 'outsiders'. . . . For me it even had outlaw overtones; the outsider standing in the late afternoon sun casting long jimmy dean shadows over the folk art world." [29] The antihero is hero. One can see the appeal of the term as a means of creating an allegiance with artists against a hegemonic art world, against "the one true church." For dealers, collectors, and critics who wish distance from this elite world—a world that rejects creations by artists lacking credentials *and* those who support these artists—outsider implies that artists and their supporters are joined in common struggle. At least it did until these articulate Americans discovered that, perhaps, they were engaging in their own false consciousness. Their revolutionary brotherhood incorporated a romantic infatuation with the poor. For good or ill, the label divides the world into insiders and outsiders. Within a community, insider and outside status may be inverted, or as one collector of Southwestern Hispanic art noted tartly, "Georgia O'Keeffe was an outsider" (Field notes).

Some are angered by the term—even if participants on both sides have solid progressive credentials. If *we*—dealers, collectors, critics, curators, academics—are insiders, the term establishes a we/they dichotomy. [30] The term feels pejorative. In the words of one museum official: "It's not democratic, and you can tell me from today until the next millennium how this art comes from outside the tradition. . . . I think it's marginalizing, insulting, and hierarchical" (Interview). A dealer finds the term "sickening and patronizing." Others suggest that the term is hegemonic, elitist, and racist. [31] Distinguished Yale art historian Robert Farris Thompson describes the term as "an arrow in the heart" [32] of those Americans who were already marginalized by other institutions. In fact, most artists function *inside* their own communities quite nicely.

Were this only a bunch of insiders carping, we might dismiss the squawks. Academics and their kin are specialists at finding the insult in the seemingly most benign remarks (such as the debate over AIDS Victims vs. People with AIDS). Yet some artists also find the term objectionable. Reverend Howard Finster, a white artist, noted, "There's no such thing as an outsider or insider artist. Just as there's no such thing as an outside or an inside mechanic, an outside or inside president or an outside or inside governor."[33] Black Chicago artist Mr. Imagination (Gregory Warmack) notes in a similar vein, "I did a lecture about 'outsider' art. I said, 'Well, I'm not an outsider—I consider myself an artist—someone who has a spiritual feeling to create.' I hope that in the future they will just get rid of the term. . . . If I want to move to this certain area, and they say, 'I'm sorry, you can't, because you're an outsider.' "[34] Images of segregation are hard to trump, even if supporters of the term insist that they honor the artist by stressing their authentic artistic perspective. While the term, as originally presented, has value in describing isolated and ill artists, most self-taught artists are embedded in communities in which they display their individuality and creativity. These artists surely are outsiders from elite art worlds, but in their communities, curators, collectors, and scholars are the outsiders.

Self-Taught Art

Each term for an artistic domain is, in some ways, a marketing device, a way to create an audience. Terms are moral claims for what the field should mean. As Jenifer Borum pungently noted, "one uses the designation that he or she hates least—for many, including me, 'self-taught' is the term least fraught with colonialist, pejorative baggage."[35] It seems to have gained ascendance as the label of choice.[36] The term makes intuitive sense for many, and, as the preferred term in Sidney Janis's *They Taught Themselves* (1942), has a lengthy pedigree. The term self-taught art, in contrast to vernacular art and art brut, is relatively accessible, and in contrast to folk art and outsider art is relatively uncontroversial, even if "self-taught," like "outsider" and "folk" refers to characteristics of the artist and not the art. Even though we use the adjectives to specify the art, they specify the identity and social placement of the artist. This is really "art by self-taught creators."

The term "self-taught" appears to be transparent; everyone "knows" what it means: the artist did not have formal artistic training and operates outside of artistic conventions.[37] But what does this mean in a world in which some prominent artists did not receive similar training? The work of Joseph Cornell, for instance, is not included in the field, even

though he was as untrained as any. His incorporation into the artistic canon seems to exclude him from the self-taught art community. On the other hand, how much training or knowledge does an artist need to be excluded? Achilles Rizzoli, drawing fantastic buildings, was an architectural draftsman. Drossos Skyllas, painting hyper-realistic portraits and landscapes, was well aware of art history. Both are considered American self-taught art masters. Few, if any artists, no matter how well trained, learned only from their mentors and their coursework. Ideas and techniques are always modified by personal vision, no matter their origin. Further, anyone who has ever attended a community art fair surely realizes that self-taught does not necessarily mean "good."

In a society in which almost every child has some form of art education in school and on television, what does self-taught mean? These individuals are sufficiently aware of the art world to know (in most cases) that art (painting surfaces or carving or assembling objects) is a legitimate and honored exercise.[38] Is anyone truly self-taught today? What do we do with artists such as Michel Nedjar or perhaps Thornton Dial who may begin ignorant of artistic history and technique, but as a result of fame or exposure become aware. The term "self-taught" privileges one sort of training (school and museum-based) over other types of learning. In the words of Tom Patterson: "Plenty of artists thus pegged have had teachers of one description or another who contributed to their art's development, even if they weren't certified art instructors. As art historian Barbara Bloemink has observed, 'The term "self-taught . . . privileges Western academic training and notions of illusionism over all other forms of learning.' In the final analysis none of us is really self-taught; we learn from a variety of other people in our lives and from experiences over which neither we nor any teacher has much control."[39]

At their best, these terms refer to overlapping circles of artists and artworks. Some people and objects are easily seen as folk, others as outsider, and still others as self-taught. Each represents a means of organizing the world and drawing boundaries. Does the field wish to be expansive, including as many artists and objects as possible, or focus on those who meet all criteria? The decision has implications for the growth of the field and the choices of dealers, collectors, and museums. The problem is that, despite a foggy penumbra, we know what we mean, but language, as philosopher Ludwig Wittgenstein emphasized, is always imprecise, lacking an exact correspondence between the world out there and those imperfect, ambiguous linguistic symbols that we use to refer to that world.

Constructing Boundaries

Within the academic industry,[40] the "constructionist" approach has been much in vogue, grounded in a profound work of sociological theory by Peter Berger and Thomas Luckmann, *The Social Construction of Reality*.[41] This approach originally asked how certain social *conditions* became considered social *problems*,[42] and provided a lever for recognizing the power of actors to shape meanings in the face of an obdurate reality. Are cigarettes a problem? Is cocaine? Abortions? Margarine? Interracial marriage? Homoerotic photographs? Each was banned at some point in our history through choices that people enforced, based on values, resources, and interests. At its extreme—sometimes found in postmodern theory or literary deconstructionism—the social constructionist approach suggests that there is no reality—ontology is only preference: if we choose it, it will be so.[43] In its most radical form, denying reality and accepted morality, it is an intellectual virus sapping the strength of those hoping for social betterment.

Ultimately the question revolves around the assignment of meaning. Some scholars—sometimes labeled *cautious naturalists*—recognize that individuals have the power to make choices, but that these choices are mediated by our knowledge and beliefs about social conditions.[44] Of course, some individuals have more power than others to enforce their beliefs. These beliefs, often taught through educational institutions, shape how we see the world. In anthropologist Marshall Sahlins's terms, "there is no such thing as immaculate perception."[45] Anthropologist Shelly Errington, in *The Death of Authentic Primitive Art and Other Tales of Progress,* argues that, "Artifacts themselves are mute and meaningless. . . . Discourses create objects. . . . Objects may physically preexist those discourses and their institutions, and they may persist beyond them; but, appropriated by new institutions, their meanings are remade and they are transformed into new kinds of objects. The notion of 'discourse' also includes the notion of power."[46] Those with power determine the boundaries of art. Art audiences think of themselves as having an "eye," but according to the late French sociologist Pierre Bourdieu, "The eye is always a product of history, reproduced by education."[47] Anthropologist Sally Price argues that our appreciation and interpretation of "primitive"—ethnographic—art is always shaped by social and political categories.[48] Art worlds are, in this view, status games in which the object is a strategic pawn.

Michael Thompson, expounding "rubbish theory," suggests that some objects are defined as "durables" and others as "transients."

Durable objects—artworks, for instance—gain value over time, while transients—a car, for instance—lose value and are discarded. Thompson notes, however, that durables do not always survive and transients do not always disintegrate; the categorization is a social construction or control mechanism by those with power (and who, not incidentally, possess the most durables).[49]

Where an object fits is subject to definitional change. Howard Becker makes a similar point in his article, "Arts and Crafts,"[50] arguing that what is art and what is craft shifts over time and according to the definitions and interests of influential actors (consider the changing museum treatment of photography[51]). These choices are political in the broadest sense of that word.

Constructionists dismiss the aesthetic characteristics of works too quickly. People respond to objects viscerally and through culturally linked ideals of beauty. While aesthetic judgments are subjective, they are not random. If they are shaped by those with interests, many have interests in a pluralist society, and though contention is sometimes evident, we place objects on our walls that contribute to our self-satisfaction.

Assigning Meaning to Self-Taught Art

The constructionist perspective is based on the claim that meaning is socially assigned. As Michael Hall noted at a symposium in Chicago: "We invent it all. . . . We assign meaning to the object" (Field notes). Hall suggested that cultural historian Kenneth Ames released an "ideological virus" (the virus of constructionism) in his influential, and, for some, infamous, address at the 1977 Winterthur conference on folk art: "Ames dared to suggest that maybe folk art as such didn't exist and that the thing we call art might, itself, be just a cultural fabrication. He concluded by taunting his audience with the assertion that folk art as an idea was perhaps more interestingly viewed as a fictive construct to be studied for what it tells us about ourselves and about the worlds we invent to support the social-cultural myths we live by."[52]

Julia Ardery's analysis of Kentucky carver Edgar Tolson's reputation is predicated on the belief—correct, in some measure—that aesthetic appreciation is a contest. She titles her article, "Loser Wins."[53] This view suggests that the validation of the work serves the needs of trained regional artists to create a non-New York model of credibility, which, in turn, supports their own artistic ambitions as artists who reside outside Manhattan.[54] Similar claims might be made of Roger Brown and the Chicago Imagists, or, during the 1920s, Charles Sheeler, Elie Nadelman, and Marsden Hartley. Those with interests—artists, critics, or

social movement activists—use whatever weapon is at hand. In response, Randall Morris contends, "We must always remember that who we are looking for are not artists we have created, but artists who were already great before we happened upon them."[55] Although what a "pure artist" might be in a world in which dealers, collectors, and museums are so central is not always clear.

The growth of this domain results from new perspectives on how to *see* the work. Self-taught art has been described as "one of the last frontiers of twentieth-century American art."[56] This construction of the field created commodities out of what had previously lacked material value. Michael Hall, referring to Kentucky carvers, suggested that over time "the market emerged and there were profits to be made and there were careers to build and there was power to wield. . . . The commodification of folk art as an idea and in terms of the objects . . . distanced the material in a sense from the artist and from the original coterie of the enthusiasts who had first brought it to light. And we began to see careerism being a part of it. Self-taught artists who suddenly saw careers available to themselves. Dealers who saw careers in the promotion of the art of the self-taught . . . there's money to be made in the sale of the material if you can get your hands on it. And so professionals come into the management of this material. That means dealers. And museums start to compete to have works in the collection and this means art history. There is a legitimization that has taken place. . . . And it was a good thing."[57]

Hall, who was himself deeply involved in the creation of Tolson's reputation and who has profited from it, nicely describes the range of effects—some unanticipated—from the growth of this art world. Yet the changes that are positive for some, others reject. Folklorist John Vlach calls it " 'a fraud perpetrated by the New York art establishment. You know the book, *The Painted Word*?' he asks, referring to Tom Wolfe's famous exposé of the emptiness of modern art. 'Well, this is *The Finger Painted Word*. . . . Howard Finster's a wacko. Howard Finster and these others are eccentric to any normal image southerners hold about themselves, but it's good enough for northerners, for Yankees, who always look at all southerners as crackers anyway, as weird, as inbred, full of pellagra and cholera and any other disease, biological or psychological. Folk art is any funny looking painting, by some guy who is slightly off the edge, a guy who talks to God and God moves his hand across the canvas.' "[58]

Whether one accepts Ardery's view that the interest in self-taught art was an attack on the New York establishment or Vlach's view that it was

a conspiracy by that same establishment, all agree that artists do not sell themselves but need to be defined and sold by those with the authority to speak about art through institutionally validated cultural capital. In other domains artists are more actively involved in creating authenticity, but always there is a process of placement and legitimation.

Ideological Work

Social worlds depend on ideological formulations, even if these are not as explicit or as fully formulated as those found in political domains. Further, these ideologies are often known through practice, rather than in theory.[59] Ideology is often linked to a set of core images and emotional responses. Ideologies, in practice, are less fully developed theories than they are guides to understanding.

Often aesthetic claims are couched in dramatic rhetorical images— part of the boundary making of social cognition. In the case of self-taught art these ideological structures relate to the power of the individual, the centrality of the creative urge, and the romance of otherness. In describing these claims, I do not endorse them, but suggest that every social world creates similar humble, plain claims, and guidelines for thought.

Enshrining the Individual

From the nineteenth-century French traveler Alexis de Tocqueville onward, a large body of analysis emphasizes that "American exceptionalism" is based on the importance of the individual: the cowboy, the eccentric inventor, the self-made man, the confidence trickster. As a result, Chuck and Jan Rosenak assert that "contemporary American folk art is the collective voice of the genius of our land, a mirror of the soul of America."[60] They hear America singing.

Self-taught art is seen as ennobling the individual. That we admire the autochthonous artist, the artist who lacks formal training, reveals something about us; the European labels of art brut and outsider art place the artist in *opposition* to society, not merely *apart* from it.

One collector explained to me that he collected this art because, "It's a personal statement. . . . The intuitive artist, they're making a very individualist expression. This is like a universe which the artist has created" (Interview). This echoes the comments of Bert Hemphill and Julia Weissman in their foundational *Twentieth-Century Folk Art and Artists:* "The vision of the folk artist is a private one, a personal universe, a world of his or her own making."[61] Curator Stacy Hollander notes similarly

that "the singular note consistently sounded in the twentieth century has been the persistence of the individual, even when drawing upon convention, tradition, or heritage. Perhaps the strongest bond shared by these artists is the fulfillment of their creative impulses through a process that developed outside of the art world."[62] These claims make sense in a culture that believes that persons can create their own worlds.

Creative Urges

Individualism feeds creativity. The artist is not merely isolated, but produces powerful, emotional images "from the very heart of human expression, from the basic creative urge":[63] a new aesthetic vocabulary for an art world in which originality is the sine qua non. Thus, collectors comment: "There's a certain honesty about the work I love" (Field notes); or "They are close to the unconscious. They create archetypal themes" (Field notes). These remarks emphasize the centrality of intuition, the power of the voice within. A dealer remarked: "[Artists] are ferociously honest and they push the barriers. . . . What I like about the work of self-taught artists is that perhaps it's more easy to see the honesty in the work, and the sincerity in the work" (Interview). Of course, all valued art should be original, rather than derivative; the issue is the ideas used to justify that originality.

For the audience, an emotional reaction makes the art powerful. Dealer Joe Adams reports: "Contemporary folk art emerged because it is filled with passion! It communicates. A friend of mine says, 'You have to look at it with an open heart, not just an open mind.' It's not cerebral. You don't need someone to analyze it for you, to criticize and intellectualize. With folk art, you're either going to love it or hate it. But you're never going to forget it."[64] Or in the words of a collector: "Why are people drawn to this art? Because they connect with it. . . . I think it's something that anybody can look at and get attached. There's an emotional level that is displayed" (Interview).

While not all accept these paeans to the ineffable, and some find them uncomfortably anti-intellectual and insufficiently theoretical, these are common arguments in the world of self-taught art, helping people understand why they appreciate the work so deeply. The assumption of unmediated communication makes the works seem so potent to those who appreciate them.

The Siren Song of Romance

All domains desire to be special, and art worlds are no exception. Purity is a central image in the discourse of the field—ignoring the uncomfort-

able racial echoes in the term. The image reappeared again and again as informants attempted, awkwardly or articulately, to explain what made *this* body of work special. In the words of a museum director: "My view of it is that there's nothing pure, but this is closer to pure than a lot of the academic art that gets made for galleries" (Interview). And, yet, purity is one of those identifiers without a clear referent. These artists are very noble savages, directing our sophisticated eyes to what is important and real. Part of the reference involves emotional directness, described above, and part is a childlike innocence. A collector asserted: "The common thread that runs through all of it is a naivete. . . . Back to our intuitive core" (Interview).

Sophisticates need these exemplars of distinctiveness. Curator Roger Manley notes, "The odd thing is, I think people like . . . you and me *do* need people like Clyde. . . . Artists like Clyde Jones, Annie Hooper, Vollis Simpson and Sam Doyle, Georgia Blizzard and Lonnie Holley, through the objects they make and the environments they build, help give our communities a sense of place, help combat the modern tendency of everything toward mass sameness, toward shopping mall and fast-food, multiplex-cinema America."[65]

Such romantic images are easy to skewer. For art historian Kenneth Ames, this constitutes "a redemptive myth, a narrative that supports a heroic image of the folk artist as a fiercely independent handicrafter who, in spite of his or her poverty, was happy to be living in a democratic country."[66] Critic Alice Thorson, similarly opined of the 1990 *O, Appalachia* show, whose pieces "fulfill the time-honored American mythos of the artist as an inventive and individualistic character, while ne'er is heard a critical word toward the ideological and political superstructure which determines the world they inhabit" and "in the censorious '90s, folk art may prove the perfect antidote to offensive art. . . . Both prongs of the exhibit tap the romantic myth of the noble savage, who, uncorrupted by the taint of 'civilization,' is deemed more natural and more moral than modern, 'sophisticated' man."[67] If these artists do touch on offensive themes, their motives are typically not attributed to willful or malicious transgression.[68] Critic James Yood argues: "The enshrinement of outsider vision is a stalking-horse concealing contempt for the aspirations of high culture; it becomes a blind behind which is concealed a disinclination and antipathy toward, and ignorance of, the dictates of contemporary art. Intuitive art is seen then as the sole art of Arcadia, all else is fraudulent, mired in intellectual corruption, needlessly obscure and pretentious. What was low now becomes high, what was high now becomes debased. New York is Gomorrah, education causes loss of orig-

inality, knowledge is insidious and rejectable, and anti-intellectualism is to be defended and made officially viable."[69]

Because a group relies on ideological formulations doesn't mean that they will be universally accepted. Indeed, these images may be rejected by others through a conspiratorial vision. Some participants in the world of self-taught art are reactionary, more Jesse Helms than Jesse Jackson. Because ideological images are often inchoate, derived from other valued discourse, we must not assume that all one's social, political, and aesthetic beliefs are consistent.

Boundary Markers

Sociologist Eviatar Zerubavel set his colleagues the challenge of determining how, sociologically, people think.[70] The answer, or part of it, is that people rely on categories: circles of meaning and of value that depend on the acceptance of an inside and outside. We need to believe that boundaries are real, even if we recognize that they are constructed. One afternoon at the Outsider Art Fair I overheard a coat checker relate to a confused New Yorker, "This is the Outsider Art Fair. Whatever you think it is, it is." While this worker might be a sturdy postmodernist, her remark would have been deeply troubling to many in attendance.

As Andrew Abbott notes, a key task for any occupation is to differentiate itself from others with similar tasks and to gain authority over these tasks.[71] Occupations are continually battling each other in a form of a social imperialism. The same is true within art worlds. Each artistic domain desires to gain resources and authority: museum shows, gallery space, art history positions, publishing contracts, curatorial appointments, grants, and prizes. Given that resources are finite (although they expand and contract), each group jostles with others, especially those defined as "near" in cognitive and organizational space. Advocates for self-taught art look hungrily at experts in contemporary art, crafts, and traditional folk art rather than at experts in Greek statuary, art glass, or seventeenth-century Dutch painting. This is encouraged by institutional realities, such as competition for space within museums. The reality is that self-taught art has not done as well as supporters wish in its public recognition and museum placement, despite all the newspaper accounts of how "hot" this field is.

Two of the most important boundaries with higher status domains are those with traditional folk art and contemporary art. In turn, two boundaries that provide potential threat are with children's art and popular culture.[72]

Traditional Folk Art: The Politics of Time

From its founding in 1961 until 1966, the American Folk Art Museum (AFAM) was named the Museum of Early American Folk Art.[73] The collecting of Americana and antiques has a lengthy pedigree: certainly since America's Centennial celebration. Early American objects have a stable market, clear value, and considerable scholarship, at least in museum decorative arts departments.

The boundary, although somewhat uncertain, is real. Gerard Wertkin, the museum's director, explained to a symposium of the Folk Art Society of America that although his museum had contemporary shows in 1965 and 1970, there was "very little interest in the museum community for the work" (Field notes). The museum's magazine did not start to cover "contemporary" folk art extensively until the mid-1980s, a decade after the magazine's founding, preferring "antique" folk art—objects from the eighteenth and nineteenth centuries. The museum was started by collectors of eighteenth- and nintheenth-century material; they were the early board members and financial angels. At some antique fairs, officials check the booths for anything judged too modern.[74] The important 1974 Whitney Museum show, *The Flowering of American Folk Art*, selected 1876 as its cutoff date,[75] with Jean Lipman writing in the exhibit's publication that, "By the time of the Centennial this art reached its peak; the machine age marked the start of its decline."[76] For others, and for Mrs. Lipman at one point, the cutoff date was 1900.[77] Both 1876 and 1900 (not 1873 or 1904) were *symbolic* turning points, even if they didn't refer to any particular moment of change.

Robert Bishop, the late director of the American Folk Art Museum—a former antiques dealer, but one interested in contemporary material—commented on the 1974 Hemphill and Weissman volume, *Twentieth-Century American Folk Art:* "This book, controversial for its time, served to polarize the field of folk art. Some traditionalists who had collected eighteenth- and nineteenth-century folk art feared that appreciation of twentieth-century works would lessen attention accorded to older works in the marketplace as well as the museums. Others believed that the earlier pieces were rooted in the traditional crafts of the country and displayed a degree of craftsmanship that was missing from the newer works by self-taught artists—and in many instances this is true, although it does not detract from the innate creative impulse that is shown."[78] The question is how to enlarge the audience, smudging the boundary, incorporating contemporary work into the higher-status traditional domain.

The museum, recognizing this division, the growth of interest in con-

temporary material, and perhaps, the increased rarity and cost of older material, decided recently to establish a "Contemporary Center" in their new building on West 53rd Street. The museum will maintain its traditional material and open a new center, although the hope is that the latter will be integrated into the former. Yet one museum guard (the museum has friendly guards[79]) told me that in his view, they should use their then-current location near Lincoln Center for their new Contemporary Folk Art Center—a dozen blocks from the new museum—emphasizing the reality of the division spatially as well as cognitively.

Even now, one museum official spoke of the division: "There are very few crossover people. . . . People understand that this new crowd is dynamic, vital, and very important to our mission. We just had a new board member who is a twentieth-century diehard. . . . And he's terrific. There was not only this feeling of strangeness, but that everybody's happy about that" (Interview). She indicated that the board recently had the opportunity to purchase an important piece for the museum. Even though a traditional piece was selected, she emphasized that the contemporary piece received some "crossover" votes. The boundary is slowly being bridged, but how far and at what cost in the disaffiliation of older supporters remains to be seen.

Contemporary Art: Entering the Big House

If the label is to be taken literally, self-taught art is *contemporary* art. Often the paint is still wet. But, of course, labels do not always imply what they say. Not all living artists produce contemporary art. Six-, even seven-figure prices are common for contemporary art, though rare for self-taught art (and the seven figure barrier has yet to be broken). Add the prestige of museum shows and publications, and it is understandable that some proponents of self-taught art wish it to be seen as contemporary art. Wayne Cox, a Minnesota collector, muses, "To the art-historical-oriented camp, 'contemporary art' begins and ends with visual expressions that are created out of a self-conscious art-historical impulse. . . . To this world, self-taught art does not meet the definition of 'contemporary art' because its artists are assumed to be not art-historical-conscious. . . . The problem comes in the cultural practice of this coterie's seeking a privileged position for its narrow portion of contemporary visual expression. . . . Occasionally, 'self-taught' is allowed into the big house—but usually on suspect terms."[80]

Yet Cox—and others—note that some contemporary artists (sometimes called "neo-naives"[81]) are using the self-taught vernacular, some-

times derived from their own ethnic or class backgrounds, and, it is hoped, will bring the works of self-taught artists into the big house of the museum with them. Some major museums, such as New York's Museum of Modern Art and the Whitney, are collecting a few self-taught works. Perhaps symbolically, when the Guggenheim Museum discovered some long-forgotten drawings by the important self-taught artist Martin Ramirez in their warehouse, they asked the American Folk Art Museum to display them.[82] The prestigious Whitney biennial has included self-taught artists, Edgar Tolson, Bessie Harvey, and Thornton Dial, but no more than one per show. Established museums are conservative, not politically but aesthetically, because of the weight of art history, preferences of donors, and budgets. The struggle to enter the big house is ongoing, with each victory trumpeted as a signal of emancipation.

Contemporary art poses a second boundary problem. If self-taught art is not as esteemed as its proponents desire, some artists find it better than nothing. MFAs (Masters of Fine Arts) want a piece of the action. One elite show organizer notes that "it is hard to say where to draw the line exactly between outsider art and contemporary art. For instance, we had some galleries who had shown work that the artists had MFAs, and we found out about it later. . . . If an artist has an MFA he shouldn't be in the show. We've discouraged galleries from showing artwork that is in the folk art style . . . that is done by contemporary artists that sort of imitates outsider art" (Interview). One dealer reported with some asperity: "Now some [trained] artists are actually in competition with this work, if not appropriating an imagined version of its process, then actually trying to falsely set themselves up as outsider artists. This goes deeper than formal appropriation, it goes further than modernistic primitivism, it goes deeper than colonialism. It is as if the white traders all got off their boats on the African coast and went Native without giving anything up or back."[83] This is the problem of "folk artists with faxes." While the appropriation of primitive images and styles has long characterized the art world,[84] now it is the artist's identity that is being appropriated. Most major dealers have been approached by trained "outsider" artists, sometimes with psychiatric diagnoses to attest to their legitimacy and sometimes relying upon a general weirdness—although in this they may differ less from contemporary artists than they might imagine. A market niche exists, which these unsuccessful, but trained, contemporary artists are willing to fill. The boundary between folk and fine art must be policed on both sides of the border.

Children's Art: Boys Will Be Boys

If lack of training is the criterion for membership in this world, children should have it made. Who could have less training than a three year old? Indeed, the works of one artist, Laura McNellis, sell for thousands of dollars. She has been included in prominent self-taught art shows. As a developmentally challenged adult, Ms. McNellis has a *mental age* of three. My sons once each had a mental age of three, and they painted. Yet, currently children's art is not accepted. Informants place the work of their children on their refrigerators but not framed on living room walls.

Explaining why children's art is outside the boundary is difficult. As one collector confessed, "there's a lot of the quality of folk art that certainly is similar to the art of children." When challenged, this collector finally asserted in frustration, "It's different. You know, it's still different" (Interview).

Roger Cardinal addressed the issue in his field-establishing *Outsider Art:* "At first sight, child art strikes one as another obvious area for consideration. Do not children have an innocent, unstructured vision of things that their drawings reflect with artless immediacy? Certainly they do enjoy the lack of training that I have argued as being a positive virtue. Yet there are reasons why their work, however appealing, does not count as art brut. Dubuffet observes that the child's psyche is not very rich, and is thus unequal to that of the adult—not altogether a very convincing argument if one considers that the 'richer' psyche of the adult is quite likely to be crammed with cultural produce. More to the point is that children do not create spontaneously once they realize the interest shown in their work."[85] This is problematic in that some children do produce spontaneously; and, more to the point, some adults, well accepted as models of self-taught artists, create for a market.

One curator explained that children do not have "a body of work" (Field notes), but some children certainly paint a lot, and some recognized artists have no more than a dozen works. Others suggest that children lack the obsessive need to create that self-taught artists have, even though some children seem to create obsessively, and some adults create only occasionally, drifting in and out of artistic production. Another collector suggests that what the child expresses "doesn't impart anything more astounding to us" (Interview), but this assumes that we understand the intent of the artist.

The boundary is a sociological one. First, children lack a life narrative, a biographical story that generates interest. Second, their career is foreshortened: soon they will lose "the eye," and their work, becoming "bet-

ter" (grounded in representational realism), becomes of less interest. Unlike Laura McNellis, whose mental age remains at three, permitting her a career as a self-taught artist, these young creators evolve. Finally, they cannot participate in the market. It is tempting to see children's art as self-taught, and a few pieces might even fool collectors, but, at this point, their social placement delegitimates their work. One should, however, be cautious of this conclusion, it wasn't too long ago that some works now accepted might have been questioned, and the presence of severely handicapped artists, marketed by their families, suggests that while not everything is possible, many things are.

Popular Culture: The Problem of Cutesy-Poo

Popular culture is ubiquitous, and despite its sometimes negative connotations,[86] it knits us together as a society, prompting coffee-pot and cocktail party chatter. Yet many forms of popular culture are mass-produced, and those that are not are often based on imitation or are explicitly designed to appeal to a market. This stands in contrast to self-taught art, at least as usually understood.

Popular culture has discovered "folk art," sometimes described as "country crafts," "junk style," or "Americana." Most weekends in Illinois—and elsewhere—there are shows in which makers of these objects display and sell their work, and these shows are well attended. Indeed, this "folk art" may be more popular than the folk art I describe. It is commonplace in a capitalist economy that entrepreneurs provide accessible versions of what in their original form are more expensive or are more challenging or complex, requiring specialized knowledge or standards of appreciation. In other domains, we find homes that are described as "French provincial" in balmy suburban subdivisions or Chinese restaurants serving dishes unrecognizable in Beijing. These translations are labeled "appropriations." Whether this represents a "dumbing down" of the culture or a source of inspiration involves a set of value judgments.

This division between popular culture and self-taught art applies to works that are both outside and inside the field. Outside the boundary, scorned, stands what Bert Hemphill derided as "cutesy-poo," those objects called country crafts. Although the boundary is uncertain, these objects are too slick, too decorative, or simply made by the wrong people or the right people for the wrong reasons (i.e., multiples, explicitly designed for a market). A former dealer emphasized that even though he sold tin cupboards and pottery, "I never bought the cutesy-poo. It really bothered me to get anywhere near it. The energy from a piece of cutesy-poo spoke loud and clear at all times" (Interview). He explains, "a guy I

went to college with opened a great big wholesale catalogue selling a lot of the same kinds of things that I was buying from the original makers. But what he was doing was training hordes of people to mass-produce them, and they lost that little quirky bit of individual character from piece to piece to piece." We might term this the McDonaldization[87] of folk art, allowing some to scorn what they might otherwise treasure. Other entrepreneurs created patterns, magazines, or kits, so that every American could create folk art.

Within the field, concern over this boundary is real. For some, part of the appeal of folk art is precisely that it is has cutesy-poo appeal. Distinguished artists such as Mose Tolliver, Miles Carpenter, and Ned Cartledge have done paintings or carvings of watermelon slices, edging dangerously close to the boundary with cutesy-poo. Accessibility can be a burden. When Bert Hemphill's collection went on tour, one of the museums that first displayed it was the Indianapolis Children's Museum, and, later, after the collection was purchased by the National Museum of American Art at the Smithsonian, Robert Adams wrote in the *Smithsonian:* "It is hard to deny, for example, that some of the collection can be plausibly described as mere kitsch. But is this a real (if inherently subjective) boundary, or does the collection strive to make another point about the continuities between art and popular culture by serenely ignoring boundaries altogether?"[88] Although kitsch and cutesy-poo are not synonymous, both question whether the material is to be elevated with the honorific label "art."

Others emphasize that the field should focus on that which confronts its viewer, as opposed to art that critics contend is "whimsical," "decorative," or "funky." While the American Folk Art Museum names their magazine *Folk Art,* Chicago's Intuit: The Center for Intuitive and Outsider Art (on whose board I sit), labels their newsletter the *Outsider.* Within the board of Intuit, folk art is negatively valued, while art brut is admired. One board member, referring to the division, noted, "If we are going to be the Museum of Art Brut in ten years, that should be reflected in our programming. If we want to be the U.S. Museum of Funk Art, our programming should reflect that." After a board member asked for a definition of art brut, another joked, "You turn over a stone and something comes crawling out." That this division—honoring the nondecorative and difficult—is hard to maintain in practice was evident in the big laugh in response to the board member who asked, "How many people in the room are secret folk art collectors?" (Field notes). These men and women are struggling with the proper boundary of the field and the means of enforcing that boundary, especially given that

what they wish to exclude may precisely be that which their audience most wishes to see. Standards may conflict with popularity, as they do in policy analysis, culinary work, musicianship, and teaching.

Border Patrols: Academics and Critics

While all actors play their part in creating the field, academics and critics are given special authority. Grudging agreement exists that critics and art historians have the authority to separate the wheat from the chaff. They consecrate certain styles and artists at the expense of others.[89] One academic explained: "I think as an art historian, it's my duty to rank artists. . . . You always say this is important, this is not important, because you're trying to teach the students a way of looking at things as a way of making value judgments. And just for convenience when they go to visit places, they'll know what is the most important thing they should see there. Just for practical reasons. So I mean I feel that's my job" (Interview). While this perspective infuriates some, it is common among art historians, and students would complain about the professor who didn't help them sift and sort. They're paying good money for expertise.

A reality of academic (and critical) life is that one is known by one's topics. There exists a triviality barrier. Better to study mathematics than marbles. Better murder than mushrooming. So too in art worlds. The stature of the art one studies rubs off on those who study it, creating a hierarchy of analysts as well as a hierarchy of art.

Pedantic Games

While there are few self-taught academics, there certainly are many who are outsiders to their disciplines. Despite the impressive growth of art departments,[90] no department can afford to have specialists in all fields. Academic specialties form a hierarchy, a hierarchy that—with some exceptions, such as nods to feminism and multiculturalism—still privileges the canon of European art and contemporary American art. World art receives attention, but, in general, folk art does not. Departments teach what they, as a community, are convinced that students need to know. Most departments do not feel that students need to know about self-taught art.[91] It is considered, in the words of one former graduate student, "a lowly art form" (Interview). The College Art Association, the disciplinary group for art historians, has very few sessions on the topic. One prominent scholar informed me that although the art department at his university wanted him to teach 'ethnic materials,' they would not

let him teach 'self-taught art,' and denied credit to students who took that course when he offered it in American Studies. By one account, only twenty-five American universities offered courses in "folk art" in 1984, and some of these were in folklore programs.[92] With the exception of Robert Farris Thompson at Yale—and he is a specialist in African and African American art—there is no art historian at an Ivy League university who is known for the scholarly examination of self-taught art. A few scholars such as Colin Rhodes are art historians, but not many. Many of those who are known for their scholarship—Michael Hall (at Cranbrook) or Andy Nasisse and Judith McWillie (at the University of Georgia)—are studio artists. Others, such as Roger Cardinal (Professor of Literary and Visual Studies), Arthur Danto (Professor of Philosophy), Charles Russell (Professor of English), and Eugene Metcalf (Professor of Interdisciplinary Studies) teach in the humanities, not art history. One academic who previously taught folk art explained that she runs a museum training program, and distinguished "folk art" from what she referred to as "art art" (Field notes). A museum director, whose museum sponsored a show of self-taught art, remarked, "I'm a victim of academic training. It's not prepared me for this kind of work. I almost got a second Ph.D. in folk art" (Field notes).

According to one passionate observer, this lack of status and lack of a critical infrastructure means that those who enter the field may not have the resources for excellent scholarship: "You can't come into the field of Italian Renaissance art or classical Greek sculpture and make your presence known, as a scholar . . . without requisite credentials. . . . So you start with all the dysfunctionals in the art world. . . . You have people who [are] wannabee scholars" (Interview). While this assessment is excessive, it makes the sociological point that the position of an academic subdiscipline affects scholarship and the recruitment of scholars. Put another way: "Critics and historians in art, they really have to go where the money is" (Interview). Whether the issue is cash, grants, or status, academics are no different from other laborers in wishing their efforts to be appreciated, and in feeling, along with cooks, attorneys, and sanitation workers, that their good efforts are unappreciated.

The decision of the late Robert Bishop and art professor Marilynne Karp to establish a Folk Art Studies Program at New York University in 1981 was an attempt to legitimate the field. As Karp noted, "It was important for the field to have a major university say 'this is valid.' "[93] The fact that the program remains at the M.A. level, taught largely by scholars who are not tenure-track faculty, indicates the problem of full acceptance.

The problem is that, on the one hand, academics who examine self-taught art are given low status by their colleagues, and on the other they are given excessively high status by participants in the art world, who simultaneously scorn their "pedantic" approach. Academics are invited (and paid) to perform at those places that collectors gather, such as the Outsider Art Fair and the annual meeting of the Folk Art Society of America. Their presence signifies that the event is "serious." Yet seriousness has its price. If you can't "do," you teach or write, "analyzing works to death," a result one curator said from being "detached" and "overtrained" (Interview). Consider this acerbic observation: "There is enough horseshit written by academics in this area to fertilize a whole new world order. . . . Pick up any catalog, put on your most pompous voice, and read a critical essay on an artist of your choice and you'll have the whole room laughing in seconds."[94] These academic "flatteners," a nifty term of Randall Morris,[95] avoid passionate discourse, so important to the self-image of collectors and dealers. Thus, one admired academic is described as "a folklorist, but a very passionate and poetic folklorist" (Field notes), in contrast to the rest of the flattened tribe.

Of course, academics are passionate; it is just that they are often passionate about issues that others find esoteric. The divisions in the academic arena are quite real, and sometimes emerge, as at the 1977 "Shoot-out at Winterthur" at the Winterthur Museum in Delaware. Scott Swank noted that, "Some conferees came 'armed for bear.' . . . Some who came ready to tackle Kenneth Ames [an art historian] found the anthropologists and folklorists an even greater threat. Many with art historical training, and perhaps sympathetic to Ames's point of view, were appalled by the folklorists' analysis of folk 'art' and found many of the folklorists 'deliberately contentious.' The conference atmosphere was electrically charged. Participants readily took sides, almost as if at a political rally."[96] The battles were between folklorists and art historians, described by one folklorist present as a contest between "the Moldy Figs"[97] (the art curators, who emphasized the traditional aesthetics of objects) and the "Pink Flamingos" (folklorists, many young, who emphasized community and contemporary creations). It was said that folklorists were ignorant of art, and that curators didn't understand folklore. And so these two groups, both academically marginal, pass like ships in the night, with few ongoing contacts (Field notes).[98] One group neglects the aesthetics, the other ignores the community. Both feel aggrieved. One museum official noted of folklorists, "There had been enmity but not coming from us. They also have in some way captured [many] uni-

versity positions. That's why there are Departments of Folklore all over the country" (Interview). Actually, there is one Ph.D. granting folklore department, compared to ninety in sociology. I don't mean to trivialize these debates of my friends. Even if the pie is small, how it is cut matters. They are fighting, after all, for truth and justice—and perhaps we are better for their disputes. Yet in a field that is so marginal, one might wish that those guarding the gates would focus on intruders rather than on other guards, but perhaps it is the smallness of the stakes that makes these wars so intense.

Critical Stances

Like baseball umpires, critics cannot win. Unlike academics, critics without university affiliations do not have the comfort brought by lifetime tenure. They expose their opinions for everyone to assess with both critics and the critics of critics having their own self-interest on the line. In many fields a need exists to establish control systems that provide for evaluation. While the line is fine between scholarship and criticism, I refer to criticism as a text that evaluates and assesses a current or recent artistic show.

Dealers believe that critics attract customers and affect the value of their inventory. One dealer noted, "Some people say it doesn't matter at all whether the review is good or bad. It just matters that you're reviewed, because lots of times if you get a bad review, people want to come and see what it is that excited someone to write the kinds of things they write. I don't know. . . . I do know that being reviewed is important and that people have noticed" (Interview). The same dealer continued, "I feel like we're doing something right if we're getting those kinds of [positive] reviews." For many dealers (and curators), outside validation matters. Some dealers struggle with whether reviewers should merely inform the public of their shows, serving, in effect, as publicists for the gallery, or whether they should critique the work.

The Politics of Distaste

Who could object to a positive assessment? If you like this book now in your hands, you'll be my friend. Or, put more accurately, I'll be your friend. Yet not all reviews are kind. In reading the critical assessments of the field of self-taught art, it must be admitted that most (even in elite sources, *Art in America* or the *New York Times*), are positive. Indeed, most reviews of *anything*, perhaps to the surprise of those who have been stung, are positive or at least respectfully mixed. Of course, a single caustic remark can spoil the entire effort.

Despite the preponderance of praise, some analyses are harsh. As a former theater critic, I know that readers (as opposed to actors) love reading a caustic review. We remember the juicy bon mot, the dart in the back. The critic doesn't want to admit to liking everything, losing the trust and admiration of the audience, but in most domains, the critic has personal connections with those reviewed and realizes that an attack creates bad blood.

As a result of the belief that reviews matter, critics as a group can be scorned, as the dealer who noted (after excepting some critics as knowledgeable) that, "They don't have any of their own insights. They just repeat things that other people have already figured out. . . . They don't know shit from Shinola" (Interview).

But more than general distaste for the critical industry, some members of the self-taught art community feel that there is resistance toward their preferred art form. Consider this assessment:

> Memorial Art Gallery has invited Phyllis Kind to bring pieces handled by her New York gallery for an exhibition of more sociological than esthetic interest. Henry J. Darger, we are told, rarely spoke to other human beings, but hid himself away to produce a 13-volume manuscript, *Realms of the Unreal,* and scrolls of pretty little girls caught in such suggestive positions and with such fruity leers that even Lewis Carroll himself might faint dead away. Are we meant to giggle or weep? . . . There is no accounting for taste, and there is no explaining a joke, and there is no proving, at least in my hands, that both concept and execution of this show give off vapors of the unpleasant. . . . I suspect that it is the sideshow aspect that will pique the interest of most, and I suspect that, for some, there will even be the mixed reaction of wry laughter and slight shame that comes, perhaps after paying to see the world's fattest man.[99]

I deliberately select an assessment of Henry Darger precisely because his stature is so assured. Is this critic deliberately obtuse and resistant, or does he just not get it? Or does he see that the emperor has no clothes?

Some suggest that the nature of the work creates hostility, either because, as in the case of Grandma Moses, the work is so popular that it must be inferior, part of the "junk pile of popular culture,"[100] or because the art is too threatening to cherished assumptions. One assessment describes the problem as "an unfortunate tendency to 'pasteurize' African American art, to confine it in such a way that the anger, the cultural resistance, the essential issue of culture are hidden in the myths of previous views of 'folk art.'"[101] These writers disagree about the source of animus, but they agree that the needs of the elite art world make it

difficult for self-taught art to receive the evaluation that it deserves in the absence of these social—not aesthetic—issues.

Being a critic is difficult. It is hard enough as an academic with years to study an artist's work to develop a comprehensive, coherent theory. Doing so in a week is that much more difficult, particularly when one may receive paltry payment or notice for one's efforts. This is made more difficult when one has self-interested observers with their own theories and aesthetics reading over one's shoulder. It is impressive that most believe that there are good and necessary critics, even if there is not always agreement on who they are. The critic, after all, serves as a gatekeeper, encouraging others to experience art that had previously been unknown. In art journals and newspapers, critics serve an uncomfortable role, but in their absence an art world would have less reach.

Creating Boundaries

This chapter has explored the boundaries of self-taught art, arguing that its development is not inevitable. First, for any field *to be a field* it must be named so that it can be recognized. Boundary making is essential for any group; we are all cartographers and customs officials.

The term warfare that is so endemic reflects the vibrancy of the field. Boundaries matter, and the field is sufficiently large that distinct groups have emerged to contest with each other. In a sense, the different terms indicate that different subfields exist, but the term warfare also indicates that participants feel the need to be joined together. Whether they will when the field is more established is an open question. Often congregations or communities split when they reach a certain size or recognize different agendas. But, as yet, the field has not reached that point. Albert Hirschman suggests that in the presence of conflict, participants have the choice of exit, voice, or loyalty: to leave, challenge, or accept.[102] While some select each, the final two predominate, and so the field abides.

Participants in all fields engage in some measure of social construction, defining what matters most to them, and in the process they establish a set of values. What is happening in folk art happens in professional wrestling, photography, and New Age sects. Ideology is always under debate, as is the question of group limits.

Common, too, are the presence of oracles, wise men and women who are given the task of establishing a theory and a hierarchy of value. Academics and critics serve many social domains as magazines, journals, and news accounts have multiplied. But simultaneously there are

opportunities to challenge or resist these claims in gatherings, real and virtual, and this is particularly true in domains, like self-taught art, that are organized by those outside of the critical and academic infrastructure or in which that infrastructure is weak. For better and for worse, self-taught art remains a field, if an occasionally uncertain one.

2

creating

biography

Professor Willem Volkersz: When did you put your name on the side of the house?

Folk Artist Hans Jorgensen: Huh?

Professor: I notice you put your name on the side of the house there.

Artist: Yeah.

Professor: When did you do that?

Artist: Oh, about three or four years ago.

Professor: It's like signing a work of art.

Artist: Hah! Would you call that art?

Professor: I do.

Artist: Do you? It's not fancy.

Professor: Plain. Plain art.

Artist: Yeah.

Professor: Well, there's some people that we call folk artists. People who didn't go to school to learn to be artists.

Artist: Yeah. Well, if I went to school I wouldn't a done this, would I?

Professor: I think you're right.

Artist: I wouldn't a done it. No. This is oddball stuff. They ain't nobody else that'd build anything like this. You don't do what majority does, then you're wrong.

Professor: I think that's true. How far did you go in school?

Artist: Hah. Hah.
Professor: Don't want to talk about that, huh?

During the 1970s and 1980s Montana art professor Willem Volkersz traveled the back roads talking with folk artists, producing a set of transcripts that he bravely placed in the Archives of American Art at the Smithsonian Institution.[1] In these transcripts, we find him trying to persuade elderly men and women that they have produced things that we and they should take seriously, we hear him struggle to find common ground with these members of a entirely different social world, and we listen to him negotiate prices for his purchases. Professor Volkersz wishes to gather material (both interviews and objects) that will permit colleagues to understand that something important is happening on the unexplored byways of America. That artists do not always smoothly collaborate suggests the social distance involved. Volkersz searches for everyday genius, creativity without credentials; he often has much persuasion to do.

Biography matters in evaluating work. This is particularly true in social worlds that esteem creative and publicly talented workers—writers, actors, politicians, chefs, business executives, or sports figures. Discourse is not only about the products or the performance, but also about the performer. The nonroutine features of the endeavor direct attention toward the characteristics of the actor. Choice is embedded in the final products, and so explanations of how choosers made those decisions are relevant. These workers do not rely upon repeating recipes for action. The deed is a reflection of the self, and, thus, publications, such as *People,* trade in personal accounts. An awareness of a life story provides an enriched insight into innovative objects and events. The who explains the what. A public biography validates the subject's subsequent work, establishing a halo of worth.

This view applies to art worlds. Art history often seems a set of linked biographies, leavened with picturesque illustrations. Given the particular importance of authenticity in self-taught art, the life history of the artist helps justify the art. Russell Bowman, the former director of the Milwaukee Art Museum, noted, "Biography plays a critical part of our notion of self-taught art. Indeed, our endless categorizations . . . revolve around biographical circumstances of artistic or social awareness."[2] But how are the lives of artists presented, given the need to establish authenticity as a primary criterion of evaluation? How do we draw boundaries for the inclusion or exclusion of artists; how are biographies managed, reputations built, and narratives of discovery shared?

At a 2000 Kohler Arts Center symposium on "Constructing Boundaries," I spoke of self-taught art as "Identity Art." For this phrase I was criticized by those who felt that the work was central. The work matters, of course—many untalented people have compelling biographies. Yet dealers sell the work by providing biographical details, details that are not emphasized to the same degree by neighboring galleries specializing in contemporary art. Perhaps they, uncomfortably, cater to their clients, but the identity of the artist is embedded in definitions of self-taught art and in the practice of selling. This is a field with "new discoveries," as opposed to "young artists," emphasizing the dealer's (or curator's or collector's) role in the selection process.

Authentic Artists

A dealer once commented to me that the status system of the folk art market is upside down. He was at a party and overheard someone ask about an artist, " 'Is he educated?' . . . 'No, oh good!' . . . 'Is he black?' " (Field notes). An artist sells signs that read: "I love folk art. I think the uneducated do such good work that I also have a folk accountant" (Field notes). A gallery owner reported, "A woman walked up to me at a show and said rather haughtily, 'My daughter and I are Outsider Artists, but because we're white and middle class, nobody appreciates us,' and I said you can't be an Outsider Artist and stand there and tell me you are" (Interview). This is a world in which standard criteria for determining status do not apply.

However, the phenomenon is not unique to this artistic domain. Americans yearn for authenticity, dismissing the plastic culture that critics find everywhere. Scholars—we might label them "authentologists"— have, of late, begun to question this idea, suggesting that our "search of authenticity" is illusory, although embraced in both academic and popular discourse.[3] Miles Orvell finds a fundamental tension between imitation and authenticity in American culture, with the latter increasingly venerated in the twentieth century. We search for "the real thing," as we mistrust that machines can reproduce originals.[4] Said one prominent collector, "There is a yearning for a table that is hand-made" (Field notes). French sociologist Raymonde Moulin speaks of an artistic ideology of the unique—part of the "return to nature" and the "return to artisanship"—a social and aesthetic evaluation (borrowing from Rousseau and Ruskin) producing rarity and value.[5]

Not incidentally, objects defined as reproductions (notably mechanical multiples, but also repetition by an artist) have a different price

structure, making them more accessible, yet less available as a status symbol. Genres such as photography, easily amenable to duplication, struggle to create the idea of the unique by emphasizing the importance of the original print.[6]

Some argue that it has become difficult to distinguish the real from the simulacra, except through narratives of origin.[7] Even the American Folk Art Museum, through their education branch, the Folk Art Institute, offers classes on "Country Tin Painting," "Crazy Quilts," and "Folk Portraiture." To be sure these classes, labeled "craft heritage," teach techniques and do not promise to create folk (much less self-taught) artists, but they do involve smudging of the real and the simulated. Authenticity implies "to authenticate," and so is linked to a market economy.[8]

Students of primitive art have come to believe that "authentic primitive art" has died, in that all creators are now influenced by a global mass culture. One dealer in ethnic jewelry remarked of her former sources, "It's all going downhill. These people used to lead such beautiful lives, and now they have pink plastic shoes. . . . So everything *real* is going up in price, because they're not making it anymore."[9] We search for "primeval authenticity," linked to alienation and isolation from established institutions.[10] Pink plastic shoes are not real.

Richard Peterson's *Creating Country Music: Fabricating Authenticity* argues that as early as 1953 record producers searched for "authenticity" in musicians.[11] Institutions, in this case the Nashville music industry, fabricate authenticity, just as they fabricate the vinyl from which records were produced. Similarly, as David Grazian points out, the performance and selling of the Blues as an authentic experience must be carefully crafted by entrepreneurs.[12] These artists come from the same backgrounds of the artists I consider here. Julia Ardery makes the same point about carver Edgar Tolson's authenticity:

> Folk art has accorded with the longings of middle-class Americans. It evokes times past through agrarian, religious, and patriotic imagery, through its wrought evidence of the human hand, and, crucially, in the period under review here, through the charisma of the folk artist—typically a rural elder like Tolson, who is assigned the part of a crusty, mythical grandparent. An object of nostalgic desire, folk art satisfied fantasies of anchorage, tenderness, and control among those who by choice and social circumstance cannot find such satisfactions otherwise.[13]

Social scientist Theodor Adorno speaks of "the jargon of authenticity."[14] Of course, claims that "we all" value authenticity have an anecdotal qual-

ity to them, and may reflect an academic fantasy as well as a public one. Yet many people, including self-taught art-world participants, embrace this rhetoric.

Valuing Authenticity

In a symposium at the Outsider Art Fair, Gerard Wertkin, director of the Museum of American Folk Art, exhorted his audience, "This is an amazing field we're in. . . . It has more power and has more of an authentic voice than most of the art we look at today. It is that authenticity that invites us in" (Field notes). For Wertkin, true authenticity is rare, and this rarity validates the work. Members of this art world have a strong preference for early, "uninfluenced" works by self-taught artists, although later works may have more artistic power, as the artist *learns* from experience, but such a view often flies in the face of the assumptions of the field. Beyond drawing our attention to art-world preferences and their implications that artists are incapable of learning, this view differentiates between the early (authentic) and later (synthetic) art. These classes of works are not only distinct, but belong to *different categories*. In this, self-taught artists become naturalized; their gifts are in their backwoods genes. The same desire to naturalize is evident in the comment of a curator who says of "deaf and dumb" artist James Castle and others, "You have to understand that they have a natural-born instinct" (Field notes). This naturalization of Idaho native Castle is intended honorably, but it is not something that one would likely say of Wyoming-born Jackson Pollock—an artist, but not one who is defined as having natural-born instincts.

It is easy to parody this desire for authenticity, as did writer Larissa MacFarquhar in a 1996 *New York* article, "But Is It Art?" In this much discussed assessment, published the week of the Outsider Art Fair, Mac-Farquhar argued that the field is characterized by: "a somewhat maudlin, neo-modernist longing for art that feels *authentic*—the product of social exile and misery, not northern-lit studios in the Hamptons. Outsider art fits the bill perfectly: A typical outsider either lives in a rural hamlet in the South or suffers some sort of debilitating mental disorder . . . outsider art is supposed to arise, twisted and singular, directly from the unconscious."[15] The presumed rarity of these artists—and their "defects"—contributes to the rarity of the art.

The Un-Real

Once I spent the afternoon at the home of a prominent self-taught artist. The home—nearly a shack—was badly in need of repair and had a musty,

pungent odor, absent in professorial domiciles. It was located in what might be called the backwoods—the first boost to my self-esteem was finding the house, after several false starts. I was greeted warmly by the artist and a brood of emaciated cats, even though I was not expected. The artist, gaunt, nearly toothless, sometimes incomprehensible, commented how nice it was to have visitors, other friends having long ago died. The artist's overweight daughter padded around. This was real! I had arrived! I was able to peel off several crisp hundred-dollar bills to pay for the work I desired before driving off in my late model car.

I poke fun at myself, but the images are real. We desire a hard-fought, gritty reality. Some self-taught artist homes are described as "real places," others are not. Dealer Lois Zetter noted, with what I take to be ironic detachment, "If one had a [James] Castle and was for some reason going to part with it, potential buyers who may be a tad, shall we say, unsophisticated might balk at the 'spit' part of the ingredients—But we! who 'get' it! It adds a certain frisson, I think."[16] Spit, Castle may have, but no polish. One collector jokes about dealers who say of their artists, " 'He is actually a retarded child who, at age eight, tore off his right leg, and had nothing to do and so he has begun with his one tooth that sticks out at a ninety degree angle—he's begun to paint these paintings, and he does it only to certain music.' Oh, come on!" (Interview). As dealer Randall Morris notes, those artists whose authenticity is beyond question are the ones whose work sells in the six-figure range, such as Martin Ramirez or Bill Traylor.[17]

If authenticity sells art, claims of inauthenticity can be damaging. Ironically, collectors themselves can set this process in motion by suggesting themes and materials. The patron can destroy both the authenticity of the object and the artist's financial future.[18] Something similar apparently happened with Georgia artist J. B. Murry, as two patrons each felt that the other was overly influencing the artist by giving suggestions and providing material (Interview). Such artists are no longer "creating from the heart," being driven to be more marketable. Providing advice about marketability is perfectly proper from contemporary gallery owners, but is seen as questionable in the self-taught domain.

Authenticity can be lost, but not regained, a problem shared by well-established artists too attuned to the market. Just as self-taught artists should not be MFAs, they also should not be MBAs.[19] Some suggest that the Reverend Howard Finster was seduced by the market, despite his often-expressed intention of proselytizing by getting as many pieces as possible into the hands of potential converts. Still, the work is treated as if the creation of the rare aesthetic object was his primary goal. Finster's

early work is revered by collectors and is expensive. His later works (those after the late 1980s) are cheaper, more mass-produced, and are less regarded and worth less. Many assumed that by the end his family was doing much of the work. One collector commented about works dated when Finster was hospitalized: "This is not good. Right there that throws a wrench into *the idea of Howard*" (Field notes; emphasis added). The toll-free number (1–800-FINSTER) and price list didn't help. Finster is given a pass by some because, as a minister, he wishes to "get the word out," but few suggest that his output of the last decade of his life is very significant aesthetically. Said one collector, Finster has become "too discovered. . . . infected by popular acclaim" (Interview). Of course, nineteenth-century itinerant painters marketed their work, too, hoping to discover what would appeal to their audience. This work is enshrined as traditional folk art with its original production motives and marketing strategies erased.

One Chicago collector wondered about their local artist, Henry Darger, performing unskilled labor in a hospital, unknown as an artist until after his death in 1973: "Would we have wrecked Darger if we had discovered him?" Added another, "Would we have turned him into Howard Finster?" (Field notes). Commented Bruce Johnson, former director of the American Folk Art Museum: "I have trouble with many of these [twentieth-century works] because the artists, as soon as they reach a point of commercial success, quickly lose the innocence I like about folk art."[20]

Recalling my experience, described above, consider the following: A collector who had purchased the work of a recently discovered southern artist, and was quite enthusiastic about it—she described the artist as "really untutored"—later told me that she now finds it "bogus." She explains that he is the wealthiest person in his (rural) town, living in a "nice new rustic house." She adds, "We lived with it for two weeks before we began laughing at it. . . . We fell for it. Everything is so overdone. So hyped. This guy is rich!" (Field notes). This collector, living in an upscale suburb, admired the piece until learning more of the artist's life story. The piece now resides in her basement. The meaning of the painting changed as biography infected aesthetics. For some, self-taught talent should be linked to economic struggle.

Marketing can be a four-letter word. A dealer noted of one of her artists, "He's very well-organized and has a color Xerox of all his paintings, and does duplicate paintings of some of them. . . . So, in a sense he's sort of commercialized himself. . . . I don't show people his color

Xerox brochures, because I think that detracts from his authenticity. I think he is authentic, but I think it turned people off. . . . I don't think they should be really good at marketing themselves. I think it detracts from their authenticity [She laughs]" (Interview). Career skills taught in art schools are counterproductive.

Drawing Lines

Given the concern with the real, how can one distinguish an authentic artist from one who is inauthentic? Take the case of Albert Louden, a British artist, whose career was detailed by John Windsor in *Raw Vision,* a leading journal:

> It isn't easy being an outsider. Once elected, there are appearances to be kept up: the solitary lifestyle, the nutty habits, the freedom from artistic influences. Above all, indifference to earning money. Scrounging for canvas and paint, going without luxuries such as food and socks, are all part of the life of austerity that one's public demands. In the end, the outsider's surest way of proving his integrity is to be dead. [Louden's] crime is that he broke the outsider's vow of poverty—by selling his paintings to commercial galleries. Such is the outsider's Catch 22. Some of the very dealers who bought and sold his work now regard him as the ousted outsider. Untouchable. He might as well be mainstream. A self-taught painter and van driver by trade, Louden lives on his own in a tiny two-story [house]. . . . He pads barefoot from room to room riffling through the stacks of paintings, whose sheer number, overflowing into garden sheds, hints at obsessiveness. Outsider bonus point.[21]

The author argues that Louden is punished for his desire to be commercial. I do not know whether Louden is or is not an outsider artist or whether the claims are just. What is important is that the author defends him by bringing up his eccentricity, his poverty, and that he is self-taught, while others (in this narrative) reject him because he is too attuned to the art world. This is the line that distinguishes "art artists" from "folk artists."

The drawing of lines is particularly problematic for educated artists,[22] with one dealer denying that every authentic self-taught artist requires an "anti-resume."[23] I know of one artist who felt that a law school education did not disqualify her as an outsider artist, because of her psychiatric difficulties. I once had a lengthy conversation with an artist—eccentric, visionary, underemployed, the subject of a laudatory article in *Raw Vision,* included at two shows at the American Visionary Art Museum—but

who took art classes at two Ivy League universities, was represented by a New York contemporary art gallery, and was a friend of some prominent contemporary artists. He said that he didn't "feel" like an outsider, and doesn't call himself that. Is he right?

Or what about Mary Nohl, trained at the School of the Art Institute of Chicago, but having turned her home in Milwaukee into a "folk" environment and was included in Betty-Carol Sellen's *Self Taught, Outsider, and Folk Art: A Guide to American Artists, Locations and Resources.*[24] She was described by a curator at the Kohler Arts Center as having "an obsessive need to create" and by another as having "an outsider sensibility" (Field notes).

Finally consider the late Malcolm McKesson, eighty-seven years old at the time, as described by his advisor, an art history graduate student:

> In terms of Malcolm being an "outsider", self-taught, folk artist, etc., I have somewhat mixed feelings. Clearly he is being marketed as an outsider. He shows . . . at the Outsider Art Fair where many people have collected his work. . . . His work is in the [collection of] the Musee de l'Art Brut in Lausanne. He lives a relatively reclusive life in his rundown New York apartment. In many ways, he is completely in his own world—he has been obsessively working for decades with no real interest in sales. His work is clearly obsessive and clearly driven by his sexual fantasies which are quite "exotic" to say the least. However, he is a Harvard graduate, relatively well-traveled, taught art education at schools and is a very literate, intelligent man.[25]

Without meaning to offend, one might ask whether being weird trumps being trained—a question that is particularly apt for trained artists with psychiatric disorders. Strange people populate all kinds of galleries, even, in some cases, as dealers. I'm not referring to the "faux-naive,"[26] in which a trained artist may intend to deceive, but to the artist who straddles the border: wealthy, educated, sophisticated, but distant from the mainstream art world.

Curator Lynne Adele speaks of a "gray area" between trained and self-taught, suggesting these categories do not perfectly describe the experiences of particular artists.[27] This blur led Jean Dubuffet to create the category New (or Fresh) Invention for artists too influenced by mainstream art to be considered exemplars of art brut.[28] A significant number of artists who exhibit with self-taught artists may or may not be defined as "self-taught, outsider, or folk." Of course, in a market-driven field, theoretical debates are secondary to whether dealers show the work, critics accept it, and collectors buy it.

Forging On

In a world in which the identity of the artist matters—and it matters in virtually all art worlds—forgery is a dangerous and common business.[29] Originals are superior—aesthetically and materially—to fakes, copies, and replicas, and, so, a group of technicians, art historians, are provided with an assumption of expertise to police the boundaries that might not be recognized otherwise.[30] Forgery represents the inverse of plagiarism. In the latter one passes someone's work off as one's own, in the former one passes one's own work as that of someone else. Of course, in both instances, the deceiver receives the material benefits of the deception.

Some who view works of self-taught art remark cynically, "I could do that, easily." For the forger that is a challenge. Dealers and collectors contend that forgeries of virtually all the leading figures in the field are circulating: Bill Traylor, Mose Tolliver, Sam Doyle, David Butler, Reverend Howard Finster, Sister Gertrude Morgan, William Edmondson, Clementine Hunter, and William Hawkins to name but a few of the major examples.

The number of forgeries in this—and other—artistic domains is unknown; it is often remarked that we know only the poor forgeries, the good ones are still on museum walls. It was once said of the nineteenth-century French artist Jean Baptiste Camille Corot that of seven hundred Corots, eight thousand are in America.[31] Dealers and collectors joke about "factories" turning out works by top self-taught artists; in the words of one dealer, talking about forged Traylor's, "it's easier than printing money." Sotheby's pulled a William Hawkins (with a $7,000 estimate) from auction because its provenance was "questionable" (Interview).[32] At times, the collector is impugned for desiring to get work cheap, to get "a deal," an instance of blaming the victim. A dealer remarked of a collector who he believed owned many fakes, "He was relying on one guy to bring the stuff, and he wanted to buy cheap. He's notorious for buying cheap, and this guy was pleasing him. He was bringing him stuff, saying 'that's a Sam Doyle. I'll sell it to you for a thousand dollars' when it might have been $4,000 for a Sam Doyle at the time, and everything in his collection that was not cheap, was fake" (Interview).

Several types of forgeries exist.[33] The rarest is the exact copy. It is said that a forgery of the *Mona Lisa* is on display at the Louvre (it was stolen in 1911 and not recovered until 1913[34]), and the real version is held in a vault by a wealthy art lover. Most forgeries are what are known as "palimpsests," works that claim to be by an artist and which use their style, themes, and images. Since artists—particularly self-taught

artists—routinely use a set of images, this is plausible. Other forgeries are what we might label "original forgeries," in which a forger uses the style (and often the signature), but creates a new work, such as the famous forgery, "Vermeer's" "Christ at Emmaus" by Dutch forger Han van Meegeren. The work is what Jan Vermeer might have painted had he attempted religious images. Still other forgeries are over-enthusiastic restorations. It is legitimate in the art world for restorers to fix paintings that have fallen into disrepair.[35] Some restorers do too much. Paint can crack on those works that stand in yard environments. Painted metal cutouts from Louisiana black artist David Butler with bright, unweathered colors lead dealers to wonder about their provenance, since most of his works were left outdoors (Field notes).

Then there is the question of the forger's identity. This is a world in which artists do not necessarily follow the rules and, indeed, that contributes to their authenticity. Is the artist who permits his family to help—as is said of Howard Finster, R. A. Miller, and Mose Tolliver—acting improperly? Are they similar to classical artists with their students and workshops or to cartoonists who let others draw the backgrounds of the strips? Does their folk stature permit communal production?

As Howard Becker notes in *Art Worlds,* art is collective activity; someone makes the frames, forges metal, and builds scaffolding.[36] How different is self-taught art from the work of Frank Stella or Robert Rauschenberg? How much brushwork does one need from Howard Finster for the work to be a Finster? Surely a signature is too little, but beyond that the boundaries are uncertain. An "Annie Tolliver" is worth less than a "Mose Tolliver," and so some dealers wish to attribute the work of the one to the other. With regard to Tolliver, one auctioneer asked prior to selling one, "Does anyone have a problem on this Mose Tolliver?" When no one responds (and why should they respond, if they won't bid?), he sells the work, insulated from criticism (Field notes).

As a result, there is desire for authentication. The Outsider Art Fair has had a "vetting committee" to deal with forgeries.[37] Sometimes restorers are brought in to examine important works that "look wrong," although the tests that are applied to older works are not reliable for contemporary works, so authenticators rely on their "gut feeling" (Field notes). Anyone can get access to the same materials as self-taught artists. Because of their value, simplicity, and ease of forging, the works of Bill Traylor are most often checked.

Forgery is a threat and a crime, but why? At a symposium, one member of the audience asked if the panelists had seen forgeries. After one dealer answered yes, another panelist added, "The next question is: Does

it matter?" The audience laughed (Field notes). If all we cared about was the work, we should be grateful for more Vermeers, Edmondsons, and Traylors, particularly if we were unable to distinguish the forgery from original. In such a case, aesthetics can't—by definition—be at issue.[38] Obviously there is the question of fraud, but there is also a claim that forgery is "cheating history."[39] Collectors and dealers are alternatively amused and angered at the objects that they recognize as forgeries. The problem rests with the ones that they don't recognize—works that may change their impressions of the artist's creativity. The importance of forgery throughout art worlds is evidence that there is no untangling aesthetics and financial value, as both are wrapped together in bands of morality.[40]

Identity Art

I don't know Clyde Angel. Neither, it appears, does anyone else. If God ever creates a self-taught artist, He might name him Clyde Angel to denote a combination of backwoods culture and divine inspiration. Betty-Carol Sellen provides Angel's biography:

> Angel, Clyde (b. 1957). Clyde Angel was born in Beaver Island, Iowa, and is a "highway wanderer" who makes his art from scrap metal he picks up along the road, often tin cans and rusty car parts. He is a recluse who lives somewhere in Iowa and does not want to know people or interact with society. Angel says people can know him from his art and the writings he often includes with it. He learned rudimentary welding techniques from a welder/fireman who became a friend and who allows Angel to use his tools. He makes two- and three-dimensional figures of imaginary women, men, and animals.[41]

It is also reported that he has been hospitalized as a paranoid schizophrenic.

Clyde Angel is currently represented by the Judy Saslow Gallery, a prestigious Chicago gallery, and his work sells for up to $1,500. Saslow hasn't met him either;[42] his work—along with his writings and videos— is delivered by his friend, his "authorized agent," Iowa sculptor Vernon Willits.

In the weekly *Chicago Reader,* journalist Jeff Huebner recounted his unsuccessful attempt to track down Angel, even combing birth records from Beaver Island, which is today uninhabited (there were apparently no births on the island in 1957), examining county school records, and talking to former island residents.[43] Perhaps for legal reasons, the author

Ram Dass by Clyde Angel (b. 1957), 1997, welded steel, 36 × 15 in. Courtesy of the Judy A. Saslow Gallery.

didn't reach a firm conclusion, suggesting that "Some people believe in angels; others don't."[44] The general opinion of the secular art world—which has whispered about Angel's authenticity—is that Clyde Angel is a moniker used by a trained artist.

My concern is not to track down the elusive Mr. Angel, but to ask about the power of biography. Put another way, I ask whether it matters

if Mr. Angel is real: the sculptures are real, so the question is whether it matters if the biography is accurate. One writer suggested, "it wouldn't surprise me if it was a made up story and *who cares anyway. [If] the work speaks for itself that's all that really interests me.*"[45]

Perhaps the question is how it matters, in that it surely does matter if dealers have been providing collectors with inaccurate information. One might ask why a prominent and respected dealer, such as Judy Saslow, would be willing to take the risk. Saslow was so confident in the work that she included it in the Outsider and Folk Art show from Chicago collections that she organized at the Halle Saint Pierre in Paris in 1998.[46] She explains that, along with the art itself, the "mystery" is part of the appeal: "Privacy comes with the territory—it's part of the deal. If you love the art, you accept the terms of that. I just try to enjoy the finished product and try not to ask any questions. If I ask too many questions, I spoil the relationship. I respect it, not just for business reasons but also because I don't want to betray any trust or confidence. It wouldn't be fair. Any good story has a hint of mystery. It's an unusual story, but not a singular one. Clyde's singular personality is what makes the work more unusual, but the rest is none of my business."[47]

Surely most of the details of biography *don't*, in fact, matter. If Clyde Angel were not his birth name, if he were not born in 1957, if he never lived on Beaver Island, none of that would really matter in a world that is used to pseudonyms. We could accept John Jones, born in 1960, raised in Dubuque. More important, essential even, is the fact that he was mentally ill, is homeless, and, especially, that he was not trained at art school. Facts have different weight in the creation of an outsider artist.

The battle over biography reminds us that, in the words of Chicago dealer Carl Hammer, there is "a heavy reliance upon the extremism of the story and not consistently on the works of art."[48] For many, it is not simply the work, isolated on the white wall of a museum or gallery. In the words of New York dealer Randall Morris, "no work can speak for itself . . . because without knowing its original context we are listening to ourselves, not the voice of the work of art."[49] Further, the uncertainty of the art world's response to Angel's work, particularly prior to the *Reader*'s account, suggests that contrary to some confident claims, one cannot judge from the work whether the artist and the work are "authentic."

Biography—and reputation—matters, but how much? A tension exists between those who emphasize biography and those who emphasize the artwork. In this way, this artistic domain differs from most others where it is clear that the art has priority, even when it matters—and matters greatly—who the artist is. The biography of Jennifer Bartlett

or David Salle is not central to the appreciation of their creations, although their signatures may be. As one former dealer told me, "if you buy a Rauschenberg, . . . you're not interested in whether Rauschenberg is married and has children and whether he lives in a pokey little home" (Interview). An arts writer noted, "These circumstances [poverty, racism, religious conviction, illiteracy] should not be used as neat anecdotes to show how 'different' the artists are, pushing them further 'outside the white-walled rooms' of art history. Imagine if every scholarly discussion of Jean-Michel Basquiat's work focused on his heroin addiction and whether or not he was ripped off by drug-providing collectors. . . . Consider if every lecture on the Renaissance masters was interrupted to determine if the Medicis commissioned any of the work, exercising undue influence on its style and content."[50] Perhaps one is buying the name, but not the story. In contrast, in self-taught art few in either "camp"—the biographical or the aesthetic—would deny the value of the other. No one places ugly objects on their walls and few have no interest in who made those objects. The issue is the weight one gives to each.

Bio First

I once began a talk by asking a question of sublime ignorance—ignorance with a subversive ring. I asked: Can anyone tell me how I can become a folk artist? The question was absurd on its face. How could I, an educated academic, become a folk artist? I had the wrong biography, the wrong story, the wrong life. I am not "folk," not "outside," not "self-taught," and, barring mental illness, could not be.[51]

I jest, but the reality of biographical narrative is important. Collector Chuck Rosenak refers to this as "the legend of the artist," a basis for labeling art and estimating value. In the case of Edgar Tolson, his violence, religion, alcoholism, health problems, his many children, poverty, and isolation each contributed to the value of his work.[52]

These biographical accounts matter to many collectors; they buy stories that they share with visitors when they display their art. This is so evident that a journalist once remarked that the "Outsider Art Fair is about stories."[53] One collector explained, "In many cases with this work, the story is far more important than the art is, and people are buying the story as opposed to the piece of art for art's sake. . . . There are artists I've supported financially just because I like them, and I like their story, but not because I believe the pieces are outstanding" (Interview). A gallery employee explains, "I do buy pieces that I don't like. I mean I've bought art before that I haven't really liked when I first look at it, but as

I learned more about the people and more about the process and where it comes from, I gotta have the piece" (Interview). It is remarkable that collectors admit—without embarrassment—to purchasing works they don't admire, but such is the lure of the story. In the words of one curator, biography is the "calling card of the field. . . . It's not the work itself" (Field notes).

Stories affect purchases. At one gallery, a couple was told a story about a homeless artist who made jewelry from Mardi Gras trash. The husband doubted the story, but the wife told him that the story might be true, and, as the pin was selling for $30, the story was worth the price (Field notes). On another occasion, a collector commented critically about a dealer who was selling work by an artist who lived under a bridge, noting, "She was pulling on our heartstrings. She was piquing our curiosity. It was like selling tickets to a freak show." Her husband added, "We bought on emotion" (Field notes). The recognition of the manipulation did not prevent the dealer's strategy from working. Some collectors specialize in troubled domains, "asking for work from specific pathologies, schizos or autistics."[54]

Both dealers and curators play on the emotions of their audience. At a symposium at the Outsider Art Fair, curator Brooke Anderson told of Kevin Sampson (seated in the audience) who became an artist after three tragedies in a single year: a cousin who died from AIDS, a son who died as an infant, and his wife who died from a heart condition. She notes that his early work was a tribute to them, and he collected materials at night so he could be a devoted single father (Field notes). On another occasion, a dealer described the tragedies that had recently befallen an artist whose work I had previously purchased: her house was flooded, her adult son with a mental age of five who had been institutionalized fell off a ladder, splintering his leg, and had to move home, and she almost died from an eye operation. I sensed that the dealer was attempting to increase her "biographical value" (Field notes). The artist's bad fortune was good fortune for her dealer.

To understand misfortune as a marketing strategy, consider Robyn "The Beaver" Beverland. According to Betty-Carol Sellen:

Beverland, Robyn (1958–1998). Robyn "The Beaver" Beverland lived in Oldsmar, Florida, in a house next door to his parents. Robyn enjoyed helping his parents in their yard and even more he enjoyed the pleasure he gave to people with his paintings. He had a very rare disease called Wolfrand [*sic:* Wolfram] Syndrome, which left him blind in one eye and only partially sighted in the other. He also had diabetes and a mild case of

cerebral palsy. Yet he was a cheerful person whose world was his family, his Bible, and his art. He painted "from his own mind's experiences" and used housepaint and plywood or cardboard. One of his most often repeated images was one of several faces of different colors called "We Are All One." After several bouts with pneumonia, "The Beaver" spent his last months on a respirator and died August 20, 1998.[55]

Upon his death, his parents placed a full-page ad in *Folk Art,* the glossy magazine of the American Folk Art Museum, in his memory, thanking his collectors. The text of the notice read, in part, "Robyn's world was His Family, His Bible, His Town, His Art Work, and YOU, the thousands of beautiful people who smiled when you viewed his little paintings. . . . EVERY DAY WAS A BEAUTIFUL DAY TO OUR 'BEAVER.' . . . He never once complained about his condition. To him, his purpose in life was to make others happy. . . . He just wanted you to smile at his art work. . . . Maybe GOD will let him paint the HEAVENS now and then—Robyn always called his paintings 'HIS CHILDREN.' Robyn, your children will live forever."[56]

The Beaver would sit at a booth at art shows and would happily paint. His family sold his works for modest prices (typically less than $100). I met The Beaver and can confirm that he seemed contented, friendly. Yet I confess that I found the episode rather creepy. Without his story, I wouldn't find his works compelling. To say hello to this gentle man was awkward, even in the guise of fieldwork, since I had no desire to purchase his work. But he did sell his work, and his work did make (low-end) collectors smile, even while his presence upset other collectors who felt, despite their sympathy, that he made the event into a freak show. One small dealer explained, "I like happy things and I like The Beaver tremendously. I think he is a very, very special person. . . . [His mother, who owns a quilt shop] told me that some days she's a little down, and the Beaver makes her day a lot brighter. And he makes my day brighter every day. I look at it every time and I smile every time. . . . It's not blue chip art, but it's pretty special" (Interview). Can one say that of Anselm Kiefer? Art has different functions for different audiences, and The Beaver's story, linked to his work, met the emotional needs of his audience better than many who are pictured in *Art in America.* His biography was what Wendy Steiner referred to as a "frog-prince parable": the sufferer who through his art finds—and gives—satisfaction.[57]

Art First

Phyllis Kind, a prominent New York dealer, often referred to as the doyenne of the self-taught art world because of her longevity and stature,

Robyn Banks "The Beaver" Beverland (1957–1998) with *Self Portrait*

explained to a critic interested in discussing biography that she is "interested in art and not sociology."[58] Her point is that it is the object that matters. The previous section will distress those who wish this art to be taken seriously and to enter art history, even if this means that the more elite players may wrest the field away from those with less status.[59] Julia

Ardery's account of Edgar Tolson's rise—even though it might be taken as a *critique* of the biographical approach—was criticized on this basis by one reviewer: "The primary focus of [many people in the field], as opposed to Ms. Ardery's, is not on the biography, the ethnicity, or any other affiliation of the maker of a work of art but on the work itself."[60]

Consider the comments of two respected dealers:

I'm absolutely not interested in anecdotal information about the artists. I think it is demeaning. So we'll put together a resume for a self-taught artist just the same way we would for a trained artist, but I'm not interested in whether they're left-handed and black, or whatever the hook is that people are hanging work [on] today. . . . Lots of it's being sold on, "He's autistic, he's in a mental institution, he was born a . . ." whatever, as opposed to saying, "Look at it as a work of art."[61]

★ ★ ★

I went to a show years ago in Cincinnati and I looked at a piece and it looked like an imitation of Dali. And I said, you know, why is this here? It wasn't appealing, it wasn't interesting. It looked like a bad imitation. It looked more like a thrift store painting than something that should've been in this museum. And the person said, you should hear the story of this guy. Well, that's ridiculous. If the story is what's interesting and appealing, then write a book. Don't hang his work. . . . People are losing sight of the piece and embellishing it with stories. . . . If I happen to know that he had fathered illegitimate children or his wife left him 'cause he was an abuser, I wouldn't share that with you. . . . What I'm pulling away from is The Beaver. (Interview)

Or consider the exhibit of several dozen artworks of Sybil, the woman with multiple personalities.[62] A dealer noted that, "the article ends by saying that the paintings aren't very good, but the story is fascinating. The implication running through it is that Outsider art really isn't very good either but the stories sure are. Again the battle cry: art before bio."[63]

An artist—not, I think, a self-taught artist—noted that clients expected these details, "Why, you may ask, does a person have to buy a story as well as a piece of art? This is a question with which I've grappled for a long time, and not merely within the context of folk art. . . . When I would meet people who had already seen my work, they would often be disappointed that I was not (pick one): divorced, obese, in therapy, from another country, and several other equally random categories that they somehow inferred from my work. It was as if, in my still married, average weight, untherapized, American-born life, I was not . . . authentic. My

paintings were not supposed to stand on their own; instead, they were supposed to be props for my personal dog and pony show." [64]

We are left with a puzzle. The art is important, but knowledge of the artist helps to enrich the experience. What to do? A sociologist would emphasize that one should examine the social context in which the work was created. In the case of Martin Ramirez to focus only on his personal pathology—schizophrenia—is, at best, a partial explanation. To ignore the artist's impoverished upbringing in Jalisco, Mexico, his experiences as a migrant worker in Los Angeles in the early decades of the twentieth century, and his experiences of mental asylums is to enrich our knowledge of his creativity. None of these experiences happened to Martin Ramirez alone, but affected social groups of which he was a member. Yet his genius and his pathology permitted his art and his life to take the specific form that it did. Although some might consider Ramirez to be a "sad case" or a "tragic hero"—turning his life into a literary genre—his life is uncomfortably similar to many others, shaped by the same social forces. This contextualism represents how a sociologist— as opposed to a psychologist or an art historian—would address the role of biography and art. As C. Wright Mills argued in *The Sociological Imagination,* sociology is at the border of biography and history. [65] Or, as a dealer expressed it, "The biography of the culture is more important than the biography of the individual" (Interview).

Constructing Biography

Although it would be nice to think that biographical accounts reflect the lives of artists, such is not always the case, a problem that some find with Clyde Angel. Of course, creating biography is not unique to this field, but dates back to the Renaissance. Bernard Berenson, the influential dealer and connoisseur, was noted as the finder (or creator) of names and identities of the creators of early Renaissance paintings, many of whom did not sign their works. Berenson realized astutely that having a "name" paid off in market value. When finding a name was impossible, Berenson's stature allowed him to find the similarity of the author's "hand" in a number of works, and so could link them to a constructed category, such as the Master of Fiesole. [66] If the construction of biography in self-taught art is more dramatic, it is not unique.

These artists and dealers, in a sense, forge a life. In the words of one self-taught art dealer: "Condescension is perpetrated by building false biographies, stories that clean up the truth, narratives designed to falsely conjure up images of the sweet old naif or the noble primitive savage,

or that emphasize psychological flaws we imagine cause people to be creative."[67] A curator noted that, "Pickers in particular make up stories to sell stuff. . . . This is the isolated, uneducated black woman. Domestic all these years. It might not ever be as made up as it could. There might be some grains of truth in it, but taking a southern stereotype" (Interview). People sometimes tidy up (or mess up) life stories to make them more salable, just as some do on job applications or dates. Shaping one's history may be as common, and as winked at, as cheating on one's taxes. Why not select the life that would be most helpful, as long as it is not too false?

Sometimes the changes seem fairly minor, as the spelling of a last name, transforming a "normal" name into a "folk art name": "I asked [Dr. Rollins, J. B. Murry's doctor, friend, and advisor] how do you spell his name. . . . He said, Murray [the author's preference], how do you want your name spelled. And Rollins said that they decided on M-u-r-r-y, but in my thinking he didn't care. He didn't write, he was not literate, and I really felt that M-u-r-r-y was connected with the outsider way of seeing him" (Interview). Mose Tolliver writes the "S" in his first name backwards. I was told this was because "a white educated woman taught him to do that, thinking it would make it more cute and fluffy" (Interview).

In other cases the biographical work is more exotic. One white self-taught artist reportedly claimed at first that his work was by "this poor black guy in the woods of Alabama that only he knows about." My informant told me that, "It does make a difference. It's like selling dishonesty. Everyone believes to be a good folk artist you need to be poor, black, dead, disabled, uneducated." The belief that biography sells inspires some, even if they don't place their plans into effect, such as two collectors who joked that they would begin producing art: "We'll live out in the woods. . . . We could write a credible tear-jerker story. Our fathers abused us, our mothers beat us. For each story our prices would go up $100" (Field notes). The market is such that these literary fancies have appeal.

Reputation: The Game of Chutes and Ladders

An artist's reputation is a function of biography and art. Yet even when the two features remain unchanged (as in the case of dead artists), reputations fluctuate. In 1971 the Museum of American Folk Art mounted a show of Isidor "Pop" Wiener, a memory painter barely known today.

For reputations to stick they must be backed by *reputational entrepreneurs*,[68] individuals who see it as in their interest to shape another's standing. Julia Ardery's account of the creation of Edgar Tolson's fame is a detailed case study of this process.[69] She notes the importance of sculptor Michael Hall and collector Bert Hemphill in transforming this backwoods whittler into an artist selected for the Whitney biennial. Through Michael Hall's strategic placement of Tolson's work, the presentation of aspects of his life history, and the use of photographs of his work, Tolson became "hot." However, it is not always art-world figures who are central; Ralph Fasanella's solid reputation is coordinated by his wife, "his tireless promoter," said one curator (Field notes). The Beaver's mother, Wanda, was the force behind his art-world participation, and the family of Laura McNellis, a severely retarded middle-aged woman, promotes her work. The Reverend Howard Finster's daughter, Beverly, now organizes his sales and set up his toll-free number and Web site. Prominent collectors with a large body of an artist's work may help to maintain his or her reputation, and this explains the concern to place works of art in prestigious collections, even when this means giving away the work or selling it at a deep discount. Museum shows and published material have a deeper effect, tossing the artist into the thickets of art history.

Surely the most effective and tireless promoter is the dealer, who has an immediate self-interest in the artist's reputation. The artist with an enthusiastic dealer is fortunate indeed. Should dealer Judy Saslow decide to drop artist Clyde Angel, and he not be picked up by another dealer, his work and reputation might vanish. As one dealer noted, "What we can do is get them some attention, so I think that's where my influence would come in. When I see somebody who I think—a newer artist, say—who I think has talent, then if my customers come in I can just bring these people to their attention, and say, 'Hey, you may want to look at this artist's work' " (Interview). Another dealer claimed that galleries were important in establishing reputations through promotion: "They spend money, they have fancy openings, they send out beautiful illustrated postcard invitations, and on a loftier level they arrange more shows in academic museum settings, and they publish catalogs" (Interview).

Some can serve, in effect, as partisan advocates for artists whom they think have been wronged. Ross Peacock, a New York dealer who dealt in works by Grandma Moses, placed a large notice in the *New York Times* protesting the exclusion of Anna Mary Robertson ("Grandma") Moses

(1860–1961) from the Whitney Museum's exhibit *American Folk Painters of Three Centuries:*

> Many have expressed outrage and disappointment on visiting this exhibition which is seriously flawed by the exclusion of Grandma Moses, celebrated throughout the world as the foremost American primitive painter. . . . If whoever is responsible for this deliberate injustice is attempting subjectively to distort and rewrite history by eliminating this great artist, it won't work. . . . Grandma's countless devoted admirers are incensed by the pseudo-chic, supercilious attitude underlying this cold, calculated effort and dehumanization. The sincerity and heart-felt emotion of the depictions of nineteenth century rural American life as Grandma Moses lived it caused millions of people to love her, and encouraged them to participate in a world of art to which they had never been enabled to relate.[70]

I can't assess the effectiveness of this blast, but it does emphasize the existence of reputation battles.

The centrality of reputation work suggests why exclusive relationships between dealers and artists can in some circumstances be so productive. The self-interests of the dealer and artist are coordinated in establishing the artist's reputation. In looking out for him or herself, the dealer looks out for the artist. Often the publicist (the financial analyst, publisher, or lobbyist) has a personal stake in what is being promoted. When sincere, the publicist truly believes what is being sold—a case of doing well by doing good.

Difficult Reputations

This art world has a high tolerance for the odd, deviant, and stigmatized, but limits exist. While many artists—prisoners, mental patients, isolates, social outcasts—are welcomed, others are problematic.

An advertisement for the artist Matt Sesow, placed by his dealer Beverly Kaye, describes him simply as "madman/artist."[71] An artist, like the Chicago "bag woman," Lee Godie—often living on a sidewalk grate, toothless, flea-infested, wearing smelly clothes, violating social taboos, and frequently cantankerous—can become a beloved part of the city art scene.[72] As sociologist Steven Dubin noted, "When she was alive, young artists were interested in the 'whole person,' not just her output. An admirer [Michael Bonesteel] knowingly stated, 'Godie's paintings are just the tip of an artistic iceberg known as the Lee Godie phenomenon. Her eccentric and unpredictable behavior, her bizarre habits and perceptions, her considerable charm and wit—all must be included

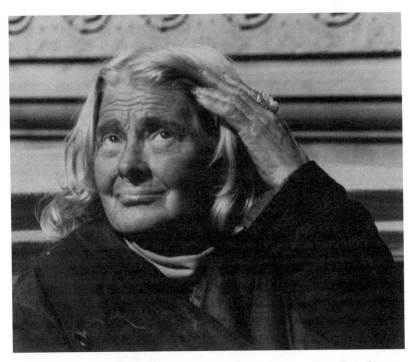

Lee Godie (d. 1994). Archives of the American Folk Art Museum, New York. Courtesy of Chuck and Jan Rosenak. Photo by Chuck Rosenak.

in the oeuvre of this Outsider artist.' "[73] Bonesteel subsequently suggested that her eccentricities, which he indicates might have been borderline schizophrenia, were defined by the art world as a form of "divine madness."[74]

However, limits exist, not so much in denying the artist a place at the table, but in reconstructing their motives and history. One of the greatest of the European outsider artists—an artist whose works now sell in the high five figures and low six figures—is Adolf Wölfli (1864–1930), a child molester and often violent psychiatric patient who spent thirty-five years at the Waldau clinic near Bern, Switzerland. Bonesteel notes, "Perhaps the greatest stumbling block to *freely appreciating* Wölfli's hypnotic and ineffable composition is his biography. Pedophilia is a hard thing to forgive. How tragic that the world's greatest outsider artist should also be one of its most disturbed perverts."[75] Wölfli's remarkable, detailed work is filled with imaginative musical scores and a fanciful life history. Wölfli poses a biographic problem, as a person easily labeled evil, if sick. Accounts of his life emphasize that, not only was he a "creative genius," but also that he was "brutalized and abandoned" as a child.[76] John Maizels

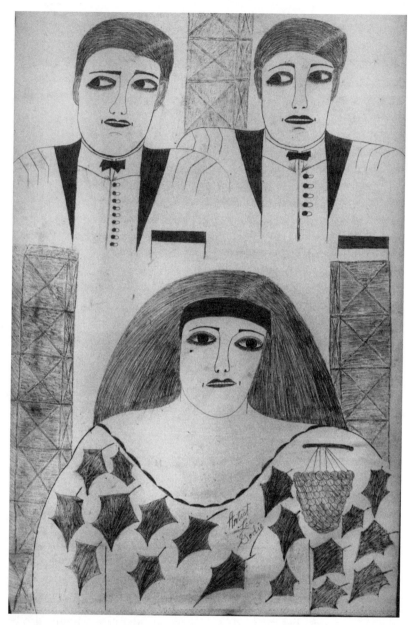

Two Prince Charmings and Lee by Lee Godie. Collection of the Smithsonian National Art Museum. Photo courtesy of Chuck and Jan Rosenak, Archives of the American Folk Art Museum, New York.

concludes his assessment: "Wölfli's compelling vision and all-enveloping creative drive stand as a testament to the power of the imagination and to the resilience of the human spirit. Adolf Wölfli was able to transcend the sadness and tragedy of his own life to create a miraculous personal cosmography, a visionary universe of epic proportions."[77]

Bonesteel concludes, "Maybe the best way to approach artists like Wölfli is to embrace them like a mother or father embraces a son or daughter who has committed a heinous act. A parent can love one's offspring without condoning their action. And we can admire Wölfli for channeling the rage of his unhappy youth into works that were ultimately healing for him and unremittingly astonishing to us."[78] My point is not to deny Wölfli the aesthetic power of his works, but to note that to accept him the art world shapes his life history to make its moral one of transcendence, forgiveness, and humanity.

The case of another artist, Henry Darger, raises related issues. Again, Betty-Carol Sellen:

> Darger, Henry (1892–1973). Henry Darger was born and lived in Chicago. His childhood was spent in an orphanage and a home for the feeble-minded. When he died, his room was discovered to contain 15,000 pages of text and 2,000 drawings. The length of his "art life," according to John MacGregor, who has written extensively about Darger, "was from 1962 to 1972." Darger's work is the story of a universe torn by warring forces of good and evil; innocent children led by the virtuous Vivian sisters, struggling to escape ruthless adult males. In the winter of 1997, The Museum of American Folk Art in New York presented the exhibition "Henry Darger: The Unreality of Being" which attracted much critical attention.[79]

From this text Darger seems similar to many abnormal and isolated outsider artists. Darger, like Wölfli, in his art and his extensive writings (fifteen thousand pages of *The Story of the Vivian Girls in what is known as The Realms of the Unreal, of the Glandeco-Angelinnean War storm, caused by the Child Slave Rebellion*), creates an alternate universe. Unlike Wölfli, Darger's artwork consists of numerous images of prepubescent girls, traced from popular culture sources, but naked and with male genitalia. Frequently—remember he is painting scenes of a war—these young girls are being violently attacked, killed, and disemboweled by the evil adult male enemy soldiers.

Eventually these virtuous Christian girls triumph (a Captain Henry Darger arrives to fight on their side), but not after much brutality, dismemberment, and torture, explicitly described in Darger's writing and

Adolf Wölfli (1864–1930). Copyright Adolf Wölfli Foundation, Museum of Fine Arts, Bern.

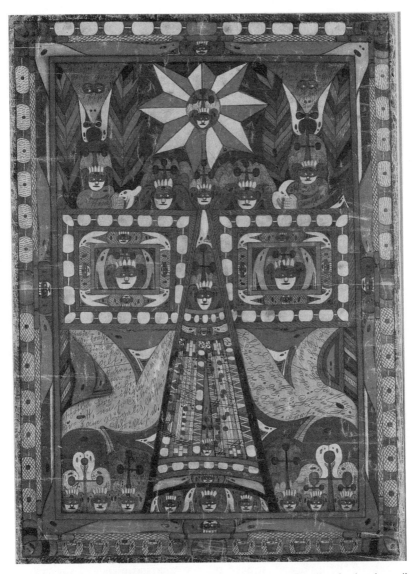

Holy St. Adolf Tower by Adolf Wölfli, Bern, Switzerland, 1919. Pencil and colored pencil on paper, 30¹/₂ × 22¹/₄ in. Collection American Folk Art Museum, New York; promised gift of Sam and Betsey Farber, P10.2000.7. Photograph by Gavin Ashworth, New York. Photograph courtesy of the American Folk Art Museum, Shirley K. Schlafer Library.

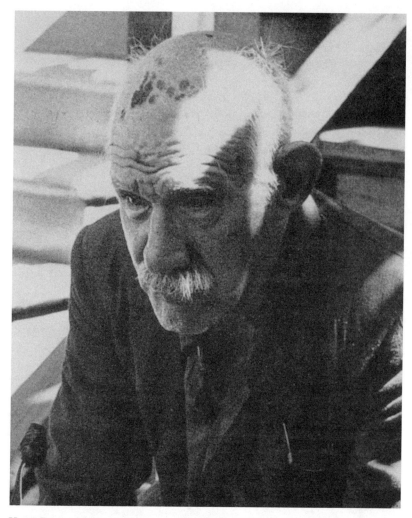

Henry Darger (1892–1973). Photograph by David Berglund.

depicted in his art: "Naked opened bodies were seen lying about in the streets by the thousand. Indeed the screams and pleads of the victims could not be described, and the thousands of mothers went insane over the scene, or even committed suicide. . . . About nearly 56,798 children were literally cut up like a butcher does a calf, after being strangled or slain . . . with their intestines exposed or pushed out. . . . Hearts of children were hung by strings to the walls of houses, so many of the bleeding bodies had been cut up that they looked as if they had gone through a machine of knives."[80] As remarkable as the paintings are in composition and color, this is strong stuff. The number of aesthetes

Detail of untitled work (battle scene during lightning storm; naked children with rifles), by Henry Darger, Chicago, mid-twentieth century. Watercolor, pencil, and carbon tracing on pieced paper, 24 × 74¾ in. Collection American Folk Art Museum, New York; Gift of Nathan and Kiyoko Lerner, 1995.23.1B. © Kiyoko Lerner. Photograph courtesy of the American Folk Art Museum, Shirley K. Schlafer Library.

who would place an image of young girls, with male genitals, being slaughtered, over their couch must be rather small. (Not all of Darger's works are so violent and graphic.)

Although a dramatic storyline enhances the work, one dealer remarked that, "I have had people say to me, 'I can't look at this stuff. It's disgusting. Look at that pedophile. And he may have even murdered children. I can't have it.' And OK, that's valid. If it works for them, it works for them" (Interview). In planning their show, which originated at the University of Iowa, the American Folk Art Museum was concerned about the public reaction. Director Gerard Wertkin noted, with some understatement, "People are going to be surprised that this work is in the Folk Art Museum. . . . We hope it will be a learning experience."[81] Would New York Mayor Giuliani, a vocal critic of "offensive" art, notice? He didn't, and the show received enthusiastic responses from critics, but perhaps for politicians and the public the small, private museum was *beneath contempt,* not worth the controversy.

There is no evidence that Darger was a child abuser or pedophile. He was a steady, if low-paid, laborer at Chicago hospitals, a devout Catholic who regularly attended mass, and a trouble-free tenant; however, none of this stopped speculation, reading from the art to the soul of the artist. John McGregor, a San Francisco psychotherapist and art historian who has written extensively on Darger, asserted at a symposium that "Darger was obsessed by little girls. . . . [Part of the work] brings us close to Darger's obscure and confused sexuality," referring to the fact that at age twelve, he was admitted to a hospital for masturbation—a fin-de-siècle diagnosis that if used in earnest would decimate middle schools. MacGregor asserts that, "One must be forced to consider the possibility, indeed the probability, that he was sexually abused at the Lincoln [orphan] home." He further speculates, "Psychologically, Darger was undoubtedly a serial killer. I don't think he acted, however, because if he'd ever started, he wouldn't have been able to stop. Instead he sublimated it into his art."[82]

This biographical reading is problematic for the market. Thus, Darger's reputation needed to be cleansed—in this case, emphasizing biographical "facts," rather than pathological interpretations. Stephen Prokopoff, the curator of the Darger show, emphasizes transcendent themes in the catalog for the show: "His public behavior appears to be without blemish. A saintly man who frequently attended mass, Darger saw himself as the ardent protector of children. He could therefore, in his words and images, subject his creatures to terrible trials from which it was in his power to rescue them. . . . If Darger's fantasies often

hovered on the fringes of insanity, his art enabled him to transform his obsessions into a luminous production that, in its best moments, transcends the pain and circumstance of its making."[83] The account, so tied to psychology, ignores the religious, popular cultural, class-based, and organization context in which the artist worked. In 1996, Intuit: The Center for Intuitive and Outsider Art in Chicago, dedicated a stone marker on Henry Darger's unmarked grave. The carved words read, "Henry Darger, 1892–1973. Artist, Protector of Children."[84]

Discovery Narratives: Outsiders Found by Insiders

"The myth of discovery"[85] is among the important narratives in self-taught art.[86] In contrast, in contemporary art, artists discover themselves, or at least work with dealers to achieve that end. For most important self-taught artists, an equally important figure within the art world recognized their genius, saving them from oblivion—sometimes, dramatically, saving the work from the trash. For Martin Ramirez, this figure is Chicago painter Jim Nutt; for Bill Traylor, it is Montgomery artist Charles Shannon; for Henry Darger, it is Chicago photographer Nathan Lerner; for William Edmondson, it is Nashville Fugitive poet Sidney Hirsch. The list could be extended. But what does discovery mean?

In discussing the creation of biography I began with the case of Clyde Angel; to talk about discovery consider the story of the Philadelphia Wireman. Betty-Carol Sellen writes:

> Philadelphia Wireman. The Philadelphia Wireman should perhaps be excluded from this list because he is anonymous. Nevertheless, his work exudes a powerful presence, easily as great and as uniquely identifiable as any artist whose name is known. He was discovered when several hundred wire figures were found spilling from a box in front of a "transient home" in a black neighborhood in Philadelphia. The structures wrapped in wire encase street debris—a bottle cap, an earring, crumpled cellophane, for instance—a whole array of objects. The figures are about seven to eight inches high, and according to gallery director Randall Morris, "Very frontal . . . if you look at them long enough you see faces."[87]

The works are sold at the Fleisher/Ollman Gallery in Philadelphia and the Cavin-Morris Gallery in New York—both respected, high-end "white box" galleries. The works, about six or seven hundred of them, sell for several hundred dollars to about $1,500. I have no knowledge

Rounded Form by the Philadelphia Wireman, ca. 1975; 6 × 2½ × 2¼ in. Courtesy of the Fleisher/Ollman Gallery.

of who the Wireman might be, nor have I any indication that the story is false.

According to one account of discovery, "A Philadelphia designer was driving home from a party one night when his headlights flashed across a heap of shiny metal objects. Hundreds of them spilled into the street from dilapidated cardboard boxes. He stopped, got out of his car, picked one up and examined it in the light. Filling his hand was a heavy ovoid sculpture made of small, colorful castoffs—a bottle cap, a folded matchbook cover, an earring, a plastic straw, crumpled bits of colored cellophane, a museum-admission button and more—all wrapped in a tornado of shiny wire. . . . He immediately recognized them as the creations of someone who shared his own visual fascination with urban residue and lost trinkets."[88] No evidence emerged as to who this artist is, or whether he (or she) is still alive. John Ollman, director of the Fleisher/Ollman Gallery, explains in an interview with Liza Kirwin of the Smithsonian Archives of American Art:

Nobody believes the story. . . . 1982 or 1983, I guess. This artist, graphic artist. . . . His story is that he was going home one night and he saw these things kind of laying out in the street, sort of been dumped out in the street. . . . He picked them up and put them in his car and drove home, unloaded them, and looked at them and put them in his basement. They pretty much stayed there for a couple of years. And then, a friend of the gallery's was visiting him. He had a few of them lying around on the tabletops or something. They said, "God, these are really pretty interesting. I think you should show them to John." So, he brought a dozen of them up to the gallery. I was like, "Oh, God." . . . If you have read Robert Farris Thompson [about African amulet charms], you kind of go like, "This is what this is." . . . It took a long time before he ever really decided that he was going to part with them or show them all to us. Finally, he did. . . . We tried to research where they had been found. It had been an old, black neighborhood in Philadelphia that had been gentrified between the time that he found them and the time that we actually came into contact with them, which was not that long a period of time—a couple years. So, nobody knows anything about them. . . . We're pretty sure they were made by somebody who is black because there are many references to black culture, again, in the pieces that are inside of them. . . . Robert Farris Thompson . . . thinks that they're urban black American nkisi, which are these power objects, which is what we think they are as well. . . . There are plenty of other stories that you'll hear about them. There are people who just are determined to be offensive about it. I present them as these

little power objects made by—You decide who made them. . . . There's a real strong feeling that you get from handling them.[89]

In this case, the first problem was one of naming. These were anonymously produced objects, but to be marketed they needed to be referred to in some way. Cavin-Morris Gallery, where the objects were first shown, referred to the mysterious maker, somewhat awkwardly, as the "Philadelphia Fetish Master." However, John Ollman felt that "fetish" had negative connotations, and the name "Philadelphia Wireman" was agreed on.[90]

The discovery story suggests that after finding these magical objects that he picked from inner-city trash, the finder placed them in his basement for several years, and when they emerge the neighborhood has changed and the maker could no longer be found. Some suspicious souls felt that this story might be fictional. Yet, Robert Farris Thompson is an exceptional scholar[91] and Fleisher/Ollman and Cavin-Morris would be humiliated if the "real creator" turned out to be not what they thought, despite Ollman's attempt to place some distance between his gallery and the story.

Fortunately for the dealers (and, perhaps, for art history) there is a coda to the story. In December 1999, two African American customers entered the Fleisher/Ollman Gallery and asked for some information about an artist. "When [Ollman] came upstairs the man was enthusiastically telling his friend . . . how he had once watched an old man making these pieces on a bench fairly close to where they were found. He even named the street. John asked him why he hadn't come forward with the information previously and it turns out he is an artist himself who has been living in Europe all this time so he missed all the attention paid to the work. Philadelphia Wireman was an old 'strange' man, African-American, who was sitting outside making these pieces."[92] This is a piece of serendipity by which art history is made.

Part of the issue, as it was in the Angel case, is whether this history matters. The objects are still the objects—magic, African American, or not. The story is what Ollman and Thompson have read into them. The objects do not care about the fuss made over them; yet, of course, a change in story involves a change in meaning and, likely, a change in value. More important, this is a classic instance of a "discovery narrative." Without the fortuitous intervention of the graphic artist, these objects would have been lost forever.

Self-taught art is always on the verge of vanishing. The field is filled with accounts of connections almost not made: the mental patient who

happened to have an interested doctor or nurse (Eddie Arning); the recluse with a kindly landlord (Henry Darger); the prisoner with a supportive guard (Frank Jones); the laborer with a knowledgeable coworker (Eddie Kendrick); the friend who happened to meet an art dealer (Drossos Skylas); the surprised family member (James Hampton); or the fortunate passerby (Charles Dellschau). Often these creators are lodged within an institution (often a hospital or prison) and so the storage and disposal of the work are linked to institutional policies and priorities. In the case of Wisconsin artist Eugene Von Bruenchenhein, who had died two weeks before the works were discovered, "the family was going to simply put it out at the curb to get rid of it" (Field notes). The work of Charles A. A. Dellschau was found on the sidewalk to be thrown away. Before they were hauled off, an antiques dealer paid the trash man $100 for the dozen notebooks. They had remained at his relatives' home for forty years until they were discarded as a fire hazard—and then "discovered."[93] These men are now considered major artists.

I present two other exemplary discovery stories, similar to, if less controversial than the Philadelphia Wireman: Achilles Rizzoli, a San Francisco artist discovered by Bonnie Grossman, a Berkeley dealer, and Annie Hooper, a North Carolina artist found by Roger Manley. Manley at the time was seventeen years old, and now, in part because of the discovery, curates art shows. While the stories differ, both capture the same theme of chance encounter and sense of awe. According to Grossman:

> On July 12, 1990, [a young woman] arrived at my gallery with a small collection of drawings she wanted to sell. The moment I saw them I was electrified. These were the creations of a wildly original mind. There were four architectural drawings and what looked like an illuminated list. . . . No history was offered with the pictures; as for the artist, he was unknown. The woman had found the work some twelve or fifteen years earlier in a house whose recent occupant had fallen ill or died. . . . In addition, there were thirty-nine sheets of vellum. . . . All were done in pencil, and all signed A. G. Rizzoli. . . . I followed up each clue and soon located the artist's great-nephew. Surprised by my phone call, he told me he had lots of his uncle's "stuff" in his garage. We arranged a meeting. The garage door was open. It was hard to know where to look first. The largest drawings were piled on rafters. . . . Hundreds of the vellums were rolled up and secured with rubber bands. Other notes and papers were loosely piled in boxes. My heart was pounding—I had uncovered a great treasure.[94]

At a New York symposium, a panelist explained that when Bonnie Grossman tracked the work down, "The family had stored the work in

Achilles Rizzoli (1896–1982). Courtesy of the Ames Gallery, Berkeley, California.

the garage and they were about to dump them. . . . They actually had a dumpster ready to throw it away" (Field notes).

The account of the discovery of Annie Hooper touches similar themes. Roger Manley is hitching a ride on the Outer Banks of North Carolina in December, and asks the driver what he might do for fun. After giving him some suggestions, the driver suggests to the then teenager that he might visit his grandmother, who "does these woodcarved things":

> The next day was just as gray but the rain had let up. After gulping a cold Pop-Tart and changing my shirt, I fished out the old lady's name and set off to find her. The address led to a largish but otherwise very ordinary white house with a carport to the side; nothing unusual about it. I knocked, and

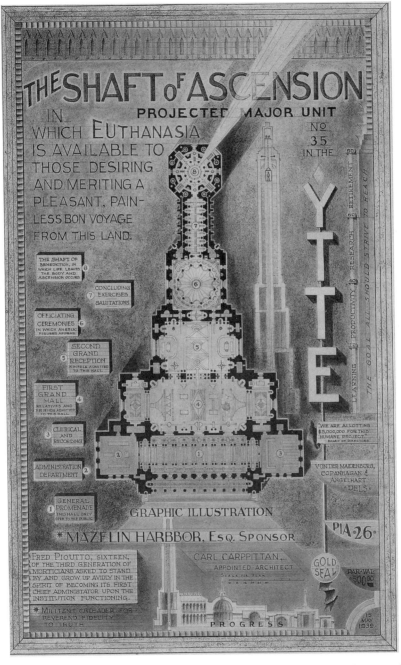

The Shaft of Ascension by A. G. Rizzoli, 1939. Ink on rag paper, 21 × 13 in. Courtesy of the Ames Gallery, Berkeley, California.

soon the door was opened by a tiny, white-haired woman who immediately ushered me inside without a second's hesitation, almost as if she'd been expecting me. It's fair to say that when I crossed the threshold into her house, my life changed profoundly right then and there. . . . When my eyes adjusted to the darkness inside the house, I suddenly realized I was knee-deep in sculpture. Angels with their gilded wings spread, prophets with their arms raised, shepherds staring wild-eyed into the heavens—thousands upon thousands of cement and driftwood biblical figures were crammed into every available space, on the floor with scant pathways left to get from chairs to doorways. . . . I had no idea what to think of what I was seeing or of the person showing it to me; both fell outside my realm of experience. . . . All I knew was that I had seen something almost unbelievable and probably impossible to describe.[95]

Roger Manley was ready for the magical experience, in a way that Annie Hooper's grandson was not. For the grandson, his relative was a curiosity; for Manley, she was a miracle.

Although these stories emphasize that art is sometimes just "happened upon," another set of stories emphasizes the need for active involvement. The "hunt" is essential to the game,[96] what Manley refers to as "the lucky shot."[97] Such was said of collector Bert Hemphill, of whom a friend reported: "I think for Bert, a large measure of his participation for such an extended time is because of the thrill of the chase, the thrill of the find. He is the explorer."[98] Or as Bert himself put it, "I'll go to the devil himself to buy art, thrift shops. And I'll go to a town when I'm traveling off the main highway. I usually use the back roads. And I go first to the newspaper publisher and ask him who is in town. . . . And I'd go to the barber shop where they often hang the local artists or the bar. And the minister and ask them 'cause they're the ones who know most of the people in town."[99]

The Active Artist

It might seem that discovery operates in a single direction. As most self-taught artists are unfamiliar with the art world that is often how it happens, but not always. A Texas artist, Vanzant Driver, after having been rejected by the owner of a gift shop, "took the sculptures back to his car and recalled 'I was a little disappointed that day, a little down in spirit, and I said "Lord, what am I going to do now? I guess I'll just take them back home and let them collect dust." But as I drove two blocks there was something that came into my mind that said go to the museum.' Although he had never been to Houston's Contemporary

Arts Museum, he drove there that day and met Sheila Rosenstein, who coordinated the sales and rental gallery. . . . Driver found a place for his work where it was received enthusiastically."[100]

Other artists, like Tennessee artist Bessie Harvey or Chicago artist William Dawson, entered their own work into art shows, where it was "discovered." They might have been uncertain of their skills, but they were confident enough that they chose to have the work displayed in public. Even Martin Ramirez, supposedly catatonic and schizophrenic, listened to a psychological lecturer and at its conclusion handed the speaker, Dr. Tarmo Pasto, a roll of his drawings.[101] Even though the standard story is that an established member of the art world will be instrumental in "discovering" the artist, the artist often contributes to the conditions under which that happens.

The Politics of Discovery

What do we mean by discovery? A discovery is a claim of priority. Sociologist Eviatar Zerubavel in his *Terra Cognita* analyzes the "discovery of America."[102] The issue is not only that there were native peoples in the Americas before Columbus. There were, of course, and they can lay claim to the "discovery." But also Vikings apparently visited American shores, even if they are not given the credit because they were members of a peripheral European society. Even Columbus (and his men: why credit management and not labor?) never set eyes on the North American continent, and was unaware of what he had found. Further, if a class of Boston schoolchildren were asked in 1770 who discovered America, they would have responded "John Cabot," an Italian sailing for the English crown who had explored North America. However, such was an inconvenient origin myth for a people who wished to deny that the British were their legitimate rulers; Columbus, exploring for the Spanish, didn't pose such problems. One could go on, but the point is that the "fact" of discovery can be a matter of contention.

Who in the art world can be a discoverer? This view assumes that the production of art is not sufficient, it must be shared with the proper others. Dealers and collectors are known by their finds.[103] Sam Doyle was creating art for several years before he was discovered by Leo Rapkin (Field notes), not the first person to see his art, but the first influential outsider to do so. Or consider Victor Joseph Gatto, who is usually said to have been discovered by dealer Sidney Janis. Where? At the Greenwich Village Art Show where Gatto was selling his work (Field notes). Surely others had bought Gatto's work before Janis's discovery. It is sometimes claimed that Bill Arnett discovered Alabama artist Thornton Dial

(though Arnett does not make the claim). Arnett was introduced to Dial by his friend and neighbor, artist Lonnie Holley.

In the case of J. B. Murry, his work was "discovered" by his doctor, Dr. Rollins. The doctor's wife was a student of University of Georgia ceramics professor Andy Nasisse, and "they invited [Nasisse] to meet Murry, and Andy basically was the one who got him connected with the art world" (Interview). So, did Dr. Rollins discover Murry or did Professor Nasisse—or both—or neither? Or consider the case of Anderson Johnson who was "discovered" by collectors who had seen a "big article" in the local paper about him (Interview). The reporter, much less Johnson's friends, didn't count as discoverers, as the collectors first introduced the artist into the market.

Sometimes an initial discovery doesn't "stick," and artists must be rediscovered. James Castle, the "deaf and dumb" Idaho artist, had his work shown in the Pacific Northwest in the 1960s, before his work was rediscovered in the mid-1990s, when his family decided to sell the work to a dealer. At that time there was considerable excitement about this important "new discovery." Something similar happened with Bill Traylor, whose works now sell in the six-figure range. Traylor's work was exhibited in Montgomery, Alabama, in the 1940s. Charles Shannon, the Alabama artist who is credited with being Traylor's discoverer and, at one time, was the owner of most of Traylor's work, explained:

> While Traylor lived, my urge to seek recognition for his work sprung from wanting to help and encourage him to continue. After his death that motivation was gone. Abstract expressionism was consuming the art world and there didn't seem to be a place for Traylor or, for that matter, myself—as a representational painter, I had my own survival to think about. So the boxes of his drawings were stored away and not brought out again until twenty-five years later, when I decided to show them to my wife Gina. She was excited by it, and so was I, all over again. We felt that it was important that this body of work take its place in the world. . . . A 1979 one-man show of Bill's drawings marked the beginning of his new appraisal in the art world.[104]

Despite the power and pervasiveness of this rhetoric of discovery, at least one person is willing to reject the model. Bill Arnett, often given credit for discovering many important African American vernacular artists, emphasizes that he may have publicized artists but didn't discover anyone. He told me: "I'm not a discoverer. I mean, I'm not looking to discover people. You know, I'm not a talent scout. I didn't discover anybody. I mean Columbus didn't discover America either, you

know. It was here and going well before he got here. I mean, what I did was went and [met] all of the existing artists . . . and then asked a lot of questions of people who had been out there, and of artists, 'Do you know anybody else doing what you've done?' I was trying to find out. I was just really trying to get a survey in my own mind of what was out there. And in the course of doing that, Thornton Dial came to light through Lonnie Holley, which was an accident and very fortuitous one for mankind, but I didn't discover anyone" (Interview).

Perhaps it is more apt to say that Arnett was an explorer from one world that was unaware of another, but one must recognize the implication of hierarchy that the term explorer implies. One can hardly deny that members of the art world with their wealth and power bestow legitimacy, but this does not mean that aesthetic objects only exist when the art world becomes aware of the art, even though this may be the case in practice.

Creating Biography

The identity of the artist is important for the art world. Virtually every dealer, collector, and curator agrees that the fact that these artists are "outside" or uninfluenced by the larger, mainstream art world is important. For most, this reality legitimates the art, places it in a category, or grants the work authenticity and value.

Not every artist can make sense of these claims; they live and work and find that others wish to define and value them in particular ways. Some artists become savvy about this interest by the art world, a community in which they may play an active part. This involvement comes at a cost though, in that it is separation that often constitutes authenticity.

To be authentic is, typically, to have a certain kind of biography. Biography becomes an asset for an artist, even if he or she does not shape it. If Clyde Angel's works are made by a trained artist, that artist is trading on the value-added quality of a suitable life history. If not, Angel is doing the trading, although his mystery may come to work against him, transforming an asset into a liability.

Perhaps the work is more important than the story, and perhaps the sociology (the social context) is more important that the psychology (the pathography), but at the moment the "who," the identity, matters greatly—if not for all collectors, then for most. The cases of Adolf Wölfli and Henry Darger remind us that biographies must, on some level, be suitably uplifting. They must be tellable and self-enhancing for collectors. The biography of the artist may rub off on the collector:

Bill Traylor (1852/56–1949), ca. 1948. Courtesy of the Luise Ross Gallery, New York, and Tommy Giles Photographic Service, Montgomery, Alabama. Photograph by Albert Kraus.

you are who you display. Perhaps for this reason in a group that adopts a multicultural perspective, the work of vernacular African American artists is so valued. It is not that this work should not be appreciated on its own terms without a "colonialist" mentality; it should, if it could. However, white collectors of the work of black self-taught artists, in part, judge themselves on the ideology of diversity and tolerance implicit in their collecting choices. Put another way, self-taught art was not "ripe" for discovery until certain ideological claims were widely shared among artistic elites, sensitizing people to look for these works and to appreciate them when found. [105]

Figures and Construction with Blue Border by Bill Traylor, Montgomery, Alabama, ca. 1941. Poster paint and pencil on cardboard, 15½ × 8 in. Collection American Folk Art Museum, New York; Gift of Charles and Eugenia Shannon, 1991.34.1. Photograph by John Parnell, New York. Photograph courtesy of the American Folk Art Museum, Shirley K. Schlafer Library.

Finally, the process of discovery is important in the construction of biography. If the works were evident for all to see, no artist could be on the outside. Institutional control or residence on the periphery justify the assessment of "otherness." The discovery story makes a claim of authenticity, that the work "needed" to be discovered, and the discoverer then gets credit for mapping what was always there, but of which those *who mattered* were unaware.

3

creating

artists

Our work can go where
we cannot go.
—SELF-TAUGHT ARTIST HAZEL KINNEY
TO JULIA ARDERY

Although supposedly about *art,* the
examination of reputation often fo-
cuses on what is done to and for artists.
The artist serves the same role as a
patient in a clinical lecture in medi-
cal school—not exactly a cadaver, but
equally mute. Yet workers of all kinds
have their own active social worlds in
which they contribute to their own
identity. If artists do not have full con-
trol of their lives and their social posi-
tions, they do have some authority to
define themselves and to control the
form and distribution of their work,
shaping through their choices its rar-
ity and the access of others to their
products.

By any count, a lot of artists work in
the United States. In the 1990 census,
224,000 adults labeled themselves as
"painters, sculptors, craft artists, and
artist printmakers." Fully 1,146 Amer-
ican institutions of higher education

offered bachelor's degrees in the visual and performing arts, with 362
awarding Masters of Fine Arts degrees.[1] One estimate places the num-
ber of art professionals graduating each year at 40,000, including some
15,000 studio artists.[2] Increasingly, artists receive advanced degrees, in
some domains a majority of artists now obtain them.[3]

How many artists are self-taught is an open question, as many do not
label themselves as such. The respected carver Elijah Pierce remarked,
"I didn't even know I was an artist till they told me."[4] As a consequence
of hazy boundaries and uncertain self-identity, an accurate census of
self-taught artists is impossible. Those who have tried, such as Jules and
Florence Laffal, find that men outnumber women by a ratio of three to
one, based on a sample of 1,234 self-taught artists.[5] According to their
research, approximately one-third of the artists sampled had less than
seven years of schooling, although about 25 percent had more than high
school education.[6] A related study of 405 self-taught artists found that
11 percent were black and 9 percent were Hispanic.[7]

Putting aside the demographic details, it is the special standing of
these artists that propels the analysis, though in many ways they are
probably not so different from so-called trained artists. These are cre-
ators who are inspired by their backgrounds, often work with materials
that are at hand, and create in consistent styles and genres. Further, they
are men and women whose lives and success are shaped by their social
position and networks.

Lives of the Artists

To focus on what it means to be a folk artist, I select a talented artist who
I have met on several occasions: Lonnie Bradley Holley. Of course, no
artist is representative, and in many ways Holley is not typical; his age,
articulateness, talent, success, and his background make him unusual.
Should self-taught, African American vernacular art become part of the
artistic canon, most would agree that Holley will be one of those artists
most likely to be canonized. A brief discussion of Holley permits us to
examine aspects of demography and culture. Although Holley's aesthetic
vision deserves serious analysis, addressing issues such as whether it is
informed by African traditions is not my interest here.[8] I begin with
Betty-Carol Sellen's summary:

> Holley, Lonnie (b. 1950). Lonnie Holley was born in Birmingham, Al-
> abama. Since the airport authorities took away his property, he moved
> to Harpersville, Alabama, east of Birmingham. He lives with five of his

fifteen children. He spent much of his youth in foster homes and reform schools. His first artworks were carvings made from industrial sandstone. In addition he paints and makes assemblages of cast-off metal and other materials. His work is highly thematic and centers on the human condition. Holley is written about frequently, and his work appears in numerous exhibitions.[9]

This brief notice scratches the surface of a life. However, it is sufficient to remind us of certain realities. Holley's work has been compared to that of Alexander Calder, Jean Tinguely, Man Ray, and Joseph Beuys. At the very least he is in good company. He has been invited to the White House, where Hillary Clinton labeled him a "master artist."

Holley is self-conscious yet articulate about his work and, more than most self-taught artists, works in numerous media. In 1979 Holley began his artistic career carving children's tombstones after a niece and nephew died in a house fire and the family could not afford grave markers. As he continued his work, he was supported by the Birmingham Museum of Art and began to think of himself as an "artist." For many years, Holley's yard art environment near the Birmingham airport was an important destination for artists and collectors. In addition, Holley created sandstone sculptures, root sculptures, and paintings. One of his yard art constructions was the centerpiece of the influential *Souls Grown Deep* show, held during the 1996 Olympics in Atlanta.

On one visit to his environment, I watched as Holley plucked objects that he had previously scavenged and then fashioned them into an art object, a work that he was able to discuss in terms of his intention and its meaning (in this case, about the ill-effects of popular culture). Certainly Holley is no theorist or art historian—his discourse would not be mistaken for academic-speak—but, in contrast to most self-taught artists, he has a profound sense of history and politics, and recognizes how symbolic creations can represent these broad themes. His works can be powerful and disturbing, such as one piece constructed from IV needles. As one academic explained, "Lonnie Holley, when he talks about his work . . . it's so eloquent. It's beyond anything I've ever seen written by an art historian or critic from any level of academe or any of these hallowed places. It just tumbles out and it's brilliant stuff" (Interview). At its best, he has a poetic vision that informs his art. Holley noted with regard to his assemblage, *The Spirit of My Grandmother Wrapped in the Blanket of Time:*

> Long ago, we used to give much more; we used to care so much more for the rites of our ancestors that were stored away. It is like storing away a

Lonnie Holley (b. 1950). Courtesy of Marcia Weber.

memory, like keeping the blanket or a quilt or keeping a flower in memory of them. But there is little of it now. And the ground could be broken; and the ground that's on them is deteriorating because of the different counterforces that we have on Earth right now. Just as we have treated their rites wrong, so have we treated our earthly rights to walk upon the Earth. The vice is not on the Earth itself but against our growth as a flower.[10]

His achievements might be envied by those who are suppler in their use of footnotes.[11]

The object is, of course, only a portion of the domain of self-taught art. We must consider the artist and his place within the broader community.[12] As Sellen's biographical paragraph suggests, Holley has not had an easy life. A middle-aged black man, he grew up in segregated Alabama, spending much of his youth in foster care and reform schools from which he would attempt to escape. He explains that as a child, his mother who, he says, had twenty-seven children, gave him to another woman, who subsequently sold him for a pint of whiskey. He has been beaten, shot, and jailed. He was wild as a young man, a heavy drinker who fathered fifteen children, ten out of wedlock. Now, after his wife left him, he is attempting as a single parent—with great devotion, although not with complete success—to raise his children.

Three of his children have been arrested for burglary and arson, a

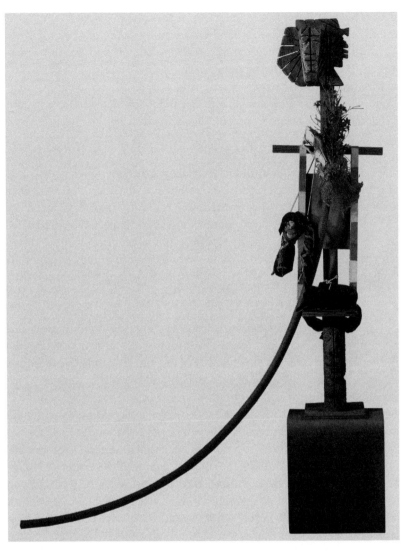

The Ancestor Throne Not Strong Enough for No Rock nor No Crack by Lonnie Holley, Birmingham, Alabama, 1993. Paint on wood with plastic tubing, artificial flowers, fabric, cord, animal skull bone, net, and string, 70½ × 66 × 15 in. Collection American Folk Art Museum, New York; Gift of Luise Ross, 2000.10.1. Photograph by John Parnell, New York. Photograph courtesy of the American Folk Art Museum, Shirley K. Schlafer Library.

matter for the courts to sort out. Despite the sales of his work, some selling for thousands of dollars, and with visiting collectors bearing cash, by 1999 Holley was broke with his phone cut off and his van repossessed. He was considering going back on food stamps. His generosity to friends, relatives, and organizations such as the United Negro College Fund drained his resources. As reporter Jim Auchmutey comments, this prominent artist would not qualify for an auto loan. As Holley's friend and fellow artist Charlie Lucas noted wryly, "We're very rich people; we just don't have none of the money."[13]

While many families in all social classes are dysfunctional, pathologies are not equally distributed throughout the class structure. Poverty is both a cause and an effect of personal problems. Although social structure has powerful effects, so does responsibility and choice, a fact recognized by Holley in his art and in his teaching as a guest artist at universities, churches, and local schools. It must be admitted somewhat ruefully though, that Holley's problems provide him with an authenticity that his philosophizing may not. Whether Holley should have recruited a financial manager from among his many elite admirers can be debated.

Holley would be the first to admit his responsibility; however, one need not be a sociologist to recognize that social institutions affected the course of his life. No examination of the life of a southern black man should neglect the residue of segregation and the reality of racism. Inadequate funding of school systems, hospitals, and governmental social services influenced the shape of Holley's biography. More recently, the decision of the Birmingham Airport authority to expand their runways, demolishing hundreds of homes in the African American Airport Hills community, shaped Holley's life. The airport originally offered Holley $14,000 to demolish his home and take his land. Were Airport Hills an upper-middle-class white community, such a figure would have been an insult, but, of course, wealthy whites would never have lived there. Holley's yard, a mecca for the art world, was condemned by the department of sanitation as "a health hazard."[14] After years of legal struggle, Holley received $165,700 and moved to a six-bedroom house in Harpersville, a suburban neighborhood known for its crack houses. Even there his neighbors were not pleased to see his relocated environment "defacing" the neighborhood.

To understand the life of *this* artist, we must not ignore his artistic achievements. Yet as a self-taught artist, Holley is a man with a biography, which while it grieves his friends, serves in its chaos to justify his outsider status. Perhaps we would not want it this way—this may be a polite form of racism or elitism—but as a practical matter it does justify

the work, possibly more than the explanations that flow so smoothly from Holley's vision.

Finally, Holley is part of a community, a community that over the years has not proven very supportive, with the exception of some members of the art world and some neighbors, relatives, and friends. Insider and outsider, Holley is also a creative artist. The biographical dilemma is to integrate these elements so that his art can stand astride his life in an art world in which biography often creates value.

Coping with Deviance

As the account of Lonnie Holley reveals, many self-taught artists live lives of desperation. The claim, made by one curator, that, "The artists are almost without exception among the sanest, funniest, and most resourceful people I have known,"[15] involves some measure of deeply felt romanticism, only possible if different standards are used than would be used for the observer's own family and friends. It demeans the artists by ennobling them in ways they could barely recognize. Sometimes, however, academics and critics suggest that oddness and social violations are "merely" social constructions. This may be comforting to those elites who have the luxury of not having to deal with the pain caused by immorality and criminal behavior. However, such fantasies do not persuade the artists, who know perfectly well the anguish resulting from their choices. If they are not always able or willing to change their behavior, they are not so naive to believe that it doesn't matter.[16]

Some artists, such as New Orleans carver Herbert Singleton and embroiderer Raymond Materson, have been in and out of prison. In Singleton's case, I was told, a fine was paid by one of his dealers who needed his work (Field notes). Others such as Frank Jones lived and died incarcerated for brutal crimes, producing their work in prison. Still others are known for their substance abuse or violence, making them a challenge for dealers and collectors. One collector remarked about her dismay during a visit to a well-known Kentucky carver, "Kids were wallowing in the mud. There was something wrong with them. . . . I had to go back to my hotel, and I said, 'what is all this about?' " She indicated the possibility of abuse or incest, making the mountain scene authentic but also troubling (Field notes).

Mental illness and social dysfunction can be romanticized. I once joked that the solution for homelessness is to give every street person a sketchpad and box of colored pencils and let them, like Lee Godie, create a market. One would imagine that the great institutionalized artists—Martin Ramirez, Adolf Wölfli, Eddie Arning—if they had the awareness,

as they likely did—would have wished their lives to be otherwise. While some note the effects of therapy and psychotropic drugs on the disappearance of the "art of the insane,"[17] few argue against such effective treatments in the name of our cultural patrimony. Dealer Phyllis Kind was quoted as noting that, "I've looked for work in [mental] institutions but I haven't found any. I've had a few prison art shows, though. Those people are not given drugs, and for some of them their anger is enough obsession."[18]

The danger in enshrining deviant artists is that we may see the deviance as the mark of quality, rather than the artistry. While obsession surely contributes to artworks, artists who lack obsession can also be important. Some artists whom we know to be important are given the honorary label of "obsessive" even in the absence of biographical information to support that claim.

Politics and Class: Dangerous Contacts

It should be no surprise that the politics of self-taught artists are highly diverse. Perhaps no surprise, yet when we examine academic life and the elite art world, such diversity is often absent. Much academic and artistic life, politically contentious to be sure, has politics ranging from the soft to the hard left: from pink to deep red with a few dashes of green. A central theme of Julia Ardery's discussion of the consecration of Edgar Tolson is that his supporters embraced progressive politics. Ardery asserts that, "The Civil Rights movement was the primary earth-shattering force that led us to the self-taught art field," coupled with alienation from the mercenary, establishment art world in contrast to the "nobler ends" of the folk art maker (Field notes).

Here, as elsewhere in artistic and academic domains, leftists, atheists, Jews,[19] gays, and lesbians are over-represented. Visiting Appalachia, and becoming friends with and patrons of the artists, helped guilt-ridden, educated bourgeois young Americans feel "a margin of escape" from their comfort and consumption.[20] For some, such as dealer Carl Hammer, it was an attempt to champion the cause of the underdog in society.[21] For others, such as collector Chuck Rosenak, it was the surprise that an underclass existed: "Suddenly [visiting Edgar Tolson] I realized, really for the first time, that America was not just the affluent middle class. I mean, there were other people and these people had dreams and visions and ambitions and that this collectively made up an America that we knew nothing about, and had never read about, had never experienced. And so I set out . . . to find out what it was like in America."[22]

The creation of the field, in Ardery's view, was fundamentally polit-

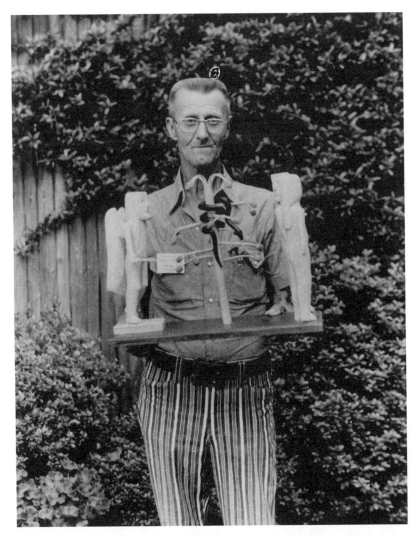

Edgar Tolson (1904–1984). Archives of the American Folk Art Museum, New York. Courtesy of Chuck and Jan Rosenak. Photo by Chuck Rosenak.

ical, linked to 1960s social activism. One shouldn't deny the reality of Ardery's observations—and the sharpness of her satire of those who, at times, were as naive as the artists they found. However, much of American culture—minimalism, glam rock, Dungeons and Dragons, public radio, Charlie's Angels, and nouvelle American cuisine—was created and/or publicized by these very same individuals. The collector who sought out Tolson could have had a brother who admired hyper-realism.

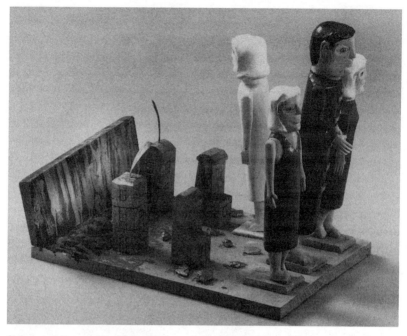

Sodom and Gomorrah by Edgar Tolson. Collection of Chuck and Jan Rosenak. Photo: Archives of the American Folk Art Museum, New York.

Ardery's argument explains too much and too little. Too much because these cultural players created more than self-taught art, and too little because it lacks an aesthetic to go with the politics. These objects could easily fit into an ideology, and the locations of elite actors permitted them to discover these objects, applying this ideology. This discovery was a function of affluence, the growth of regional universities, government programs, and a visual culture that the artists drew upon to create works that were meaningful to their collectors. In other words, the politics and persona of the collectors were linked to the choices of the artists to produce the folk art market.

This art world involves the intersection of groups who would not ordinarily meet. Such contact can produce condescension by the more powerful (and rage or amusement by those less powerful). Does contact invariably involve colonization? Some claim that they "treat everyone as equal, as no different, no better, no worse" (Interview). Yet, this is easier said than done. If elites treat the impoverished by elite standards, they can be criticized for cultural imperialism, but if they treat them according to their perspective of the other's culture, they can be accused of being patronizing. Curator Lee Kogan even argues that "direct quotations"

from artists "point up the socioeconomic deprivation of many of the artists, which, *probably unintentionally,* causes a divisiveness and classism, in effect separating artist and reader."[23] Is it better to erase the artist's discourse or to increase divisiveness by including it? Elites can't win—except for the fact that, of course, they *always* win.

The artists themselves are a diverse group, so diverse as to make creating a coherent "field" difficult. Many artists are profoundly religious, a stance relatively uncommon among secular art audiences. A patron told me that, "[Reverend Howard] Finster . . . he's our minister" (Interview), and another noted that, "[Sister] Gertrude Morgan got me reading the Bible," but these comments imply that they lack a church affiliation and a faith grounded in community. While some artists, such as blacklisted union activist Ralph Fasanella, Ned Cartledge, and Thornton Dial, display progressive politics, others such as Jesse Howard (who believed there were twenty-five thousand hard-core communists in Washington[24]), Norbert Kox, and Alpha Andrews do not. Some, such as Keith Goodhart and Gregory Van Maanen, seem fiercely libertarian and opposed to government, while still others express in their art a set of "agreeable, humane 'personal values' . . . suitable for decorating the living rooms of liberals and conservatives alike."[25]

IMPROPER POLITICS. What is to be done with "politically incorrect" artists? Some progressive artists or curators feel they must "tone down" their works or shows to make them broadly palatable to buyers and funders "in deference to reactionary collectors and other cultural conservatives on the self-taught bandwagon."[26] I must confess that was I unable to discover this surreptitious reactionary group, with the exception of a few moderate Republicans.

The greater problem is those artists—some few who still use the "N-word" or speak disparagingly about Jews—who reject norms of tolerance and respect for social groups. One collector notes that, "I met a real sweet couple in Kentucky whose work I liked and who started talking to me about 'Jew this' and 'Jew that,' and I said 'Now listen, I want to talk to you about this, and I did. I said I didn't like it. I said that my partner was Jewish and I didn't want to hear any of this stuff. . . . I realized at the time that that had no meaning to them. They'd probably never seen a Jew in their lives" (Interview). Of course, if collectors had visited these artists, they almost surely had.

A dealer once explained to me that, "I'm dealing with a man now who's an absolute, total, livid racist. I mean he killed a black man this past year, and he was joking to me on the phone about it today that the KKK sent him a Christmas card. . . . There's no way if he was a folk

artist, I would be involved with him. I wouldn't be involved in his work on any basis. But he is in a racist community where I can buy stuff that will one day serve [to allow us to understand] the social conflict. . . . You know, he's still human. . . . I want thoroughly to understand why did he become such a hater" (Interview). This dealer claims he would reject this man's art, no matter its aesthetic quality, but because he can provide historical artifacts, a relationship is legitimate. On another occasion a curator explained that her museum had to decide whether to preserve the work of an artist whose beliefs are unpleasant. She asserted that some colleagues did not wish to preserve it for that reason—a political decision with real consequences for whether that creator will enter the art-historical canon.

My point is not to excuse, but to recognize that the political standards of dealers and collectors may differ from their artists. Can we ever only care about aesthetics, or does the personality, the beliefs, and the background of the artist force themselves upon our evaluations? If only artists were all as good, as kind, as enlightened as the community of collectors and dealers! As Kenneth Ives asked: "Is folk art a way to say reactionary things and still keep liberal company?"[27]

The Color Line

If race is the American dilemma and the color line is the problem of the twentieth century, we shouldn't expect less in art worlds. Yet in several decades we have moved far. Consider a 1963 newspaper notice from Fayette, Alabama, a feel-good feature about one of the less threatening "colored men" of the town, Jimmy Lee Sudduth:

> A popular yard man, who does not have enough time to get around to all his customers, Jimmy Lee says he really appreciates his white folks. Jimmy Lee takes great pride in his [art] work, using colored crepe paper and shoe polish to get his colors. He has never had any training. . . . Jimmy Lee and his wife live in the servant house of Mr. and Mrs. Eric Grimsley and they take great pride in their home and surroundings. He even has put artificial blooms on the shrubbery.[28]

On rare occasions one will find individuals, typically marginal to the art world, whose expressions can be taken as overtly prejudiced: a southern gallery owner who objected to too many blacks in the gallery for a folk art event or a woman who wanted to commission a work (from a black artist) without any black faces.[29] Most racism, if it can be called that, must be read against a veneer of tolerance.[30]

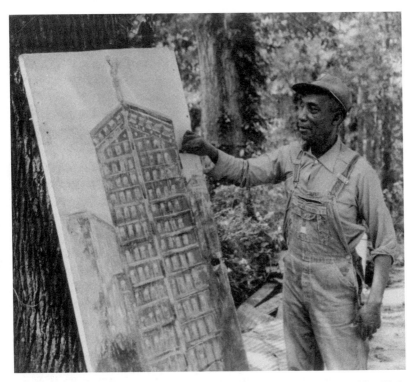

Jimmy Lee Sudduth (b. 1910). Archives of the American Folk Art Museum, New York. Courtesy of Chuck and Jan Rosenak. Photo by Chuck Rosenak.

Thus, it is controversial when some proponents of African American vernacular art suggest—without compelling evidence—that curators and museum officials wish to preserve their temples as bastions of whiteness. As one suggests, "these museum bureaucrats did not work their way or claw their way or lie their way to the top so that they could hang out with uneducated blacks. That's not what they want from their environment. They don't want their openings of their most important shows to have a lot of black people there and black artists" (Interview). While overt racism is rare, an expectation exists of who and what belongs in an art museum, and some self-taught art and artists don't quite fit, perhaps explaining the difficulty of bringing black audiences to museums. While in self-taught galleries, black artists are typically not separately marketed in distinct categories as they are in the music industry,[31] the division is real. Self-taught art provides an opening for black artists, but delicacy exists in handling this color line.

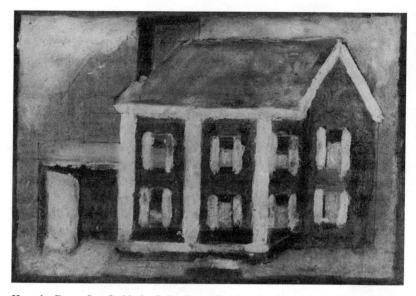

House by Jimmy Lee Sudduth. Collection of Smithsonian National Art Museum, New York. Photo courtesy of Chuck and Jan Rosenak.

William Dawson, a prominent Chicago black self-taught artist, commented that he had never sold a work to an African American.[32] While African American collectors collect African pieces or those of trained African American artists, most ignore self-taught work, perhaps sensing the white establishment's enshrinement of the primitive.[33] As one black told a white collector: "The work you collect represents the past we left behind." He reports that one African American museum guard commented disdainfully, "This is like stuff I remember from my childhood."[34] A curator commented, "One member on our board, who is African American and has been very active building our African collection, she said to me, it's not that I don't like Mose Tolliver's paintings. I think they're fine. But she said, we, and I speak for a lot of the black community here, are so tired of seeing the only art by blacks in museums are African art or self-taught art or folk art. She said all these eccentric guys who are sitting in their homes and they're painting because they're sick or they're painting because they're mentally disturbed. . . . We want some mainstream black artists in here" (Interview). As a collector told me: "I think they want to support the blacks who have done the white thing by going through the academic end of it, and they're going to support the people who are trying to make a living in art which is difficult at best" (Interview).

CREATING ARTISTS | 113

Displaying either self-taught artists or trained black artists can be seen as revealing racial politics. It would have been nice to get the perspective of black collectors, but the problem is that with the exception of one man who collected some self-taught pieces along with African and trained African American works, I could not find any significant collectors. Perhaps collecting this work is troubling for those whose soul and identity are connected with the establishment and legitimation of the "best" of African American culture. Buying and displaying self-taught works does not add to the African American collector's cultural capital, but may diminish it.

Justifying Art

People who do the unusual typically are asked to provide an accounting, lest they be labeled as deviant.[35] If an action is seen as inappropriate, some excuse may be expected. Self-taught artists deal in justifications: why do these unexpected people do these unexpected things. These artists typically cannot rely on the claim that art is a career or a means of contributing to a national or global culture, as fine artists can. Nor can they claim that this activity is something that they learned about and enjoy doing, as they might enjoy any hobby, the way that middle-class floral or landscape painters do. Such claims, such as that by James Harold Jennings who reported, "it is the thing I like to do the most. I can do it at home,"[36] might diminish the otherness of the artist. The artist must construct a suitable justification that establishes his or her "right to create," since standard artistic justifications are unavailable or lack force.

COMPULSION. One effective claim is that art is something that a self-taught artist *must* do; obsession is a central image in the discourse of self-taught art. These people are driven to create, an urge sometimes linked to mental imbalance. Virginia artist Marion Line stated, "I make art because I must."[37] As one dealer said of her artists, "They do what they do, not because it's art, but because they feel that they have to do it" (Field notes). Such assertions, whether by artists or by dealers, diminish the artist's will, and transform the artist into an outsider to his or her self.

SELF-SATISFACTION. A second argument relies on self-indulgence. Artists create for themselves—and not for the market. Folklorist Simon Bronner argues that the chain carvers he studied create from a deep engrossment, escaping a world that often lacks personal satisfaction, providing in the form of the completed whittled chain a profound sense

of accomplishment.[38] Artist Ralph Fasanella reported, "When I became an artist all of a sudden every fiber within me was alive. My body was constantly excited, intoxicated with wonderful feelings of joy."[39] Often this turn toward art occurs after a major life-changing event: an illness, injury, or death in the family, as in the case of Lonnie Holley.[40] This rhetoric rejects the idea of a cognitive plan in the face of emotional satisfaction.

VISIONS. Some artists claim that an external force impels them—a dream, a vision, a revelation. For some this begins with a single and singular experience; for others these visions are continuous. Often the vision is religious or evangelical. Some artists claim to be commanded to create, while others see this as a talent that they shouldn't waste.[41] The Reverend Howard Finster is a case in point, as he claims that a "face" on his finger, dipped in paint, instructed him to create "sermons in paint" to express God's message, creating "sacred art" on materials at hand.[42]

Tennessee artist Bessie Harvey wrote: "[My ideas come] out of the dept of the ener me. I make what I see with my spirits eyes. The gift of God, it is a gift we don't wont to fight because he has chosen us to give site to see this art and to give it to others that cant see and it give us that do it much joy".[43] Sculptor William Edmondson said that he heard God tell him to pick up his tools and begin to carve. "I looked up in the sky and right there in the noon daylight He hung a tombstone out for me to make."[44] Religious visions constitute a central justification for the artists, part of the authentication of the Other.

Given the emphasis on religious visions and the demands of God, it is significant that much of the audience for this work is secular. I have never heard a collector or dealer claim that Finster's work has moved them to a closer relationship with God, becoming reborn. Finster's fans include rock stars such as Michael Stipe of R.E.M. and David Byrne of the Talking Heads, Jewish and agnostic dealers, and elite collectors who relax Sunday mornings completing the *New York Times* crossword. Although millions have been exposed to Finster's messages about salvation, it is unclear if any have responded as Finster hoped. I had dinner with the Reverend Finster one night, and during the meal I asked him whether he knew Jerry Falwell and Pat Robertson. Finster told me that he admired them and had sent money to their ministries, but admitted that they had never contacted him. His natural constituency—those he most respects—ignore him. Finster appeared on the *Tonight Show*, but not on the *700 Club*. It is secular humanists that feted Reverend Finster,

asking him to paint album covers for rock musicians.[45] His visions fall on deaf ears but awed eyes.

Making Art

Artists like all workers differ in their orientations to their work. For some creating is a special moment, a mystical high, for others it is manual labor. Inspiration comes from all over, a trip to New York, scanning a magazine, or receiving a postcard. For some the fact that self-taught artists are inspired by images from outside their community is "treated like an embarrassing secret."[46] But it could hardly be otherwise. Artists, trained and self-taught, rely on contemporary visual culture. Why give more weight to a flower than a postcard of a flower? Indeed, it is part of their everyday genius that they incorporate aspects of the mundane into objects that audiences find transcendent. The very fact that most self-taught artists gather images from all over without self-conscious punctiliousness makes the work striking.

Although he could barely read, Alabama painter Mose Tolliver had art books around his home: "Using periodicals, books, and pictures found or brought to him, he transforms images in a singular, personal style—a dollar bill inspired his *George Washington;* a transfer-printed china plate in his home inspired *Mary and the Bible;* a picture postcard sent by Anton Haardt, a Montgomery friend, was the source of the *Statue of Liberty.*"[47] Should this influence of art or popular culture upset audiences? Critic Jerry Cullum notes, "Let's suppose that [an artist] did see some possible artworld model for his artwork at some point early on in his career. *So what?* Hundreds of mediocre trained artists around America have seen exactly the same books and posters, and they are still turning out dreck. . . . Anything from [this artist's] experience might find its way into his art, but transformed by his personal imaginative vision."[48] Artists take inspiration from all over and shape it. The question is how?

Sociologist Howard Becker in *Writing for Social Scientists* asserts that writers do not often talk about *how* they write.[49] They talk about what they write, of course, and even talk about how they think about writing. But the act of writing is often hidden. What time of day does the writing occur, for how long, how is rewriting done, does one first clean the house, on what kind of machine is the writing done, is a cup of coffee or a beer nearby, is music playing in the background? Becker argues that the process of writing is faintly embarrassing—involving our personal quirks and the mundane mechanics of the production of the sublime—

and in which we are ignorant of the strategies of others. In many other domains, we are similarly ignorant of the routines of creation.

The Doing of Work

How do self-taught artists do what they do? If we can't know about inspiration, we should have some idea about techniques. Some strategies may seem odd, but this may be because we know little about what trained artists do in their private studios. Of course, we know something about the making of Jackson Pollock's art, but only because Jack the Dripper's technique was considered so distinctive—and, for the skeptical public, humorous.

One central dimension is pace. On this score, vast differences exist. In chapter 2, I described the tremendous output of Adolf Wölfli and Henry Darger in their closeted worlds, but extensive output is hardly unknown among artists who actively display or sell their work. Rudy Rotter, a retired (now deceased) dentist in Manitowoc, Wisconsin, and proprietor of the Rotter Museum of Sculpture in his hometown, was proud of the fact that, since retirement, he completed over fifteen thousand pieces and admitted that he strives for quantity. Reverend Howard Finster, who numbers his work, has produced more than Rotter, and in a timed demonstration made seventeen artworks in twenty-five minutes: a useful skill for a preacher who wishes to spread his message.[50] In twelve years, Finster had produced over twelve thousand works, on average three a day. With his focus on production and with the assistance of his family, Finster's workshop is sometimes likened to Andy Warhol and his Factory.[51] His grandchildren cut the wood panels, sand the edges, prime the pieces, and even paint the primary backgrounds.[52] At his death, Finster may have completed nearly fifty thousand objects—some important and timeless, some not.

In contrast, other artists complete few works. Thornton Dial, also with the help of his family, completed eight large assemblages—triumphalist paintings—in a year (although with many more drawings), and worked thirteen to fifteen hours a day on one piece throughout one spring and summer (Field notes; Interview). For other artists, such as P. M. Wentworth and Drossos Skyllas, only several dozen drawings or paintings are known. Artists who operate on their own time and schedule—who are often unknown, unpopular, or with great ego-strength—can avoid the demands of dealers and customers. But those who want to satisfy their market frequently rely on helpers and keep a list of back-orders, focusing on their "bread and butter pieces" (a death skull for "Son" Thomas, carved watermelons for Miles Carpenter, Elvis

for Finster, or Adam and Eve for Tolson) or figuring out how to produce art more efficiently.

For Edgar Tolson, "by 1968, presumably to meet stepped-up demand, Tolson developed a swifter technique for figure carving. Most of his earliest dolls were fashioned from one block of wood, the arms set off from the torso by laborious gouging. Beginning in 1968, however, Tolson began whittling arms as separate appendages and then attaching them with glue, a much faster process."[53] In the exaggerated words of Roger Manley, "a visit to any one of the 20 or 30 'name' Outsiders these days is more likely to resemble a tour of a sweatshop than an audience with a prophet."[54]

Speed and collaboration combined is only one element of how art gets made. Equally significant is what happens when an artist sits down to create. Place can be important. Wölfli and Darger had their little cells. Some criminals find that they can only create while in prison, but not on the outside. One artist, a former Nazi concentration camp inmate, draws in a narrow room that reminds her of her wartime experience (Field notes). While not all artists need confinement, such a special space seems helpful to some.

Artists' daily schedules differ according to their preferences. Howard Finster reports, "I start painting, long about ten o'clock in the cool of the evening, no children running and things is closed up. I drink me a large cup of coffee and can paint for hours sometimes. It's quiet and I meditate. . . . I paint till just a little before daylight the next morning."[55] In contrast, there is Ab "The Flagman" Ivens: "A typical day for me would be, get up about 6:30, 7:00. Drink some coffee, watch the news, kind of start in the back of my head. I can almost feel it. I can start thinking about what I'm gonna be doing today, and if I'm working on something from last night, I like to take it and look at it for a little while. . . . I usually go outside and turn on like some kind of news program or a little bit of music, depending on what kind of mood I'm in, and start working on things" (Interview). The only commonality is the coffee.

Of course, as with writers, each artist has techniques that are comfortable and conducive to creativity, even when those techniques differ from how art school students are trained:

A radio was going strong tuned to the local favorite soul music station . . . in the middle room, was Mose [Tolliver], sitting on the edge of his bed painting on a board which he held on his lap. . . . He used his bedspread to wipe his brushes on, and his shoes and pants were covered with splatters of paint. Cans of mis-mixed and cast-off paint in random colors were

stacked all around his bed, ready for the next picture. . . . On any given day there is always a group of admirers at Mose's house.[56]

★ ★ ★

Starting with a level board for his "canvas," [William] Hawkins often poured a thick foundation of enamel paint across his image plane. Working with colors directly from the can, and using a single brush or stick, he then began to manipulate the tacky paint surface in an impromptu manner. Pushing, mixing, dripping, swirling, and scumbling pigment, he built up rich visual textures as he began to "shape out" the form of his emerging subjects. Working and reworking his pictures, Hawkins never erased his original compositions. Instead he added to them, or painted over them, creating in many works a kind of layering in which earlier images show through and intermingle with later formal inventions.[57]

★ ★ ★

[Joe] Coleman works for eight hours a day on his minutely detailed canvases, peering through a jeweler's magnifier. He starts in one corner and just carries on until the painting is literally full up.[58]

Some artists are fastidious; others are casual, but each relies on ideas of how they should work. The point is not to make fun or dismiss these techniques, but to recognize the range of forms that creativity can take, given the lack of formal socialization or any collective sense of how an artist *should* work.

The Material Basis of Creation

Each [primitive art] piece listed materials, the way Western art is labeled "gouache on paper" or "acrylic on canvas." This practice was presumably intended to domesticate the exotic by treating these objects like understandable and uncontested art rather than as tokens of exotica. I found the effect quite the reverse, however, in labels like "WOOD AND SHOE POLISH" or "WOOD, PLASTIC INSERTS FOR TEETH." Some of the materials nearly leapt out of the confines of the genre: "WOOD, PAINT, PORCELAIN, COWRIE SHELLS, HIDE, VEGETABLE FIBRE" and "WOOD, PAINT, PORCELAIN, CARPET TACKS, METAL HOOKS, RED BEADS."[59]

The production of visual art requires material objects. Even conceptual art requires some documentary material to capture the experience. However, the possibilities are remarkably diverse, linked to availability. In every case what is available is a function of societal organization. Critic Jerry Cullum notes, "Bill Traylor couldn't have drawn his quite

wonderful animals and people on cardboard shirt boxes until cardboard shirt boxes became commonplace refuse. There was assuredly a time in the South, one that lasted for decades after emancipation, when the region's general poverty militated against the rise of throwaway items of any description."[60]

Although this might appear like a trivial point (of course, there must be cardboard boxes to paint on cardboard boxes!), it goes deeper. The type of art that can be produced is a function of social choices, and these choices are outside the hands of the artist. How art looks is not only a function of the artist's intent, but a function of what others make available to a person in a particular location.[61] The self-taught aesthetic—and all aesthetics—results from social organization and the materialist form of a culture. Howard Becker argues that art is collective action, and that artists depend on those who supply their materials as "support personnel."[62] In the case of the self-taught artist, the entirety of society constitutes their support personnel.

Impoverished painters, such as Sam Doyle, use leftover or mis-mixed house paints. These "improper" colors affect the aesthetic, allowing the artist to use "color combinations that a trained artist might not attempt" (Field notes). Wisconsin artist Rudy Rotter used leftover wood from a boat-building company and Georgia artist Ab "The Flagman" Ivens has the same relationship with a futon maker. Georgia artist Nellie Mae Rowe sculpted with used chewing gum. While these choices bedevil conservators, at the time the work is created the material choice is just fine.

"Canvases" may be whatever boards are available in the neighborhood. Many artists, such as Lonnie Holley, Ab the Flagman, and Kevin Sampson wander the streets looking for objects that they can incorporate into their works—ceiling tiles, broken pottery, window shades, used barbeque grills, and sawdust. Each year the family of Thornton Dial roasts a goat, and Dial takes the horn and hide of the goat and includes it in his work, believing that "nothing should be wasted" (Field notes). Even without intending it, these artists are "recyclers" and some shows have focused on this process of reusing materials.[63]

Sources of discarded objects channel the art. Mental patients or prisoners rely on institutional detritus and institutional policies for dealing with that waste: toilet paper, soap, chewed bread, used envelopes, and paper fished from wastebaskets.[64] Martin Ramirez used mashed potatoes and Raymond Materson used unraveled socks to create their art. Although not all self-taught artists abjure professional supplies, prestige art materials typically do not have the status-enhancing value that

they often have for trained painters. Certainly, folk artists are rarely concerned with the *brands* of paint, crayons, and paper about which trained artists sometime obsess.

In self-taught art, collectors and dealers often are directly involved in providing materials. These men and women typically express noble motives, supplying artists with "better" quality material, helping conserve the work, even while influencing the final product. Accounts of generous elites are common. Within two weeks of his discovery, Charles Shannon was bringing Bill Traylor better paper, pencils, and paint. Traylor had a sufficiently strong artistic vision that he selected which gifts to use, continuing to use cardboard and paper that he left out to "weather."[65] J. B. Murry was given higher quality paper, crayons, and markers, first from a discount store, and later, once art professor Andy Nasisse became involved, professional art supplies.[66]

Some question the consequences of collectors and dealers becoming involved in providing artistic products. As collector Jim Arient reflected, after claiming that he purchases high quality paper or wood for artists who request it:

> I know of a story where somebody offered to the Smithsonian this ship by Walter Flax and they refused it because when they took x-rays of it, it was loaded with termites. How could it not be. . . . Those pieces are lost and it's sad. . . . Part of the product is the ephemeral nature of it. Some of it is done on shirt cardboard and cardboard boxes. It's already gone to hell. That's just the way it is.[67]

Is it better to permit these creations to decay, or should collectors and dealers affect the work, even the aesthetic vision, in making them collectible commodities? Does Martin Ramirez deserve paste to attach his drawing sheets or are only mashed potatoes authentic?

Although what is available matters, this does not fully *explain* the art. There is more junk in the world than an artist could ever use. Artists do not just use *whatever;* they choose what "junk" to incorporate, a process of bricolage that involves the creator's eye even if sometimes, as in the case of the Reverend Howard Finster's shift from paint to colored markers, few prominent collectors or dealers agree with the choice.[68]

The availability of materials and the choices that artists make affect their aesthetic production. Artists use materials to solve problems of creativity, as in the case of Alabama painter Jimmy Lee Sudduth:

> His subject matter is almost literally rooted in Fayette in that he uses local clay and mud to paint his pictures. He is a man and painter of the soil. His

basic materials are clay, vegetables, sugar, and water, which he applies to locally manufactured plywood. When he begins a picture, he surrounds himself with containers holding sands, soils, and clay. He likes to use white, gray, and brown sands as well as brown and black soils. He prepares these by adding sugar and a little water to the sand, and syrup to the dirt and clay to help them stick to the board. According to Sudduth himself, this technique was developed gradually and somewhat by accident. "I worked with cardboard but the mud didn't seem to hold up so well. So I went to plywood, somethin' that holds up. But I still didn't know how to make the mud get hard. There was a man lickin' syrup one day and he dropped some syrup on the ground. I got that syrup and I put it on a board and that was it! I went up there and got juice from the [sorghum] mill. I put it in my mud and put it on the board and it got hard and wouldn't come off. I said, 'I got what I want now.' I went wild!" [69]

Sudduth colors his work with materials such as molasses, coal dust, crepe paper, pine needles, berries, grass, Coca-Cola, and the exhaust fumes from his lawn mower. [70] Sudduth has the traditional concern of the artist, figuring out the solution to a set of practical problems, adjusting his aesthetic images to the reality of what is accessible.

Sometimes the availability of materials is recognized as having direct aesthetic consequences. For instance, Georgia artist Archie Byron mixes sawdust with glue; this became the material base of "his trademark highly textured paintings," adding "a greater dimensionality." [71] In the case of noted Nashville sculptor William Edmondson, in 1937 the first black artist to have a show at MOMA, these choices are aesthetically consequential:

Many of the skills Edmondson had acquired and maintained in various earlier occupations were called into play. He adapted a number of iron railroad spikes into crude stone chisels and used a common household sledge-hammer as a sculptor's mallet. Most of the local limestone used in his early carving came from a pile of demolished building debris that had been dumped by the city adjacent to his back garden. As his production increased, he found that a ready supply of such stone could be had for the asking, or for a low payment to the dump-truck driver. This source of recycled building stone, much of it in cubed blocks, would have a great effect on the geometric forms and composition in many of his finished works. [72]

Although one might claim that Edmondson had not originally planned to sculpt in the form that he did, he made aesthetic choices, consistent with the choices of Nashville civic authorities to use his neighborhood as

William Edmondson (1874–1951), sculptor, Nashville, 1937. Photograph by Louise Dahl-Wolfe. © 1989 Center for Creative Photography, Arizona Board of Regents.

a dumping ground. His choices were ratified first by MOMA and more recently by an important traveling show,[73] emphasizing, just as is true for trained artists, that the material basis of art matters.

The fact that some self-taught artists (and some trained artists) claim that the materials "speak to them," determining the shape of the final product underlines just how important materials are. As is said of painter Sybil Gibson: "She starts by wetting a pad of paper assembled from grocery bags, and smoothes the paper flat on a table top. She takes her cues from the shapes developed in the blending on wet paper. 'I let my paint dictate to me all the time.'"[74] Whatever the reality of the rhetorical image, it is clear that the materials artists work with shape the final product, and the materials selected are only in part a free choice of the artist.

Lady with Muff by William Edmondson, Nashville, ca. 1940. Limestone, 15½ × 6½ × 6¾ in. Collection American Folk Art Museum, New York; promised gift of Ralph Esmerian, P1.2001.344. Photograph by Gavin Ashworth, New York. Photograph courtesy of the American Folk Art Museum, Shirley K. Schlafer Library.

Artists and Their Worlds

Self-taught artists, no different from others, live in a world of family, friends, coworkers, and acquaintances. Their networks may be tight or loose, but they are real. These relations include those between self-taught artists and the art world in which they ostensibly are a part, those involving a network of artists, and those involving friends and family.

The Artist and the Art World

As crudely genuine and innocent as his carvings, Clyde Jones is among the growing number of folk artists who have been discovered—and thus poked, prodded, and at times exploited—by those for whom art is big business. The collision between these two worlds is sometimes amusing, as when Jones was flown to New York City by one of his exhibitors and told to show up at the exhibit the following day at seven. Jones dutifully arrived at the gallery at seven the next morning, unaware that he was twelve hours early and that his patrons, like the rest of the Lower Manhattan demimonde, were only just now getting to sleep.[75]

Culture clash is one of the traditional bases of comedy—the *Beverly Hillbillies* is a central text here—the stereotypical innocent who behaves "inappropriately" in the eyes of the corrupt and cynical elite. The episode of *The Simpsons* in which Homer proved, for a moment, to be a hot outsider artist was of this type as was John Waters's film, "Pecker," about a self-taught photographer. A Roz Chast cartoon in *The New Yorker,* titled "Folk Art of Midtown," includes such creations as Post-It-Note Quilt, Takeout-Menu-Rug, and Portrait in Latte, White-Out, Pepto-Bismol, and Scotch.[76] These pieces of comic business ostensibly satirize the art world, while never losing sight of the fact that this art world is an audience of the humor. The fact that the creators are themselves members of this elite should make us pause to consider the deeper meaning of the text: are they truly about the innocence of the outsider or about the self-enhancing ability of the elite to laugh at themselves when those laughs truly do not matter?

Michael Hall likens the artist Martin Ramirez to "the Lone Ranger," noting:

Americans especially are disposed to embracing the primitive myth of modernism. . . . We need to believe that the Lone Ranger exists. We need to believe that he possesses dignity, cunning, natural instincts, and an indomitable will to prevail. We need him to be an outsider. We need him to be a man behind a mask. But do we need Martin Ramirez to be the

Lone Ranger of art—masked behind his psychosis? Nobody, it seems, really wants to know who he was. They simply seem determined to cast him as the Natty Bumppo of finger painting. His supporters want him to ride into town, guns blazing like those of his own soldados, laying waste to the archfiends of Minimalism and Post-minimalism. Seen as a hired gun, he is also useful as a rallying figure for the hordes of Neo-expressionists exploiting the new cult of the obsessive compulsive.[77]

Who Martin Ramirez was is less important than who he needs to be.

COMPARISONS. Artworks, each with their own style, can be said to resemble one another, much as every person looks *in some way* like most others. We are all separated at birth. The greater the social distance, the more successful the jest. Our need to categorize makes us see similarities in the absence of influence.

Artworks, too, are, in effect, separated at birth. These comparisons run rampant, either as a means of legitimating the work of the self-taught artist or as a means of claiming that the trained artist is authentic. Comparisons between the taught and the self-taught abound. A sampling of these comparisons include:

Nellie Mae Rowe: Frank Stella, Marc Chagall
Ronald Lockett: Julian Schnabel, David Salle, Robert Rauschenberg
Minnie Evans: Man Ray, Miro, Jean Arp, seventeenth-century Indian artists
Thornton Dial: Anselm Kiefer, Goya, Jackson Pollock, Picasso, de Kooning

The diversity of these references should give pause. What do Stella and Chagall or Goya and Kiefer have in common? While we must credit that the works did inspire these comparisons, connections are loose, perhaps suggesting that the self-taught artist is "just as good" as members of the canon. While each critic had a comparison in mind, the range of comparisons suggests that the canonized position of the trained artist is hoped to rub off on the self-taught artist. Trained artists are compared as well, but in those cases it is often assumed it is because of a process of self-conscious influence.

A *fictional influence*—perhaps suggesting Jungian archetypes—is made concrete in a series of museum shows that compare, through side-to-side display, the work of trained artists and those who are self-taught, just as some museums display ethnographic artifacts or popular culture icons next to the work of trained artists. On these occasions the trained aesthetic legitimates the non-trained work, and the trained artist is validated for the catholicity of his or her vision. In self-taught art, the most

influential show of this genre was the 1992 *Parallel Visions: Modern Artists and Outsider Art* show held at the Los Angeles County Museum of Art. Throughout, the hierarchy of the art world remains unruffled.

Although some object to the pairings, citing the lack of theoretical knowledge of the self-taught artist, privileging theory over practice,[78] the combination satisfies supporters of self-taught art by implying that these works are "just as good" as trained works, and satisfies supporters of trained art by demonstrating that these creators draw from authentic impulses.

ARTISTS AS SUPPORTERS. While comparison is important, interaction within the art world is equally central. Some trained artists are friends and supporters of self-taught artists. The example most evident in Chicago is the tight linkage in the 1960s and 1970s between the Chicago Imagists (e.g., Roger Brown, Jim Nutt, Gladys Nilsson, Ray Yoshida, Karl Wirsum) and the black self-taught Chicago artist Joseph Yoakum. Dealer John Ollman noted, "When Yoakum was alive, the Imagists made sure that he was always shown with them, that he was considered to be a contemporary of theirs, and they supported him. I mean, they made sure that he had money, that he had everything that he needed. When he was in the hospital, every single one of them went and visited him at least once or twice a week. He was considered an artist in the same rank as they were. And that's what it should be like."[79] In this case—admittedly unusual—the relationship between the Imagists and Yoakum constituted a school of thought and a school of activity.[80]

This may involve "identity work," constructing an "outsider ethos" for themselves in contrast with the New York art world (a claim of Julia Ardery[81]). Certainly the Imagists' support of Yoakum contributed to their sense of being a group with an aesthetic vision. I previously noted the personal friendship of Charles Shannon and his New South circle with black artist Bill Traylor, and that of Michael Hall and the art community at the University of Kentucky with Edgar Tolson. Hall asserted, "I suppose at a certain point my ideas for myself and my view of my career and my idea of Edgar and my advocacy for his art ran conveniently parallel toward the same goals. I never confused myself with Edgar, but on the other hand I sort of felt we were in the same boat, and there were times when I didn't mind rowing for both of us in what I viewed as the art professional arena."[82] Networking can count for a lot.

MUTUAL INFLUENCES. The influential critic Lucy Lippard argues that folk art has shaped contemporary art: "Folk art has had a huge influence on modernism in general and on the white avant-garde of the '70s and '80s, from Claes Oldenburg to Red Grooms and David Bates

(both of whom were raised in the South). But for artists like Joyce Scott (and probably for many white rural and rurally raised artists), it is a direct source of empowerment."[83] It was not only the Chicago Imagists who were influenced by self-taught art, but "during the seventies, almost as a backlash against impersonal and minimal trends of the New York art scene, SoHo artists 're-discovered' expressionism and the delighted dealers and critics proclaimed a 'post-formal' period that featured a more personal and eccentric kind of exploration. To many avant-garde artists, dealers and collectors, the posture of the untrained artists' work was refreshingly free of the stale and tired conventions which characterized the formalist doctrine of minimalism."[84]

Some critics suggest, however, that "self-taught art is a bad influence on trained art, that it's making contemporary artists raw and nasty and giving up drawing, and that the coarseness and rawness is having that sort of effect. And we know it's really been a lot of the academic artists who have discovered a lot of these artists and bringing them to the attention of curators in the field" (Interview). But for good or ill the influence is real.

This influence can go in both directions, boundaries being permeable. As one curator told me: "[The trained artists] are picking up more from the untrained artists than the untrained artists are picking up from them, but now I'm beginning to see as [self-taught] artists go to more museum openings and are more active in the art field, there might be some of this influence going the other way. . . . I think you see this in Purvis Young [a Miami self-taught artist]. As I understand it, he really does study art history books in the library and looks at abstract expressionists" (Interview). Ultimately conventions of representation, found in self-taught art, must be learned somewhere, "an inevitable absorption of visual culture."[85]

Interaction allows for aesthetic influence. Of course, not all self-taught artists are interested in the works of their trained friends, but some are. Perhaps most notable is the case of George Andrews, "the dot man," a Madison, Georgia, self-taught artist and his son Benny, a well-established, trained, New York–based artist, formerly director of the National Endowment for the Arts' (NEA) Visual Arts Program and faculty member at the New School for Social Research. One writer notes that, "As a result of father-son cross-pollination, George's flowers, dots, and other decorative symbols sometimes reappear in Benny's later canvases, but as carefully selected background details rather than as part of the main design."[86]

Artists have trekked to Reverend Howard Finster's Paradise Garden,

Lonnie Holley's Birmingham environment, and William Hawkins's apartment, and as tokens of esteem they bring their own work and discuss the problems of making art. If these visits are part of the elite's appropriation of outsider imagery, the visits also involve homage and respect. Self-taught art with its authenticity bolsters the trained, but simultaneously the techniques and knowledge of the trained can bolster the confidence of the self-taught.

THE ACTIVE ARTIST. It may appear that the self-taught artist is simply *there*, waiting for others to come calling. This image, not totally false, is misleading. Self-taught artists can be active in the construction of their careers. Some artists attend symposia at which their work is discussed. Other artists are actively involved in curating their shows. Lonnie Holley—the closest to a self-taught art theorist—served on the curatorial committee of the 1996 *Souls Grown Deep* show, sponsored by the Carlos Museum at Emory University. Black Alabama artist Charlie Lucas was a guest artist at Yale.

Some artists send their works to dealers or museums, and one self-proclaimed self-taught artist, Francine Gertrude Strauss, even placed an advertisement in *Folk Art* seeking gallery representation, including her phone number and e-mail account.[87] Chicago's Intuit: The Center for Intuitive and Outsider Art receives several dozen packages from artists and their relatives each year, hoping for an exhibit (Field notes). On occasion such strategies are effective, as in the case of Missouri artist Robert Eugene Smith: "Back around 1981, Bob marched into the Springfield [Missouri] Art Museum asking to see 'whoever was in charge.' Dumping out the contents of a sack, Bob revealed several colorful paintings. Declaring them to be 'wonderful works of art,' Bob interested the curator of collections, Greg Thielen, to see more. With that bold and naive act of self-promotion, Bob landed a one-person show there in 1984."[88] While one imagines that such midwestern chutzpah would only work in a small-city museum, it does suggest that artists can hasten their own acceptance. Galleries may be more open to such strategies: Marilee Stiles Stern sent her work to SoHo's Phyllis Kind Gallery, which now represents her.[89]

Of course, the artist must accept the rules of dealers and critics. Criticism can be a problem for those who see their work as authentic self-productions. One dealer noted, "We recently had a show reviewed of art by a woman who was a manic depressive person. . . . She received a review from this guy and it was very negative, and it affected her deeply, and that made me realize that what we do is a little bit different than a typical art gallery. When you're dealing with people that are overcoming

mental and physical challenges to get the work out there. . . . It's a little bit of a different relationship with critics. . . . Here's a woman that's literally spent six months in hospitals because of depression, and she's gotten to the point in her life where she's able to put a body of work in front of a group of people, and feel good about herself. . . . and that kind of criticism hurts" (Interview). An artist writes about a critical review: "How can [critics] really judge and feel that someone's honest work is false if the artist has painted his or her heart and soul into it? . . . I am serious about what I do and know that I must work in the style that I do in order to be a complete person. It is that important and real to me."[90]

Given this exquisite—if real—sensitivity, what is the critic to do? Sincerity is only one characteristic on which artworks should be judged. The critic needs to be an honest broker for readers and simultaneously helpful to the artist; an artist who rejects the former—and many do when the comments are harsh—undercuts the role of critic. Should critics be therapists? Artists sometimes do not realize that an art world can be a dangerous place.

Artists Together

The world of self-taught art is sometimes pictured as comprised of discrete individuals who are sometimes, particularly in the case of those labeled folk artists, linked to their home community and sometimes to the mainstream art world. However, there is on occasion a network, a community, of self-taught artists.[91]

At times these connections are grounded on friendships, either because the artists are neighbors or have met at shows (sometimes exhibiting artists meet at receptions, such as at the Kentuck Festival of the Arts in Northport, Alabama). Pennsylvania artists Justin McCarthy and Jack Savitsky became good friends after meeting at local art shows, talking about their art and trading artworks, even though their different aesthetic sensibilities were not altered by their relationship.[92] Georgia artists Howard Finster and Eddie (St. EOM) Martin became friends after sharing a taxi in a Washington snowstorm on route to a show opening at the Library of Congress. Despite the fact that Finster was a fundamentalist proselytizer and Martin a flamboyant gay fortuneteller, the two continued to phone each other.

Occasionally an artist's aesthetic is shaped by others. Sometimes the influence is direct, as in the case of Georgia woodcarver Leroy Almon who was trained by Ohio carver Elijah Pierce. More often the influence is a function of exposure to other artists and their work. Lonnie Holley is an excellent example of a central aesthetic node. Holley introduced

Minnie Adkins with her work *Coyote.* Photograph by William Oppenhimer.

art patron William Arnett to Thornton Dial in the mid-1980s. A decade later that network was denser; Holley had met all but one of the living artists displayed in a 1997 exhibit of the Shelp Collection of African American vernacular art at the Schomburg Center of the New York Public Library (Field notes).

Further, Holley is influenced by—indebted to—the work of other African American self-taught artists. One of Holley's large sculptures, *Big Bird Landing,* is a tribute to James Hampton's *Throne of the Third Heaven of the Nations Millennium General Assembly* at the Smithsonian's National Museum of American Art. Holley claimed that Hampton's "spirit came home with me."[93] On another occasion, Holley produced an homage to black artist Mary T. Smith, and in turn one of Thornton Dial's works pays homage to Holley.[94] Within the network of southern African American vernacular artists, Holley is a central figure.

A second artist with a similar networking role, though less explicitly tied to aesthetic theory, is the Kentucky woodcarver Minnie Adkins. Adkins perceives herself as a mentor for younger Kentucky artists—a supportive figure who helps others market their work. She has a room in which she displays the works of other artists. In addition (until recently), each June she organizes a "Day in the Country," an annual event in which collectors, dealers, and artists meet, buy and sell, and eat barbecue at her home in Isonville (Field notes). Support for the event comes from an auction to which artists contribute.

As one dealer put it, "she has been a one-man promotion, and has

Possum and Babies by Minnie Adkins, 1993. Paint on wood, 11 × 41 × 5 in. Photograph by Katherine Wetzel.

inspired at least a dozen other artists, younger artists. . . . She has inspired a number of stonecarvers and many other woodcarvers" (Interview). A Kentucky dealer and curator commented, "Minnie was a mentor [for local artists]. She would encourage them in the work, but I think as much as anything what she did was direct people to go see them, to go visit them. When people would come to see her, and it still happens very often, if somebody is coming from any great distance, Minnie will have arranged this itinerary for them."[95] Whether the support involves an aesthetic vision or an organizational structure, self-taught artists can see themselves as a community with shared interests.

The Demands of Family

Perhaps more evident than an artistic network is the presence of family. But how should we think about an "artistic family"? Although there is a powerful image that an artist is an isolated genius, creating from personal insight, the role of an artist's family undercuts this impression. Once artists become well known and well rewarded, unable to cope with the demands of admiring collectors, they often turn to their family.

Art is often a skill that people, when trained, can learn to do passably well. The Finsters and Tollivers are known for their "collaboration," although it is the paterfamilias whose signature bestows value. This stands

in contrast to families in which members of the clan have their own style, such as the Dials (Thornton Sr., Thornton Jr., Arthur, Richard Dial, and Ronald Lockett).[96] A collaborative family constitutes a workshop, following in the tradition of workshops in classical art.

Does this mode of production affect the work? Is a work by the Finster family—putting aside differences in aesthetic merit—worth less than one by the Reverend himself? Does having Mose Tolliver touch brush to board enchant the object, or only the audience? Perhaps the idea of an art family suggests that anyone could produce the art and undercuts the idea of personal genius. Collectors, even those sympathetic to problems of production, wish to purchase those works with sole authorship. This is problematic when the artist is elderly or infirm; yet he or she remains the family's "meal ticket."

To watch the family business disintegrate is difficult, and, as a result adjustments are made. In the words of a collector, "Sometimes the artist didn't even know what was going on. There's a story now of David Butler, in Louisiana, who did these wonderful tin cutouts. Actually he probably hasn't done any work for several months, however if you go to the house where he is, you can buy his pieces but they're done by his kids. He doesn't even know they're doing them. . . . It's a production line. He's their meal ticket. He's a virtual prisoner in this house, he's real old, sick. . . . They just pass them off as his."[97] I previously raised the issue of forgery. Here forgery is not quite the issue; the concern is the sacredness of the artist's touch. Is the family a true folk community or just a group of differentially talented individuals?

FAMILY FEUDS. The fact that an artist can create work that brings in considerable income can change family dynamics, particularly in those families that have only known poverty. Perhaps elite audiences assume too much about Gothic family doings as the folk art equivalent of *Tobacco Road,* but stories abound. It is said that the son or daughter of one well-known artist stole thousands of dollars that the artist had hidden in buried coffee cans. The Finsters are said to battle over how to market Howard's work, a division labeled the "Finster Feud." I was told that the family is only being held together by Howard's continued productivity. When he dies, I was warned, "the thing is going to go up in flames" (Field notes).[98] Whether these unkind predictions have become true in the years since Finster's death, I cannot say; however, the stories point to the difficulty of dealing with sudden wealth—a problem known to sad and surprised lottery winners.

Whatever the truth of these stories, families are intimately connected with the production of self-taught art—both in the doing of the work

and in the decisions about how the money should be spent. It is false, prejudicial, and slanderous to suggest that all of these families are dysfunctional, but there are enough problems in Dogpatch to comfort other dysfunctional families living Uptown.

The Burdens of Fame

The 1982 *Black Folk Art* show, opening at Washington's Corcoran Gallery of Art, so important in establishing the significance of the work of African American self-taught artists, represented a remarkable culture clash. Many artists attended the opening in the midst of a blizzard, having left their southern communities for the first time, brought to Washington with "chaperones." As if the sly tricks of weather were not sufficient, the artists were introduced to First Lady Nancy Reagan. As one observer commented, "It was somewhat surreal to see that group of men from their culturally and economically deprived backgrounds among these educated intellectual folk, theorizing as to what the impetus, value and quality of their art was. . . . Son Thomas, the Delta Blues musician and participating artist, entertained the audience with his 'Big Legged Woman' songs."[99] Suddenly they were famous, but to what effect?

Public notice has the potential for changing the lives of artists and the life chances of their offspring. In a society that has so passionately embraced the cunning charms of capitalism, such notice would seem to be a largely unalloyed benefit. That it doesn't happen that way suggests something about how elites conceive of the effects of money on "pure, authentic" artists, and, to some extent, the reality of life in which one's worldview is based on expectations of a particular income level.

The effects of fame are complex. Folklorist Rosemary Joyce writes, " 'Fame doesn't make the sun any cooler,' professed an Ohio folk artist. The line demonstrated his scorn for the attention lavished on him for several years. Such seeming indifference is countered by his delight in that attention: the stream of visitors, the newspaper and magazine articles, the banquet invitations, the television appearances, and the demand for his wares. . . . Fame doesn't make the sun any cooler, true. But the warmth of that attention is a heady experience. It has its price. And if that is, in fact, the loss of the artist's original tradition, cultural aesthetic and subsequent income, the price is too high."[100]

A critic raises a similar concern: "In drawing public attention and critical acclaim to the naive artist, is the artist truly being helped or actually are the seeds of destruction being planted? Certainly there are financial and social rewards for the artist in the discovery, exhibition, and

acclaim of his or her work. Yet these are benefits only if one assumes that they are basic goals of the artist. There is little to suggest that this is the case. Perhaps inflating the value of the artist's works as commodities and the discovery of the artist as a social figure, in fact, interfere with the normal conditions within which the naive artist originally worked."[101]

Who is to decide? Given that most of the writing pro and con is by critics, collectors, curators, and dealers, any claim can easily be interpreted as having an elitist tone. There is no way to predict the effects of sudden fame, just as many inner-city athletes become upstanding citizens along with teammates who find themselves in court or drug rehabilitation.

THE BENEFITS OF FAME. Given the diligent search of so many for esteem and wealth, it might be surprising that relatively few observers argue that fame in general has any sustained benefits. (Artists seem more sanguine and uncomplaining about fame and wealth, if not about the burdens of fame.) Significantly, those who contend that fame has a positive effect focus on the work itself.

For some artists, recognition provides them confidence to work on more complicated and larger pieces. Who among us doesn't feel self-assured from the compliments of others? This is certainly true of Thornton Dial whose small, carved fishing lures have given way to monumental assemblages, addressing important social issues. One academic noted of artist Nellie Mae Rowe, "The better known she became, the better the work. Her later works were very complex and just profound. . . . She got money for what she did and [it] gave her a true sense of worth" (Interview).

Something similar happened to South Carolina artist Sam Doyle, one of the participants in the 1982 Corcoran show: "When he returned to St. Helena Island, he was a local celebrity. . . . Following the success of the Corcoran exhibition, Doyle painted feverishly and some of his finest works were produced between 1982–1985, when visiting collectors, academic artists, photographers, and curiosity seekers flocked to his outdoor museum in ever-increasing numbers. Fortunately Doyle benefitted financially from the sales of many of his works."[102]

Similarly, a collector noted that Mr. Imagination (Gregory Warmack) is "wearing $2,000 leather jackets and stuff like that. Totally, completely different from like three years ago . . . and he's still as nice as ever. I mean the guy deserves a nice coat and stuff like that. [His art has] gotten better. It's gotten sophisticated." The collector's husband added, "He hasn't gotten mainstream or streamlined his stuff, or duplicated things at all" (Interview). These artists cope with fame, and their work—at least as judged in the art market—continues to improve.

THE PAIN OF FAME. It is more common for collectors and dealers to bemoan the effects of fame on artists. In the words of one romantic, "There's a huge negative side. I think success almost destroys the very essence of what this is about. But what can you do?" (Interview). In my experience, few artists are as ardent as this comfortable collector in rejecting the material benefits that fame brings, but fame can be a burden. Public attention can cause artists to feel overwhelmed, even leading them to have difficulty creating:[103] "One elderly artist, sensitive to the stream of visitors that interrupt his solitude these days, threw up his hands when asked to paint a wooden egg for the White House Easter Egg Hunt. 'Now the president's after me too!' he cried."[104]

Before being "discovered," many self-critical artists—trained and not—feel that every work must be their best. However, after success is assured and "anything" will sell, it may be difficult to resist the demands on them and spend more than the minimum amount of time to create the objects. According to a dealer, "[An artist] got selling so fast she didn't even finish her paintings when she brought them to the gallery. They weren't even half-painted. Because she was just whipping them out, and bringing them in" (Interview).

The demand to produce can reach a fervid pitch, leading artists to think of art as production work and themselves as order fillers. Some, like black Alabama artist Charlie Lucas, embrace capitalist theory: he and his dealers raise his prices to the point that the number of purchases roughly equals his production capability (Interview).

Part of the elite's concern with fame involves artists spending their money in ways that collectors or dealers feel is inappropriate. One dealer commented, "When I buy Mose Tolliver's art, I'm buying Mose Tolliver some more drink. I am part of Mose Tolliver's problem in life in this whole system of exploitation" (Interview). A second notes of Tolliver, "I got a feeling if you looked in his pocket at the end of the day, that $2,000 is gone. He's not a businessman. His kids probably take half of it. He probably spends the other half on unnecessary stuff, and I think he's just as poor the next day, and just hopes that someone comes by and buys some more" (Interview). These assessments may be correct, but they raise the question whether people should be able to make their own choices. As one dealer and friend of Mose Tolliver noted self-critically:

> Once you hand money to somebody you just cannot give them directives of what they're going to spend it on, not if they're free people, and it is very important for these artists in particular to remain free of having directives put on them. . . . I would always get to Mose's early in the morn-

Mose Tolliver (b. ca. 1919). Archives of the American Folk Art Museum, New York. Courtesy of Chuck and Jan Rosenak. Photo by Chuck Rosenak.

ing because he didn't have air conditioning. It was just sweltering hot in the summer and I remember sweating all over a check as I was writing it early one morning. I think it was maybe for $700, $800, but it was a substantial amount of money. . . . And I looked at Mose, and I said, "Mose, you know what. With this money that I'm giving you right now, I could make certain there was a nice air conditioner put in that room right there. And I'd bring you back at least half of this money, and I could have that done probably before the sun was down today." And he looked at me and he said, "Air conditioning? Why would I want an air conditioner? I don't like air conditioning." And that has always stayed with me . . . a rule I've had to apply to all these situations that I put money in their hands and they are free to spend it on whatever they want to spend it on. . . . He likes his life just the way it is, so why should I come in and try to change it in some ways? . . . Now if it comes to their health, I'll stick right in. . . . But he really doesn't have anybody take care of his finances. I have taken him to the bank a bunch of times to deposit some money, but I am very fearful that somehow somebody is not being straight with Mose, because he would be a much wealthier man as a result. . . . There's no deposit ticket, there's great opportunity for abuse and there's no checks

Self-Portrait by Mose Tolliver. Archives of the American Folk Art Museum, New York.
Courtesy of Chuck and Jan Rosenak.

or balances, and, I mean, it really concerns me, but I don't know really what I could do. (Interview)

This informant raises important issues. Although she feels that it is inappropriate to become too involved in an artist's finances, such distance may allow others, even bankers, to cheat the artist. Is personal freedom sufficient in the absence of financial knowledge? Does a hands-off approach, seemingly noble, permit others to steal? Expertise can be patronizing, but sometimes father knows best.

Fame without Effects

Perhaps the most common claim is that fame does not, truly, matter. Such a startling perspective rests on the assumption that these artists are authentic. They are rooted in their culture, their community, and on their land. When I visited the homes of some prominent artists, I was surprised at the conditions—the squalor—in which they lived. I grant that squalor is my assessment, but it is not mine alone. Given that these men and women are exposed to television culture—almost all have televisions—it is startling that advertising has been so ineffective in producing a desire for consumption. While this does not apply to all artists—Thornton Dial lives in an impressive home, once owned by a Birmingham doctor—it applies to many. A curator told me that "a lifestyle change is not that desired among the people I know."

These artists can be extremely generous. As one academic told me, "Dilmus Hall gave away most of the money he made. Gave it away to people in the neighborhood. So does Lonnie Holley. That was the pattern. . . . Hall had about $2,000 stuffed in his overalls two weeks before he died, and nobody knows whatever became of it. He would give money to people" (Interview). Other artists support large families, not caring whether their living conditions compare to that of their collectors. Their choices validate the desire of many collectors to find the natural.

One dealer, noting that some successful artists still live in shacks, referred to them, somewhat unkindly, as being like "the Beverly Hillbillies" because "it's not the money; it's the culture." Perhaps it is "the culture, stupid," but the television show, while exoticizing the other, also satirized dominant elites—the Beverly Hillbullies. It is to be expected that one's values and standards serve as the criteria by which to judge others, yet this is a problem when elites attempt to understand how people from different backgrounds should respond to the fame for which they, themselves, are prepared.

Creating Artists

The analysis of any work sphere depends on its producers and the relations of those producers with those who have the power to shape their lives. As a result, it is important to appreciate who makes art, how, and why. There are considerable similarities in artistic impulses, but whenever one draws distinctions, differences are perhaps most salient. When trained artists have problems, those problems do not define who they are. In contrast, for many self-taught artists, their problems define them in practice. Although Lonnie Holley, the artist with whom I began this chapter, is a profound creator, he struggles with life circumstances, some of which he made and others that have been thrust upon him. Whether he will continue his production at the same rate and same level of accomplishment remains uncertain. It is not only the construction of biography, but also the obdurate effects of biography that matters.

Artists develop explanations that legitimate their artworks: perhaps it is a job, a calling, a divine demand, or an obsession. Trained artists typically are not asked the question; art is their profession, and they are careerists. Self-taught artists need an account for behavior that would otherwise be considered strange. Since they cannot rely on the rhetoric of career, they must create alternative claims.

In the doing of work, they must find techniques of practice that permit the construction of products in the absence of a professional supply system, on which trained artists typically rely. How they work and what they do does not depend on conventional standards of practice within an occupational community. In contrast, these artists must create standards and must persuade others that their activities are legitimate.

To be a self-taught artist is to be a creator: not only a creator of the works themselves, but also a creator of a justification for doing the work and a creator of a system of resources that permits artistic creation. Given their lack of formal training, this ability can be inspiring.

4

collections

[White people are] a whole nation of museum
keepers because what they do is build a house,
then they spend all their time painting it and
cutting the lawn and keeping the windows
clean, and then building little shelves all over
inside their houses and filling the shelves up
so that they have to spend all their time
dusting. And when you go to some white
person's house, what you do is get a tour of all
the *things*. . . . It's just like a museum tour.
What do white people do with all
those things?
—A NATIVE AMERICAN IN CONVERSATION
WITH FOLKLORIST BARRE TOELKEN

As I write this, I sit in a room in which
there is displayed some forty southern
pottery face jugs; a Howard Finster
print of Uncle Sam; a Tubby Brown
cutout of Santa Claus riding an alliga-
tor; a Herbert Singleton carving of a
man and a snake; a Bessie Harvey root
sculpture of a woman's face; paintings
by Jimmy Lee Sudduth of the Statue
of Liberty, by Alpha Andrews of Janet
Reno's "crime" at Waco, and by Ber-
nice Sims of the Selma march; bas-
kets by Native Americans (reed, pine

needles), Hmong immigrants (plastic strips), black southerners (sweet-grass), and white southerners (oak); an old baseball glove; and much, much more. In my study, I display over a hundred objects—things I collected (purchased) for their aesthetic and symbolic value—arranged on walls, shelves, and tables. As Walter Benjamin noted in his lecture "Unpacking My Library," "the collector's passion borders on the chaos of memories."[1]

I am my own curator—we all are. Commodities and noneconomic objects combine to define us and to satisfy our desires. Whatever else collecting is, it is fundamentally social. In the view of anthropologists Arjun Appadurai and Igor Kopytoff, things have a biographical aspect—a life history of the object, but this biography becomes linked to its possessor.[2] Sociologist David Halle notes that we all place "things" on the walls and tables, and these things communicate to us and to others about our claimed identity.[3] Objects are selected because of their meaning, even if that meaning is only that we find the form decorative, feel the colors are restful, or that the object fits above the couch.[4] Often, as in the case of abstract art, the collector's justifications are less impressive than expected. Even those elite and sophisticated Manhattan collectors that Halle interviewed didn't talk about abstract art in terms of aesthetic theories of "flatness," but in terms of its decorative character and emotional resonance. The same is true of self-taught art. Halle argues that theories that emphasize the intellectual abilities or economic position of class groups—such as Marxist materialist theories or the theories of cultural capital of Pierre Bourdieu—miss the point that people of all social classes develop emotional attachments to objects. Few among us are theorists; even those of us who are theorists in our public speaking, privately sound like anyone else. While conspicuous consumption might motivate purchases, in explanations of purchases that motive is conspicuously absent.

Perhaps instead of thinking of collectors as domestic curators, we should conceptualize them as artists who take found objects and create an assemblage: a home. The display becomes an object in its own right.[5] In our everyday tasks we reveal a creativity, a genius, for which we may not always garner credit. To understand art as commodity and as an identity claim, we must recognize how collectors perceive their activities, their relationships with one another, the relationship of collectors and artists, and the display of objects. When analyzing the social dynamics of collecting, this discussion reveals a close resemblance between those who collect self-taught art and those who collect in other domains of art.

A Passion to Collect

I write for a living, but I am also the owner and curator of what is almost
certainly the world's largest collection of crack [cocaine] vials. . . . For a
decade, the vials have been made illegally in an abundance of styles, and
they have been discarded by the tens of thousands on the streets of New
York. My collection is a measure of this abundance and a small monument
to it. . . . In Harlem, while I was on my knees sifting through a scattering
of crack vials under a park bench, a young woman lolling on the bench,
who was high on something, said to me, "You don't care what people
think about you, do you?"[6]

Much has been written about the drive to collect. In a society that de-
pends on continued and expanding consumption, collecting is taken as
exemplary. If crack vials can be gathered—and written about—so can
anything. For some, the psychological components of collecting rise to
the surface: psychoanalyst Werner Muensterberger claimed in *Collecting:
An Unruly Passion* that collecting assuages the fear of loss, part of self-
theory.[7] Unlike parents or lovers, the objects remain (although of course
they can break or fade, too). The objects have stories associated with
their acquisition that connect the collector to his or her past, providing
for a continuity of identity.[8] Economists downplay psychic needs and see
collecting in the context of consumerism generally—consumption writ
large, a tournament of value—part of the perpetual pursuit of inessential
luxury goods.[9]

My approach, developed in an ethnography of mushroomers, is to see
collecting as occurring within social space, as a collective enterprise. The
accumulation of objects and their valuation depends on an audience, a
like-minded community that shares impulses and rhetoric.

I have previously described the stories that collectors tell about artists,
but collectors also talk—at great length and with passion—about other
collectors. Two such cases are that of Herbert Waide Hemphill Jr. and
Chuck and Jan Rosenak—who have generously made their papers avail-
able to scholars at the Archives of American Art at the Smithsonian,
so we know more about how they built their collections than we do of
others. Hemphill was one of the earliest collectors of twentieth-century
self-taught material. "Bert," as he was universally known, was beloved
within the community. A gay New Yorker (originally from Columbus,
Georgia), Bert not only was a mentor and source of inspiration to many
in the field, but one of the organizers (and early curator) of the Museum
of American Folk Art. In a field that could sometimes be contentious,
he was perhaps the only figure of whom I heard no one speak ill, even

if his collecting was referred to as obsessive. The results are now part of the collection of the National Museum of American Art, and so belong to the American people. The Rosenaks, two attorneys, now living near Santa Fe, New Mexico, are major collectors and authors of the *Museum of American Folk Art Encyclopedia of Twentieth-Century American Folk Art and Artists* and *Contemporary American Folk Art: A Collector's Guide.* The Rosenaks, vigorous collectors, insist on visiting the artists that they collect. Although visiting artists is often a solitary pursuit, the Rosenaks talk volubly about their own adventures. As with Hemphill, the field would not have the character it has without the Rosenaks. The recognition of these collectors—and the legitimation of the collecting enterprise by their "obsession"—reminds us of its social character. Further, it suggests that we should dissociate obsession from its psychiatric baggage—these obsessives did, after all, sell and gift their collections.[10] While surely a few are pathological, most of these obsessives might be more kindly labeled passionate lovers.

The Temptation and the Passion

Collectors in all domains describe themselves as obsessive—mushroomers certainly did. However, in a field in which the character of artistic production is often described as compulsive, this metaphor is particularly powerful:[11]

> He had to have his buying fix. It wasn't a good day if you weren't out collecting. . . . I think Bert Hemphill was out of control. . . . It's just not normal in the sense of normal. (Field notes)[12]
>
> ★ ★ ★
>
> Their [a collecting couple's] passion is unbelievable. . . . There's a line where these people go over the bridge, over the wall, and become crazy people. That's all they think about. It's an obsession. . . . It's like having a mental illness. It's like being a glutton. . . . It's lucky they don't take up alcohol. (Field notes)

I emphasize that these speakers are "joking," and are, perhaps, a bit envious in that these collectors are doing what the speakers enjoy, only more so, but such rhetoric also justifies the more moderate approach of most collectors. Speakers also joke about their own accumulation, as one claimed that, "I went off to the woods for two months, mostly to try to wean myself from buying art" (Field notes); another collector claimed, "I wish I could say I'm no longer a buyer, but there are so many things out there" (Field notes); a third wrote, "I do not believe that my collecting is obsessional, although I am willing to concede that at first

glance my carton-filled, over-stuffed apartment might lead the faint-of-spirit to consider it excessive."[13] These collectors are, in the words of a dealer, "artoholics." On the one hand, these collectors are gathering beautiful, treasured objects, but on the other they are gathering objects of which they or others must someday dispose.

FOCUS. Despite their rhetoric, collectors do not collect random objects. Each senses the "kind of things" they admire and wish to display. In talking about mushrooming, I spoke of walking in the woods. However, for committed naturalists, few simply walk in the woods. There is too much present; the woods are a booming, buzzing confusion. As a result, naturalists often focus: some listening for birds, others treasuring wildflowers or trees, others searching for beetles, and, my friends, eyes cast down, hunting for fungi. So it is at art shows and flea markets. Two collectors can visit the same gallery and alight on different pieces: the issue is not absolute value, but personal value. Some pieces are edgy, others are whimsical, and collectors become known for the style of their pieces. Others collect by subject matter: alligators, owls, Adam and Eve, political themes, religious imagery, or erotica. A dealer noted of his clients: "Some collect paintings and carvings of animals. Some collect the work of artists from one particular state. I have a client who buys women in bathing suits. Another collects Statues of Liberty. Many people collect only the work of African American artists. Some collect religious art."[14] One recognized collector explained, "I think it helps to have some focus . . . It could be that you collect portraiture or collect flea market art or collect landscapes. I think it's far more interesting and far more impactful if there's some focus to the collection. Otherwise, it's a hodge-podge" (Interview). While a narrow or explicit focus does not characterize every collection, often an implicit order or aesthetic exists. Collecting is means by which people play with categories.[15]

FOR LOVE AND MONEY. One cannot engage in this extensive effort without a felt love for the activity and an appreciation for the objects. While individuals differ in the degree that they think about—and admit—that their collecting involves an economic component, one on which they may eventually make or lose money, economics is entwined with aesthetics for reasons that relate to *communal valuation* and *personal constraints.*

Price is integral because prices and changes in price stand for the evaluation that others—including institutions—have of the work. Prices reflect a shorthand for aesthetic judgments; judgments are fundamentally social, grounded in the activities and shared values of members of

a community.[16] A work that is defined as beautiful, profound, or moving will have a greater value—and more buyers willing to expend more resources to possess it—than those that lack these qualities.

Further, collectors operate within resource constraints: household budgets. While a few collectors bankrupt themselves in the process, this is unusual, perhaps a function of the bountiful credit available to these elites. One may set a price limit for purchases, and once one steps up to a new limit ($200, $2,000, $20,000) that becomes established as the price that one expects to pay for major objects. I have met collectors whose two-hundred-piece collection is estimated to be worth $25,000 and others whose collection consists of many objects individually valued at more than that. Some collectors may purchase one or two major items each year (one pointed to her "1998 purchase"), while others are promiscuous in their purchases, but in each case they think about the constraints of their cash flow.

Some collectors allege with sincerity that, "These are my children. I don't want to make money from them" (Field notes).[17] Said an academic: "We want art to move us. We don't want it to follow the Dow Jones index" (Field notes). Yet, others are not so sure that monetary value is entirely absent. How many people purchase works that they believe will decrease in value—in other words, that are "overpriced?" even if the work moves them. One collector noted of a valuable work that, "We've never been tempted to sell it, but it's nice to know we can use it to help our retirement." A major collector admitted that, "I've spent a fortune over the years buying art. So, the answer is that I wouldn't have gone to the intensity that I did, if I didn't think it was valuable. All right. But the value in it is not the reason that I did it. I've never bought anything I didn't like" (Interview). These pieces are not purchased as short-term investments but the reality of the market is not wholly lost on these collectors. Recently a number of major collections have been donated to museums (sometimes as a mixture of gifts and cash purchases, but typically involving tax write-offs) or have been placed at auction. The great collectors have "given away" or sold all or part of their collections, often at considerable profit. These prominent collectors aged, downsized, or changed focus. The 3Ds—Death, Divorce, and Debt—are the major causes of deaccessioning, and the museums and collectors who gained those works were happy to have them, although dealers, the beneficiaries of the largess of these buyers, are pained whenever a major collector leaves the market. Perhaps these collectors were conscious while accumulating that this financial appreciation might occur,

but one would be both be unkind and incorrect to suggest that this was the primary motivation.

The Competitive Collector

Just over a century ago, in 1899, a young Norwegian American economist—some labeled him a sociologist—coined the term "conspicuous consumption."[18] By this Thorstein Veblen meant that people—particularly, though not exclusively, the group that he sardonically referred to as the "leisure class"—attempted to surround themselves with objects the mere presence of which would demonstrate to others that they were men and women of quality. He argued that commodities without clear function—useless objects—served best in this status game.[19] These objects were symbols of class position.[20] Their presence—indeed, their conspicuousness—announced the social position of the owner. This signal inspired jealousy, a desire to "keep up with the Joneses," what Veblen termed "pecuniary emulation." Few objects have less functional utility than art objects that, after all, merely gather dust. They have a pure expressive quality. Further, they are situated within the life cycle. I was told that Robert Bishop, the influential dealer and museum director, claimed that young people spend money "on their backs and in their driveways—on their fancy cars and fancy clothing. Collecting art is a later stage of affluence" (Interview).

Given the dynamics of collecting as a social world, it should hardly be surprising that this is a competitive world of the kind that Veblen described. The evidence is embedded in a joking culture. When a collector visits the collection of another, there is almost invariably a comparison between self and other. A fantasy of "shoplifting" is not unknown. Let us label this "pieces envy." A husband commented about a proposed public display of the couple's collection, which they eventually decided against, "We could match anybody's show piece for piece."[21] I visited a remarkable collection and overheard one visitor say to another, "How would you like to move in?" and then joke to the hostess, "We're going to spend the night" (Field notes). One guest pointedly remarked, "If God had money, this is the kind of house He would build" (Field notes).

Several friends reported the identical story about three important (male) collectors assessing their holdings during a party. A female collector walks in from the patio, telling another, "I couldn't stand it anymore, being out there with those guys, treating folk art as if they were

comparing the size of their dicks" (Interview). Jerks or not, this collector admitted that, "I stay away from those people because I find myself getting competitive and getting a little bit angry. I [have] a little class reaction to the people who can buy anything they want to. I keep thinking, 'Oh, go buy Rembrandt, go buy Picasso. Why don't you leave us alone.' [she laughs]" (Interview). For this collector, these men are in a league of their own, even while she recognizes her own competitiveness. As one collector with a mid-level collection admitted, "It's really funny how you get sized up by your collection. People ask, 'What do you collect? Who else? I see.' . . . Like if you use the name R. A. Miller [an inexpensive Georgia artist], your collection is in the toilet" (Field notes).

One collector remarked of her experiences with others in the self-taught art community: "They begin to size you up. You're either in the top crust of collectors or the bottom crust. It's a closed league. . . . When people discover that you started collecting in 1990 [late in the growth of the field], you get dissed again. The potato chip versus the blue chip" (Field notes). Whether her assessment is accurate is beside the point; it feels real to her and others. If condescension is a problem in the relationship between collectors and artists, so it is among collectors. Despite an assumption of ranking, unlike hockey or beauty pageants, there are no clear rules for "who wins," an ambiguity that makes hierarchical ordering more difficult, and means that collectors search for collective validation, loaning their valuable objects or opening their homes to strangers.

These concerns, projected outward to others, reveal only part of the story. Individuals judge *themselves* on their collections. The quality of your own collection in light of those of others is a marker of your economic success, your aesthetic taste, and the quality of your life. It can be a means through which one evaluates personal success—the outcome of one's life as measured through gathered artifacts. Further, because one's collection is shown to others, one fears that others will come to recognize one's limits both financially and culturally. As a result, impression management is essential on home visits. Guests must find something flattering to say about the display. Silence can be taken as a brutal insult by uncertain hosts. The fact that all collectors fabricate compliments means that the sincerity of those received is precarious. However impressive one's collection, the belief (and dread) is that there is a better one down the street, gathered by a more impressive soul. The social psychological terror of placing oneself in public through one's objects is real. These people participate in groups in which the judgments of taste

are not from anonymous others, but from those with whom long-term relationships develop.

This competition—whether based on self-esteem or envy—also is found in stories from collecting expeditions. Collectors are treasure hunters, searching, like mushroom hunters, for hidden caches.[22] As one dealer explained, "It's sort of like a club. They're busy trying to make sure their collection is better than other persons' collections they saw. . . . I think that part of the field for many people is to hunt. It's just like hunting deer. They may not really be, in some cases, real venison eaters, but they're out there hunting. And maybe they don't really need this art, but it's this game they're playing. They want to have the best collection for the least amount of money they can put out" (Interview). Said a collector, "When you go to a flea market you never know what may happen there. It's like a treasure hunt, the energy that's there. You're up early and your blood's pumping and you're thinking what's here today. Who knows, there could be anything there."[23] A dealer remarked of a recurring dream as a child, "about a bakery filled with the most exotic pastries in the world and being allowed to sample them one by one. . . . There are some theorists who say the whole collecting experience is an attempt to replicate the first thrill of the first piece. That is why some go out on more and more precarious limbs."[24]

The treasure hunt—and the associated personal validation—is evident when collectors talk about their "deals." One collecting couple told me that they purchased some Joseph Yoakum drawings for $10, pieces that now sell for about $3,000 (Field notes). A collector told me of another: "A santo maker was the guest of honor [at a party] and he claims that [a collector] went up to the santo maker,[25] and started reaming him out because he had learned that the artist sold something to another collector for less that what [he] had paid" (Interview). Few collectors would be so aggressive—and the story was presented as a moral warning—yet many collectors would be annoyed if they learned that something that they owned was now being sold for less. If nothing else, that second sale might indicate that others were given preferential treatment.

My argument is not the psychological one that every collector has an intense desire to compete—collectors, operating with different personalities and in different parts of the market, differ—however, the desire to compare what one has found with others has a profound social dynamic, explaining the great success of visits to collectors' homes as fund raisers. Collectors of self-taught art belong to a reference group—a point

of comparison by which they can judge their successes (a comparative reference group) and by which they evaluate their actions (a normative reference group).[26] The fact that participants belong to the same group and feel an allegiance, translated into friendship, explains how competition and rivalry in leisure worlds is tamed into community so effectively that many do not recognize that their comparisons reveal the unflattering dynamics to which Veblen referred.

Folk Art Adventures

It's another road trip, a regular visit with any one of six favorite Georgia or Alabama self-taught artists. . . . These questions are perpetually going through my head: 1. Am I overdressed and is my Jeep too new and bright? 2. What if there isn't ANYTHING to buy? 3. Did the dealers get there yesterday afternoon? Early this morning? 4. Sure that I have enough cash? What's my limit today, this week, this month? 5. Is the Kodak MAX film loaded in the little pocket camera? 6. Should I have brought home-baked cookies or a bucket from the Kentucky Colonel? 7. How many stories/sermons until . . . ? 8. Have I remembered all the rules and customs of the pilgrimage? FINALLY, will it all add up to an authentic folk art adventure story?[27]

This message from an avid collector nicely summarizes several aspects of the "road trip," the cementing of relationships between artist and collector in a domain in which these personal ties are critical. This makes self-taught art unlike many other artistic arenas in which the relationship between producer and consumer is expected to be mediated, notably by dealers, privileging the object over the story of the creator, and professionalizing and routinizing the transaction in which the object is acquired. The "folk art visit" is a recognized event with rules and customs, but personal throughout. For participants it is a notable occurrence: an event about which people expect to tell stories. At one time—from Columbus's voyages through the nineteenth century, it was common to find that exotic people—the savages—were on display; now the objects serve that role. Yet, even today remnants of this tradition, swathed in respect for the performers, can be found at the Smithsonian Folklife Festival on the Mall in Washington.[28]

Julia Ardery notes in her account of the contact of collectors and dealers with Edgar Tolson, the Kentucky carver, that over time the visits became structured:

The folk art homes tour, while undertaken in a spirit of serendipity and adventure, is in fact a tightly choreographed interaction. With role expectations bordering on rules, this cross-class ballet is a highly structured encounter. . . . The uncertainty of these travels [in the ability to make appointments] seems to inspire rather than discourage visitors, redoubling their sense of excitement. . . . Lacking the means to travel themselves . . . folk artists, especially rural dwellers, have been easily turned into tourist sites. . . . The folk art homes tour entails several props also. The artist, of course is expected to supply a piece or, preferably, a selection of pieces for sale, and the collector or visitor is expected to bring cash. . . . Folk art collectors also tend to come prepared to document their visits. When in the summer of 1987, I dropped in on painter Jimmy Lee Sudduth at his home in Fayette, Alabama, Sudduth greeted me cordially, showed me to a room filled with teetering stacks of his plywood paintings, and pulled out a harmonica to play a song. "Where's your camera?" he asked. "Where's your tape recorder?" [29]

A decade later Sudduth asked me the same questions. These adventures remind one of the "legend trips" that newly mobile teenagers take to graveyards, haunted houses, or other sites of adolescent angst. [30] Even if nothing much happens, the teens bring home suitably massaged stories. Folk art locales become tourist attractions, and local businesses in popular but remote areas—Kentucky, Alabama, New Mexico [31]—may benefit from the traffic.

This discussion has the unfortunate tendency to level all trips. First, not all artists want visitors, although some such as Jimmy Lee Sudduth (once described as "the Muhammad Ali of folk painting . . . an entertainer" [32]), Mose Tolliver, Howard Finster, and Mr. Imagination, among others, are welcoming. Other artists prefer to work through galleries. One dealer noted, "We have artists who ask us please not tell anybody how to get in touch with them. . . . They're reclusive. They are private. They don't want the world at their door. . . . In fact, when anyone asks me for an artist's name, I ask the customer for their name, and then I mail that name to the artist. And then it's up to the artist to contact them if they wish. In fact, I gave the name [of an Atlanta artist] to a Frenchman who was in here . . . because I didn't have the artist's telephone number. . . . The guy's mother got a gallery in Paris and I wanted the guy in Atlanta to get his work in Paris. . . . The Frenchman went straight to his door in Atlanta that night. And the artist called me up on Monday and said, 'Please, don't ever send anybody over here again' " (Interview). Even if it is in an artist's economic self-interest, personal preference may

outweigh, just as it often does for contemporary artists. But given that the art adventure is so ingrained, these artists are at a disadvantage, unless they have a dealer with sufficient clout to overcome the desire of many collectors to touch the hand of each artist they collect.

The Authenticity Trip

The idea of authenticity is so central that seeing the artist in his "natural setting" validates the work. This certainly was the case in my visit, described in chapter 2, to an impoverished artist. Discarded chicken bones, peeling paint, mangy dogs, and outhouses do wonders in the search for sacred relics, or, in the words of Julie Hall, for "icons of the true cross."[33] Meeting a grizzled artist satisfies the desire for authenticity, a "nostalgia for paradise"[34] or "nostalgie de la boue."[35] Visits to Edgar Tolson's residence have this quality in Ardery's account. The first meeting between well-dressed urbane collector Bert Hemphill and Tolson in the latter's rundown house was described as an "American episode," an event that shaped Hemphill's collecting.[36] Collector Gayle Mendelsohn similarly describes her visit to Thornton Dial: "We stayed in Thornton Dial's house with about thirteen other people. For breakfast we had bacon from the pig we'd met the night before. Mrs. Dial made all the southern black fried food that I've never had before, with the grease and the oil and about 6 million grams of fat. My husband wanted to kill me at the time, but I said, 'In a couple of years, this is going to be a wonderful experience to talk about,' and now he agrees with me."[37] Through the experience an aesthetic judgment can be made. "Herbert Hemphill explained, 'It's much more fun for me to collect living artists when I can meet them and decide whether I think they're truly naive or primitive.' According to Jan Rosenak, 'We insist on visiting the artist. You can often make your judgment based on visiting the person.'"[38] This led one artist to practice impression management, keeping a donkey, so that his city visitors will know they have been in the country.[39] These experiences make the trip to "the middle of nowhere" worthwhile. Some baby-boomer visitors to the white rural South feel they are encountering the characters of *Easy Rider* or *Deliverance*.[40] Visitors to black communities have other images, which, given racial politics, they are often too polite to announce. The evaluation does not derive directly from the work itself, but by the work as filtered through an experience of the environment in which it was collected.

Friendship Patches

The problem with being skeptical of the claims of collectors—not that skepticism is totally unwarranted—is that such a stance denies the felt

emotions of the visitors. Collectors insist that they are thrilled to meet these artists; why should I doubt them? One explained: "Once you start doing road trips, you have to do it every so often just to get a fix" (Field notes). Most artists are flattered by the attention. These episodes may be comic when described in paneled seminar rooms as examples of the chasm of class, but they are no less moving for our skills at ripping them from their context. Artists and collectors may become friends, and both may enjoy the experience.

Several collectors insisted with deep sincerity that they were truly friends with artists, and when I observed them interacting with these artists, their stories held up:

I got to the point where I was going to visit R. A. Miller about once a week. . . . I really liked going there. R. A. and I would paint together. We'd concoct things. I'd say, "Well, what about this, R. A.?" I'd take him stuff and get him to do things with it. I'd stand there and do it with him. I really like him. I've eaten dinner at his table in his kitchen with him and his family. (Interview)

★ ★ ★

I just went to [Ulysses Davis's] barbershop and introduced myself and talked with him, and then came back and back and back, and we built up a rapport. I just loved him. He was the closest thing to a living saint that I'll ever [meet]. . . . This was a man that just exuded gentleness. I mean it was just as physical as wind, and you really felt special that he would give you his company and attention. (Interview)

★ ★ ★

Down in Alabama there was an enormous, huge rainstorm, floods, and I ended up spending about eight hours in the dark with Charlie Lucas in one of his little workshed places. He was like digging around for candles, and couldn't find them, and the power went out. And I was there literally from five in the afternoon to around one or one-thirty in the morning. . . . We had just incredibly deep conversations because Charlie's such a profound and spiritual guy. (Interview)

★ ★ ★

Wife: We stayed at [Elijah Pierce's] house several times, slept overnight.
Husband: He called Beth and me his white grandchildren. He adopted us, he really loved us and we loved him.[41]

The artists themselves also talked about friendships with collectors, although surely for some visits are awkward and inconvenient, but few wish to turn away the wealthy and powerful.[42] I wouldn't if Madonna or

the Pope came calling. One artist explained that she likes to know people who buy her works, and was offended by a collector who wanted to purchase her work through a dealer (Field notes). Of course a collector will not have close relationships with every artist—most are merely pleasant acquaintanceships—but the belief that these tight friendships are possible is real and affirms the collecting enterprise. The visit validates the art, not the other way around.

On a few occasions artists are invited to stay with collectors, but typically the visit operates in the other direction. It is assumed that the artist would not feel comfortable in upscale houses, while many collectors claim to feel comfortable in tarpaper shacks. In general, collectors take the lead in establishing and maintaining the relationship through visits, letters, and phone calls, although exceptions exist. Some artists, such as Reverend Howard Finster, are avid letter writers to favored collectors; other artists attempt through letters and calls to interest collectors in their work; several letters in the Hemphill and Rosenak files are from artists hoping to receive attention from these leading figures. Collectors argue that these special relationships are "on the level of one human being to another," but sociologically the collectors have the power to propose a structurally unequal relationship as if it were egalitarian and hope that the artist agrees.

Purchasing Respect

The souvenir is an important part of Western culture. It is not enough to be there, we need to bring home a token, perhaps, given our faulty memories, to help us recall and, as a visual aid, to help us tell.[43] Some critics are disturbed by the removal of objects by those with greater financial resources. One observer suggests that this process, even when well meaning, "can become the moral equivalent of slash-and-burn-clearcutting,"[44] similar to the systematic stripping of the cultural patrimony of third-world nations.

In road trips, what is brought back is more than a token. It often has considerable value, even if the likelihood of resale is small. As one collector notes, buying art from an artist "is the opposite of buying a car. When you buy a car, and drive it off the lot, it depreciated $2,000. Here you drive it off the lot, it triples in value [to gallery prices]" (Field notes). Some collectors are explicit about their desire for a "deal": "It can be fun. . . . Plus you can save a little money on the work, which is no small consideration for me. It fact, that's probably as much of a thrill . . . meeting them is like being able to actually afford one of their pieces for

a change" (Interview). Some collectors use strategies to make the artists sympathetic to them, such as bringing their children or bringing a bottle of liquor to get the artist in a generous mood. While such strategies may be unappealing, leaving a faint odor of exploitation, in theory they pay tribute to the artist as a free economic actor who can choose to set prices as he or she wishes.[45] Given that the collector has structured the visit as one between friends, the price offered to a friend should be reduced. This illusion of embedded transactions among friends emphasizes the distinction between this art world and that of the professional, gallery-based sales of contemporary art.

As the field grew, so did pressure on artists. I mentioned that some artists created what were in effect production lines, but others simply felt overwhelmed. These artists are unable to let visitors down, but are unable to continue to produce works of quality. In North Carolina, Clyde Jones has removed his phone and spends the weekend at his cousin's house to avoid the pressure.[46] In the years prior to his death, the Reverend Howard Finster hid except for Sunday afternoons. He told the story of two Atlanta collectors driving a late model Mercedes who purchased two angels with the paint not even dry. He tried to warn them that the wet paint wouldn't come off the leather seats, and they responded, "That's OK. We don't care if we get paint on the seats. . . . We can get another car, we can't get another one of these."[47] Although Finster was dumbfounded, the irony was that the collectors could have purchased many similar angels. The visitor, of course, knows nothing of who appeared the previous hour, and, after the drive, hopes not to leave disappointed. Of course, this pilgrim is just one in an endless parade of cars and checks.

While the artist can be constrained, so can the collector. A fundamental assumption, supported by the gap in wealth between artist and collector, operates: the latter will purchase from the former, typically at the former's price. As one collector admitted about their frequent visits to a nearby artist, "We can't really go to visit someone like that without buying some things. That's why we've ended up with a lot of [his work]" (Field notes). Other collectors, who genuinely like visiting artists, find the need to purchase frustrating. One admitted a commitment to make a purchase, "and in almost every case, I deacquisition [sell] whatever I purchase" (Interview). In other words, the cost of the visit is the difference between the purchase price and what the collector can later sell it for. Another says that she will not visit an artist until she has seen the work and knows that she likes it. "I don't like

to just go and see artists because I don't want to disappoint them" (Interview). In effect, the visit is not to learn about the artist and the work, but to make a purchase. The assumption is so ingrained that a curator organizing a trip to an artist's environment reminds her audience, "Nothing at her home is for sale [the audience laughs]. You laugh but we have had problems with that in the past" (Field notes). Who is the artist to prevent collectors from the souvenirs to which they feel entitled?

Such an assumption, of course, affects dealers who sell works by friendly local artists, unless they can convince clients that they have the best work. Dealers and artists compete, with the latter often having an edge, lacking overhead and the fees of a middleman. Some dealers are frustrated with the structure of this art market:

> Because the public was allowed to get to these people, it did two things. It made it harder for us to make a living because there were so many people that finally figured out, here's how much the galleries are charging for stuff. We'll just go buy it ourselves. And it diluted the work, because the work just became worse and worse. Because the public's demanding, not for someone to make the greatest art they can, but that just to make anything so they can get a piece of the action. (Interview)

<p align="center">⋆ ⋆ ⋆</p>

> There were so many collectors, and the more collectors there were, the less sales we seemed to do. . . . All that was like a map from AAA of how to get to the art, and most people could care less about a dealer who was championing these people. They had no qualms about going in and some people would take works that are unfinished. . . . Collectors gotta have that bone from the weekend trip. (Interview)

Both these men are former dealers. The marketplace, rough as capitalism often is, did not work for them. Other dealers specialize in art of the dead, or, as often is the case, represent trained artists as well, where they don't have this problem. Others mislead clients or refuse to give out the information, as in the case of one dealer who explained that B. F. Perkins, an artist from west Alabama, lived in the eastern part of the state. Others suggest that visiting is hazardous: "We determined to find Edgar Tolson. Jan eventually located Mike Hall and he warned us that to visit Edgar Tolson was extremely dangerous because they made boot-leg whiskey in Campton, Kentucky, where he lived and someone might shoot at us."[48] With highly motivated collectors such strategies are rarely successful. The reality is that the market takes into account the

fact that these visits occur and that financial transactions result. Perhaps this has led to a diminishing of the field driven by collectors, more than dealers or curators. Yet, this is the personal, authentic structure that so many admire.

On Commissions

If artwork is the authentic product of a creator's soul, how should we think about commissioned works? Folklorist Rosemary Joyce worries about the accumulated consequence of these requests: "Granted, it does not seem a cardinal sin to ask artists to make small changes in their basket or jug or cane or embroidery—just a handle adjustment here or a pattern shift there, or perhaps a bit of color coordinating everywhere. Nonetheless, the sum of those seemingly insignificant changes is, ultimately, a breakdown in the whole chain of generational continuity and a loss of family or community tradition, leading to the abandonment of ethnic or racial or religious culture."[49]

Collectors are ambivalent about this practice. On the one hand, it permits them to acquire the piece they most desire; on the other hand they are shaping the artist's creativity, imposing their values and preferences on the authentic vision of the artist. A balance exists between appreciating the object and appreciating the artist. One collector asks an artist to sculpt rabbits for him, but adds, "It's kind of chintzy to ask an artist to do it." Also, collectors who request commissions are stuck with the piece that is produced, however unsatisfying. Typically when one visits an artist several pieces are available, and when visiting a gallery, one is free to leave empty-handed. As one collector noted of an unsatisfactory commission of a winter scene: "When I went to pick that up, I was devastated. I really was awfully disappointed in it. . . . There's some charming spots to it, but I don't think it holds together very well as a composition. . . . I felt bad about it, because she's a sweet lady. I said 'Oh, that looks wonderful.' . . . I would never spend two hundred dollars for it if I'd seen it in a gallery" (Interview).

From the standpoint of the artist, the commission is sure money, and in the words of one artist, "to me, it's a challenge" (Interview). For Earl Simmons, a Mississippi artist, "the commission gives him a chance to feel out the customer, discover what he or she wants, and conceive a strategy for achieving it. In a sense, the commission is a dare, and Simmons loves a dare. The commission also gives Simmons the opportunity to design and make things that, in the normal course of things, he

might not have either the time, materials, or inclination to undertake."[50] Artists such as Edgar Tolson, Grandma Moses, and Howard Finster accepted, if not commissions, at least requests.[51] For Reverend Finster such requests were common until he became overwhelmed, including a request from Chuck and Jan Rosenak: "I am sending a couple of photos of Rory [the Rosenak's dog]. When we last visited you, you mentioned you'd like to do a painting of a dog. We'd, of course, like to buy it if you do," and one from Jim and Beth Arient: "The spot we want to hang it needs a lot of color so a painting of some BIG red devils or a BIG beautiful angel with a bright robe would be great. You used to put glitter on some of your paintings but we never got one of those. That would be great." Such commissions potentially distract the artist from whatever he or she might otherwise choose. Of course, contemporary artists and sculptors are often commissioned, and that is seen as appropriate. An indicator of the authenticity of self-taught art is that commissions are seen as problematic.[52]

Difficult Times

To assume that visits are invariably pleasant is to misstate the case. Some are dangerous and some are frustrating. The dangerous ones, at least, authenticate the art and provide a dramatic story that enriches the object. Most of these artists—white and black, urban and rural—do not live in the garden district, a reality that gives the visit some of its piquancy: that is why it is called a "folk art adventure." However, in some cases, either because of the artist or the neighborhood, the danger is palpable. David Philpot, a Chicago cane carver, living on the South Side, once invited a collector to his home on a Friday evening. This collector waited until Saturday morning (Field notes). On another occasion, this on a Saturday morning, a collector left, after a group of men, drinking, made "unpleasant comments to him and his wife, and he felt threatened enough that he went. He really felt physically threatened" (Interview). Another artist "pulled a gun on a friend of mine, and he was just about to [shoot]. Bob had a check [from Alabama to pick up work for a dealer], and [the artist] was savvy enough to see 'you're driving a car with Massachusetts plates. You're trying to give me a check from this other person, drawn on an Alabama bank,' and he thought he was getting ripped off" (Interview). With artists and their neighbors sometimes violent, antisocial, drunk or high, it is clear that these excursions can be perilous.[53] Such culture bridging can be a learning experience, either breaking down stereotypes or strengthening them.

Aside from danger and offense, visits can be frustrating in other ways. Collectors are, in the main, highly verbal, subtle, analytical, with large vocabularies. Often in dealing with artists they must slip into a different linguistic register; sometimes I found it well-nigh impossible to understand these mumbling artists, especially when they spoke in a heavy regional accent. Conversations are often one way. One listens, and hopes that one can understand. When Bert Hemphill trekked to rural Kentucky, Michael Hall had to serve as translator, cutting through Tolson's mountain dialect. One collector admitted that she occasionally felt ensnared: "We set something up on Saturday morning, and we all drive up there, and [the artist] launches into this tale of woe. I mean this tale of woe with every disease imaginable to man and every disease of every cousin that she has. We listen to it, you don't want to be rude or anything like that or interrupt her . . . and you feel trapped" (Interview). Another collector, more candid—or less tolerant—than most, admitted: "I have to say that I get really bored of talking to these people for endless amounts of time, and I don't seem to be able to extricate myself. . . . I'm interested in talking to them to a point, but in finding out what made them do what they have and finding out what influences their work. But you know many of them can talk forever, and I really get very bored" (Interview). At times I could sympathize.

Frustration (or even danger) can go both ways. Just as artists may manipulate prices, charging what the traffic will bear, or may be dishonest about their works, some artists have been "ripped off" by strangers. Sometimes if an artist is not at home and the work is displayed outside, collectors may pick a piece to their fancy and leave whatever they feel the work is worth. Such activities verge on burglary, sometimes crossing the line. Other instances come close to fraud. Some collectors take work, leaving bouncing checks (Mose Tolliver collects these checks); others leave a down payment on which they never follow through. On one of my visits to an artist I was told of an architect who purchased a piece of pottery. He later wished to return it because he found it cracked. She refused to take it back, assuming that he broke it and was attempting to trick her (Field notes).[54] Of course, it is not only financial trickery that is at issue. Rich people can be as tiresome as poor; white folks gab, as any observer at an art opening can attest.

A visit can go well or poorly, however, often the structure is such as to make disengagement difficult for either party without insulting the other. Impression management is a delicate matter when crossing cultural lines. This bridging makes the road trip alternately so exhilarating and so frustrating: a danger of authenticity.

Patrons and Social Movements

No one can doubt that a power imbalance exists between collector and artist. Some collectors, feeling close to particular artists, do more for artists than simply purchase their work, even befriending them.[55] Although these individuals are not dealers as such, sometimes that line is smudged. Examples include the role of Michael Hall for Edgar Tolson, Nina Howell Starr for Minnie Evans, Charles Shannon for Bill Traylor, Louis Caldor for Grandma Moses, Sterling Strauser for Justin McCarthy and Jack Savitsky, and William Arnett for Thornton Dial. The list is sufficiently long that one museum official suggested, sardonically, that every artist needed "a keeper" (Interview). Most recently Mera and Don Rubell of Miami Beach, prominent contemporary art collectors, purchased the entire contents of the studio of black Miami self-taught artist Purvis Young. The Rubells hope to donate this vast resource to museums, and given their stature such patronage legitimates Young within the art world. Many of these artists, unsophisticated with regard to the ways of the market, could well use such brokers.

Although in some cases these patrons serve as dealers, their role is more that of advocate, or as I describe in chapter 2, as reputational entrepreneur, building the public notice of the artist. While the role has been taken as being colonialist,[56] such a view assumes the ability of the artist independently to reach the art world. Without their patron, most artists would not have the same fame, and we, viewers, might lose the opportunities to see these works. Without romanticizing, such reputational entrepreneurs have a real, if uncertain, heroism. They can be honest brokers, mediating between the artist and the art world; more problematic, these intermediaries, believing that they know the desires of the market, may shape the artist's output, substituting their vision for that of the person they support.[57] Such influential patrons can be seen as guardian angels or as Kurtz exploring the heart of darkness:

> The Strausers became zealous patrons, providing moral and financial support for . . . [Justin] McCarthy and [Jack] Savitsky. . . . Their generosity also extended to their well-made connections in the art world, where they have especially promoted the works of McCarthy and Savitsky. Through their efforts, both men quickly began exhibiting in galleries and museums in Pennsylvania as well as New York City.[58]
>
> ★ ★ ★
>
> Louis J. Caldor, a man who approached everything with great intensity, zealously undertook to help Grandma Moses in every way he could. Finally, in October 1939 [after a series of failures to interest galleries],

Caldor achieved his first success. Caldor's jubilation was occasioned by Sidney Janis's decision to include three Moses paintings in a show of "Contemporary Unknown American Painters" that he was organizing for the Museum of Modern Art.[59]

If not totally altruistic, these patrons establish connections between distinct social worlds that the artist could not achieve alone. This bridging has its counterpart in other domains in which the discourse and interaction of the groups diverge, such as music promoters, sports agents, and lawyers for the mob.

Patrons believe passionately in the abilities of their artist, and they believe that these individuals deserve to be recognized by the art public. Their interest extends beyond their personal collection to the shaping of art history.

Self-Taught Art as Social Movement

Patrons focus on promoting the works of particular artists or styles of art and, in this, they are perhaps not so different from figures throughout art history, such as Émile Zola, whose support and talents at publicity meant so much to the acceptance of the impressionists,[60] or Clement Greenberg who played a somewhat similar role, as critic, in the careers of the abstract expressionists.[61] Self-taught art, however, is a field in which the identity, the who, of the artist is as important as the stylistic consistency. The personal equation, linked to categories of the oppressed and identity politics, leads to the possibility of a social movement to gain "justice" for unfairly ignored artists.

The efforts to preserve threatened environments, such as those of the activist group SPACES and its crusading founder Seymour Rosen,[62] have this quality, modeled on well-established movements for historic preservation.[63] A more dramatic example of the linkage of art worlds and social movements is the attempt to make the art world aware of southern African American vernacular art in the face of indifference or, perhaps, hostility. This is linked to struggle for civil rights, creating "for African-Americans in the South the confidence, encouragement, and opportunity to openly affirm their identities through art."[64] According to Atlanta congressman John Lewis, a veteran of the Civil Rights movement, the effort to publicize African American vernacular art, "should be viewed as a reflection of the on-going struggle for freedom."[65] Vincent Harding, the former director of Atlanta's Martin Luther King Center, noted, "from the first moment that I experienced these liberating, signifying,

conjuring works of art, I recognized that their creators were kin to the spirit-honed artists of the southern freedom movement."[66]

When I first met William Arnett, a prominent Atlantan, I was puzzled. Arnett lives in a large home on Tuxedo Road, Atlanta's best address. He was a man who was well recognized for his world-class collection of African art, and since the 1980s had been amassing self-taught African American art from the South. In this he was not so different from collectors who had discovered the aesthetic power of folk or outsider art. Yet Arnett was different in his passion. Not only did he consider this art to be the most important art of the century—Thornton Dial, the black Bessemer, Alabama artist, was the Michelangelo of the twentieth century—but also his opponents were conspirators denying these artists their rightful place in art history. These opponents were not the Klan, but the leaders of the art world, museum directors, respected academics, and admired collectors and dealers. Some of these enemies were my friends or informants, in whose statements I could hear no hint of bigotry; like much of the art world, these conspirators seemed progressive. But Arnett insisted these villains were suppressing this work from "Afro-phobia" or racism.

These charges—rants—led some to suggest that William Arnett was deeply mentally ill. Not being a psychiatrist, I cannot judge, except to say that I have not heard or seen any evidence of schizophrenia. However, if he is paranoid, he is what clinicians label high functioning. Arnett gathered a vast body of work, supported perhaps two dozen artists, produced two related exhibits—the *Souls Grown Deep* shows, during the 1996 Atlanta Olympics in association with Emory University's Michael Carlos Museum,[67] which *Newsweek* critic Thomas McEvilley in *Art in America,* and many Atlantans, felt was the cultural highpoint of the event—and coedited the first volume of a projected three volume set, *Souls Grown Deep: African American Vernacular Art of the South,* an opulent 544-page opus that some consider among the most important books about art ever published.[68]

How can William Arnett be explained? He gathered art, but unlike most collectors did not hang most of the works on his walls. A visit to his Tuxedo Road manse felt like a visit to an upscale warehouse. Works of the highest quality were stacked against walls and placed in closets. Unlike many collectors, Arnett was not living with the works, but only sharing his house with them. In turn, Arnett sold art—and consigned work to galleries—but he was particular about whom he would sell to and at what price. Dealers must set prices so that the works that they own "move."

Arnett's prices were linked to what he believed they should sell for—often substantially above auction or market prices. Rumors surfaced, given credence by Arnett's own statements, that his financial situation was precarious.

Consider Arnett's claims:

> I supported financially and otherwise about twenty-five to thirty artists. . . . My terms are only being that these artists do the best they can, do what they want to do, don't tailor their art to what the people coming to their house tell them they ought to be doing, and then, the further thing that I guess was the downfall, I required the right of first refusal, which is what . . . anyone should get. I mean I'm not the NEA. I'm not Santa Claus. I'm not the Lone Ranger. I was trying to document something. I'm not even an art collector. . . . I'm certainly in some eyes the most gluttonous or avid or fanatic collector they've ever seen, and I don't even think of myself as an art collector. . . . I mean, there's no art in the house. [My wife is] always saying, "Let's hang art in the house." I don't want to. I don't even need to look at it. . . . I'm certainly not a dealer. People want to see me as a dealer, but if I'm a dealer, I'm the most unsuccessful art dealer in history, because I have never made money dealing in art. . . . I do not need to own it. I do not need to have title to it. I don't need to profit from it. I don't want to do any of those things. And I've been trying to give the damn stuff away for a decade. And every time some institution wants it, some wave of bad publicity gets generated to keep them from taking it. (Interview)

Arnett in his own words is neither a dealer nor a collector. He describes himself as a patron, and his willingness to back artists bolsters that claim. Yet the oppositional character of his talk suggests something else: that he is a social movement activist—a powerful advocate for those whose voices are often muffled. Arnett's rhetoric suggests a Manichean view of the world often found in the discourse of movement leaders. He claims, for instance, that the motivation for the disparaging of the art is partly racial and partly a part of what he describes as totalitarian capitalism, having to do with protecting investments in other forms of art. The first volume of the *Souls Grown Deep* trilogy includes contributions from movement activists John Lewis, Andrew Young, and Imiri Baraka; Arnett now has financial backing from Jane Fonda for his projects.

One dealer felt, from the first moment she met him, that "he had been charged with some mission" (Interview). I was informed that Arnett was told by artist Lonnie Holley, "You're leading a Second Civil Rights Movement. You'll have to expect beatings just like we had" (Field notes).

In Arnett's case that beating—a "televised lynching"—was a 1993 seg-
ment of the CBS program *60 Minutes,* narrated by Morley Safer. While
the segment had little impact outside the art world, within it, it was
earthshaking. The segment focused on two white collector/patrons, an
Alabama judge and Arnett. Although the charges against the judge were
more serious, Arnett was the big fish. The show focused on Arnett's
patronage, the desire, some said, to control the lives of these African
American artists: his demand for the right of first refusal of their art; his
influencing their art by providing materials and ideas; his desire to shield
certain artists, such as Thornton Dial, from visitors; and his financial
control, noting that the mortgage on Dial's home is in Arnett's name
(Dial is happy with the relationship). Arnett felt that the piece was a set-
up, engineered by his (and the artists') enemies, and some of his critics
agree. The segment revealed television's penchant to create heroes and
villains; Arnett was among the latter.

Arnett would insist that the focus must be the art, but here as else-
where, the art does not speak for itself until someone provides the mega-
phone. The committed fanatic can change the world, but that change
can only occur when what is being pushed has a vitality and quality that
others can appreciate.

Aesthetic Weight

The Eye of Quality

One does not simply collect, but rather one collects objects: things of
particular shape, design, color—and value. For each object aesthetic
decisions must be made in practice. Yet, often a coherent aesthetic or
theoretical infrastructure is absent,[69] as one analysis of the rise to promi-
nence of Jackson Pollock claims. Although Tom Wolfe suggests in *The
Painted Word* that theory is replacing the work as the sine qua non of
contemporary art,[70] that assessment, exaggerated as it is, applies more
to critics and curators than to collectors, and to contemporary art more
than to the rest of the art world. Sometimes aesthetic standards are
local, recognizable within a particular community,[71] unknown to those
outside, as in judging butter sculpture or heifers at state fairs.[72] Some-
times these standards cannot be articulated due to the absence of an
elaborated aesthetic code, except in metaphorical and symbolic fashion,
linked to social experiences and collective evaluations. This reveals the
difficulty of constructing meaningful boundaries in a linguistic commu-
nity. In the image of philosopher Ludwig Wittgenstein the problem is
how to describe the sound of a clarinet.[73]

Self-taught art with its uncertain aesthetic standards represents a case of the difficulty of discourse. Chuck Rosenak claims that "folk art is not based on aesthetics—that's the whole point. . . . Those who have not studied the history of folk art collecting try to find the black, Southern or hillbilly aesthetic, and there is no such thing."[74] Rosenak does not mean that pieces cannot be differentiated on quality; after all, he chooses to buy some and not others. Instead, he means that formal theoretical language does not apply. In the words of one curator: "You discern it with your eyes, you discern it with your heart, you discern it with your gut."[75] An art show promoter contended, "You look at it and you get it right away. There is no secret agenda. . . . It's not intimidating . . . it doesn't take research, education to understand it."[76] Whether this claim, perhaps with some anti-intellectual overtones, overly diminishes the possibility of thoughtful commentary, many point to the absence of a formal aesthetic, which some contend leads to the low status of these works.

In place of an explicit aesthetic, an implicit aesthetic is claimed, sometimes referred to as having an "eye." This eye, similar to perfect pitch, permits the observer to know the aesthetic value of a piece without articulating the standards by which the judgment is made. The claim of having an eye is an honorific within the art community, an image that justifies the absence of criteria that can be taught. Of course, this claim of having an eye is illusory as, given the lack of a formal aesthetics, the question of which pieces are best remains subjective. If you don't choose those works that esteemed others judge the best, you don't have that eye, but if you don't have the eye, you won't choose those works: a circular argument. Because of the uncertainty of knowing one's eye, collective validation is especially important, and, so, one prominent collector noted proudly that two of the works he had loaned to an important exhibit were singled out by a critic as being especially noteworthy. His vision was affirmed.

The problematic nature of hierarchical judgment is evident in the claim of one curator, who, radically in her view, wished to show works of quality, differentiating between "good, better, best." She spoke approvingly of what she labeled the C-word: connoisseurship, implying that like the F-word or N-word this is a stigmatized concept in polite society (Field notes). When, on another occasion, a questioner asked a curator, "How do we define quality?" the respondent uncomfortably and haltingly responded that quality is evident in "the artist's lexicon. . . . that germ of originality, that germ of creativity. . . . We try to determine if the artist has an authentic voice. Is this an authentic expression of the muse?

Does the technique work for the artist? Does the technique look sloppy? That's OK, if it works for the artist" (Field notes). The first curator searches for external, art-world criteria, while the second locates quality within the context of the production of particular artists. The former has benefits for organizing a field, even if the latter has a more humanistic flavor. To become an artistic domain some criteria of ordering is ultimately necessary, if for no other reason than to determine what gets to be displayed. As Allen Weiss notes, criticizing a "sociologically oriented art history" that embraces greater and lesser works equally: "Quite simply, not everything deemed art is great art. If we are willing to speak of mediocre and even poor works of art in general—as is the job of every art critic [to] differentiate—why are we not willing to do so for Outsider Art? Why this double standard? Why should Outsider Art be a category that contains only masterpieces?"[77] Once we make these judgments, we can begin hanging and placing, creating an aesthetic environment.

As I have noted, self-taught work is a low-status domain, compared, say, to contemporary, pre-Columbian, or Japanese art. As a result of the status hierarchy, little academic, critical, and theoretical work has taken place. Indeed, some collectors in the field—and no doubt, in other fields—are explicitly atheoretical. One prominent dealer noted: "I talk to collectors who have vast holdings . . . looking at this stuff, and you're thinking, my God, some of this is really awful. But there are a few things that are not. [I ask] why don't you get rid of all the other stuff. . . . They have an attachment to it. It's not important to them somehow to rank things. . . . These are basically anti-elitist strains and quality as we hear ad nauseam is an elitist concept. Quality really doesn't matter to vast segments of this market" (Interview). Claimed journalist Larissa MacFarquhar, speaking of elements of the field encouraging a "Perot-style championing of the proud ignoramus": "Self-taught art, after all, is perfect for the kind of people who say they don't know much about art but they know what they like. . . . And as Frank Maresca puts it, you don't have to be a horticulturalist to appreciate a flower."[78] These claims are surely unfair to many collectors, but they reflect some of the stigma that the field endures, some of the reality of its openness, and some of the diversity of aesthetic standards. Hierarchy, evaluation, and exclusion can have value as means of establishing status and policing boundaries.

Hanging Tough

One collector muses that sometimes he will purchase objects, thinking of their aesthetic value without regard to where they will be placed; when he does his wife sharply reminds him, "You know that's where we have

to live. This is *not* going to be a museum. You know, we need to *live* with that" (Interview).[79] When purchasing, art collectors sometimes imagine that these objects will be hung in a white box, a gallery space without other content. However, the objects in a home are part of a context, a social and behavioral space. As curator Robert Hobbs pointed out at a public lecture, "If you see a work in a gallery, it looks very different from elsewhere. It changes the art. Maybe for the better, maybe not, but it does change" (Field notes).

Perhaps it is a function of the desire to demonstrate through conspicuous consumption how many works one has collected, or perhaps, more hopefully, it is that collectors cannot bear not viewing their works, but many collectors have homes jammed with objects, from floor to ceiling, as museums used to display their art: walls without wall space. One curator noted, most "like having all this clutter all over the place," contrasted with the clean, sparse environments of many contemporary art collectors (Interview). On a home visit one prominent collector jokingly pointed to a table, "They're not true collectors. Look, there's space" (Field notes). Another collector was quoted as sneering, after leaving the home of some prominent collectors, "They're not *real* collectors. It's all on the walls. They don't have anything piled up, or under the furniture, or on the floor, or stacked against the walls, or in closets. What kind of collecting is that? All they've done is decorate the house."[80]

I have been impressed at some of the upscale homes that I have visited by the sheer amount of stuff—stuff that to my eye would have been more impressive if there was more space between the pieces. Some collectors remove mirrors or cover windows to gain more space.[81] Visiting these houses induces cognitive overload. One collector speculated that he owned fifteen hundred pieces, along with a closet filled with a hundred works by Howard Finster. He has given up the possibility of cataloging the work, admitting that "it would take too much [time] away from collecting."[82] One gatherer attempted to justify the overload: "[My house] was pretty much covered, you know. I mean just every inch of the wall, and little things hanging from the ceiling. It was just *saturated*. I guess my sense when I curated shows, when I installed exhibitions, I tried to install them in the same spirit that the work was made. Like Finster's garden and Nellie Mae Rowe's house, which was not too dissimilar to my house. There tended to be a lot of visual clutter" (Interview).

The archetype of this collector was the influential Bert Hemphill whose New York City apartment was stuffed with his purchases.[83] Friends spoke of this quality as "Bertness," and noted that other collectors have "Bert rooms." As a curator commented: "There was a magic

moment, there was a turning point somewhere, where it went from everything in its place to: You mean there's another place I have to put something in?"[84] In another account: "Every wall, floor, and surface was engulfed by a rotating and carefully placed assemblage of objects, leaving little room for anything other than study and contemplation."[85] The apartment was such that Hemphill's landlord at one point attempted to have him evicted in part because "the condition of his apartment constitutes a fire hazard."[86]

Art objects are not spatially interchangeable. Most collectors feel pieces belong in certain spaces. By this I only partly mean that certain houses (French Provincial, say) look better with certain types of art.[87] I have seen some traditional homes that look, in my eyes, quite wonderful with self-taught art, although one large formal home with expensive and traditional furniture looked odd with edgy outsider works on the walls: the culture clash was too great. One collector explained that she "hadn't realized the power of some of these pieces to change the atmosphere of the room" (Interview). A couple—important collectors—moved from a traditional apartment with relatively low ceilings, not suitable, they felt, for displaying their large, bold, controversial works, to a loft with more wall space, more like a gallery or artist's studio. They wanted to "live with the work" (Field notes), a move that would not have happened without the dimensions of their stuff.

Dealers remark that many who purchase self-taught art do so for second homes—typically more casual and rustic, where the works fit. One collector places self-taught art in the garage, transforming the space into "a makeshift museum of folk art," but indicating that it doesn't belong in the "big house."[88] For these collectors the issue is whether they will display their art or display their house.[89]

Collectors differ on how permanent they perceive their choices. For some, once a work is placed, it remains. Some informants pointed to works that they purchased a quarter-century previously, remaining in that same spot ever since. Others rehang regularly. One commented: "I think a collection is probably breathing. . . . A collection will change as we change. [GAF: Do you change the display of the collection?] Absolutely. That's what makes it exciting. When you have as many pieces as most of us do, . . . it's wonderful to change things on the wall and the way the light hits them. I mean we start to take things for granted when they get up there, and they've been there a long time" (Interview). Another collector noted: "I'm rearranging monthly. It's fun. That's part of the game. . . . I tell you, I have a pet peeve, when people say to me, 'Well, I don't think that piece of folk art would go in my house. I don't think it

would go with my sofa. It wouldn't go with the colors that I've chosen for the chintz on my chairs. I don't really have a place for that.' . . . I absolutely could scream. . . . I have to restrain myself when people talk to me like that, because with me it's like the art comes first. . . . You *will* find a place for it. You will rearrange and you will pile art upon art upon art. It'll just make you happy" (Interview). There may be a "chain reaction" when a new piece displaces an older one, and that piece displaces a third, and so on, but changing one's collection monthly—or even annually—is rare, in part because of the effort and in part because of a desire for visual stability.

A final issue follows from the desire for change. Will works continue to have appeal over time? One collector explained, "You look at a piece one hundred times and someday you'll walk through and just something new will catch your eye. They're constantly renewing. . . . To me these pieces really are complex, a lot of them, and they constantly are giving, they have many layers of meaning to them."[90] However, for others assessments can change.

Rearranging a collection is one way in which one can force oneself to pay attention, treating the objects as something other than visual Muzak. One collector explained, "Sure they become part of the environment. I mean if you've had them up for long enough, but I still will look at things and think about them, and see new things in them. It helps sometimes to rearrange things. . . . But if you move them around they take on a whole different context and you see things differently. For instance, this Bessie Harvey mask over here was originally, when I bought it, I put it right there, and my children said it was haunted, that they could not sit in this room and watch TV without feeling like there was some spirit watching them. It scared them to death, and I eventually had to move the piece over there, because it was so disturbing to them" (Interview).

Sometimes the placement of objects makes them emotionally or cognitively salient, such as the collector who explained, "I pat Abe Lincoln's [head] everyday. That stone piece that's standing in the foyer, and even my cleaning lady said, I don't think I'm ever here that I don't pat this" (Interview). Even though it is a material object, the work of art is not passive, but speaks to the collector.

While the act of collecting is important, it reveals itself in the act of display. For most people, if they merely had objects locked away, it would not truly constitute a collection. Out of sight, out of mind is a rule that applies to accumulations as well as to friends. The choices for displaying one's objects are many, raising the question of whether the collection should determine the layout of the house. In the case of self-

taught art the issue may be particularly dramatic in that most homes in which educated, wealthy art lovers live do not have the roughness of the spaces in which the works originated. The reality that so many collections do fit their new homes suggests the plasticity of human vision and sense of place.

Creating Collections

The collector is essential in creating artists. Someone must *want* this work, or it merely exists as objects and not as art. Collectors operate in interconnected social worlds, a world that they share with one another and one that they share with artists.

Collecting is economic, aesthetic, and psychological, but it is also fundamentally social. It is the rare collector who locks away his or her purchases, and the unusual one who does not invite others to see the display. The act of collecting involves a process of comparison. One wants to know what others have found, in part to admire these works that they love, but in part to compare one's success with others, the same way that birders talk about life lists, mushroomers weigh their morels, and high-end art collectors hope to receive museum shows. One judges oneself on how one measures up. The art might remain, but without the presence of caring others—who are similarly passionate—the activity would lose some of its luster. Art lovers enjoy collecting, but they equally relish talking about these objects: to display the objects and themselves, transforming consumption into a verbal and behavioral domain. The display serves as an announcement to others about one's quality and a standard for judging personal success.

For self-taught art, emphasizing authenticity, collecting depends on the touch of the artist. One not only wishes a piece of the true cross, but a message from the Messiah. Thus, many find satisfaction in the road trip, the folk art pilgrimage. Being on the backroads or in the inner city convinces these men and women that they have touched a deep reality. The game is authenticity: reaching the artist and then returning to tell about it. On a larger, more intense scale this is evident in becoming a patron. When the act of collecting for oneself is insufficient, some become activists, attempting to persuade organizations—primarily museums— that this body of work demands to be taken seriously.

Finally, there is the desire to display, particularly as collecting is practiced in the West. In some sense, art has no end in itself; it doesn't do anything; it is not able to speak for itself. Yet, it does do something. It decorates in a culture in which homes are expected to be decorated, and

in which these decorations are thought to reveal something important about those who reside within. Without art, homes are bare, and bare homes reveal bare selves, an external manifestation of an internal deficiency. Art fills the self and provides a self-satisfaction and satisfies the desire for beauty and meaning. Collecting—large-scale or small, self-conscious or not—reflects our placement in a consumerist society in which identity rubs off objects into hearts and minds, contributing to what we take as our humanity.

5

creating

community

Before knowing [other collectors] I
felt that I was an isolated weirdo.
—COLLECTOR

Community is one of the central images by which we understand how the world hangs together. Whether real or imagined, community matters. A sense of belonging is the glue that transforms individuals into a group, both psychologically and as a social reality. The analysis by political scientist Robert Putnam, *Bowling Alone: The Collapse and Revival of American Community,* claims that America is weakened by what he perceives as the decline of groups and social institutions.[1] Yet, if formal organizations have declined, *focused networks* may have replaced them: congenial intersections based on common interests. Even though bowling leagues have declined, Putnam is wrong, people *do not* bowl alone! We bowl with friends, with those in our networks. The world of self-taught art—and indeed most art worlds—is a case of a focused network.

Community—especially the traditional communities in which people reside—originates in time and space. Small towns, urban neighborhoods, and, even, suburban subdivisions consist of people meeting and identifying because of their continuing co-presence: they are together frequently, talking and acting together because of common interests and concerns. However, some groupings do not have this quality of routine togetherness—people from "all over" choose to belong. Consider a chess club or a grief support group. Whenever individuals discover a common focus, and then find a time and place to get together, a community forms. While these gatherings typically involve face-to-face interaction, Internet chat rooms suggest the possibility of virtual communities.

Putting aside cyber-groupings, most interest groups depend on gatherings, permitting an outpouring of affiliation and effervescence. Emotion abounds in these shared spaces. As folklorist Philip Nusbaum notes of the gatherings of spear fishing decoy collectors, "pervasive sociability . . . rewards and motivates people to take part."[2] And so it is with those interested in self-taught art. This is a group that consists of collectors, dealers, critics, academics, curators, and museum officials (with the occasional artist).

Great, Good Places

Along with the annual meeting of the Folk Art Society of America, art fairs provide opportunities for festivity and community, in addition to their formal function as markets. Gallery and museum openings, and the occasional symposia or auction, have a similar function, allowing for *focused gatherings*. That participants know each other allows the economic and social to fit together seamlessly with the latter a cover for the former. These gatherings of friends can be emotional—filled with laughter and sometimes tears. Consider the 2000 Finster Fest in Summerville, Georgia, held soon after the Reverend Howard Finster was released from the hospital with double pneumonia:

> [A friend] and I attended Finster Fest at Paradise Gardens yesterday, glad that we did, but it was a sad state for Rev. Howard. [Alabama self-taught artist] Butch Anthony ceremoniously escorted him to the old entrance of the Gardens in his highly decorated folk art hearse. The Rev. entered the gate amidst cheers and two video cameramen following him the entire time—during the autographing session from 2–4 p.m. . . . Howard started to preach to the gathering throng, and his voice cracked and he started

crying. He looked so frail. He talked about his imminent demise, how he is waiting for the angels to come in the middle of the night. The crowd was hushed. . . . [We] came away in a very somber mood. (E-mail message)

This is a dramatic instance; sadness is much less common than joy at such events. At the festivals, shows, parties, and auctions palpable excitement reigns.[3] The first night of the Outsider Art Fair has this quality. This opening reception—a fund-raiser for the American Folk Art Museum—costs extra and permits attendees the first opportunity to examine the dealers' wares. However, long-time attendees, many from out of town, emphasize that, for them, it is a social event at which they know "everybody":

> It's getting to be more of a convention. More of a fraternity. Tomorrow you have all the New Yorkers come. (Field notes)
>
> ★ ★ ★
>
> There's always a frenzied sense of happening. Conversation is rich and continuing. People are always coming together. . . . Pungent and creative happenings. (Field notes)

This group is an invisible college, a network of individuals, meeting occasionally, who share common interests and values. The trading of gossip reveals how tightly knit the partygoers are. One year a "hot" topic was that a well-known artist was arrested for sexually molesting a young boy; another year, it was a dealer who was investigated for trading in stolen property. The conversation frequently turns to who bought what; who sold what; how much objects brought at auction.[4] Some object to gossip, feeling that personalistic talk is demeaning, although even they are hard-pressed to avoid it. However, gossip can be defended as revealing the interest that people have in others in their social circle and recognizing that sharing information links them, diminishing the possibility of an unintentional gaffe. We talk about others because we care for them. While some gossip is *reputational work,* designed to alter the stature of another, most bolsters communal connections. This reputational work, in the words of a collector, includes " 'Oh, so and so's cheating this artist' or 'Do you know how he got the pieces?' or 'Well, the piece isn't right, because they didn't sell it' " (Interview). Such instances are memorable, and perhaps because of their salience we conclude that they occur more often than they do. Gossip, after all, is simply talk about an absent third person—good or bad, true or false.[5] Negative examples are juicy and dramatic, easily spread, but positive and neutral gossip outweighs the

negative, even if the former is more forgettable.[6] Still, this routine talk makes the community real to members.

At these events there is a genuine, if imperfect, effort to extend networks. Friends are introduced to others, opening the possibility for additional ties based on shared interest, creating a denser network. Over five years of research, I came to know several hundred members of the community, and I have been introduced to hundreds more.

In addition to public events, open to anyone with the requisite entry fee, other events are by invitation. Each year at the Outsider Art Fair, galleries hold dinners or parties for particularly good friends—and potential customers. New or marginal participants can sometimes tag along into the inner sanctum. The existence of these events reminds us that in this community, as elsewhere, there are levels of membership. Occasionally parties or "salons" are organized, as did dealer Judith Alexander in Atlanta and Greenfield Village museum director Robert Bishop in Michigan, important for knitting the field together:

> Judith Alexander was the grand dame of art in Atlanta. . . . She taught most of us who know anything about art. . . . She had little salons and that's where all the artists hung out and talked to each other, and had parties and socialized with one another. . . . She introduced folk art to this part of the country as an art school. She was the great mentor for me and for many people. (Interview)

> ★ ★ ★

> Bob [Bishop] in the early seventies, started having what you might call folk art "salons" over at his house. They were actually just the funniest cocktail parties you ever saw in your life because Bob could put together the strangest menagerie of friends you can imagine for a party. He was comfortable across all sorts of class lines. . . . And the guest list would include very sedate, conservative . . . "old wrinkled money" collectors from Birmingham, Michigan, and Grosse Point who would find themselves rubbing shoulders with very stuffy curators from the Henry Ford Museum who in turn would be rubbing shoulders with college students and young collectors from Cranbrook. All these folks were thrown in with businessmen, art investors, and sometimes even motorcycle club members, all of whom would find themselves discussing Bob's latest finds with people in green chiffon cocktail dresses and beehive hairdos that Bob had met at some seminar on quilts that he had run over at the museum. . . . He liked to have people around and he loved to entertain. He also was building, very

carefully, a new coalition of people who might be interested in American decorative and folk arts.[7]

In any social world, certain individuals serve—like Judith Alexander and Robert Bishop—as connectors, linking social networks that might not otherwise overlap.[8] Collector Bert Hemphill was also widely known as a connector, described by Michael Hall as "the great needle that sewed the folk art world together in the late sixties and early seventies."[9]

Networks can be latent, activated when needed. Many in this art world have resources that can be used for those—the artists—who need help. Art collectors and dealers gathered to purchase grave markers for Henry Darger and Sister Gertrude Morgan. In the case of Sister Gertrude, prominent Louisiana enthusiasts assembled for a moving dedication ceremony, as did a few from outside the community, along with the Preservation Hall Jazz Band.[10] After the death of black Mississippi artist Mary T. Smith, an out-of-state supporter paid for her funeral.[11] In 1991 a benefit was held at the American Primitive Gallery in New York to raise money for an operation for black Mississippi artist James "Son" Thomas after he was burned in a house fire.[12]

The Sunny Side of Community

Most observers agree that the community found in voluntary social worlds has numerous social benefits, preventing alienation, isolation, and depression. Whether we think about Dungeons & Dragons in which "oddball" teens find companionship decimating imaginary ogres, mushrooming in which "oddball" naturalists find companionship digging in the dirt, or self-taught art in which "oddball" aesthetes find companionship visiting dilapidated shacks, that others share one's values and behaviors is self-validating. Robert Putnam's argument is precisely this: communal affiliation is helpful. This belief is widely shared. I have no definitive evidence that such claims are accurate—it is "feel-good" discourse—but the support and fellowship that are so evidently part of a community can reasonably be seen as beneficial. As one collector noted: "Our social life revolves around the field of collecting self-taught. . . . We've made many nice friends. We get together with people that are other collectors, so we revolve our vacations around collecting, around meeting people with our business, meeting with museums" (Interview). The quarterly newsletter *Folk Art Finder* was founded because Florence and Jules Laffal (a ceramic artist and a psychiatrist) "wanted to accomplish an exchange of information among collectors, gallery owners, museum

personnel, and whoever might be interested in folk art."[13] Collectors express moral unity when they admit:

> I feel we're a family. Some of the people in the room I've known for twenty years. It's a great adventure we've been on together. (Field notes)

<p style="text-align:center">★　★　★</p>

> We were always drawn to outsider art without knowing there was a group. So we felt validated. (Field notes)

On some level the community argument is circular: one chooses one's friends because of one's interests, and then one's friends shape one's interest. Often someone without interest in self-taught art finds a friend with the interest, and so the art becomes appealing. As the art increases in appeal, one attends events with others who share that interest, in turn increasing the objects' appeal. One collector, a museum docent, decided to join a folk art study group because of a friend, but without "the slightest interest in the art" (Interview). In time the interest emerged, at least in part because others that she was with were so enthusiastic and because it is hard watching others happily engage without participating.

The Boundaries and Hierarchies of Community

Groucho Marx once joked that he wouldn't want to be a member of any club that would let him join. In cynicism, Groucho made an important point. We care about boundaries. If a community is to have status, if it is to validate a self, it must maintain a boundary, however permeable. As self-taught art became more popular in the 1980s and 1990s, some early enthusiasts abandoned it. This domain was increasingly becoming "mature" and "institutionalized," as the innovators—those who desired less institutional support—drifted away. Doctors, lawyers, managers, and Hollywood showfolk replaced practicing artists as central collectors. Some early collectors were explicit about their desire to be pioneers. As Chicago artist and collector Roger Brown explained, "For me part of the excitement of collecting [folk and outsider art] was the thrill of discovering people doing things that the intellectual art world didn't know anything about. When a whole society seems to want the stuff, I want to go in another direction."[14]

Groups often are cautious about accepting novices, watching and waiting until these neophytes have committed themselves by learning, spending, asking, or traveling. While art worlds, unlike social worlds, such as mushrooming or rock climbing or high-steel construction or white-water rafting,[15] do not involve danger, people must "pay their dues" to show that they are serious. Some novices, particularly those

without sponsors, find this frustrating, and complaints are common about the "folk art mafia." One prominent figure remarked that at the first symposium she attended "there was definitely an insider track and an outsider track. You had to know other people to get comfortable. . . . They weren't very friendly" (Interview)—at least not to her. A second commented that when, as a neophyte, she asked about Miles Carpenter, a prominent Virginia folk artist, she was told, "you'll find out when it's time for you to know. I thought, 'well, thanks' " (Interview). To be accepted, in any subculture, one has to know how to talk and who to talk about. Within the self-taught world, members know who is being referred to as Phyllis, Bert, Mose, and Howard: outsiders will not.[16] The world of self-taught art shares the reality of a boundary with all focused networks.

Multiple Roles

In most definitions, a role is a set of obligations and expectations: behaviors that are expected to be enacted and an identity that incorporates these behaviors. Doctors and nurses have positions in hospitals, but so do patients, what has been labeled the "sick role." For organizations to achieve their ends and for interaction to flow smoothly, roles must be enacted with participants trained in impression management. That is, according to sociologist Erving Goffman, people shape interaction so that it is self-enhancing and smoothly flowing; they must present their public identity so as to make others feel positively toward them and to feel comfortable in the setting.[17] While some argue that role behaviors are relatively fixed and predetermined, others suggest that autonomy and the negotiation of role behavior are more significant, but in either event a division of labor in a community is created.

In thinking about communities, we assign persons to particular roles. However, what becomes clear here—and elsewhere—is that an assignment to a single slot is misleading. People often have several roles—sequentially or simultaneously—and these roles may bolster or interfere with each other. One informant explained, "for the game to be played, you have the artist, the collector, the curator, the dealer and the critic" (Interview), but these do not have to be different persons. Professor Willem Volkersz interviewing the granddaughter of self-taught artist Oliver Edward Wells asserted: "I collect folk art myself, and I'm organizing an exhibition for the Kansas City Art Institute right now of work by folk artists that's going to be for sale. And so when I saw those, the ones I bought in Jamesport, I bought them to resell them, although

I'm going to keep some of them, because I really like them very, very much."[18] Volkersz, an academic, asserts that he is also a collector, curator, and dealer. Such is not atypical. Michael Hall, Tolson's patron, was not only a trained artist, but also an academic, critic, curator, collector, and dealer. Robert Bishop was during his career a collector, critic, dealer, curator, and finally museum director (and, as a dancer, an artist, too). Julia Ardery (herself a critic and academic) notes that "dealers routinely wrote catalog essays touting the artists whose works they had for sale and collectors, like Hemphill, authored picture books featuring their own possessions."[19] This can be considered synergy, rather than hypocrisy. There is nothing *inherently* good or ill about such multiple and permeable roles, and in small and developing fields such may be essential. If collectors do not write criticism, who will? If dealers do not curate, the shows are undone. Collectors may become dealers to gain resources to keep collecting. Yet, these multiple roles fly in the face of the assumption of the nature of the art world, and recently there is greater emphasis on the dangers of conflict of interest.[20]

In art worlds, almost everyone is a collector, even some self-taught artists, as are many trained artists. Some self-taught artists, such as Jimmy Hedges, a Tennessee carver, have become well-established dealers, and Linda Anderson, a prominent Georgia memory painter, has had a gallery and has curated shows. In turn, a few dealers have tried their hand at self-taught art—ignoring the rumors of dealers who paint using an outsider "nom de brush." The making of art, whether a full-time, part-time, or leisure pursuit, is one that many Americans choose.

Dealers often were collectors before they—lawyers, teachers, bankers, artists—decided that they could profit from their pleasure, despite an art world saying that "you should never collect what you sell" (Interview). One dealer noted: "The work I have in the gallery is work that I have personally selected. There's not much here that is slipped onto these walls or on these shelves that I haven't personally said, 'Yes, yes, let's have it.' . . . Some I loved more than others, but by and large it's work that I feel strongly enough about and hope that the public also appreciates it, and when somebody actually buys this work, there's part of me that really feels flattered. But there has been real conflict sometimes" (Interview). This dealer sometimes brings works home with her, agonizing whether to keep it in her collection for now or forever. Another dealer admitted that a gray area exists between what was her collection and what was her inventory—a matter of tax law as well as salesmanship.

Dealers who sell from their home can live with the work, but they

must always be prepared to empty that space on the wall or table—or forgo the sale, perhaps persuading themselves that they do not belong in the business. Some dealers are less sentimental—a sale is a sale, the kid needs braces—but after all, they wouldn't make the effort if they didn't love the stuff.

Those dealers who have some artistic background feel a kinship with their artists, which, they claim, helps them be fair and honorable. As one dealer noted of herself and her husband: "Both of us have spent so much of our life on the other side of the desk. [My husband] writes. He writes poetry, he reads his poetry; he's played music. I've danced for twenty-seven years. I've gone through the cattle-calls of auditions. You know, we have struggled for our per diems. We have done all of that so we have, I think, a very sympathetic artist relationship. I don't see an artist coming in the door, going 'Oh, God, how am I going to screw this person over to the best of my ability.' It is not in our make-up. I'm not saying other dealers do that. I'm just saying that we have a particular sensitivity" (Interview). My point is not to endorse nor to deny this dealer's claim, but to suggest that she feels that their multiple roles affect the doing of what many would now see as their primary role, operating a gallery.

The assumption that people are assigned to particular roles needs to be rethought. Of course, we do this when we are referring to separate domains (father, son, doctor, chessmaster), but these multiple roles also coexist within the same domain, and they can intersect. The dealer has to choose what to collect, the artist is affected by the choices that must be made as a dealer, the critic's remarks may be colored by what is placed at auction, or the academic is tempted to supplement a salary by curating the works of favored artists. These are conflicts of interest, but perhaps they are natural in a domain in which people do not wish to be confined to a single category of activity. Within each multiple role set, ethical issues can emerge as economic self-interest contends with the ethics of what each role requires.

Mediating Community

The art dealer is, like so many shop owners, a mediator—a small businessman who hopes to connect buyers and sellers: a bit player in the world of commerce. In most stores buyers only know the corporate identity of the maker, but in art worlds it is the personal identity of the maker that is crucial. In the world of self-taught art that maker may

even be available, competing with the friendly neighborhood shopkeep, even if that neighborhood is SoHo. The goods that are being traded are nonessential luxuries—like fine wine or fudge. As Alfred Taubman, once in charge of Sotheby's auction house, stated: "Selling art has much in common with selling root beer. People don't need root beer and they don't need to buy a painting, either. We provide them with a sense that it will give them a happier experience."[21]

The image of the corner grocer reminds us that, unlike other prominent businesspeople, the art dealer's work involves both commerce and friendship. These twin elements are complicated by the reality that dealers have passion for their objects, making separation painful. Some dealers told me that they hate to have their favorite objects taken from them. One admitted that "there are some objects that just get into my soul. . . . Those still tear my heart out" (Interview). That these elements—business, friendship, and passion—conflict should be no surprise, as financial necessity may conflict with personal desire. One must decide what to do with works that do not fly out the gallery door and with one's artist-friends whose work just sits there. Further, to generate excitement many galleries feel that they need new finds. Often nothing— new or old—sells, and dealers struggle with paying the bills, particularly if the gallery is, like many, undercapitalized. Wealthy friends or family are a boon. One successful gallery owner suggested that a dealer "should probably have enough money to make it through at least a year without making any sales," and must decide whether to have a "real gallery or a shoppe."[22]

What could be more obvious than to say that galleries differ; however, in self-taught art, perhaps they diverge more than in most artistic domains. Although I speak of dealers, the reality is that many are gallery owners, operating a space of public accommodation.

In contemporary art, galleries are typically found in major urban areas, and architecturally tend to be fairly similar: a SoHo gallery is not identical to a gallery in Atlanta, the former may be a room in an office building full of dealers, the latter a detached house, but the two are recognizably instances of the same phenomenon. Most have white walls to display the work with track lighting for visual emphasis. Aside from the owner, there may be a handful of other employees (often decorative young men or women), including sometimes a gallery director—an informal small group.[23]

In self-taught art, there is a steep status gradient among galleries. Galerie St. Etienne, which despite its French name, is best known for German expressionist art and very high-end self-taught art, such as Henry

Darger and Grandma Moses. It is located on New York's 57th Street—an uptown gallery with a traditional feel. Most other elite galleries—Phyllis Kind Gallery, Ricco/Maresca, Cavin-Morris, or Luise Ross are located in New York's SoHo or Chelsea. A smattering are found in other metropolitan areas such as Chicago's Carl Hammer or Philadelphia's Fleisher/Ollman Gallery. These high-end galleries remind one of contemporary art galleries, and indeed several also show contemporary trained artists. Many of these galleries have cultivated a national clientele, what economists speak of as their "catchment" area. They cannot rely on the sparse walk-in trade. Running a gallery can be a lonely profession, punctuated by a few major transactions.[24] Each gallery must differentiate itself from other competing galleries, creating a market niche. Thus, one gallery specializes in European artists, another has many Caribbean artists, a third has prison artists. Among the top galleries, some have exclusives with or specialize in prominent artists: Luise Ross for Bill Traylor, Phyllis Kind for Martin Ramirez, Carl Hammer for Henry Darger, or the Ames Gallery in Berkeley for Achilles Rizzoli. For galleries to succeed, they must become known for their collection and/or their director. These galleries must carry a range of artists: one 1988 advertisement for the Janet Fleisher Gallery (now the Fleisher/Ollman Gallery) listed sixty-five artists who they "represent" (i.e., for whom they have some work on hand).

In contrast, small galleries dot the South in both urban and rural areas—Rosehips Gallery in Cleveland, Georgia; Weathervane Folk Art Gallery in Thomson, Georgia; Gilley's Gallery in Baton Rouge; American Pie in Wilmington, North Carolina; Red Piano Too Gallery on St. Helena Island, South Carolina; and Yard Dog Folk Art in Austin, Texas. As a group the latter dealers are more diverse in format than the elite, SoHo-type galleries. Add to this many dealers who operate from their homes or by appointment, sales outlets for centers for those with disabilities, and a few virtual, Internet galleries, and it is clear that if one judges the market by the place of business this hardly seems like a single marketplace.

Finally there are "pickers"—a term borrowed from the antiques trade: men who travel the countryside searching for people who might have "interesting" objects to sell. Typically pickers—middlemen between owners and galleries—turn over their found objects quickly to established dealers or collectors with whom they have relationships. One picker explained that he has "a passion for the discovery angle of it," whereas having a shop would tie him down. They begin the "food chain" that results in sales from elite galleries.

Over the past thirty years there has been a dramatic increase in galleries specializing in self-taught art. In 1970 no galleries regularly showed contemporary self-taught art. In 1972 Phyllis Kind, then a contemporary art gallery in Chicago, showing the Chicago Imagists, organized such a show. This was followed in 1975 by a show at the Janet Fleisher Gallery in Philadelphia, and the establishment in this period of Jeff Camp's American Folk Art Company in Richmond, Virginia. In the summer of 1978 only three contemporary self-taught art galleries advertised in the *Clarion,* the magazine of the Museum of American Folk Art. In the summer of 2000 approximately three dozen galleries (depending on one's criteria) advertised. In her recent book, *Self Taught, Outsider, and Folk Art* (2000), Betty-Carol Sellen lists, using generous criteria, 187 galleries (101 or 54 percent are located in states of the former Confederacy, a strong Southern tilt). This is an increase from 135 in her book's 1993 edition.[25]

Consider a major SoHo gallery specializing in self-taught art—I'll call it the Regina Mutt gallery. Most elite galleries take the owner's name, emphasizing how integrated the owner's persona is in the business. Mutt is located on the fifth floor of a large, older building filled with gallery spaces. The display area consists of an otherwise empty space that has been partitioned into two sections, permitting two shows simultaneously. The walls are white, the lighting bright, with track spotlights focused on the art. Perhaps sixty works are displayed at any one time, with one or two artists or groups of artists featured. These are shows, smaller versions of what museums do, and often consist of works of artists that are thought to be of museum quality. Indeed, one function of a gallery opening is to interest museum curators in the featured artist. The gallery sponsors four to six "openings" each year with the requisite white wine, cheese, and pretzels—"brie and Chablis." For the opening the gallery invites attractive young people: one stunning woman explained that she was often lured to openings and parties because she was decorative (Field notes)—lending a warm glow to what is on the cold walls. Beefcake and cheesecake, served with the snacks. On one side of the room is the modernist desk, with price lists available, as prices are rarely placed near the works in top galleries, as the financial information might stigmatize the aesthetics. There is also a guest book for visitors to sign, along with their address, if they wish to receive mailings. Off the main room is a small office for the owner to work in and to meet special clients and another, larger space that serves as a storage area for the many works that cannot be displayed, although it is a space to which enthusiastic clients are escorted. Given the limited size of the self-taught

art market most elite galleries also show the works of trained artists or ethnographic work from outside the United States. While these combinations may be ideological (as many top dealers do not wish to ghettoize self-taught art) and often the trained artists share an aesthetic with those self-taught, it also broadens the potential market. Galleries may also attempt to expand their activities, as in the case of one high-end Atlanta gallery that provided appraisals, advice on collection development, installation, as well as hosting corporate parties in the gallery space.

Contrast Regina Mutt to Small Potatoes, a small shop on the outskirts of a southern mountain town. This gallery is located in a faux mountain cabin, a homey site, with low rent and overhead; indeed, in contrast to SoHo, the owner may own the space. As in SoHo, there is the owner and perhaps a few helpers. Again, there is one large room; however, the walls are not white, but unpainted wood; the lighting is not as bright. In contrast to the cold SoHo space, these spaces are often warm and personalized. Art is hung close together with the prices on or near each work. The gallery has perhaps twice as many pieces on display as the Mutt Gallery, and they are considerably less expensive. The gallery owner tries to have "artworks" that range in price from the cost of a souvenir ($10) to the lower end of the Mutt prices ($1,000). Objects for sale include paintings, sculpture, pottery, quilts, books on the region, and other miscellaneous objects. Small Potatoes does not have shows, but rather has its art inventory displayed all year. With the exception of a summer open house for tourists, there are no gallery openings.

The rule of thumb in real estate that the three important aspects of property are "location, location, location" applies to galleries. Galleries tend to huddle together, creating arts districts, needing reasonable rents and suitable space, and then moving on when their success propels rent beyond what they (and the neighboring artists) can afford. The creation of SoHo was motivated by a gentrifying real estate market, as is the transition to Chelsea.[26] Even in cities like Atlanta, location matters. One folk art gallery was recruited to a small shopping plaza by a craft gallery, which arranged a reasonable rent. Another high-end space opened in the heart of the gallery district, as if to make a statement to elite clients about their seriousness. One regional dealer says that she is often told that "if you were really something you would be in New York" (Interview). Finally, the internal design of the space sends a message. As one SoHo white-box dealer put it, "It's about respect for the work. You show it well. You put a light on it" (Interview). The space and its location legitimate the art and the prices that are asked.

Gathering Art

In much contemporary art the dealer and the artist are relatively equal in status, at least in principle. The contemporary artist has comparable levels of cultural capital with his or her dealer. Despite economic assumptions of careful mutual monitoring of producers and buyers in constructing a market, such is not the case in the self-taught art community.[27] If the artist is inspired by everyday genius, this insight does not always extend to the salesroom. Here the dealer is the gatekeeper or guide for the artist entering into a foreign and exotic world. The dealer must bridge two dramatically different communities, and must be comfortable in each. As one dealer put it, "one day I'm out in the field, in the mud, and the next day I'm in the country club" (Interview). Organizational theorists distinguish between the input and output boundaries of an organization: gathering material and, after processing it, distributing it.[28] While typically the individuals with whom one comes into contact on these two boundaries differ (for instance, contemporary artists and patrons of the arts), in few instances could the difference be more dramatic than that which is found in the world of self-taught art between outsider, untrained artists and a highly literate set of collectors.

Many organizations (say, automobile companies or music labels) transform or package the material, but with the exception of framing, the material that comes in the door of the gallery leaves in the same condition: the dealer's task, when successful, is to find those who might be persuaded to own the work.[29] Given that the dealer doesn't "do" anything to the objects, the question is what purpose does this person serve—a frequent tension between artist and dealer. Dealers engage in networking and pricing, significant skills that depend on the interpersonal knowledge and communal trust that artists may lack;[30] further, the dealer "promotes" the artist—situating the artist in an aesthetic discourse that is appealing to collectors, who use the works both for their aesthetic appeal and for identity work. Although I focus on the relationship between dealer and artist, dealers sometimes purchase at auctions, flea markets, estate sales, and may receive consignments from other dealers or collectors. With the exception of relations with deaccessioning collectors, these other strategies for gaining product do not involve the same level of interpersonal skill.

Friendly Promoters

Without question, the relationship between dealer and artist can be powerful: a reality in all artistic domains. Dealers and artists need not merely

be business associates, but are often friends—just as are collectors and artists. One male dealer described one of his artists as his "best male friend in the world. I would go to him for counsel. . . . If I had a problem or I wanted to know something that had nothing to do with the art world. I would just say, 'What do you think I ought to do?' . . . I think we did become a part of his family. You know, he had always wanted grandchildren" (Interview). Yet, here the economic relationship is more entangled, since the dealer attempts to profit from the skills of the artist, while simultaneously allowing that artist to profit as well. If the dealer does not truly feel kinship, she or he must have the schmoozing skills so that the artist feels a kinship exists.

In the case of self-taught art, differential power and resources affect this friendship. Several dealers travel with artists, squiring them around. During the Outsider Art Fair, one dealer guided a southern self-taught artist, who had never visited New York, to the Empire State Building, Ellis Island, and the Statue of Liberty (although, significantly, not to MOMA or the Met) (Field notes). Ironically this artist had painted images of an imaginary New York, and the dealer joked that, having seen the city, "I was afraid that he'd be painting [his home town]," presumably a less salable image.

One dealer, Aarne Anton, hired an impoverished self-taught artist, Ionel Talpazan, to make bases for sculptures in his gallery, as well as choosing to represent him.[31] Friendship is so ingrained that a dealer scornfully criticized another for not visiting an artist in a nursing home. For her, this was not merely a business contact (Field notes). In the extreme, I was told that one married, middle-aged, female dealer was having sexual relations with two elderly black male artists. The charge was so ludicrous that I giggled and assumed that my informant was teasing, but he insisted that he had been told that this was her technique of getting the best work. More important than whether the claim is true, it was told and defended as true. Still, the roles of intimate and business partner may conflict. One dealer explained, "That's been hard for me to go from being able to be objective friend and longtime collector to someone who is in the business, because now when [an artist] hands me a contract to read and asks me advice about it . . . I could have a conflict of interest. I could actually take off my gallery hat and put my friend hat back on, but other people would look at that as not possible. . . . So, I know that's there a real need out there for a lot of these artists to have somebody who really cares about them to interpret the printed word when they can't" (Interview). The rhetoric of friendship poses a problem for a dealer, when the artists "need their hand held," for which

the dealer representing numerous artists may not have time. One dealer sighed:

> I tried to give all I could. I tried to be as sincere as I could. I had an experience with [an artist who had] a very fragile ego. I gave him his first one-man show, and I spent a lot of money doing it. I hooked up his phone, the first phone he ever had in his life. I called the child support office and kept them from taking a warrant out on him because he was behind in his child support payments. . . . He was calling me seven or eight or ten times a day. . . . I think he wanted to become Howard Finster, and I warned him that beforehand it wasn't going to take place like that, and of course it didn't, and then he got upset with me and wouldn't speak any more. . . . He was my first real bad experience, finding out that some of these artists can be a bit of a burden. (Interview)

Friendship can be a chore, and from the perspective of the dealer it should take second place to the representation and promotion of the artist. This can include arranging a spread in *Life* magazine, as Jeff Camp did for Finster;[32] promoting inclusion in major shows, as Michael Hall did for Tolson; or organizing a regular gig at Jazzfest, as dealer and New Orleans Preservation Jazz Hall founder, Larry Borenstein, did for Sister Gertrude Morgan.[33] The dealer as promoter must decide whether to emphasize immediate sales or longer-term stature, a dilemma raised by New York dealer Randall Morris:

> When I work with a new artist I make it clear that there are two paths one can follow that don't necessarily meet, although in the best of worlds they can, one is a strong and known presence in art history as an artist, and the other is making money. I am interested in the former but it is much harder and riskier. In the meantime how does the artist eat? . . . I don't promise sales. But I promise that within a couple of years the name will be known, the prices will be regulated, and the artist's integrity respected.[34]

While this perspective is defensible, one can appreciate the frustration of the unfortunate artist with a name, stable prices, integrity, and deepened poverty. This underlines the artist's goals—or fantasies. At the beginning of the relationship dealers represent the artist because they are convinced of the quality of the work and—usually—its sales potential.[35] But this may lead to unrealistic expectations, as evidenced by the artist who wanted to be another Howard Finster. When impoverished, artists who depend on their art income may ask for advances, not always living up to the production demands that this places on them—a dilemma known to

writers where "the advance" has been more institutionalized. One dealer told me that one artist had called her "twice this morning, desperate for money. Desperate. And you just don't know what to do. . . . Go get me the money order, send him the money, save me the piece. Sometimes he does, and sometimes he doesn't. You've got to get it or you ask him to send it, or you never get it and it's very difficult, and yet you don't want to say no to someone who's in a desperate situation. . . . I'm very tenderhearted and it tears me apart" (Interview). Yet she is in business, and cares about her own family. With a dealer enthusiastic about the work, artists may assume that sales will result, and some artists see the typical collector as wealthy, and thus wonder why they receive so little, so infrequently, sometimes feeling themselves treated as a commodity.[36] Others know that they can sell from their porch, and wonder why their dealer should receive half the profit: even when half of a dealer's price can dwarf what they would otherwise receive.

In their push to promote, dealers may engage in activities that others in this divided world find inappropriate. I have referred to dealers who bring artists to shows and have them draw or paint. While this simplifies the "road trip" for collectors, it removes the artist from a home environment, makes him or her an object rather than a creator, undermines connoisseurship, and suggests that self-taught art is easily produced.

The Commandment of No Consequences

Dealers are men and women of experience and taste. These talented few are in the business of helping their artists sell as much of their work as possible. This is their purpose. Thus, it is something of a surprise that there is an assumption—often violated—that dealers should not use their considerable expertise to help their artists determine how to appeal to the market; they should provide no advice that affects the content of the art: these artists are authentic and advice might spoil their vision. This is what I expect of my editor as I revise this manuscript, though, and what others expect of music producers, movie executives, and contemporary art dealers. Sometimes we do not accept the advice, but in principle it is not seen as demeaning.

Almost without exception, I found the rhetoric of no consequences tightly held. Dealers *should not* tell artists what to create: a commandment, like others, with many sinners. Purity must be tightly guarded, and guarded not by the artist, but by those who display and sell the work.[37] One dealer reported a story involving one of his artists: "[At an opening] a man said would you carve me a sphinx with a penis sticking out of it. And I didn't say a thing. I just let it go by. . . . And then when

[we] were together driving back [to the artist's home] the next day, I said, 'You know that guy last night. I said, well, Bert [Hemphill] told me something when I first met him. . . . Bert told me that you should never carve stuff that other people think of. You should carve the things out of your own mind and your own heart'" (Interview). Yet, this dealer was reported to have told this artist that he should work "big." Perhaps this is not the same as requesting a phallic sphinx, but it was a directive comment.[38] One dealer made what seemed a subtle distinction: "[One of my artists] did painted frames and unpainted frames. . . . I would say to him, everybody loves your painted frames. I would not say to him, you should paint all your frames because people like them better" (Interview). This dealer relies on the artist understanding what she means without having to say it. A gallery associate notes that when a particular kind of piece doesn't sell, the artist is told that "we're not doing real well with these. We're going to give them back to you and maybe you can try to sell them somewhere else. I don't think that encourages him to do anything differently. . . . And we would never say these aren't selling 'cause they're not as good as your other things" (Interview). Yet, it would only be the obtuse artist who would miss the point. Dealers must express their beliefs without seeming to "call the shots."

A few dealers find no need to be subtle, assuming, perhaps, that their doings will remain hidden. Critic Roger Manley saw some requests for an Alabama artist: "Fred Webster showed me some gallery orders for statues of angels with four wings. 'I never heard of such things, did you?' he asked. A dealer in Tuscaloosa, Alabama, had ordered '. . . a Noah's ark, and be sure to include two dinosaurs and two earthworms, he told me.'"[39] Some dealers provide precut cut-outs that the artist only needs to color, inserting themselves as part of the factory system. Friendly artists such as Mose Tolliver and Jimmy Lee Sudduth are particularly likely to receive orders for favored images—ten bicycle men, twenty George Washingtons, fifty watermelons—orders that they are willing to fill. These artists, like musicians, are often forced to replay their "greatest hits." The Finster file at the Archives of American Art is replete with requests to repeat pieces or to produce what someone believes will sell. In one case, "The Marilyn Monroe painting . . . was not Finster's idea; he was commissioned to make it by entrepreneur Peter Paul, president of Spirit of America, Inc., who suggested works—like Marilyn Monroe—that might appeal to the clientele at Gallery Rodeo. The question is, of course, can a 'visionary painter' produce paintings to order without spoiling his vision?"[40]

Yet before we condemn these dealers too quickly, they are doing what businessmen in most other domains are expected to do: providing producers with expert information about the market. These dealers may succeed, or fail, vanishing in a puff of red ink. If we assume that creators have the power to accept or reject the requests, what is bothersome is that this system flies in the face of the romantic ideology of outsider art—that of the uncontaminated creator. Many in the art world assume that, first, the formal qualities of constrained work decline and, second, the motives of the artist matter. In this the artist is seen as other than a jobber who works under the hand of those who have a broader market vision.

Contractual Entanglements

The economic order requires regularity. Predictability of production is a virtue for those in a market. Imagine the dealer is known for carrying the work of a particular artist. The dealer has paid for advertising, openings, and other forms of promotion. Now, suddenly, the artist decides not to supply more pieces. The investment of the dealer that assumes that the promotion will have lasting effects is for naught. For this reason businesses rely on predictability, such as contracts that are legally binding. Contracts, of course, help not only dealers but also artists, specifying the rights and responsibilities of both parties, laying out the ground rules so that third parties can settle disputes. Such a pretty picture of modern capitalism assumes that both parties have the full knowledge and information to judge the contract. While we should assume that both parties have goodwill, it is easy to convince oneself that what the contract says is what one needs it to say. Many artists have problems with contractual relations, but perhaps for self-taught artists, more likely to be economically vulnerable, these problems are magnified. For those who are unfamiliar with contracts the problems may be greater, making contracts ethically troublesome. As a result, some dealers prefer to purchase works outright, sell work of dead artists, or obtain work at auction. They gain full possession instead of selling on commission, without worrying about contractual niceties, erasing the moral dilemmas of working with living artists. This can mean, of course, that dealers can reap a tidy profit, which some label exploitation, but it can also mean that the risk is one-sided as stockrooms filled with art attest.

Contracts announce the commission that the gallery will take (often fifty-fifty), the other galleries with which the artist can deal, and whether artists can sell their own work (and whether they need to split the profits).

In addition, a contract can specify whether the gallery will pay a monthly stipend, providing a predictable income for the right of first refusal, for a certain quantity of work, or to "bank" future income.

The most sensitive contractual arrangement is an exclusive relationship in which an artist only deals with one gallery. Such an arrangement has advantages and drawbacks for both parties. If the dealer is to spend on promotion, she or he needs to know confidently that the investment will net a return. As one dealer asserted: "If I undertake the representation of Mr. Jones, and literally put in money out of my own pocket up front to promote him and maybe have an exhibition and framing and gasoline back and forth and shipping and insurance and wine and crackers at the reception hall, I want something. My competitor will walk in and say I like the work . . . and I'd like you to work with me. And suddenly I put in all that money with no protection" (Interview). Most dealers have several dozen artists whose works they sell. The question is which ones should be pushed. Perhaps the dealer emphasizes the best work, but often it is the best work of which the dealer has a stock, like restaurant specials. The exclusive relationship means that such an artist will gain priority.

For the artist, an exclusive relationship can provide benefits. An exclusive relationship places the dealer in one's corner, handing one's reputation to someone who has the economic incentive to build it. This can give the artist freedom, if the dealer is not too intrusive.[41] The arrangement, when it works, places the artist's career in the hands of a skilled professional.

However, although exclusive contracts frequently benefit dealers in a competitive market, there are some disadvantages for artists. While monthly stipends help, many exclusives are based on commissions, which may be slow in coming. Further, reputations take time to build. The dealer presses the artist to produce, but no short-term benefits are evident. A collector described her visit to an impoverished artist under contract: "[She] was living in poverty, and she had leaks in the ceilings. Half the house was getting ready to cave in. She needed a check that day, frankly" (Interview). One artist told me: "I was giving [my work to] him only, and he was selling a few pieces of art, and he wanted me to make a lot of art. And then it came time where he wasn't selling any of my art yet, because I was relatively unknown. I needed some money [to] pay some bills, because I spent so much time working on art. He wouldn't give me a couple of hundred bucks just to get my bill paid that I needed to have paid. And so all these people that are gallery owners had given me their cards, and they said I could call them if I need to sell my

art. I told him 'Is there any way I could go sell work to somebody?' He said, 'Oh, go sell one to [another gallery].' [He] started all highfalutin and had this kind of pompous attitude which I'm not really into. I didn't have any written agreement with him, and I told him, as long as he could make me $500 a week that I would do that for him, that it had been two months, and he hadn't even made me $200. . . . I went ahead and sold some of my own art that I had in my house. . . . I started paying my bills on time. And it was great. I was eating. . . . I had a little too much of smarts for him. I wasn't going to let him take advantage of me like that" (Interview). This artist, fortunately, found other prestigious dealers and he also sells work himself with considerable success.

Sometimes the novice artist selects a small or regional dealer, which may work at first, but after the artist becomes better known, other, more prestigious, dealers beckon. One artist who specializes in painted doors had an exclusive relationship with a small southern dealer. In time, she was picked up by a New York gallery, who permitted her to continue to sell smaller pieces directly to her original gallery (Interview).

The classic instance—known to most in this self-taught world—is that of the late Reverend Howard Finster, who for several years had an exclusive relationship with Virginia dealer Jeff Camp, who devoted considerable effort to promoting Finster's work. Both men left their papers to the Archives of American Art, and so the breakdown of the relationship can be tracked. Camp, living in rural Virginia, lacked the resources of New York dealers and Finster felt that he could receive more money and more prestige working with a New York dealer, the Phyllis Kind Gallery. During these years, Finster was being discovered and was influenced by many sources, each of whom had their own interests—altruistic or economic. In time, others began criticizing Phyllis Kind, suggesting that she, like Camp before her, was "cheating" Finster, and eventually that relationship ended. This is not to say that the gossip was accurate, but it reminds us of the dangers of exclusive relationship. The visitors to Finster's Paradise Garden had sufficient reasons for disliking the exclusive relationship, whatever the justice of their claims.

Dealers emphasize that in practice these contracts are unenforceable. Taking an untrained artist to court is unlikely, although some artists have gone to court to reclaim their work from galleries, and, of course, galleries may sue one another.[42] Dealers assert that the contract is valid only so long as the artist is happy. As a result, some dealers do not even put the contract in writing, a handshake will do in a world in which courts do not rule: a case of order without law.[43] Artists, however, may feel constrained, not realizing how easy it is to become free.

The Dealer and the Collector

The relationship between dealer and collector is, like that of dealer and artist, based on the importance of the personalized transaction, making this a commercial community—communal and commercial both.[44] A long-term economic connection depends on the establishment of a social tie. In contrast to the relationship with the self-taught artist, the dealer and the collector typically come from the same social world, and in general share the same values and aesthetic. Of course, each dealer has a life history that seeps into the gallery work and which might attract or dissuade clients.[45] Would one prefer to buy from a lawyer or a poet? A teacher or a banker? A gay dancer or a middle-aged mother? A New York Jew or a Boston Brahmin or a Good Ol' Boy? These variables do not matter to all clients—and certainly in this world they rarely are conscious considerations—but they underline that this economic transaction is embedded in a social relationship.[46]

The dealer must create the illusion—or the reality—of a positive, friendly relationship, motivating the collector to do business. The effective dealer will, like the politician, train himself or herself to remember the details of an acquaintance's life, able to display a tight concern, generating trust. I was always impressed, as an ethnographer, trained to observe and remember, how much more most dealers could recall about my preferences than I could recall about theirs.

However much a dealer might know about art or business, if that person cannot make others trust her or him, the gallery is likely to founder. Even when they do not wish to believe that selling art is a "popularity contest," the personal equation cannot be dismissed. In their embeddedness these relations are not so different from other economic ties in which bankers seek out personal information about clients to determine how trustworthy they are, hairdressers encourage personal stories from clients, car salesmen want to persuade customers that they have their interests at heart, and even grocery store checkers develop relationships with regular customers.[47] In contrast to the economic image of strangers rationally comparing price and quality, we are motivated to deal with acquaintances who we expect will treat us well. The dealer who seems "too focused" on making a sale will be scorned as a "dealer wheeler-dealer" (Field notes). An ongoing relationship helps both parties establish trust, a variable conducive to smooth social relations.[48]

Not surprisingly, collectors have varied impressions of dealers. One can easily find positive *and* negative assessments of the same dealer by different collectors. For instance, one dealer was praised for her skilled

eye and charm, and as the "mistress of shmooze," who scorned those insufficiently wealthy (Field notes).

Marks and Angles

Dealers evaluate potential customers, figure out the needs, hopes, and desires of these buyers, and convey that they—and their objects—can bring fulfillment. Part of what is involved, even when art is front and center, is to convey that the purchase will contribute to one's sense of self and quality of life, in the process "educating" the client. One dealer noted, emphasizing impression management, "You're selling to feed a person's ego" (Interview). Put cynically these customers are marks for the dealer who must figure out which angles will be most persuasive. In turn, the establishment of this relationship may benefit the collector as the lowered transaction costs (the time and expense searching out an appropriate client)[49] may encourage the dealer to give the loyal collector first notice of important work, lower prices, or extended payments. Galleries may give small gifts—a folk art pin, instance—to favored clients (Field notes). Chicago dealer Carl Hammer brings clients to his home to view art in a more relaxed setting—a process that may reveal a dealer's personal enthusiasm and excitement for the work.[50] Others invite collectors to travel with them when they visit artists—combining a "road trip" with a sales opportunity. For the collector a favored gallery can generate a "home field advantage."[51] As a corporate CEO collector explained, although it is a commercial relation, mutual trust is essential (Interview). By creating an embedded, long-term relationship both parties gain advantage since neither is motivated to cheat.[52]

The intersection of friendship and self-interest is made evident in this account from a collector:

> [A dealer] was out here helping us rearrange things . . . there are a couple of panels over the piano out there, and she said, "Boy, those are just screaming for Thornton Dials," 'cause she knew that we liked his drawings an awful lot. And so she kind of planted the seed. [Later she called before the Outsider Art Fair], "We wanted to make sure that if there was something here that you wanted before we put it on the truck for New York. We want our [local] people to have first crack at the nice things, and if you want to come down and take a look, feel free." And, boy, it worked like a charm. Down we went. [Collector laughs]. . . . I don't resent that one bit. . . . I like her a lot, and I have a great deal of respect for her, but we've never really had a social relationship. . . . I don't think she was

insincere. I'm sure she would prefer to have her choicest pieces out here. (Interview)

The belief that the dealer has this preference serves to cement this collector to the dealer. She trusts the dealer, and the dealer trusts the customer enough to believe that the art will be well cared for and well paid for.

Price as a Marker

In the art world it is typically assumed by collectors—and many dealers— that a discount is to be had. Discounts are routinely requested, not only by urban sharpies, but also by "collectors from Keokuk" (Field notes). Most often negotiation occurs through euphemism, such as "what can you do for me?" or "what is your best price?" A too explicit emphasis on cost undercuts the assumed—if impossible—separation among aesthetics, friendship, and investment.

Some collectors prefer to avoid bargaining and consider those who do to be dishonorable,[53] and dealers, understandably from their perspective, dislike discounts, but may feel constrained, building in the discount (10 to 20 percent) to the price or telling clients that "we will work with you on the price" (Field notes). Two dealers explain:

> When I started the gallery, I didn't [give discounts]. That's the price. That's it. And I priced as close to the bone as I could, because I wanted to sell it. . . . I personally am not comfortable with negotiating. . . . Sometimes because I've priced so low, I don't have negotiating space, and there are times I have to say no. . . . I don't want to be a car salesman. (Interview)
>
> ★ ★ ★
>
> We're always interested in giving you a better price. If the artwork is priced at $150, we will gladly sell it to you for $200. Now that's better. I don't mean to be flip, but we're not selling used cars. . . . If your doctor gives you a discount, I'm more than willing to give you one. . . . A lot of dealers I know are more than willing to give attractive prices to collectors who buy from them on a regular basis.[54]

The key is to persuade that "special clients" will be offered "special pricing." As a result, some clients prefer to deal with those galleries where, given their relationship and track record, preferential treatment is assumed.

Pressured Communities

Although one might assume that the client who walked into a gallery is entirely free to leave, the establishment of a relationship makes this

dicey. Visitors believe that they are being judged and while this pressure is nowhere near as powerful as the pressure to purchase from an impoverished artist, it can still be real. Collectors may feel the need to make the owner happy, not leaving a gallery "empty-handed." In many instances, the visitor enters a space that is entirely empty except for the dealer, who may helpfully hover, making the client self-conscious, and, if not, may be considered uncaring or hostile. A purchase demonstrates that a collector really *belongs* in that gallery, an illusion that it is in the dealer's interest to maintain, even if not consciously considered. One collector speaks of being "in the clutches of a dealer" (Interview). This is particularly powerful for those dealers who operate out of their home—the visit transcends business, but has the illusion of friendship—one is pressured to buy from this special host as at a Tupperware party. As one such dealer noted, "it makes people uncomfortable to be in this environment that looks like a home and it's all actually for sale" (Interview). The private space structures emotions, both helping and hindering the embedding of economic transactions.

On Not Cutting the Mustard

The belief that dealers size up potential clients reflects the nature of the art business, based as it is on the establishment of relationships. Relationships take effort and time to establish and maintain. As a result, dealers must prioritize their relationships. One dealer told me that he sizes up potential customers, and spends more time with those who seem to be "serious," a perspective he shares with maitre d's, police officers, and prostitutes. Art collectors who are not previously known face the problem of young black males; being well dressed affects their treatment. One dealer noted sarcastically that "we only eat the rich."[55] This is a field in which one dealer commented that there are only thirty major collectors who matter. Establishing a close tie with any one of them can be the difference between paying the rent and giving up.

When one must choose between talking with a stranger in Levis and one in Armani, the choice is easy—or, so, the jean-clad assert. A private dealer wrote, "A young woman artist friend of mine was in New York a week ago . . . she went in several galleries and later told me she'd never do it again. She said they were rude, sneered at her, made her check her bag at the counter and wouldn't answer her questions. . . . It was obvious she didn't fit the gallery 'profile' for an art client. . . . She also said in most cases she was nearly the only person in the gallery."[56] Another collector reported of a prominent dealer, "he treated me like I was scum. . . . My husband and I went in there, and we were dressed in

jeans. . . . I'd say we looked kind of poor that day. OK, so we go in there, and he didn't speak to us. . . . He's dressed in black silk from head to toe, and he's got on a Gucci belt and he has on these thousand dollar Italian loafers, and he's all turned out. And it's like, you know, 'What are you doing here?' The feeling is like, 'I don't want you as a customer.' " When they asked about a major piece that they could afford, they felt that he barely cared, "I'm saving that for one of my major collectors. I'm saving that for my customer who has a big name. Who are you?" (Interview). There may be some truth in that assessment, as some dealers attempt to place their major pieces in important collections and then sell other work by remarking that this artist's work is included in that major collection.

I can speak to this assessment from personal experience. During the Outsider Art Fair I visited one SoHo gallery. While I was there, the young assistant in charge answered the phone and talked about a reception the gallery was having during the fair. I asked this young man if I could attend (as an unknown customer, not as a prominent sociologist!). Obviously nervous, he hemmed and hawed, finally admitting that, "Well, I guess if they knew you [you would have been invited]." I am not in the habit of making life difficult for underpaid gallery assistants, but his reaction indicates that known collectors receive special treatment. As one collector noted: "Many galleries foster the idea that a particular collector is favored, as certainly any collector would want to be favored. To lose favor is to lose access. I am sure I have lost some in this regard."[57] To be sure, such a collector could have insisted on making a purchase, pretending that the economic transaction is neutral, but this would fly in the face of a negative moral evaluation.

Although it might be surprising, given the thinness of the profit margin, some dealers claim to refuse to sell to certain buyers, supporting the claim of certain people that they are defined as unworthy:

> We're a fine arts gallery that prides itself on the quality of the things we carry. . . . We are polite to those people, but we are not interested in people who are looking for decorative art in any way shape or form. They come in with paint swatches and are trying to decorate, this is not the gallery. (Interview)

<div align="center">★　★　★</div>

> There have been a couple of occasions where somebody has come along that I didn't feel had the respect for the piece and shouldn't have it. I said, "I have a hold on that" or "I'm sorry it's not available." (Interview)

These dealers, bolstering their identity work and market niche, operate against their immediate economic interest, although perhaps in the

long term such exclusivity and boundary maintenance may bring desired clients: a realization of haute cuisine restaurants, luxury car dealerships, exclusive jewelers, and upper-end boutiques. One's customers serve to define one, announcing that this is an establishment that "people like that" patronize and that I am a person who serves "them," explaining why some resorts once preferred empty rooms to Jewish guests. Given the market, there will always be some dealer ready to sell similar works, but one can appreciate why clients feel that they are being judged.

This status game leads some collectors to ask friends to introduce them to established dealers, establishing their bona fides through network affiliation, in the same way that senior professors will introduce their junior colleagues to publishers, or informants will introduce friends to police. Dealers place advertisements in *Folk Art* and *Raw Vision*, but in gaining long-term customers, networks are more effective. Ultimately the dealer and customer personalize their transaction, focusing with one eye on the art and the other on the quality of one's partner.

The Ethics of the Bozart[58]

Any community that involves power inequities and financial transactions raises ethical questions. Dealers, although economically motivated, are no more unethical than most, but one might not know it if one listened to the amber waves of gossip. The previous section has hinted at some of these concerns, but to understand how the structure of the art world affects behavioral practices, I address them directly. I particularly focus on five ethical issues, which blend together: theft, rivalry, ownership, dilatory payment, and exploitation.

Stealing the Booty

In some ways theft perhaps is not an ethical *issue* since there is so little disagreement. There are no defenders of those who take another's work without approval or reimbursement. Yet, even here, sociological matters are involved. First, we are *not* talking about breaking-and-entering. I have not heard the claim that an artist's home was ransacked. Instead, theft involves the disappearance of pieces that are left outside. These are objects that until the artist became "known" lacked value to the surrounding community. Once the curtain of fame has risen, pieces vanish. No legal record exists as to whether the miscreants were punished, but the changes are serious. Jesse Howard, a Missouri self-taught sign-painter, found his yard stripped after an art lecture. The lecturer

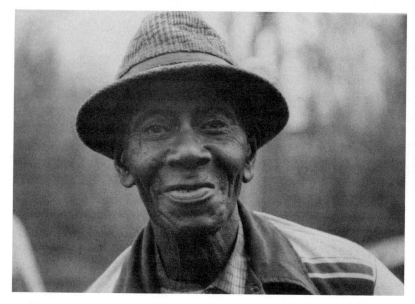

David Butler (1898–1997). Archives of the American Folk Art Museum, New York. Courtesy of Chuck and Jan Rosenak. Photo by Chuck Rosenak.

recalled, "I remember giving a lecture as a visiting artist at the Chicago Art Institute and immediately after that a bunch of graduate students who were artists just went down the road to Kansas [*sic*] and grabbed Jesse Howard's work—I later saw it in their apartments. They just went and took it."[59] A still more extreme case is that of David Butler, an elderly black Louisiana artist, whose yard was stripped, forcing him to move in with his niece.[60]

> Butler had created this environment that was like a temple. It was very personal, very private, and it was a really magical place. He had cut holes in all of his walls, and he had tin covering with the images cut through the tin, and light would project these images on the floor, and it was a really amazing place, and the first thing that happens—the local people—started accusing him as being voodoo . . . and then museums and collectors and dealers started coming in, and his family realized that, "Ah, hey, crazy Uncle David over here might be worth some money," and so they got in the act. . . . He left his house, eventually his house was stripped. It was vandalized. (Interview)

More common than theft is the dealer who, not finding the artist at home, takes objects, leaving a note and payment—but a payment to which the artist never agreed. It might be argued that the visitors, who

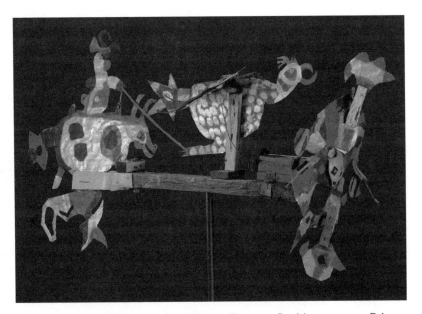

Detail of *Windmill with Rooster* by David Butler, Patterson, Louisiana, ca. 1950. Paint on tin with wood and plastic, 29¼ × 49½ × 24¼ in. Collection American Folk Art Museum, New York; Gift of William A. Fagaly in honor of Bruce Johnson, 1977.15.1. Photograph by John Parnell, New York; Photograph courtesy of the American Folk Art Museum, Shirley K. Schlafer Library.

may have taken some effort to reach the artist, feel that they were acting appropriately, perhaps checking back later to see if the payment was satisfactory. Still, such doings, although understandable, cross a moral boundary, and are not likely to occur had the artist more social capital:

[According to dealer Tom Wells] this one dealer from North Carolina came down and looked at the paintings in Jake's yard, and Jake wouldn't sell him anything. Looked at the guy's money and turned him down flat. So this guy [later] left him a note and put $30 inside Jake's screen door and took two paintings. [61]

 ★ ★ ★

One trained artist received a call from his aunt one night about a self-taught artist: " 'I got Steve here in the kitchen and he's all upset because when he came home today, everything in the yard was gone and there was a note in his door with a check from this guy that said, "I was up today. Missed you. Bought a few pieces." ' Well, this guy had stolen the stuff out of the yard basically and paid the guy $200. . . . It was probably 60 or 70 pieces. So, I called the guy because I knew him. . . . And I said, 'You've

got 24 hours to get all that stuff back up there or my aunt's going to call the state police and they are going to prosecute you.' "[62]

One must emphasize that I have but one side of the story, but the accounts surely raise the presumption of impropriety, putting aside whether the payment was fair or the relationship between artist and dealer was long-standing. Objects belong to their maker, and the right to transfer ownership belongs to that person.

The Klondike Paradigm

Sometimes it is not the art that "goes missing," but the artist. Here I refer to dealers who steal artists from one another. The rules governing this matter in the self-taught Gold Rush are hazy as both artist and dealer have freedom, particularly given the weakness of contracts. One observer speaks of this as "the Klondike Paradigm": "You go up into this vast, uncharted territory and take a gun and a pickaxe, and if you see somebody staking a claim that looks interesting, just sneak in there at night and crack their head open with a pickaxe or shoot them with a gun" (Interview).

Of course, dealers are often able to work together profitably. Sometimes dealers in a particular location collaborate, as in the case of three dealers in the Georgia mountains—Main Street Gallery, the Hambidge Center, and Timpson Creek Gallery—who for many years coordinated an opening and barbecue in July, enticing Atlantans in a way that a single opening might not. At other times, a gallery in one city may receive an inquiry about a particular piece or artist, owned or represented by another. That second gallery might consign the piece to the first, with both profiting. Sometimes several galleries collaborate on exhibitions, transferring unsold pieces. However, the fact that relations are often harmonious doesn't mean that they always are.

At one point animosity developed when two Atlanta galleries competed for the works of Willie Jinks. An elderly and infirm black man, Jinks had an exclusive relationship with one of the galleries, but not understanding or not caring about the agreement, Jinks continued to sell from his home, undercutting the prices of his local exclusive dealer. The second gallery eventually displayed his works (at a reduced price) angering the first, which considered the behavior "immoral and shameful" (Field notes). Eventually the first gallery let the matter drop, and rarely displayed Jinks's work, which is now inexpensive and sells to budget-conscious buyers. Whether he should have been asked to sign an exclusive contract and whether he is better served by the flow of small checks

is debatable. The ethical question in this world is whether a contract with an uneducated artist transcends his or her own immediate needs. The answer in practice is no.

Possession and the Last Tenth of the Law

One of the truly important, "blue-chip" self-taught artists is the black Alabama artist Bill Traylor. Sitting on a downtown Montgomery street, Traylor drew pictures—stark and humble images of people and animals—that he sold for a nickel. There were few takers, but there was one, white trained artist Charles Shannon. Shannon befriended Traylor and collected hundreds of his works in the 1940s. When they were exhibited in the late 1970s, they became popular and expensive (up to $170,000 by the late 1990s). In time—1984—Traylor's granddaughter discovered that her grandfather was an artist, and a prominent one at that. Eventually the Traylor family, which apparently had never met Mr. Traylor, filed suit against Shannon, claiming that he cheated their grandfather, and demanded his work and the money that derived from it.[63] Eventually the suit was settled out of court with twelve drawings placed in trust for the family. This settlement at today's prices might net the family a million dollars.[64]

The suit was settled without trial, but what are we to make of it? Does an artist—or his descendants—deserve a share of the resale of art, particularly in cases in which the creator may not have been fully aware of the art market and when the prices appreciate tremendously. Five cents to $170,000 is a price increase that well outpaces inflation. A settled case does not produce any legal precedent, but it does have implications. Not surprisingly, the art world, almost unanimously, took the side of Shannon. One curator described the suit as "real scary stuff"—pointing out both the unique particulars of the case and the general principle. A curator noted: "If it hadn't been for [Shannon] . . . who else would've saved this work? . . . I think for the family realistically to expect that they would share in the proceeds now is maybe not right, not fair" (Interview). More generally a collector noted: "It has so many repercussions on artists, collectors who have the artists, museums that have the artists. . . . If we started to return everything to the place where it came from, we're in big trouble. It would destroy all museums."[65] The ethical issue relates to current laws that operate under the materialist assumption that purchase transfers ownership, but as to whether artists should forever lose the rights to their work or whether special conditions should apply to resold artworks can be debated. At issue is the social organization of ownership—in the art world and elsewhere. At present,

we do not have "artist commissions" on resales, but some argue that it should be considered, particularly in dealing with artists without the social capital to fight for themselves.[66]

This issue helps to explain the case of Henry Darger, dying apparently without close friends or relatives after living for thirty-one years in a single room. His closest contact—perhaps his friend—was his landlord, noted Chicago photographer Nathan Lerner. Lerner claimed that before he died Darger told him to take his possessions, which turned out to be a treasure trove of remarkable artwork, eventually worth millions. When Lerner was approached by John MacGregor, a psychiatrist and art historian, hoping to write a study of this remarkable artist, Lerner was uncertain. MacGregor reports that "after assuring Nathan that he had no intention of tracking down any possible Darger relations—which might have meant contesting the rights to the artwork—there were no more obstacles to his access."[67] The completeness of the research project had to be sacrificed to the desire of the owner to avoid any conflicting legal claims.

Art Floats

No dealer desires to be an accountant. Yet, even so, it is surprising how difficult it is to get art returned from the maw of (some) galleries. Many artists, some elderly or impoverished, have such stories, and some, such as Jack Savitsky, have gone to court to recover their work.[68] Even dealers who have consigned work to other galleries have had to resort to legal action. As one small dealer noted after an unpleasant experience with a top dealer to whom she had consigned work for a show and who refused to pay for her expenses and for the sales, "I tried to figure out how we could get a payment plan going. . . . I found out 'Sue me, that's the best way to get me to pay you' " (Interview). Given the expenses of the lawsuit, she dropped the matter, but has a juicy story to share.

Artists and collectors expect—reasonably from their perspective—that if their work sells they should receive their consignment fee immediately, rather than having the dealer live off it and its interest. Late payments are common, and stories are told of top SoHo galleries and less prestigious ones. This strategy is common among contemporary art dealers as well.[69] Such "floats" are understandable, even if they are on the outer edges of ethics. These are small businessmen, often undercapitalized, sometimes disorganized financially, who may be just as close to disaster as is the artist or collector whom they are not paying. One collector who used to consign his work to dealers, now sells at auction,

noting: "[The dealers] were so disorganized that they just seemed to forget, and I don't ever seem to get paid" (Interview).

Art dealers may appear wealthy—they need their front to sizzle in order to impress clients—but they often lose sleep over their precarious financial fate. A slow check may be better than a rubber one. The Jeff Camp files at the Archives of American Art are probably somewhat representative. Camp, an early and important dealer, is continually asking for payment from those galleries to whom he consigned work, and, in turn, several artists request the same of him. From his rural Virginia location, he did not have the financial support nor the cash flow to make a go of it, and this uncertain cash flow contributed to his reputation. Other dealers told me of lean years in which they dipped into personal savings to rescue the business. I was told that one well-known dealer, a regular participant at the Outsider Art Fair, had to place a work at an auction simply to pay the rent. One dealer is explicit about the problem:

> Let's say you have things on consignment. So the month goes by. Then all of a sudden, you've got to pay the rent. So, the consignee, the person that you owe money for selling their object would be about the last person that you would pay. . . . The last person they're going to pay is the person that didn't even know you sold it. So you're going to pay the rent. You're going to pay the telephone bill. You're going to pay all that stuff first. If there's nothing left over. . . . That's not really considered unethical. I mean, I guess it's unethical, or it's not fraudulent. I mean it's just like business, you know. It's what happens in business where you get overextended. (Interview)

When questioned, dealers create narrative webs to justify their behavior. One dealer who had consigned an important work to a major SoHo gallery learned after a year that it had sold; when she contacted the gallery they "just said that someone is looking at it" right then, permitting them to pay her without the embarrassment of admitting that they were surviving on the amount that she was owed (Field notes). A collector told a similar story about selling some work during a period of price increases:

> I gave her [some Sister Gertrude Morgan drawings] and we decided on a price and the whole market sort of exploded after the Black Folk Art [Corcoran] show, and I just had a lot going on in my life, and suddenly I realized . . . those things had increased in value a lot since I had consigned them to her. And so I called and said, I wanted them back and she

begged . . . and she said, "Oh, well, I have to check on something. I'll get back to you." She sort of hedged and she said, "Didn't you get a check?" and I said, "No, I didn't, and I'd really like the pieces back." Well, she said, those were sold [and] I'll get the check to you right away. Well, of course, they hadn't been sold, but they were about a third of the value that they should've been. (Interview)

It is surely true that dealers have diverse ethical standards, as well as different financial situations permitting the luxury of selecting their ethical standard. What seems unquestionable from the stories that I have heard from artists, dealers, and collectors is that this practice is common, perhaps like money laundering in the banking industry or mob payments by restaurateurs: unethical certainly, but so common, given the structure of the business and its cash flow, that it can barely be considered deviant.

The Calculus of Exploitation

Given the vulnerability of artists, much talk exists about exploitation. But what is it, and how would one know it when it appears? Black Alabama artist Charlie Lucas, on the CBS show *60 Minutes,* commented that, "I've been treated like a dog." But what does this mean? Lucas claims that he wasn't paid fairly for his work, but what is a fair or equitable price within a market, when buyers and sellers make deals, and objects are worth what someone is willing to pay at the moment. Is there a magic point that separates justice from exploitation? Is any price particularly moral? Good deals can offset the poor deals previously made. Further, given the extraordinary case of the escalation of the prices for works by Bill Traylor, "Everybody's trying to find his own Bill Traylor."[70]

Is it ever possible to under-price work, if that is the agreed upon price? Perhaps if the assumption of open information is violated. Markets depend on the belief that all parties have access to complete information should they wish to make the effort; when this assumption is violated, as it often is in the case of self-taught artists, a "free market" is undercut (and, thus, the concern with fraud[71]). As one prominent collector asserted, "it's exploiting the lack of information, that's the unethical part that the early sellers don't know the values and therefore they get cheated due to their lack of information . . . in the case of Charley Kinney [a Kentucky artist] who's cranking out pieces and selling them for twenty-five dollars while they're being sold in New York for twenty-five hundred. Somebody's keeping him in the dark to make that dynamic" (Interview). In theory, artists can discover the prices for their work—

traveling from the hollers of Appalachia to the hallways of SoHo—but in practice, the information is inaccessible, unless third parties intervene. Hiding information can be dangerous because others might "spill the beans." This may have happened in the case of Howard Finster in which art-world friends wrote about both his first and second dealers: "[Your dealer] has over 200 of your very best works of art. He has been selling them for high prices and has not given you anything in return" and, later, "I am fearful that she is screwing you financially. I believe she is selling your paintings for several thousand dollars and telling you she is selling them for a lot less."[72] It is *not* that Reverend Finster had unethical dealers, but rather that others in the art world can communicate to artists their belief that the artist is being exploited.

Not all see exploitation as a problem:

> I think the ethical problems are greatly exaggerated overall. I think that that's almost a red herring people that don't understand the business throw out. There are lots of intellectual problems, much more so than there are ethical problems. At the very base line, you have artists whose work would be worth nothing making money, and God knows a dealer also needs to make money. If the dealer, if the collector, didn't step in there, the artist would have no income from this stuff. . . . I think the school of hard knocks is a pretty stirring teacher and some of these artists have been through plenty, and perhaps have more real world savvy than art school graduates do. (Interview)

<center>★ ★ ★</center>

> These guys [self-taught artists] make, I mean you have no idea. That's the thing people should be writing about, how much money they make. There's so much myth about how they were all exploited. I mean that's bullshit. They exploited us if anything. If it weren't for people like us, in this business, they wouldn't even exist. It's like the marketplace . . . that's what made them into what they are. (Interview)

Perhaps we shouldn't weep for the poor exploited dealer, but these comments cause us to consider what might otherwise become seen as a romantic narrative of exploitation. This is a market in which individuals make decisions. The artists may receive less than they might otherwise get with more information, but they surely receive more than what they would have received without this market. The ethical issue of what constitutes a proper payment is real, but the determination of value is always contentious. The point is not that the relationship between dealer and artist is inherently unethical or exploitative, but that the idea and ideal

of community keeps coming aground on the materialist needs of the participants.

Creating Community

All social worlds—commercial and not—require a sense of community. There must be a culture, evidenced in gossip, stories, and social control, that bring people together: a subculture, composed of intersecting small group cultures, permits meaningful interaction, a shared past and prospective future.[73] The cultural elements of self-taught art demonstrate the power of a group of disparate individuals, and, in its inclusion of impoverished artists and elite collectors, a community that embraces the entirety of the American class structure. The artist is a member of this community, but sometimes interactions are uncertain and awkward. Still, despite the difficulties, this broad congregation of persons distinguishes this social world.

Like most communities, a division of labor is to be found, but also like most communities, that division into roles is not as sharp as might be imagined. Participants may have diverse roles, sequentially or simultaneously. In an extreme case an artist can become a dealer, and can continue to do both simultaneously. Some artists even are asked to be critics, which they do in their fashion. A few roles are more problematic (what sociologists call "empty cells"), such as the joint role of academic and artist, although it might be possible for a Professor of Electrical Engineering to be quite as self-taught as the few bankers and lawyers in the club. An academic—mathematician John Nash, perhaps—who developed a defining and confining mental illness might, in some instances, be considered a true outsider, although I am unaware of anyone who fits that category.

Key to building an artistic community is the dealer: a man or woman who serves as a conduit between artist and collector, mediating their differences. The dramatic differences among galleries—from Downtown to Dogpatch, white walls to split logs, testifies to the diversity of the artists and collectors. The importance of folk art adventures suggests that the dealer must compete with the artist, even if the dealer occupies a structured and recognized role.

In this role, the dealer presents objects that clients do not "really" need. The power of the ideology of art is such that often this is a case that is easy to make, but it does mean that other needs of clients can easily take priority. Collections are a byproduct of affluence. To sell their objects, dealers play on the status and identity needs of clients. For

collectors, all art is "identity art." This strategy requires a finely honed sense of impression management, shaping the interaction to permit the scene to proceed smoothly. It is not that dealers are "con artists," but, as in the deceptive trades, meaning must be fabricated—a task that the critical establishment justifies in the name of Art.[74] The collector through emotion work and the establishment of a trusting relationship can easily become convinced that a body of salable work is "where the action is."

However, just as the collector relies on the dealer, the dealer relies on the collector. Trust flows both ways, and depends on the information that each gleans about the other. Monetary arrangements are part of the calculus of trust, but so is the choice of the collector to spread the word with the art serving as a framed signboard for the dealer. This trust means that collectors consider which dealers to patronize. From the standpoint of the dealer, the response to the visiting collector must be modulated: from an enthusiastic embrace to "cooling out the mark,"[75] hopefully with the pest none the wiser.

Given the broad spectrum of this field in its monetary and social characteristics, ethical problems abound. While some of these appear simple, I assert that even those that seem least problematic are organized by the structure of the field. Doing right is a necessity, but in a diverse community with many role divisions, what is right may not be as clear as the high priests of justice contend.

6

markets

[The market for self-taught art is] more like the drug world than the art world. The artists, like the coca-leaf growers, get nothing, but by the time the art and drugs hit the streets in New York the prices are astronomical.

—CRITIC ROGER MANLEY

To analyze money, filthy lucre, in a book about art has elements of sacrilege. Art is pure, cash corrupt—or so the ideology claims.[1] Yet, of course, all art worlds are based on economic exchange, and without markets art and artists would not have flowered.[2] Aesthetic hierarchies, mediated through the assessment of rarity, cannot be disentangled from financial value.[3] The market is the means through which Western societies organize artistic life. As in other domains, the innovator gains the credit—and the rewards, and, when this innovation is recognized, the artist has a monopoly on the production of this scarce and desired good.[4]

Together rarity (supply) and aesthetics (linked to demand) determine how artistic objects are valued. The art

market is structured to generate prices based on the supply of and demand for these objects. While consumers of art often do not wish to recognize that they are investing—and often they are not, consciously—the price of art objects indicates their taste. It is the only objective measure around. Consumers make a "double bet" that the purchased work will increase in aesthetic value and in exchange value.

By examining the art world through a detailed study of self-taught art, I explore the dynamics of aesthetic markets. That the economic exchange occurs within personal relationships—embedded transactions—distinguish art-world markets from others that are more impersonal. Further, self-taught art differs from other artistic markets in the explicit emphasis on authenticity (creating an inverse relationship between formal credentials and status), and, in part as a consequence of this ideology, in the marginal position of the artist in the market. These workers have only a limited influence as market-makers, often only barely aware of how their production decisions affect the rarity and value of their products. Their genius is tied to the routine production of their work without an awareness of how those choices impact the evaluation of audiences, both aesthetically and financially.

The Realm of the Coin

This stuff doesn't become "outsider art" until someone PAYS for it. It may have been created by an artist in a vacuum totally removed from financial gain or reward . . . but until it reaches the market . . . it isn't art.[5]

Markets are essential to art, dangerous, debasing, perhaps, but necessary.[6] Art, to have value, must be commodified. Someone must want it sufficiently to trade resources and to have these objects produced on a regular basis; the producers must be remunerated. Producing art is not always leisure, and producers forgo other activities to create for others to own. While the above quotation, radically constructionist, pushes the matter too far, suggesting silent trees falling in the forest, it recognizes that the idea of art as a commodity depends on a transactional arena in which the object is given value and transferred to others through exchange. Some dealers, ardent in their passion, suggest that money is a root evil—what anthropologist Stuart Plattner refers to as an "antimarket mentality."[7] Randall Morris argues that, "Money—and its distribution—is the final moral evil perpetrated on the artist. Money has become a language we speak with all these artists. . . . The prevailing idea of 'buy cheap, sell dear' is an abhorrent one."[8] But if money

is insulting, what dialect has a more kindly face? Morris, and others, wish to remove self-taught art from competitive markets, placing it in a gentler market, treating the artist as in need of special consideration and the objects as other than commercial goods. Dealer John Ollman, historicizing the development of the field, suggests that it is not only the artist who is polluted but the dealer: "There's so much discussion of money and investment. . . . When we were first dealing . . . the people who were collecting loved it. . . . [Now] you feel like you're selling them stocks and bonds."[9] Of course, consumers could easily purchase those stocks and bonds, yet they choose to purchase art. There is a value-added quality to art that financial instruments simply do not have. Just as Ollman selects objects that he believes will (or should) sell, his customers purchase objects, not only that they like, but that they feel others will like, leading to the possibility of a secondary, resale market, in which a claimed price can be ratified.

To recognize the claim that art is sold partly as an investment, consider a handout publicizing Atlanta's Folk Fest:

> Before Folk Fest '95, an art collector, Margaret Doan, with work by William Adkins, an unknown artist, phoned the Folk Fest office. She inquired about the cost and procedure of setting up a booth at the show. At Friday night's show opening collectors had an opportunity to purchase works for $1,000 each. . . . Now, if you are hoping to acquire a piece of Adkins' work, take your checkbook and head to New York. Ricco Maresca Gallery has Adkins under exclusive contract and is charging many times the original asking price at Folk Fest '95. Let that be a lesson to shop with an open mind.[10]

Those with an "open mind" saw their purchase multiply in value. The works had become validated by a prominent gallery, *assuming* that the gallery can make the price stick. Setting a price does not mean making a sale, but it does provide some communal assessment. A collector, who had purchased a piece that he didn't find very attractive and which he kept hidden, explained he called a dealer about the cost of a comparable piece by the same artist. When the dealer asked if he were interested at $5,500, the collector responded, "No, but I can take the picture out of the basement" (Field notes). When he looked at the piece he now saw the judgment of his community.

Of course, despite a belief in markets, not everything is monetized (kidneys, adoptable children, government favors, or religious prayers). Morris, Ollman, and others insist upon an image of artistic transactions that not all share, and without a strong value consensus or state

involvement, markets will triumph. In art worlds, despite the discomfort, commensurability (a system of equivalent exchange) exists between artworks and monetary instruments.[11]

This is particularly dramatic in the case of self-taught art in which elites strain to protect pure and authentic artists from the rough-and-tumble of the market. Folklorist Alan Jabbour asserted, quoting Shakespeare, that folk art will be "consum'd by that which it was nourish'd by."[12] Even the enshrinement of the self-taught artist, treating him or her as one might treat a contemporary artist, is dangerous in some eyes, as one reviewer of a glossy art book, *Bill Traylor: His Art—His Life,* claimed: "It is sadly ironic that the vicissitudes of Traylor's posthumously established reputation as an artist are almost wholly determined by the marketplace and its acolytes. This book represents the zenith of the beatification of Bill Traylor. Surely Traylor's art speaks for itself. But by relegating almost all discussion of the images to the mute framework of presentation and packaging, this book finally fails to respect either the art or the artist."[13] The critic seems to desire more description of the work's "searing plainness" and its cultural context. Fine. But one might wonder exactly how a book with beautiful images demonstrates a lack of respect for an artist or his art. Is it that this beautiful book demands to be seen as a commodity? These critics at times seem like environmentalists who wish to protect the wilderness so that none but the most energetic have access.

Self-taught art is now fully commercialized, whatever was the case in its halcyon days—a myth of primal innocence. Scholars have examined the attempt to market and monetize Appalachian crafts from the 1920s to the 1960s, through community cooperatives such as the Southern Highland Handicrafts Guild and the Grassroots Craftsmen of the Appalachian Mountains;[14] similar efforts occurred in New Mexico pueblos and Hispanic villages.[15]

One element of commercialization is that the artist becomes a "brand," as people do not trust their own taste—not that many ever did, except in our romantic fantasies. Michel Thévoz, formerly curator of the Collection de l'Art Brut in Lausanne, Switzerland, writes:

> I naively supposed that people's financial interest in the field would stimulate fresh discoveries. But I have observed with consternation that, at least as far as Europe is concerned, gallery personnel place no faith in their own eyes or private responses, but instead look only for the label. And the label "Art Brut" implies being featured in the museum which bears this name. If Aloïse were to show up in a gallery today with a pile of her

drawings, all the gallery director would do would be to check out whether her name appears on our list.[16]

Of course, it is not only a museum list that counts, but also whether the piece is sold by a "New York gallery" or owned by an important collector; hesitant people are more confident with the credibility that comes from purchasing labels. Provenance and place contribute to trust.[17] The object may be the same in Waxahachie, Atlanta, or SoHo, but the buyer's confidence and, hence, the price elasticity varies.[18] There is a value-added quality to a work provided by the reputation of its seller.

Control and the Market

A standard—and effective—commercial strategy to exert control is to allow a market maker to set prices. It is a delicate matter to predict how much supply will maximize demand; too little supply is likely to push the artist out of sight and out of mind. A small number of works does not necessarily lead to increased value. Rarity must be constructed.

An art market needs to be defined so as to include some works, excluding others, insuring that there are not too many competing objects. As sociologist Raymonde Moulin writes, "The artwork is the ideal-type of a rare good with rigid supply, which value is determined by the demand,"[19] but as Moulin notes, rarity doesn't just mean that there are few objects (their uniqueness), but the number of objects is tied to their socially defined excellence.[20] This excellence is validated by the choices of relevant others. Some objects are defined as belonging to the art world, and others (no matter how unique) as lacking excellence and relevance, and thus are placed outside the borders of the art world. Boundary work connects to price.

In theory, supply affects demand. Even though artists may create the supply, in practice the supply is affected by middlemen as well, who may control the availability of objects. Commodity brokers sometimes get into trouble for such manipulation, which in some financial domains is considered predatory. But while we may worry about cornering the market in silver, the market in Darger or Ramirez is another matter. Exclusive contracts are permissible (if not always admired) and galleries do, legitimately, own the estate of an artist. Other times they attempt to corner the market. One gallery employee claimed that the Phyllis Kind Gallery has attempted to "set a price structure" for the works of Carlo, an artist whose work the gallery largely controls in the United States. Likewise, John Ollman of Fleisher/Ollman Gallery, purchased

much of the work of James Castle from an Idaho dealer, and put out a catalog, permitting him to be influential in setting Castle's prices, which, given the weakness of a secondary market, one collector labeled "smoke and mirrors." One of Thornton Dial's dealers purchased the work that a rival dealer was selling at reduced prices at the Outsider Art Fair, which had the secondary effect of having the dealer place "red dots" on them, a standard symbol that the works had been sold, suggesting Dial's popularity (Field notes). By removing work from the market and increasing the valuation of the works, these dealers affect their perceived rarity.

Another dealer who wanted to control the works of a woodcarver paid him more than any competing dealer would likely pay this unknown artist. He notes: "I'll make so much more money in the long run by paying well for things than I will by begging for them . . . when I went in this man's house, I looked at his wood carvings and I asked him would he sell? And he wasn't interested in selling . . . and I realized that in order to get these objects, I was going to have to pay a lot of money, so I offered him two thousand dollars for a woodcarving. . . . He had sold one for ninety dollars . . . that's the most he ever got for one. . . . I cut out almost all my competition. So, I can rest assured that nobody's going to walk in there and buy one for a hundred dollars tomorrow or five hundred dollars" (Interview). If this dealer can convince the market that these are desirable goods, the price structure is his, as long as his artist doesn't choose to compete against him.

However, as speculators recognize, cornering a market can be risky. One can find a lack of interest, a lack of trust, or the discovery of fungible goods that serve as well. The works of the artist may become rare, but there are other, "equivalent" artists for buyers to select. The "exclusive relationship" between dealer Jeff Camp and Virginia carver Miles Carpenter is a case in point. In the 1970s, Carpenter was seen as an important artist, but unlike Edgar Tolson, his star did not continue to rise. According to some, this was because Camp, located in rural Tappahannock, Virginia, raised the prices of a Carpenter more than the market would bear, given alternatives. As one dealer noted, positioning is crucial, and Camp "positioned Miles very poorly. . . . Jeff priced him out of the market at a point in time when he was the only person priced out of the market. People went, 'Oh, Carpenter. Twelve thousand dollars? Oh. I think I'll get the S. L. Jones. . . . It's only eight hundred."[21] The control of Carpenter's work and the lack of recognition of the limits of price elasticity of the market for Carpenter's works prevented him from

entering the highest canon of self-taught art. If Camp didn't overprice self-taught art, he misjudged the willingness of the art world to consider his prices the legitimate expression of a free market.

The Dialectics of Value

Value (and price) is on some level a construction of concerned parties: an art and a business.[22] Markets imply this construction through the negotiation of supply and demand. However, in the absence of a routinized market with repeated transactions, considerable ambiguity exists in setting prices. Given that prices are public matters—although the transactions are private—reducing prices can be seen as a negative judgment on the art in a way that a constantly low price will not be. How to judge what something is worth? Claiming that the worth of an object depends on what someone will pay does not solve the problem—except partially at auction—in that someone needs to propose a price or an estimate and that someone has to learn that an object is being offered. Further, others are selling similar objects, and so competition is evident, given the extent to which comparative information is available. Many idiosyncratic, if not bizarre, buyers exist, but they are not common enough to make a market. If I were to buy a can of "Billy Beer" (the brew named after Jimmy Carter's brother) for $10,000, it wouldn't make that price realistic, even though I elected to pay it. So it is in the art world, filled with odd tastes, uncertain vision, imperfect knowledge, and considerable wealth, leading to unstable prices.

Information is central to the construction of an efficient market, providing confidence to expend resources on rare objects, and, if we trust it, our confidence increases. This explains the power of academics and critics, who, even if they don't buy or sell, contribute to market-making. Uncertainty of aesthetic merit—a crisis of authority—here, as in peasant markets, leads to emphasizing relations of trust.[23] In this market in which buyers typically know less than dealers about the product's value—contrary to, say, produce markets or new car dealerships—buyers must depend on the self-interested dealer. One prominent collector expressed the problem forcefully:

There's a market, just like a stock market. . . . And it is hard to get information about the market because I think that the dealers are generally deceitful, secretive people in this field who try to keep the knowledge of the true market to themselves. . . . In the case of outsider art, I think there's a gigantic disparity between what theoretically is an efficient market price and what the traffic will bear. . . . So the disparity is inherently mislead-

ing to buyers who are in the dark, but it's helpful to sellers. . . . Folk art buying and selling is arbitrage. These guys are going out there, buying these pieces for ten dollars in the South and pricing them at ten thousand in New York City. . . . I think it's unethical, but I probably also think it's good business, and I probably also think it's fully legal. . . . Buyer beware works well if you have an intelligent buyer who's well informed, and buyer beware works terrible and leads to unethical results, when you don't. . . . Dealers keep everybody in the dark with phenomenally high asking prices, and then the asking price fuels price proliferation, because everyone tells each other their asking prices. . . . I think the problem is pulling the wool over the eyes of the first-time buyer. That's what this is all about. This is saying that some fool who isn't hip to what's going on can be taken for $20,000 for the same piece you would have been willing to sell for twelve. (Interview)

This harsh assessment reflects what economists speak of as a "lemons market"—making the gallery into a used car lot; the misleading seller can easily manipulate the buyer about value, although, presumably, not about the satisfaction that one gains from looking at the work.[24] However, if that satisfaction is based on the way one believes that others assess the work then even this can be manipulated.[25] Often in such cases it is not only the customer who is persuaded, but the dealer as well. Sincerity consists of convincing oneself that one's self-interest coincides with the public interest.

The ideology that buyers should only care about aesthetics—their personal love for the work, removed from a context of communal value—lifts responsibility from the shoulders of the dealer. To the extent that dealers focus on selling at the highest price, they potentially downplay building a long-term relationship, as the relationship can be undercut with knowledge of comparative pricing. This is not to claim that sellers are unscrupulous, but only that trust in the seller becomes paramount. Sellers can focus on either short-run or long-term trust, and these may work at cross-purposes in maximizing profit. The dealer who wants to cultivate customers will avoid maximizing profit on each sale and will be more ready to provide background information for which others will vouch.

Rarity contributes to value, even if the uniqueness of an object doesn't invest it with quality.[26] The more of something, the lower the price, controlling for demand—a problem for multiples (e.g., prints or photographs) in the art world, and a problem for those artists, even excellent ones such as Purvis Young and Thornton Dial who draw rapidly. Fur-

ther, a large supply can decrease demand, making the object less of a status good. The market-savvy artist and dealer must control production and availability to maximize demand.

The ideology is, of course, that ultimately the market will decide, and that this decision will derive from the characteristics of the object. As a museum official shrugged about the Outsider Art Fair: "There are some prices I don't understand, but I guess the market will work that out" (Field notes). One dealer, more attuned to the market than many, noted: "I'm very geared to investment. I'm very geared to a side of the art world that you get your money's worth. That you buy something that you know is going to be worth, and should be worth, five years down the road, it should be worth more that you paid for it" (Interview). This dealer suggests that if others come to value (and desire) the work its price will rise. One attempts to predict the future taste of the community in the context of one's own preferences. Since display is part of collecting, the relevance of the judgment of one's community is clear.

If there are fewer newly available works that the community esteems, supply and demand turns to the secondary [resale] market. This historicizes the market, creating a canon of past works as the basis for value, establishing price predictability, a process that is only now developing in the world of self-taught art. However, if new works that are defined as equally collectible flood into the market, a secondary market is less likely to thrive. The lack of newly discovered self-taught artists may not be desirable for collectors, but it stabilizes the market.

The issue is not the normative one of whether a market is desirable in art worlds or the technical one of whether such a market will create stable prices, but that participants believe that a prediction of future demand is possible, permitting investment.[27] If confidence exists that works will hold value as a result of quality and scarcity, a resale market is possible and appraisals are meaningful. One prominent dealer, doubtful of this stability, explained:

I think [the field's] finished already, if the truth be told. I think it's very close to dead. . . . The dealers who established this field for the most part have neither the interest nor the ability to develop a secondary market, so the growth of the field is being ceded to the auction, which is very bad, because this material routinely brings 50 to 60 percent less at auction than it does in the galleries, which is very damaging to collector psychology. . . . [The absence of a resale market among dealers] makes people feel that they've been cheated and taken advantage of. It makes them not want to buy more of it. I mean it's a stupid and shortsighted thing. (Interview)

This dealer's point is that the market will remain unstable until collectors realize there is exchange value in the objects that they own—that these objects are liquid,[28] and that other collectors are willing to pay a premium by purchasing through a network of dealers who can maintain price stability. As the above dealer noted, it is rare for an object to be *resold* by a dealer. Until then the value of an object is in whatever pleasure it gives the owner. Ironically it may be the monetizing of artistic objects that permits artists to receive the prices that some feel they so richly deserve, transforming their trinkets into durable goods. Put another way, a market validates the aesthetic content of the work.

Pricing the Profound

On a museum tour, the docent explains that Augustin Lesege, a French coal miner, set the price of his work by adding the cost of the materials to his coal miner wages multiplied by the number of hours on which he worked on the piece. The group laughs. (Field notes)[29]

Sometimes in rejecting the market, we neglect that the success or failure of a gallery has consequences, affecting the lives of toddlers, teens, and spouses. This is not to mention the effects on creditors, consignors, the neighborhood, or the owner's self-esteem. As a result, a dealer must develop survival skills: recruiting customers, having an array of appealing objects, and pricing those objects suitably. While the first two elements are problematic, the third is still more challenging, particularly given the weakness of an established market. Consider two anecdotes about pricing by self-taught artists:

In the early 1950s a curator of the Abby Aldrich Rockefeller Museum was driving along one of the back roads of Virginia when his eye caught a sign meant to advertise the watermelon stand that Miles Carpenter ran. . . . "Be interested in selling it?" asked the university-trained curator, pointing. . . . "How about two-fifty?" Carpenter answered. The curator reached for his checkbook, wrote out a check for $250, and thus discovered one of the foremost folk sculptors of the 20th century. For his part, Miles Carpenter, to his dying day, never understood why the curator wrote him a check for $247.50 more than he asked for.[30]

★ ★ ★

[Drossos] Skyllas never enjoyed a lifestyle of gallery exhibitions, patronage, celebratory toasts at opening receptions, or critical acclaim. One factor that ensured his isolation was the artist's insistence on charging exorbitant prices—$25,000 for a portrait commission (plus $5,000 for a

landscape in the background) and between $250,000 and $300,000 for already completed works. It is not surprising, then, that there exists no evidence that he ever executed a commission or made a sale while he was alive.[31]

Bargain Prices

One of the benefits of the self-taught market is that, in contrast to contemporary art, it permits collectors who might not otherwise participate in purchasing original art to do so because of the relatively modest prices for high quality works. Important self-taught artworks are available in the four-digit range. Perhaps this field attracts more than its share of "bottom feeders" or "bargain hunters," but it also permits those who care about the work to participate in ways that in other domains would be impossible. As Roger Cardinal commented about the allure of this art in practice, if not in theory, "Some see this art as a cheap way of covering a wall with quite interesting pieces."[32] A museum director explained, "[This is] a market one can enter. You can buy a significant work by a fairly well-known folk artist for a lot less money than you can from a person who went to Yale graduate school for an MFA" (Interview). A major collection (e.g., the Hemphill collection, purchased by the Smithsonian's National Museum of American Art) may be worth less than a single work by an established contemporary painter, such as Jasper Johns. A journalist writing in *Smart Money* states this attitude dramatically: "So it's finally time to replace the living room's framed Ansel Adams poster with some real art. But let's face it: Most of us aren't going to get any closer to owning a Van Gogh than reading in the newspaper how much it sold for at auction. How can the average Joe get his hands on art-world-sanctioned art without dropping major bucks? Consider outsider art."[33] Hopefully from the dealer's perspective this will be an "entry level" for more serious collecting. Given that a dealer may conclude that the self-taught artist really doesn't need much income, that he or she is disinterested in the market—perhaps a bit of cash for cigarettes or liquor—these low prices can be justified, at least for the dealer and collector who are satisfied with a modestly priced market.[34] Higher prices may justify the art, but until a market exists for expensive works, prices must reflect the market that exists. Rarity has no particular value in the absence of a community of buyers.

Despite the desire for a deal, deals produce anxiety. We are told that you get what you pay for—in used cars, real estate, illicit drugs, and art. As a result, reducing prices too far can have unexpected results: a high price may gainsay quality. One collector was concerned about

a Bill Traylor drawing because it seemed priced too low (at $14,000, as opposed to $20,000). She asked a dealer friend to examine it (Field notes). He felt it was genuine, but her anxiety is understandable. On another occasion, after an auction in which a Sam Doyle work sold for $14,000, a customer asked a dealer, selling Doyles for $8,000, if they were genuine (Field notes). As a dealer notes: "This is a field where price seems to be equated with acceptance and quality. That's why Hawkins and Dial were priced the way they were. It was a businessman's call. If I underprice an artist I wish I could show you the suspicion I am greeted with."[35] A St. Louis dealer in contemporary art commented half-jokingly to an artist, "Let's put it at twelve hundred dollars. If it doesn't sell, we'll raise it to eighteen hundred dollars."[36] The psychological danger of underpricing is not confined to self-taught art.

Premium Prices

High prices convey respectability. It must be tempting for insecure collectors—all of us some days—to leave the price sticker on the work. The prices of Bill Traylor and Martin Ramirez works are, in some regard, a measure of respect for two artists who received little enough respect during their lifetimes. Perhaps it is the association of these artists with two galleries that handled major contemporary art (Hirschl & Adler for Traylor and Phyllis Kind for Ramirez) that provided the work with credibility. Although much of self-taught art is relatively inexpensive, prices are edging up for blue-chip artists. If Mose Tolliver sells in the hundreds, William Edmondson sells in the hundred thousands.

Yet, high prices carry their own risks. In some ways they spoil the party, creating invidious distinctions among collectors and an increased market orientation. Viewing the changes in the field, collector Bert Hemphill was concerned, as a friend noted: "The kind of collector and dealer rush and escalation of prices that has developed had for Bert, as he once said, taken the fun out of it."[37] Mistakes had become more costly.

Further, some artists are judged by the price placed on them. If the prices are judged too high, sales sink. When the artist, believing that she or he understands the market, insists on inappropriate prices, a gallery may be forced to terminate the relationship, not wishing to waste space or insult their clients with prices defined as excessive. What is excessive depends on the reputation and the production of particular artists. One dealer told me of an inexpensive artist, "Let's say they pay him fifty cents for something, and sell it for $30. I have no interest whatsoever. . . . It's just madness. . . . They're worthless to me" (Interview). Similarly a collector noted the high prices for one artist, telling me: "How do

they command those prices? He's not that significant an artist" (Field notes). The answer may be that, in fact, he doesn't command those prices: the price tags merely decorate paintings that will remain in the gallery for eternity. Once I overheard a dealer expressing relief to a long-time customer that he didn't find the price of a piece outrageous, noting, "You know sometimes when you say a price, people will just look and not say anything" (Field notes). Prices can poison the relations between dealer and collector without a word being spoken.

Surely the most challenging pricing decision concerns new artists—work for which no track record exists. Is a piece worth a hundred or a thousand? Too high a price might kill a career before it begins; too low might leave the artist on the bottom of the market forever. A trained artist told me (some years ago) that the general rule of thumb in contemporary art was to start at $300, which "was pretty much what relatively unknown artists got for small works" (Interview). A dealer commented, "If it's a nice innocent artist that has never shown anywhere before, I'd like to start out inexpensive, because if somebody's never seen the work before and they come in here . . . They come in and they see something totally new that they've never seen anywhere, and it's $500, they're not going to buy it, whether they're in love with it or not" (Interview). A New York dealer notes, "A brand new artist often does works on paper well under a thousand dollars, and contemporary artists are often smart enough to encourage that, and say, 'Look, I'm just beginning. Let's keep it inexpensive so people will buy it at that price' " (Interview). As musicians know, sometimes it takes several times before audiences discover that their works are worth hearing, and so concerts often emphasize the artist's most successful works, pieces that audiences know they like.

Artists must pay their dues, and low prices are part of those dues. While those who only wish blue-chip items in their collection will pass because of the low prices and uncertainty of the artist's future reputation, the more adventurous—and the more frugal—may provide for an early career that can then be developed before prices stabilize at a higher level.

The Buying Game

I've seen this guy's work in the show and I just loved it. . . . I ordered [a] boat, and I took him to dinner, and I took him to lunch the next day. And then I wrote him a letter to follow up my visit with something in writing, so that he wouldn't forget, and then I called him regularly. And for two years when I called him . . . and he would say, "Well, I just haven't found the stuff yet to start on your boat yet." And I finally said, "I've been calling

you for two years. I ordered this piece two years ago." . . . So, he finally started working on it, and he made the shell of the boat, and then that's all he had for several months. And finally, once he really [began] doing it, he put it together fairly quickly. But it took three years for him to make this piece. [GAF: Had you agreed in advance on the price?] We never talked about price. . . . He didn't want me to give him any money. (Interview)

Buying art, like having sex, is an intimate transaction—personal preferences and private acts. With the exception of auctions, the purchase of art occurs without witnesses.[38] Even if, as at shows or gallery openings, others are present, they engage in civil disattention, pretending not to notice the transaction. There is something secretive about these purchases, involving unique goods, variable and negotiated prices, and relationship talk.[39] The above example, extreme though it is, represents the "art of the deal." It involves negotiations (not necessarily over price), and recognizes that there is a process of buying, a process that may, in some instances, take time. The transaction reminds us of the importance of commitment, persistence, and the willingness to consider purchasing an object that one hasn't seen and for which the price is not firm. This example also involves economic relations with acquaintances. It reminds us that the art market depends on social, embedded relationships. The who of the parties is as significant as the what that is being exchanged.[40]

This privacy permits the establishment of discounted prices, although at times dealers, seeing customers examine a piece that hasn't sold, might spontaneously offer a significant discount, as happened to me as one dealer, seeing me examine a collage, offered $100 off the $450 price, leading me to be suspicious of the value of the work and wondering what might be the lowest acceptable price (Field notes). These can be delicate negotiations; any counteroffer would have been taken as a commitment to negotiate. Similarly, if my offer was too low (say $200, less than half of the original price), it could be taken as insulting, polluting a future relationship. It may be better to pass on a piece than make an offer that is unlikely to be accepted, given the embedded qualities of the relationship.

In a few cases (when buying from artists[41]), the purchaser may insist on a higher price, believing in light of the larger market, that some artists "underprice" their works. One collector asked an artist to make her an "Adam and Eve" for Christmas. "He only wanted to charge us $300 for that "Adam and Eve," and I said that's too cheap. I'm going to give you $350" (Interview). Whether $300 was too low or $350 too high is an open question. The point in this arrangement between collector and artist is that the higher price assuaged the conscience of the collector,

providing a sense of justice. This collector is not the only one with similar scruples. I frequently heard this about low-priced art objects, for which a somewhat higher price made the buyer feel better. Payment can, in other words, be an emotional salve. For dealers, this sense of ethics and emotional balance, may, at least in a small way, hurt the bottom line, as it might not be passed on in the dealer's selling price.

In contrast, sellers, perhaps uncertain about the buyer's interest, desperate for income, may reach below the buyer's target price. At one show, I visited a self-taught artist's booth. His works were priced at $1,200 at the Outsider Art Fair, and he offered me a piece in the same series for $450, a reasonable sum but more than I was prepared to pay. As I turned to leave, he offered it to me for $250. As I pulled out my checkbook, he said he'd take $200 cash (Field notes). I never made a counteroffer.

Some collectors and dealers see negotiation as part of the "game," whiles others reject it. For the former it is not only that it involves saving money, but it is also emotionally satisfying, as long as it doesn't rend the relationship. One collector noted, "I like to work on them. That's part of the fun," although his wife, not a negotiator, noted, "They see him coming, and I'm sure they raise the price, because they know" (Interview). For some, it is the nature of the relationship: a long-term relationship should not depend on intense negotiation. As one collector explained: "I want them to know that if they find something that's great, where they can choose the institution or the collector with whom to deal, I would rather be known as the collector that's not going to chisel them on the price. If I pay a little more, OK, but my horizon is thirty years" (Interview). The danger for this collector is that he can become known as an easy mark, suitable for presenting inflated prices.

Family Ties

Part of the negotiation occurs between couples, typically husband and wife. Some partners are adamant about collecting together, while others assign one as the "lead collector." At the extreme, a spouse may hate the entire field, thinking that the purchases are a waste of money and pollute the home environment. Unless these spouses can be made to see the investment benefits (as some do), or other points of contact exist in the marriage, the relationship will be unstable. One collector, now divorced, explained: "It was my passion. She absolutely hated the work, but grew to appreciate it as it grew in value. . . . I think she appreciated my eye, but the art was a problem" (Interview). If she admired his eye, it was not enough.

Frequently one spouse takes the lead, either because it is their passion or their money. Hopefully the enthusiast infects the other; collecting

is something that couples can do together. Within this shared activity, couples differ in whether they have the same eye, or different ones. The latter seems somewhat more common, as personal aesthetics differ:

> Wife: I could go off, and get into the more weird aspect of some of this stuff. . . . I like some of the mental institution kind of stuff. . . . If he really doesn't like a piece that I'm crazy about I won't buy it. (Interview)

<div align="center">★ ★ ★</div>

> Wife: I go for some things that are more in the contemporary [direction] or that would cost more. Or [my husband] would go more at what we consider sort of folk traditional memory painting. (Interview)

One wife will not let her husband, a prominent collector, bring southern face jugs (sometimes called ugly jugs) into the house.

In contrast some couples claim the same vision:

> Husband: It's just karma.
> Wife: We're just on the same wavelength.
> Husband: We've never had an argument about what to buy. We just always have had the same feelings about all of it, which is amazing. It's astounding but it's still true to this day.[42]

These lucky couples inspire the rest of us to fits of envy.

Shopping as Therapy

Although economic transactions are often seen as rational, they are laced with emotion. In this, buying art is hardly unique, although perhaps because the function of art is expressive, external justifications are more uncertain. One collector noted that, "a lot of the art I've bought through the years is more retail therapy as opposed to being important to the collection. . . . I think a lot of times that we go out and buy things more for the experience of buying them rather than the need or love for them. And it's just something to make us feel good for a few minutes" (Interview). The reality that one gets emotional jolts—highs—from purchasing encourages a large number of purchases, rather than a few major ones. A sign of a maturing collector is that he or she searches for a small number of quality objects, rather than a large amount of stuff. As one dealer put it, "If you collect baseball cards, you start out [by getting] one of every kind, and then you've got whole volumes of baseball cards, and then eventually, after enough time goes by, you want the '52 Mickey Mantle [his valuable rookie card]" (Interview). One collector who used to buy in volume told me that now she and her husband hope to buy, "two really nice pieces a year," although she knows she will not be able to resist

"the little finds" (Interview). Even more dramatic is when a collector is willing to sell or give away cheaper pieces, replacing them with those of higher quality.[43]

In a consumption society, the purchase is emotionally enriching, making us feel alive. Some collectors treasure the spontaneity in their purchases, buying art unseen, writing large checks on the spur of the moment, or making spur-of-the-moment decisions at auctions. One major collector told me that his theory is, "If I don't get it now, I'll never see it again. I'll never get the opportunity" (Interview). In one instance, "Howard Finster sold a piece of art work to a New Jersey patron for $20,000, 'sight unseen.' The story goes that Stephanie Tardell called Finster to ask if he had any art work for sale. Finster described the piece and quoted a price. Without further ado, the piece was sold, and a check for $20,000 was in the mail the next morning."[44] Whether the purchase was wise, it certainly must have been exciting for Ms. Tardell, not to mention Reverend Finster. One collector noted that, "We usually discuss [making a purchase] in depth, and sometimes we don't buy fast enough. Like we've let some good things get away because we talk, we tend to go into this angst thing over, 'Well, should we really buy this?' . . . I would like to be in a position where I could really go with my gut feeling, just as a visceral kind of thing, because if something just really captures my soul, just really speaks to me, I would like to be able to just walk out immediately from the gallery [with the piece]. . . . To be able to just be more spontaneous about what I buy" (Interview).

Other collectors with a different emotional calculus consider objects in quiet contemplation: will the work still speak to them tomorrow? Some major collectors insist on bringing work home with them to see if they can "live with it." One says that perhaps 20 percent of the time, he returns the piece, because "it doesn't look right or there's something about it that bothers me" (Interview). Another puts holds on pieces, tentatively committing herself, claiming "I can't make a decision so fast. . . . I don't take very long to decide [e.g., a few days], but I need a little longer than three seconds." Still another notes that, "A piece, it kind of seduces you. Sometimes I think about it for years." Only with inexpensive or insignificant pieces will he buy "without thinking." He notes ruefully that this strategy means that he loses some pieces, "I still think about that [one]. It was so inexpensive and so wonderful. I just didn't buy it. It was like a lost child. If I ever saw it again, I'd recognize it. I'd still want it. But maybe my taste will have changed. We've grown apart" (Field notes). These collectors are as emotional as their more spontaneous colleagues, thinking of art as lost children, but their emotional preferences differ.

Purchases—and not only art purchases—remind us that although we think of commodities as having fixed value, and purchases being determined by an economic calculus or rational decision making, the social, aesthetic and emotional features of the deal compete for dominance.

Selling the Farm

Markets consist of buyers and sellers. For buyers, the process is emotional and relational, sellers with their desire for cash are less likely to be so romantic. However, even here the artist or dealer must dispose of objects that they treasure.

Marketing involves impression management. Cheaper work generally sells before those objects that are more dear, even if in the words of one artist who likes to work big, the emphasis on the smaller works makes him feel "trinketized" (Interview). The question is how to make the paintings move, while still "respecting" them, combining hype and hope.

Many dealers invite clients into their storerooms, in part because that is where much of their stock is kept on wooden racks, but also because such a visit symbolizes trust by admitting them into the backstage—the inner sanctum—of the business, where, like the Wizard of Oz, truth is to be revealed. What is on the walls becomes, in this sense, a "loss leader," enticing potential clients into the space. A dealer may play directly on the status insecurity of the collector[45] by insisting that a client "needs" an important work that they have in stock, by asserting that they would particularly like this collector to own this work, by hinting that others are examining the same piece, or by suggesting that in purchasing an important piece the client is ready to move up in the hierarchy of collectors (One asked: "Are you ready for a Traylor yet?" [Field notes]). Dealers historicize the art, talking of the importance of classic works. Equally significantly, dealers of work that is newly produced (including dealers of contemporary art) are engaged in "selling the future . . . telling people what will be important tomorrow" (Interview), shaping the field by what they choose to push. They are creating value through their claims of excellence and scarcity. These dealers in their marketing are attempting to situate their clients within art history.

Self-taught artists have different considerations from their dealers in dealing with customers. They cannot rely on claims of the past or future, and cannot play too directly on the status needs of visitors. These visitors are full of themselves just by making the trek. Instead, they

sell—unintentionally or not—the authenticity of their existence, even
while some artists have a finely attuned sense of the market. A possibly
apocryphal story is told about Alabama artist Mose Tolliver:

> An eager student of folk art . . . not long ago visited a well-known black
> folk artist. The student asked the aged painter how he decided on a sub-
> ject. The artist thought a minute and replied, "Animals is fast and flowers
> is slow." The enraptured student, sure he was on to some brilliant meta-
> physical insight from this simple old man, asked the artist to explain. "You
> know," said the painter. "Animals sell fast and flowers sell slow."[46]

As with so much in this field authenticity affects marketing. Lee Godie,
the outsider artist, living on the streets of Chicago, was particularly adept
at appealing to her clients. While one should not romanticize her dif-
ficult life, she was not without marketing savvy, choosing her locations
and clients carefully: "[In 1968] she was noticed selling her paintings
on the steps of the Art Institute of Chicago, flashing open her ragged
coat stuffed with rolled-up paintings and announcing in a toothless but
engaging way, 'Would you like to buy some canvases? I'm much better
than Cézanne.' "[47]

Less effective, but equally authentic, was Pennsylvania outsider artist
Justin McCarthy's manner of selling his work: "[At outdoor art shows]
he would hang paintings on fences by pounding nails through them, or
he would lay them out on lawns. His prices were unexpectedly high, and
sales were seldom consummated."[48]

The dilemmas of marketing are evident in the "selling of Howard Fin-
ster."[49] Throughout his career, but certainly by the early 1980s, when
he appeared on the Johnny Carson show and produced record album
covers for R.E.M. and the Talking Heads, Finster was aware of the value
of publicity and the importance of the market for disseminating his re-
ligious message. By the mid-1990s as Finster's health deteriorated and
as his environment, Paradise Garden, was sold off, his daughter Beverly
began a marketing campaign, in part through a 1–800 number, a topic of
sarcasm from collectors, even though other dealers have 1–800 numbers
and Web sites. Along with the number was increased emphasis on tourist
art aimed at marginal participants in this art world. This marketing has
been intensely resented by collectors, only in part because the quality
of the work is seen to decline. When Finster sold himself, it was cute,
but the family's efforts seemed inauthentic, and upsetting for those with
an image of Finster threatened by the efforts at "Kmart"-style market-
ing. Whereas Lee Godie's marketing successfully enacted the role of the
authentic self-taught artist,[50] that of the Finsters undercut it.

Buying Spaces

In chapters 4 and 5, I discussed two of the central locations at which objects can change hands: the artist's home and the gallery. Art is also bought and sold at shows and at auctions. Both of these locations create a market as a "public space." Attending shows or auctions is social, and establishes one as a citizen of the public community of buyers.[51]

Place and Show

The institution of the art show or art fair is well established, ranging from national gatherings with the booths of top dealers of art or antiques to local outdoor craft shows and flea markets. Shows may focus on particular artistic genres—photography, ceramics, prints, or contemporary art. Until 1993 no show specialized in folk, outsider, or self-taught art. Noticing the press attention that folk and outsider art had received, Sanford Smith and his associates, art and antique show promoters, decided to organize a show—the Outsider Art Fair—in the Puck Building in SoHo in late January. His attempt was to bring self-taught art to the pulsing heart of Contemporary Art. The location was not accidental, close to numerous leading galleries. Thirty-three elite galleries of self-taught art agreed to participate, a number that has remained relatively constant, and the emphasis was on rare, relatively high-priced works— no country crafts, no multiples—the best from this art world. Booths cost somewhere around $4,000. Over the years, the Outsider Art Fair has come to focus less on "southern folk art" and more on "European outsider art." The location of booths is a spatial indicator of a gallery's status. In the first room are the New York galleries, Phyllis Kind (booth one), Ricco/Maresca, and Luise Ross. The second room has other major galleries, with the third, largest room (called "Siberia"), reserved for the galleries that have less stature.[52] In conjunction with the American Folk Art Museum, a symposium was organized, and for several years a benefit dinner was held as a fund-raiser.[53] Over time the number of attendees increased from 4,500 to perhaps 7,000 (and the fair expanded from two to three days).

The following year a young promoter from Atlanta, Steve Slotin, organized an event in Atlanta that he labeled Folk Fest. Folk Fest, held each August, has a different tone and purpose from the New York event. Slotin's Folk Fest is a glorious free-for-all. While there are some limits even here ("inappropriate" dealers are not invited back), the seventy or so dealers tend to have lower-priced objects from a wider range of artists, including objects that are similar to crafts. The show is more likely to

have artists in attendance. Booths at Folk Fest cost about $800. As noted previously, there is little overlap between the dealers at the two shows, and in 1998 only five dealers participated in both. Slotin's event, held in a suburban trade center, draws some 9,000 visitors in its two days. Perhaps significantly both shows were organized for slow times in the art market, late January and late summer.

Given the success of these two shows, others followed. A well-established Alabama arts and crafts show, Kentuck, has come to focus more on self-taught art. In 1997, Chicago's Intuit: The Center for Intuitive and Outsider Art, held Collect-O-Rama, originally allowing members to sell their excess collections to their friends, but by 1999 operating more like a smaller version of Folk Fest. Finster Fest, is held in May in Summerville, Georgia, by the Finster family with many artists from the region. Outsiders Outside is organized in Harbert, Michigan, a vacation retreat for residents of Chicago and Detroit, and artist Minnie Adkins organized "A Day in the Country" at her home is Isonville, Kentucky, for local artists and dealers.

A show permits collectors to view art rapidly, comparing works and prices, a reality that some, reflecting on the cognitive overload, describe as overwhelming, unable to "see" the work because of the crowds and clutter. The survey nature of the shows provides a sense of what objects sell for on the open market and permits dealers to exhibit "new finds." It represents a combination of "availability and marketing" (Interview). The show is a subcultural event, "a grand shmoozing affair" (Field notes), a public space. However, because of the crowds, there are not the same opportunities to develop relationships with dealers, or to purchase objects in private without hordes of onlookers. The emphasis is on sales, leading one collector to describe it as a "frenzied, junk bond like orgy."[54] Impulse buying is common and expected. One prominent dealer joked at a symposium, "I'm going to bring in [to the Outsider Art Fair] a lot of dross [audience laughs], because everyone loves it [audience laughs]. There's too much good stuff. There's caveat emptor" (Field notes).

While there are differences among these shows, they have a similar feel. In 2000 two elite dealers—Fleisher/Ollman and Cavin-Morris—decided controversially not to participate in the Outsider Art Fair, "for moral, aesthetic, and other theoretical reasons," arguing that the fair was "undignified," "exploitative," and "runs counter to the respectful way we regard this art." Publicity focused on the "abnormality and weirdness" of the artists (i.e., their biographies), validating the stories, rather than

the quality of the art. The presence of artists at booths was similarly derided.[55] This decision led one collector to note comically:

> Outsider is dead, and self-taught is deflating, as we speak. . . . We are like old drunks finally realizing that we have a problem. And just IMAGINE, among the first benefits we reap: No more squeezing through the crowds worried that someone is going to rip your James Castle out of your hands, like happened to that person standing next to you. . . . No more still-wet drip paintings being hawked by someone with an attitude, telling you a story about the artist that suspiciously combines the life stories of Traylor, Darger, Ramirez, and Tolson, all into one seamless shameless schmooze. No more feeling debased—then getting back to your hotel room, and for a fleeting moment wondering what the hell have you gotten yourself into.[56]

These shows can be thrilling. As parties stuffed with art objects, they are likely to continue to flourish, but as the Outsider Art Fair makes clear, they have ideological aspects. They present objects without a clear aesthetic justification, attempting to get as many people under the tent as possible, and in doing so the sorting process in which particular types of collectors visit particular types of dealers is broken with inappropriate clients and dealers interfering with the smooth functioning of a status-linked market.

On the Block

Auctions are a form of market-making. The results link prices and objects. Yet, as sociologist Charles Smith[57] notes in his fine observation, numerous types of auctions exist. While auctions have common elements, they differ depending on the nature of the audience, the price structure, and whether the auction is "live" or "silent." (Increasingly there are auctions on the Internet, many, like eBay, are "silent," with a set closing time, and technologies are being developed for live Internet auctions.) Smith argues that auctions are likely to flourish when conventional ways of establishing price have proven inadequate, especially when dealing with unique items.[58]

As I noted, the world of self-taught art has not established an active secondary market, given the lack of resale of major pieces. With the exception of a few, older blue-chip artists (William Edmondson, Bill Traylor, Horace Pippin), most pieces are sold once, and then enter collections where they remain.

Over recent years there have been an increasing number of auctions

of self-taught art. The first and most significant is the annual Sotheby's Auction of Folk Art in mid-January, held since 1990. The Outsider Art Fair is scheduled the week after the Sotheby's Auction when some major collectors are still in town. Since the mid-1990s less prestigious auctions have been established, notably Slotin Folk Art Auctions in Atlanta and Kimball Sterling Auctions in Johnson City, Tennessee. These auctions routinely generate over $300,000 in sales. The houses are in competition with one another, and look not only for the best objects, but also for the best collections, as when prominent collectors sell some or all of their objects. The presence of an object in a particular collection may add to its value through its provenance.

An auction is, in some measure, a pure market in that a community of potential buyers collectively sets the price for an object, determining what is the most that a member of the audience is willing to spend. As a result, collectors and dealers examine auction prices to determine the market value of objects. The strength of the prices of works of Bill Traylor (with one selling at auction for $170,000) and the weakness in the prices of Thornton Dial have affected their gallery prices. Dealers are often in the audience, looking for works that they can purchase for half of what they feel that they can resell them. At Folk Fest, I witnessed auctioned works for sale the following day, priced at twice the final bid.

Given the importance of auction results, a tendency exists to manipulate them. Anxiety is evident when a major work goes to auction: a low hammer price can depress the market in works by that artist, as a high one can increase it. One seller, who had put a Martin Ramirez work up at Sotheby's, had paid $60,000 for it, and placed an estimate of $30,000 to $40,000 on it (a museum donation would have resulted in a $60,000 tax deduction at a 35 percent marginal tax rate). The seller notes: "A couple of dealers were very nervous about the sale. They were afraid that [it] would not make the minimum. They're selling at five times the amount." In fact, that Ramirez work did not meet its estimate, perhaps softening that market, while earlier another Ramirez piece had sold for $180,000. If the piece sells low, dealers' inventories and appraisals are diminished, and the purchase of a Ramirez at auction might remove one potential buyer from the market.

Two strategies offset the problem of low bids. First, reserves can be placed on objects, so that if there is insufficient bidding, the object will not be sold. These figures are secret, but generally somewhat more than half of the lower estimate. However, knowledge that a reserve is not met becomes seen as symptomatic of the lack of interest. More ethically questionable is the strategy of supporting a price. Either the seller or

a dealer with a considerable body of the work may have someone bid up the price to insure that it does not appear that there is a lack of interest or to indicate that interest in the work is hot.[59] Once when a William Hawkins painting sold below its estimate, a collector claimed to be shocked that the major dealer of Hawkins's work did not support the price. The dealer explained that he never bids on his artists at auction, but it is symptomatic that collectors felt that dealers would "protect" their investments. Another collector used this unwillingness to "back what they sell" as an indicator of the weakness of dealers in the field (Interview). Of course, in these situations, the dealer who hopes to support the prices of his or her artists will have to pay the "buyer's premium" to the auction house (usually 10 to 15 percent above the bid price), but paying this percentage to a middleman may be preferable to seeing a body of work suddenly lose value.

The claim that a live auction represents a pure market is an illusion. Given that these are unique, nonfungible objects, much depends on who happens to be present and what their interests are. Auctions are where both the highest and lowest prices are to be found: record prices and incredible bargains.[60] Take the hypothetical case of a Bill Traylor drawing of an owl. If no major Traylor collector is present and the auction is not considered major, the piece may be sold at a discount to a group of relatively modest collectors, who could not afford the high estimate. Should the work be sold at a higher end auction, it might surpass its estimate. Let us assume that there are two wealthy collectors who specialize in images of owls. Both may feel that they *must have* that piece and participate in a bidding war, much to the pleasure of the seller and auction house.[61] That price may be far in excess of what the piece would have sold for if one had the flu or if it depicted a crow. The possibility of some works being sold for substantially below their estimates (and below dealer prices) leads some collectors to purchase objects at auction, even if those objects would not be those that would have been selected from a dealer with a wider range of choices. Given a budget, some feel that it is better have an adequate work for half the price of a work that one might ideally prefer.

The diversity of the self-taught market is evident in the fact that at auction pieces can sell from six figures to one figure! Auctions permit house cleaning, with occasionally satisfactory results, even if a commission (10 to 20 percent) must be paid to the auction house. One major collector noted that, "We made $30,000 by cleaning out the attic" (Field notes). They were not leaving the field, just selling secondary work in storage.

Another feature that differentiates auctions from pure markets is the presence of *estimates*. These are claims in the auction catalog that the auctioneer or consigner expects that the object will sell within a range. In the Outsider Art Auction from the Gitter-Yelen Collection (auctioned by Kimball M. Sterling on 29 July 2000) an R. A. Miller flag is given an estimate of $50–$100, while a Sam Doyle "Jack O Lanton" is $7,000–$10,000. These numbers are, of course, guesses. On the one hand, high estimates might convince buyers that the objects have considerable value and that the auction is of high quality; if objects do not reach that level, bidders may believe that they have gotten a deal. On the other hand, high estimates might frighten buyers, and when many objects do not reach their estimates, observers conclude that the auction was a disappointment and that the field is in trouble. Some bidders, not otherwise familiar with the objects, use the estimates to determine their high bids. In some cases it is possible to purchase a work at a price above the high estimate and still pay half of what one might pay to a dealer.

AT THE AUCTION. The first contact between seller and bidder is the catalog, which may be provided gratis or may be sold. Catalogs are printed books or "magazines," typically in color. While auctions differ in size, the Slotin and Sterling auctions will typically have anywhere from three hundred to seven hundred objects for sale. The catalog is formulaic. For each object, there is a lot number, a picture (sometimes two), the name of the artist (and whether the work is signed), the title (if any), the medium (paint, mud, panel; coat hangers, wire; porcelain washing machine top), the size, the date, and the estimate. There may also be additional information, such as any museum show in which the work was included or its provenance.

In a truly free market, an assumption of full information exists; yet, in auctions, information is mediated through what is defined as relevant. These standards of relevance vary from field to field. In self-taught art auctions, previous owners, circumstance of purchase, previous price, the brand of materials, the underside or backside of the work, and the condition of the work (observable nicks and marks) are often not included, although, of course, some information is available by examining the objects during the "preview." Some fields, such as book auctions, have developed catalog conventions, particularly with regard to condition. Photographs, seemingly objective, may be imprecise. A picture may be worth a thousand words, but sometimes those words are muffled. One auction house printed pictures in which the colors were "off," making judgments difficult. In small pictures, the details of the work may not be

evident, and it is easy to be surprised at an object that one has purchased by a mail, phone, or Internet. Although the size of the object is stated, the picture may imply a size that the actual dimensions do not bear out. While auction houses stand behind the information they present, one notes:

> Kimball M. Sterling has endeavored to catalogue and describe the property correctly. All property is sold as is and neither the auction company nor the consignor will be responsible for descriptions, genuineness, provenance or condition of the property. No statement in the catalogue, made orally, or otherwise shall be deemed to be a warranty, representation, or an assumption of liability. [62]

In other words, legally, nothing in the catalog (or in the auction) matters. Caveat emptor. In practice auction houses provide satisfactory descriptions, as they would have to for repeat business, and may make adjustments if there are problems.

While bids can be made through mail, fax, phone, e-mail, and Internet, the heart of a live auction is its emotional immediacy. A group of people meets in a room, and each person is given numbered paddles or cards to wave, although some people speak their bids or use gestures. Their co-presence generates excitement, transforming auctions from a rational pricing contest. Auctions involve embedded transactions, as people make decisions on their trust in the seller and auction house, and on the responses of the audience. If others are bidding, a collector may judge the quality of the object based on the reputation of other bidders. Sometimes people do not bid against friends or bid hard against rivals. At a charity auction, a self-taught sculpture was sold for significantly above what was expected, because the winning bidder disliked the rival bidder, and wanted to make sure that he would not win (Field notes).

This atmosphere is encouraged by the provision of food and, especially, drink. A nice "spread" builds emotion and decreases inhibitions. The period before the auction is characterized by gossip and evaluations, increasing community. Conversations demonstrate that people compare their collections to others, building competition. It is a mark of personal failure if one leaves empty-handed.

Central to the event is the auctioneer, who may or may not know much about the objects he or she is selling—mispronouncing names that every participant in the community would know. His or her job is to cajole bids, using auctioneer slang ("Let's do business here. . . . If you help me, I will help you. . . . Are you a player? . . . You can make money

off this."). While these art auctions are not characterized by chants, common at agricultural auctions, there is a rhythmic and formulaic quality to the patter of good sellers.[63] In addition to the auctioneer, spotters insure bids are seen. Also, phone answerers, computer technicians, runners, a bookkeeper, cashiers, security, and caterers must be hired. Effective auctioneers are able to joke with the audience, kidding them along, making people feel happy and competitive, and moving the auction. If the auction has four hundred objects and if one sells ten each hour (six minutes per object), the auction would last forty hours, a workweek. Most auctions attempt to sell sixty objects per hour—a mad and confusing dash that often requires two auctioneers spelling each other every hour. Typically the objects with the highest estimates are placed about thirty minutes to two hours into the auction to insure that everyone has arrived, that they are still fresh, and that people haven't left (at the 2000 Gitter-Yelen Auction, the object with the highest average estimate was #63 at $11,000. Only one of the first forty and none in the last seventy-five objects had an estimate of over $1,000, even though several dozen pieces were in that range. An auction is exhausting for auctioneer and audience, even though it is punctuated with excitement. Toward the end, people drift off, paying for their objects including a buyer's premium of 10 to 15 percent (and sales tax), which makes the final price 15 to 25 percent more than the bid.

Given that this is an economic market in which a missed bid can mean the loss of an object or a higher price, auctioneers must note each bid and judge the priority of bids. Deciding when to end the bidding can also provoke discontent as some bids are seen too late, and others, too late, are accepted. As this means that some bidders may lose works they "won," losers must be pacified. Further, some bids (those under the reserve and bids from the consigner) can be illusory, leading to claims of "shenanigans" or worse (Field notes).

While auctioneers often attempt to start the bidding at or near the estimate, they rapidly decrease the opening invitation to bid until they find a response. In practice bidding typically begins at about half the lower estimate, and either remains there or increases, sometimes rapidly, often with a frenzy of paddles. As one auctioneer jokes, "It's not where we start, it's where we stop I'm interested in" (Field notes). Relatively few objects are sold above the higher estimate (at one small auction only one of forty pieces), and many, sometimes as many as half, don't reach the lower estimates. Bidding is not random but follows a predictable numerical pattern—ten dollar increases, hundred dollar increases, thousand dollar increases; breaking this pattern is difficult, although as the

bidding gets higher the auctioneer has some power to switch the numerical sequence. [64]

Each piece generates its own "story," some interesting, filled with competition and emotion; others routine. At some point bidding quiets, and it is the auctioneer's job to promote bidding wars between two or three buyers who must decide on the spot whether the new price is worth contesting. [65] To respond too quickly one may overpay for a piece one doesn't really want, too slowly and the piece will be lost to another. The auctioneer must, through friendly teasing, increase the emotional pressure, while being conscious of temporal demands, deciding on the likelihood of squeezing another $100 from the bidders. Then, ritualistically, the auctioneer says, "Going once, going twice, sold for . . ." or "last call" and the bidding is forgotten as attention turns to the next item. The auction is a book of four hundred stories with a few memorable because of the prices, rivalry, humor, or passion. These stories are narrated and discussed after the event, discourse that is part of the *referential afterlife* of the community. [66] An auction is a dramatic performance, filled with intense emotions, expressive gestures, comic events, and plots. [67] Perhaps because these are luxury goods and the audience is a dense network, the atmosphere is convivial, and ill will is rarely publicly expressed.

EMOTION WORK. Potential buyers face a challenge. Decisions must be made rapidly, but the pressure tends to make them thoughtless. Yet, some bidders make decisions and "cannot be moved." As one said, "At a Christmas party one guy was sizing me up, and I knew who he was. He was an auctioneer. . . . He said, 'I've been doing this for years, and you're the only man I cannot move at an auction.' And I said, 'Well, that's because I just have an idea of what something is worth, and I'm willing to go into that zone, and when it leaves the zone I leave.' I said, 'It's real easy. I don't get worked up over it' " (Interview). Many claim to share this emotion-free ideology, but few can maintain it, a problem among card players or budget negotiators as well. As one husband commented, "We put a price for everything, but the way it ends is it doesn't end that way." Explained the wife, "[My husband] gets very, very excited at auction" (Interview). Said another collector: "For every success, I think, I've been burned. . . . Another piece I got at that auction is just horrible. I brought it home and it is horrible. And my husband said, 'Put that thing in the basement.' And he's right. And I wasted a hundred dollars on it. I got carried away" (Interview). Especially when surrounded by friends, having consumed a few drinks, one can "get carried away," demonstrating that one will not back down and will have something to show for the day. Emotions are contagious, and auctioneers structure

the event to play on this emotion in which others are looking over one's shoulder, judging one's mettle.

The Silence of the Lambs

While major auctions are live, silent auctions, often used for charity, as at the Folk Art Society of America (FASA), carry fewer emotional burdens. Artists, dealers, and collectors donate work to be sold to the highest bidder, with bids written on sheets of paper. At FASA auctions, the organization has made as much as $35,000, excluding their minimal expenses.

Competition at silent auctions can sometimes be more evident than at live auctions, as the control system is less enforced. At these auctions bidding on objects will close at a set time. Sometimes there is only a single bidder, and I have watched that bidder change the price of the sole bid downward, getting the best possible deal at this charitable event. In contrast, there is frequently too much competition: two bidders may strive for the same object. How are they to determine who gets it? Given uncertainty about the closing moment, bidding can become musical chairs. If these are acquaintances, one may bow to the other or bidders may pretend that it doesn't really matter, as it is all for charity—a delicate problem of impression management in the face of intense desire. On one occasion, a bidder told another that she would bid as high as necessary to win the piece, leading the other bidder to drop out and the winner to purchase it for less than she might have had she not tried this bluff (Field notes). Sometimes the competition is palpable, and cannot be redirected. Once, a friend asked me to stand by the bidding sheet of an object she wanted and for which she had the highest bid. With ten seconds remaining, she bent over the paper, pretending to write a new bid, until the bidding closed (Field notes). This, too, can involve emotional investment, if not frenzy. I watched as one bidder competed against another, finally winning the piece, only to discover that neither she nor her husband really cared for it. She asked the other bidder if that person wanted to buy it for the (now inflated) price. Fortunately the other bidder did (Field notes).

In some cases, silent auctions are so contentious that the organization transforms them into live auctions "since it is for a good cause." On one occasion, the organizer joked, "Jack is going to have a special bid-off to avoid blood" (Field notes). Desires for community and self-interest compete when supporting the organization and not antagonizing friends conflict with the desire to get a most wanted piece at the lowest price. It is the ostensibly good-natured aspects of the auction among friends,

coupled with an absence of formal social control, that permits silent auctions to become emotionally boisterous.

Creating Markets

The awkwardness of discussing aesthetic worlds as economic worlds is palpable. It flies in the face of an antimarket mentality. However, we reside in a society in which markets are primary and in which objects are commodified. Indeed, it is difficult to imagine what an art world might look like if it weren't commodified. In this all art markets are similar. Self-taught art, while not gaining value from the institutional credentials of its creators, needs to gain value somehow. Authenticity becomes a credential: one that is ascribed by others, rather than achieved by the artist. By collectively determining authenticity, relatively stable expectations for pricing are developed through the collaboration of collectors, dealers, and artists. Perhaps the market in self-taught art could be structured to avoid some of the ethical complaints described in chapter 5, but if audiences lacked some consensus on art's material value and rarity, creating a distribution system would be chaotic. We might wish art only to have aesthetic value, but such a hope would not produce organized buying and selling.

An efficient market is one that brings buyers and sellers together with as small a transaction cost as possible. Expectations are built into price structures. For this a set of market-makers, such as dealers and auctioneers, is needed. In such circumstances it is easy to do business, information is readily available, trust is established, and prices reflect the wider market, not the particularities of the circumstance in which goods are exchanged. Put this way, it is clear that art markets are not maximally efficient. As is generally true of sales, location matters, prices are variable and negotiated, and the connections between buyers and sellers shape behaviors.

Pure economic rationality is, of course, not all that there is. Embedded economic relations—those in which the social relationship between buyers and sellers affect the transaction—produce trust and other forms of efficiency. The dealer vouches for the art and the collector vouches for its proper care. If the prices are not identical to what they would be in the absence of these embedded relationships, they are satisfactory to both buyers and sellers, who often engage in repeated transactions with preferential treatment emerging from the repetition. Indeed, one of the paradoxes in the debates about how dealers should treat artists is that the artist may be perfectly content with being "cheated," even in some

instances in which she *knows* that she is receiving less than what she might otherwise get in a fully free market. The transaction is defined as fair, even when profit has not been maximized.

Buying and selling occur in different spaces—at quiet galleries, congested art fairs, and noisy auctions. Each venue has its own peculiarities, having to do with the presence of alternate buyers and/or sellers. Central to this argument is that not only is the relationship important in an economic transaction, but so also is the location and conditions under which the transaction occurs. While economic theory explains a lot about efficient markets, to understand how people think about their transactions demands social and cultural analysis.

7

creating

institutions

There, on the museum's pristine white walls,
were the frenetically lined drawings of the
Mexican-American schizophrenic Martin
Ramirez, who in a California asylum drew
undulating cityscapes on scraps of paper
cobbled into scrolls with saliva and potato
starch. . . . Can works produced in the service
of exceptionally bizarre personal vision and
private obsessions be seen properly in art
museums, or is our appreciation of
them impoverished when they are
cleaned up and brought inside?
—JOURNALIST JENNIFER SCHUESSLER

Art worlds rely on the institutions that
surround them, connecting them to
the larger society. In this, they are no
different from other social worlds. In-
stitutions, like individuals, negotiate
to smooth their dealings. As such, the
relationships among institutions and
organizations have an embedded, so-
cial quality.

Galleries are, of course, a part of
this linkage, small as they are in orga-
nizational terms. So, in a way, are art
schools; even if they are not attended
by self-taught artists, they often are by

239

academics, critics, dealers, and collectors who are trained artists them-
selves. Art schools, particularly over the last thirty years, have pro-
duced art-invested citizens.[1] Even if most do not remain professional
fine artists, they provide an infrastructure, support network, and lobby-
ing base for the arts.

Even elementary schools and television, both influential cultural in-
stitutions, shape self-taught artists and their patrons by providing every
American with a visual language: a system of representation. Cartoons,
movies, and elementary school arts education provide training in aes-
thetics, even if not explicit. Most children in the post–World War II
era have been exposed to the arts, even if they have not been taught
technique.

However, the State and the Museum are the central institutions link-
ing the art world to core social domains and influencing artistic produc-
tion and display. The state provides incentives and disincentives for the
doing and selling of art. Museums, as repositories of culture, affect, not
just art history, but all corners of the art market.

The State and the People

We are told that we have a government that is of the people, by the
people, and for the people. While interest groups influence state pol-
icy, the attitudes of the governed shape the perspectives of government
workers. "The people" is of course a fragile and constructed concept.
Art dealers and curators are part of the people, as are many individuals
who are blissfully unaware of or unconcerned with self-taught art. This
latter group is a majority of the citizenry. The public as considered here
is that body of the population who has an opinion about this art, even if
casually formulated and weakly held.

The Public Weal

Many who are aware of self-taught art have positive attitudes with
responses ranging from polite to enthusiastic. Much self-taught art
is colorful, apolitical, and viewer-friendly,[2] suitable for sponsorship
and purchase from major corporations—Philip Morris and Brown and
Williamson, Coca-Cola and Pepsi-Cola, and the Ford Motor Company
and Ralph Lauren. Viewers at self-taught exhibitions can be inspired,
although some, a minority, are disgusted or cynically amused. William
Arnett notes of the "comments" book at the *Souls Grown Deep* exhibit of
African American vernacular art during the Atlanta Olympics: "These

comments read more like the visitors' log at a pilgrimage site than comments at an art exhibition, people by the hundreds writing that they never knew art could be so meaningful, that they never imagined their region or culture could produce such beauty."[3] While there certainly is a sampling bias in who visited and chose to comment, these comments reflect those at other exhibitions.[4]

Of course, not all reactions are so positive. Artists who create folk art environments may find their property vandalized. This reality is made more salient by the fact that many artists live in impoverished areas where the creation of art is not seen as legitimate. When coupled with strange behaviors, the creation of art environments may even lead to talk of commitment, as happened with Jesse Howard and the Reverend Howard Finster until their works were sanctioned by art world interest.[5] Before then, the compulsion to create odd and unusual objects seemed obsessional and a rejection of communal norms. This activity can easily be read as "residual deviance," a category of inexplicable behavior that is often labeled as mentally ill.[6] The artist's genius is read by those who do not recognize the legitimacy of the activity as psychological and social incompetence.

Some communities go beyond words: Eddie Owens Martin (St. EOM) found his magnificent environment "Pasaquan" in rural Buena Vista, Georgia, vandalized by neighborhood teens, although his exoticism (he was a homosexual fortuneteller) may have contributed to this unwanted attention. Teens threw stones at the Milwaukee art environment of Mary Nohl, who they dubbed "The Witch of Fox Point," gossiping that she had killed her family, that her sculptures were tombstones, or that she would turn intruders into stone.[7] Neighbors of Atlanta artist Nellie Mae Rowe whose rundown house with its junk-filled yard was located in a rapidly suburbanizing upper-crust neighborhood believed she was a "hoodoo woman." Her home and yard were vandalized until she became a local fixture and gave tours of her home to neighbors swayed by the art world's legitimation.[8] North Carolina wind sculpture maker Vollis Simpson was once arrested and placed on probation for firing birdshot into a vehicle full of teenagers who had vandalized his property.[9]

This subversion may even originate within one's own home, as a spouse or child may be no more sympathetic than neighboring teenagers. Thornton Dial's wife said that at first she was ashamed of her husband's art, which she referred to as "the mess." Today, after art-world attention, she comments, "I wish I had a lot of that stuff he threw out—I know now it was beautiful."[10] Other spouses discourage the artist from "wast-

ing their time" or hide their art materials (Field notes). This reached its apex with artist Irene Hall, whose grandson reports:

> It's incredible that my grandmother was able to even do her artwork, because [her husband] *hated it,* he threw it out. . . . I can remember him always thinking that my grandmother's art was, you know, lunacy. . . . It was merely junk and trash. . . . In fact, he . . . felt so strongly about it that . . . he never lived in that home. . . . He was humiliated by it. And, and he did everything he could, applied every bit of psychological pressure and, and verbal abuse and everything he could to get my grandmother to stop that.[11]

She was one strong woman, willing to suffer for her art: a dramatic case of what other artists feel, even some who are not self-taught. These deviant doings require legitimation.

Secondary Deviance: The Collector's Plight

Collectors, though perhaps seen as eccentric, are not stigmatized as are artists, particularly given the advantages of their class position. Still, collectors sometimes told me, with some stubborn pride, affiliating themselves with the plight of their artists, that people laugh at them and call them strange. One woman even admitted that she "decided to collect this art to shock my neighbors" (Interview). Another woman told me about a service call from the cable repairman: "He was here for six hours. . . . The last ten minutes he finally goes, 'well, what is all this stuff?' So, I started telling him, and I thought he was getting interested, telling him how we've gone on these trips. He looks at me and he goes, 'I prefer Monet'" (Interview). Monet is precisely the kind of popularized artist that middle-class service workers know and can legitimately present as their favorite. Henry Darger or Bill Traylor require explanation.

Perhaps the most common comment—known to collectors of abstract, nonfigurative art as well—is that it looks like "children's art." One collector said that a friend with a severely handicapped child told her that her son could do some of this art (Interview).[12] Another collector told me that her secretary commented, "I don't mean to demean your collection, but my five year old could paint as well as that" (Field notes). Suggesting that this powerful art is created by children "de-means" it, stripping it of significance.

Sometimes accommodation is evident. One dealer, who had once specialized in abstract art, noted that her change was not well accepted at first: "I had developed a very nice following from my first gallery of abstract painting, and the people, I think, felt betrayed. At least, that's

how they expressed themselves, and they didn't come to my gallery. . . .
One person I admire said, 'I didn't know you could find art in the garbage
can' " (Interview). In time things change, as with a young collector who
narrates her aesthetic transformation:

> There was a time, not many years ago, when I was a snob about outsider
> art. . . . My roommate brought [an empty can that once contained peas]
> back to our dorm at Wake Forest and waved it proudly before me. "Look
> what I got! A Howard Finster!" she exclaimed. . . . I carefully inspected
> it, turning it slowly to see the heavenly faces that Mr. Finster had painted
> with the grace of a calligrapher. A can of peas as the canvas. Happy faces
> on clouds. You paid money for this? I didn't get it. Today, I know better.
> I'm a convert.[13]

Whether this writer knows better for admiring a painted tin can, she
certainly knows differently, and this aesthetic embrace links her to a
community of like-minded others.

While vandalism is rare in the upscale neighborhoods in which most
collectors live, other forms of social control exist. One prominent col-
lecting couple who had a brightly colored and valuable Vollis Simpson
whirligig behind their house were told by the neighborhood association
that it would have to be dismantled, as the covenants of the neighbor-
hood prevented external changes to the property. The neighborhood
secretary suggested that it might be accepted if it were painted; some-
one else suggested that they should place a flag on top, as flagpoles were
permitted (Interview). They removed the piece. Their dilemma reveals
that neighborhoods are seen as "aesthetic environments," where the vi-
sual appeal of the place is linked to quality of life, affecting property
values.

Family can be the cruelest critics. One father, commenting on a valu-
able piece, asserted, "If you paid more than nine cents, you should take
it back" (Interview). A dealer tells the story of how his father held up
one of his treasured finds to his buddies, commenting unkindly, "This
is how my son makes his living. Isn't this stupid?"[14] However, it is not
only the older generation that is unsympathetic. One father explained
that his middle-school children found his collection "weird" and were
embarrassed when friends visited. Another told me—perhaps joking,
perhaps not—that she couldn't keep a boyfriend because of her passion.
A third explained that when she was to meet her daughter's future in-
laws, she was asked (and refused) to hide some of the more controversial
pieces. The daughter had to provide a disclaimer to her fiancé's parents
that her mother was strange.

Thinking like a State

States have various attitudes toward art. In Western democracies, it is common for the state to fund the arts, and considerable support exists for this practice,[15] despite complaints by some who prefer government to have a more limited role.[16] Sometimes—and not infrequently—states use art and artists to legitimate their rule, as the prestige of art can rub off on government. Most troubling, the state may intervene to contain art, memorably in the Nazi 1937 exhibition of "degenerate art," but also in attempts to withdraw funding from museums or to demolish artistic environments. These state options, grounded on the diversity of public opinion, emphasize that states do not have a single perspective.

STATE SUPPORT. Government funding is integral to much artistic presentation. Even if one might agree, in principle, that support for the arts should be private and voluntary and that government agencies should not be directing aesthetic choices, given the growth from the 1960s of federal, state, and local support, a purely private system would cause a sharp decrease in support for the arts. Since even tax deductions are a form of indirect state subsidy, a fully private system would require that contributions from individuals or corporations be taxable, decreasing support still further.

Under the present system, many museum shows are supported by state subsidies directly or indirectly through support of operating expenses. The Smithsonian-sponsored Festival of American Folklore, held each year on the Mall in Washington, is one such example, bringing artists like Edgar Tolson (also an National Endowment for the Arts fellow) to public attention. Many major exhibitions of self-taught art have governmental support. The state of California appropriated a million dollars to preserve Simon Rodia's Watts Towers in Los Angeles.[17] New York City provided $2.5 million for the American Folk Art Museum's new building.[18] The state of Kentucky awards $200,000 annually to the Kentucky Folk Art Center in Morehead.[19] In Newport News, Virginia, murals on the walls of Anderson Johnson's Faith Mission were preserved through the city's use of $30,000 in HUD community development grants after an outpouring of neighborhood and art-world support.[20]

THE DOWN SIDE. What the government can give, it can take away. Those who believe that the actions of politicians should reflect their core beliefs, should honor California congressman Elton Gallegly, a Republican backbencher from Ventura. After the Northridge earthquake, the Federal Emergency Management Administration (FEMA) allocated $455,400 to help restore the damage caused by the earth-

quake to Grandma (Tressa) Prisbrey's Bottle Village in Congressman Gallegly's district, a folk art environment that had been awarded city, county, and state landmark status. Congressman Gallegly successfully pressured FEMA to rescind the grant to restore these fifteen structures constructed from bottles set in cement, even though the money would have been spent in his district and the tourism would also have helped the local economy. Of course, before we praise the congressman too heartily, he did not oppose other local FEMA projects. A similar view to Gallegly's was expressed by Kansas's director of tourism, Cathy Kruzic, who stated about the unique folk art environmental masterpiece, S. P. Dinsmoor's Garden of Eden in Lucas, "The Garden of Eden is . . . not something I jump up and down to promote. I don't like the image of Kansas to be downtrodden with such attractions that probably every other state has."[21] Ms. Kruzic emphasized the state's lakes and rivers.

The Bottle Village is not the only victim of government's malignant glance, although environments are most often the source of such ire. One curator joked that, "Houston is the great art environment place. The reason is that Houston has no zoning" (Field notes). I mentioned earlier that the city of Birmingham, Alabama, had tried to clean Lonnie Holley's yard environment, claiming that it was a "public health hazard" and eventually forced him to vacate in order to expand the airport.

Some works have been demolished by the state for violating ordinances, often because the work is on state-owned or condemned property. Artists who create an outdoor environment may be cited for making their home a "hazardous eyesore" or for "illegal open storage," and in some cases may be evicted.[22] The two most noted examples are the Heidelberg Project of Detroit artist Tyree Guyton, a recipient of the Governor's Art Award in 1992, and the Ark of Newark artist Kea Tawana, both art environments located in impoverished cities. The city of Detroit has long waged war against Guyton's efforts to transform abandoned buildings in drug-infested neighborhoods into "magical" art environments. Detroit has torn down his work on at least three occasions (1991, 1999, 2000).[23] In Newark artist Kea Tawana was forced to dismantle the eighty-foot, three-story wooden ark she had created over two decades. The city claimed it was "unsafe," built without a permit, and had zoning and building code violations. Despite support by many in the art world and the neighborhood, the city was unmoved, and after a court battle, the ark sank.[24]

Before one concludes that it is the forces of night—the dark hand of repression—that lead the charge against these monuments to the human

Grandma (Tressa) Prisbrey (1896–1988). Archives of the American Folk Art Museum, New York.

spirit, a significant foe of public religious art is the American Civil Liberties Union (ACLU). Self-taught artists are often inspired by evangelical fervor. Creating art on public land, they are said to undercut the separation of church and state. The state is permitted to display religious art in museums, but only because that art (e.g., the Renaissance masters, and even the Reverend Howard Finster) is not taken as religious proselytiz-

Dollhouse by Grandma (Tressa) Prisbrey, Bottle Village, Simi Valley, California. Photograph by Amy Skillman. Courtesy of Preserve Bottle Village.

ing. It is, after all, only art. Environmental works seem more fervently religious. For example, "San Bernardino County, which owns and maintains the Desert Christ Park, has changed the name of the environment to Antone Martin Memorial Park in an effort to forestall an expected suit by the ACLU. The American Civil Liberties Union contends that the county maintenance of Martin's park with its 40 Biblical figures violates the constitutional separation of church and state."[25] Currently debate rages over what to do about Leonard Knight's "Salvation Mountain," a 100-by-300-by-200-foot adobe mountain in the desert near Niland, California. The monument, on public land near an abandoned army base, has religious messages—and lead-based paint. While the mountain has not been razed, the combination of religion and toxicity places its future in jeopardy.[26]

THE LEGITIMATION OF ART. In addition to helping or harming the arts, the government can snuggle up to them, gaining credit, whether or not it is deserved. The visit of First Lady Nancy Reagan to the *Black Folk Art* show at the Corcoran Gallery of Art, chatting with the artists, is a case in point.[27] Mrs. Reagan hoped to demonstrate by her symbolic presence support for African American aspirations and achievements, which some could not find in her husband's policies. First Lady Hillary Rodham Clinton did the same, but with fewer art-world snickers. When the Catholic Dickeyville grotto was dedicated in 1930, Wisconsin's Governor Kohler showed up to give his blessing.[28] In return, some artists are pleased to support fawning politicians. Edgar Tolson gave canes to

Kentucky governor Bert Combs, who later restored Tolson's civil rights, lost as a convicted felon.[29]

Most recently Congress has provided support, although no funding, for the American Visionary Art Museum in Baltimore. In 1992, the U.S. Senate, not known for its aesthetic pronouncements—although they have debated whether the square dance should be America's official dance—passed a resolution stating: "Visionary art should be designated a rare and valuable national treasure to which we devote our attention, support and resources to make certain that it is collected, preserved and understood, and . . . the American Visionary Art Museum is the proper national repository and educational center for this art."[30] The first exhibition, *The Tree of Life,* had Vice President Gore as its Honorary Chairman,[31] and the museum has been endorsed by former Kansas senator Robert Dole and Maryland senator Barbara Mikulski. Although such endorsements did not sit well with all in the self-taught art world, given competition for resources, support for art, particularly without funding, can be a means by which politicians can gain favorable notice. Operating at the margins of artistic and cultural worlds, state intervention has an institutional presence that can be supportive or harmful.

The Organizational Life of the Arts

The museum typifies the arts organization. The museum, focused on obtaining a collection and displaying it, is not the only form of arts organization, although it is the most prestigious. As one former museum director explained, "being called a gallery isn't as glamorous as being a museum" (Field notes), and there is a strong pressure to upgrade one's status: the Smart Gallery at the University of Chicago is now the Smart Museum; the Block Gallery at Northwestern is now the Block Museum, a status-based process akin to the change in name from "College" to "University."

Relatively few museums routinely exhibit the work of self-taught artists—among them the American Folk Art Museum, American Visionary Art Museum in Baltimore, National Museum of American Art in Washington (now the Smithsonian American Art Museum), Abby Aldrich Rockefeller Folk Art Center in Williamsburg (now renamed Museum), Menil Collection in Houston, Museum of International Folk Art in Santa Fe, Mennello Museum of American Folk Art in Orlando, John Michael Kohler Arts Center in Sheboygan, Wisconsin, and museums in Milwaukee, Birmingham, Atlanta, and New Orleans. Many of the most prestigious museums are absent: the National Gallery, the

Met, and the leading museums in Chicago, Los Angeles, Philadelphia, Boston, Cleveland, and San Francisco. The coverage of self-taught art is, to be charitable, spotty.

Some institutions are labeled art centers: typically arts organizations that sponsor shows, but lack permanent collections. The largest outsider art center, Intuit, is located in a building in a gentrifying area west of Chicago's Loop. Intuit, founded in 1991 by a few interested collectors, trained artists, and dealers, lacks a permanent collection—a matter of debate for the board—but has shows in their gallery space.[32] Generally four shows a year are mounted in the larger gallery with a typical show budgeted for $3,000 to $4,000. The organization maintains a small gift shop, and sponsors lectures and fund-raising parties. Intuit has a FY 2000 budget of approximately $350,000, two paid staff members (an Executive Director and Associate Director), a few interns, and a board of thirty-two members. These people lack the clout of the board of the Chicago Art Institute or the Museum of Contemporary Art, but they have sufficient resources to provide for the continuing growth of the organization.[33] Over ten years Intuit gained a new, permanent home, expanded its exhibitions, increased membership to about seven hundred, created a respected newsletter, and sponsored an art fair. Other cities have their own groups—some without permanent homes (such as Envision in St. Louis), and some without exhibition programs (the Orange Show in Houston). In addition, the Folk Art Society of America is an affinity membership organization with about seven hundred members, which sponsors an annual meeting and a magazine.

The health of the field depends very much on where one is located. Self-taught art is healthier, by the chance of organizational presence, in Milwaukee than Minneapolis, Houston than Dallas, Chicago than Detroit, Atlanta than Charleston. Numerous major cities—Boston, Los Angeles, Cleveland—lack contemporary self-taught art resources and major galleries. Art worlds of all types are locally based, as well as national, and their local strength is a function of the gathering of resources by individuals within the community.

A Nation of Museums

Museums have become important institutions in contemporary Western society. They provide education, social status, tax relief, and are significant tourist attractions, affecting the local economy. Over twenty-five hundred new museums opened in the United States between 1950 and 1980.[34] Of the 749 arts organizations examined by sociologist Diana

Crane in 1987, fully 58 percent were founded after 1940, and one-third since 1960.[35] We have become a nation of museums.

Yet, museums are fragile institutions that, in their organization and their displays, reveal conflicts in the larger society.[36] The museum must gather resources, and reliance on state largess and individual contributions is insufficient. Increasingly museums, for good or ill, rely on merchandising, marketing, and corporate contributions. This affects who is asked to serve on the museum board. While boards are somewhat diverse with a few artists and major collectors, increasingly they are stocked with those who can help sell the museum to publics and corporations. Two of the recent additions to the American Folk Art Museum's board have specific skills in sales, and a third was involved in non-profit fund-raising. In addition to support from private donors, corporate support is essential; expanding these revenues is a central feature of the job description of any museum director. This was one of the great skills of the former American Folk Art Museum director Robert Bishop, a natural showman and salesman with scholarly interests and deep roots in the field. Bishop saved the museum from extinction with his considerable fund-raising skills. Multiple revenue streams are needed, and AFAM's current Director, Gerard Wertkin, was a guest host on QVC, the cable shopping channel, on 4 July 1996, hawking the museum's licensed products, "inspired" by folk art designs, such as those produced by Takashimaya. In winter 2002, the Museum's "family of licensees" produced quilts, jewelry, magnets, scarves, ties, mouse pads, and, most curiously, "organic deli items." Most major museums have similar programs, although perhaps because of the emphasis on artistic authenticity, such efforts require more careful consideration at this museum.

In addition, museums need a market niche—or "brand"—attracting an audience, a not inconsiderable challenge for museums with better-funded, more prestigious rivals. The fame of Howard Finster throughout the Atlanta region produced an overflow crowd of 5,000 for the opening of the Finster Paradise Garden exhibit, with enthusiastic younger Atlantans in attendance, perhaps knowing him from the record album covers he created. The Finster opening was a major "event," distinct from most museum openings. One museum director, described as "no folk art fan," was shocked that a self-taught art show at his museum in the late 1980s "broke all kinds of records for attendance and sales in the [gift] shop." His curator adds, "I'll never forget the conversation we had just after it all came up, because he congratulated me on what I had done and in the same breath said, 'I don't want you to start thinking that what you want to do is to become a folk art curator.' . . . He said,

'that will never happen at [my museum]'" (Interview). Even with the attendance and sales, the boundaries were, at that time, impermeable.

Self-taught art also contributes to a museum's mission of gaining a multiracial audience. Several museums, notably the High Museum of Art in Atlanta, self-consciously use "folk art" to attract the black population of Georgia, a group, which, to the consternation of officials, do not see museums as welcoming. Shows that display black self-taught art, even if the works are not collected by African American elites, draw crowds. A show that featured two local black self-taught artists (Mr. Imagination and David Philpot) at Chicago's Terra Museum of American Art set attendance records and brought in many blacks who had never previously visited the museum. The Corcoran's *Black Folk Art* show was in part chosen to appeal to black residents of the District of Columbia. Even if most viewers are white, a larger proportion of blacks attend. As one southern museum official noted, "It occurred to me that part of the issue I was facing . . . was, 'What could the museum feasibly collect, what could we collect that would give us a special identity, and what was relevant to our locale that would distinguish us?'" (Interview). Even if a museum director doesn't have an affinity or emotional attachment, displaying the work may be a wise strategic decision. In both the North and South, self-taught art can attract African Americans to a museum from which they might otherwise feel excluded. Even if this strategy is not financially motivated, it cements the legitimacy of the institution as community based, an image that can leverage funding.

A Tale of Two Museums

In the United States two museums specialize in contemporary American self-taught art: the recently renamed American Folk Art Museum in New York and the American Visionary Art Museum in Baltimore.[37] While neither museum has the lengthy pedigree of the "great American museums" with AFAM opening in 1963[38] and AVAM in 1995, the two museums differ in their structure and position in the art world. Comparing the two in their relationship to art world legitimacy explains strains within peripheral art worlds.

AFAM. From its first years AFAM modeled itself on the Museum of Modern Art. Its first home was a rented property a few houses down 53rd Street from MOMA and its first director was hired from that institution. This museum felt the need for hired curators, a professional director, a reference library, and a permanent collection. Even if they were unable to achieve these goals rapidly, the museum defined itself as a New York institution. One is struck by the lengthy attempt, just now successful, to

gain a permanent home and to build their own collection. AFAM was always undercapitalized, and there were years from the late 1960s until the mid-1970s when its future was very much in doubt. Some of the permanent collection was auctioned in the early 1970s. The museum was saved, most agree, by the fund-raising ability of Robert Bishop, the director from 1977 until his death in 1991. There were periods as late as the mid-1980s where the museum had no regular exhibition space. Over the years numerous announcements have been made of a permanent home—on 75th Street, at the South Street Seaport, and, most often, on 53rd Street, next to MOMA. In 1997 the museum once again announced that it would build on 53rd Street. They had made similar announcements in the *New York Times* in 1970, 1983, 1987, and 1990, so doubt was understandable. However, as a result of the surging interest in self-taught art and the robust economy, the new museum was completed, and opened to glowing architectural reviews.[39] The museum has increased its permanent collection substantially, has hired several curators, has established a master of arts program in Folk Art Studies in conjunction with New York University, publishes a glossy magazine filled with scholarly articles, and maintains a serious library. If AFAM has not reached the level of a "mega" New York museum—MOMA has nothing to fear, yet[40] —the museum is increasingly recognized as a serious organization, even if it is not yet as serious, scholarly, or professional as some dealers and collectors wish.[41]

Throughout its history the museum has been split between those who are primarily interested in early American folk art (the original impulse for the museum) and those who are primarily interested in contemporary self-taught art, now including global works. While a few have broad interests, such as the museum's early curator Bert Hemphill and its former director Robert Bishop, the two camps are easily divided. Early proposals to explore twentieth-century work met with "volatile reactions" from the board.[42] In a survey conducted in 1989, only 57 percent of its magazine's readers expressed an interest in "contemporary folk art," uncomfortably close to the 47 percent who were interested in articles on "home decorating."[43] Even now the magazine is careful to balance articles on "traditional" and "contemporary" folk art. Ralph Esmerian, president of the museum's board, commented that as late as the early 1990s there was conflict between the museum staff and the trustees about the value of contemporary self-taught art: "We felt the 20th-century work was more of an urban pill, not from the countryside where the real folk art was from. And we didn't want to get dragged into hobnobbing with 20th-century dealers. There's so much fakery involved

in that gallery scene."[44] The board grudgingly accepted contemporary works because of the interest in this work by others. In 1999 the museum announced that in the new space they would establish a "Contemporary Center," testimony, however well intentioned, that contemporary self-taught art was separate from the rest of the museum. Decisions on which major works to purchase for the permanent collection, usually won by the traditionalists, still cause anger by those more interested in contemporary work (Interview). This suggests that the museum in many ways continues to think of itself as conservative and traditional. It hopes to overcome its marginality by echoing more established institutions.

In 2001—after the observational portion of this research was completed—the museum decided, in time for the opening of its new building, to change its name from the Museum of American Folk Art to the American Folk Art Museum, a subtle and ingenious shift. Does "American" modify Folk Art, or does it modify "Museum"? The change permits the museum to establish a global collection, overcoming regional limitations on collecting and curating. With this studied ambiguity Americanists and internationalists, traditionalists and modernists were satisfied.

AVAM. If AFAM strives mightily to be taken seriously as an elite museum, the same cannot be said of Baltimore's remarkable American Visionary Art Museum.[45] If it is not quite an "anti-museum" or a "visionary museum," it is an "outsider museum." The museum is located on the Inner Harbor on land given to it by the city with the proviso that they clean up the pollution from the copper paint factory and whiskey warehouse that had stood on the land. The museum opened in November 1995, and has carved out a niche in the self-taught art world. The museum, housed in a striking building, has an annual attendance of about 55,000, about as much as one Orioles game. The museum has 32,000 square feet of exhibit space, more than twice the 15,000 square feet of their New York compatriot. The museum is also planning a repository for threatened folk art environments.

AVAM might be most profitably understood in terms of what it lacks. This is a museum without a significant permanent collection, without curators on staff, without a major library, and, until recently, without members. The museum has something of a new age aura, focusing on the "visionary," rather than the more traditional categories of self-taught, folk, or outsider. Its shows are "thematic," not on an artist, group of artists, or artistic highlights. While AFAM has had shows presenting the work of Henry Darger, Nellie Mae Rowe, and "self-taught artists of the twentieth century," AVAM has sponsored shows with titles such as *Tree of Life, Wind in Your Hair,* and *The End Is Near.* The museum also

sponsors some wild gatherings, such as Goddess Sleepovers in which women spend the night partying at the museum.

Unlike AFAM, and most museums, often run by old, gray men, AVAM was "birthed"—founded and directed—by Rebecca Hoffberger, a former psychiatric nurse, who lacks substantial background in the arts and desire to be an art-world "player." Hoffberger is a self-taught director. She reveals a disregard for academic scholarship, noting that, "I'm always amazed at how much junk there is in the academic world which passes for truth."[46] She wishes people to feel the art, to enjoy and have fun, rather than to think deeply about it. The museum rejects "seriousness," defined as pedantry and pomposity. At the same time, Hoffberger is passionately committed to representing the insights and vision of the marginal members of society.

The six-year effort to establish the museum is astounding, raising over $6 million from her husband, Leroy, the Body Shop's Anita Roddick, and others sympathetic to her vision.[47] This achievement is particularly remarkable given the travails of AFAM to establish its own space over more than three decades. In her showmanship, flamboyance, and her ability to raise quantities of cash, she reminds one of AFAM's revered former director Robert Bishop, but Hoffberger lacks his scholarly enthusiasm, sedate appearance, and extensive network. A less-than-flattering New York Times profile described her as "a high school dropout with a cheerleader mane of strawberry-blond hair, who is displaying much cleavage and wearing a heart-shaped diamond ring the size of a York Peppermint Pattie."[48] Much attention to the museum, perhaps because of the absence of a permanent collection, is focused on its director. She has created the museum on her own terms, rather than aping established institutions.

The art world is known for eccentrics. Yet, the distaste among some in this art world is palpable with many expressing their hostility openly, commenting on what they consider the "bad taste," Jungian sentiments, or Disney World ("kid-oriented") feel. One prominent dealer vowed never to set foot in the museum and a few collectors refuse to lend their works to the museum's shows, even when organized by credible curators. One dealer noted, "it is people like this who think they are making the art democratically available to the general public but who in reality are creating a bastion of cuteness and whimsy and insanity that does nothing but denigrate the image of the work."[49]

AVAM's success must surely grate on officials at the American Folk Art Museum and the New York dealers, who have been given short shrift in Baltimore. Aside from real philosophical differences, there is surely

a tinge of resentment by dealers at their exclusion. AVAM, in its large, snazzy space and with its Congressional endorsement, underlines the lack of resources of AFAM, even if AFAM has expenses that a museum without a permanent collection or professional curators doesn't have. Hoffberger hasn't paid her dues, and shows little sign of wishing to. Chicago dealer Carl Hammer speaks specifically about the problem: "To open a museum of this magnitude, and the fact that no one had ever heard of her before. . . . She totally ignored the rest of scholarship and just did it completely on her own. It gave people immediate bad vibes. . . . The museum did things its own way, without coming to anyone else."[50] This comment is symptomatic with its reference to "no one," "people" and "anyone"—Hammer does not mean that she had no contacts with other human beings, but that Hoffberger didn't curry favor with the art-world community. I do not suggest that if she had there would not be discomfort with her approach, and pressure would have been brought to bear, but one imagines that the hostility would be diminished. If the museum survives, it will not be until a new director is named that art-world elites will consider taking it seriously. Until then the tens of thousands of visitors will be inspired or disconcerted, as they will. These two organizational case studies remind us how different institutions can be, even if classed together under one heading and apparently doing similar things with one embracing the model of elite institutions and the other aiming for popular appeal. Even if organizations are classed together, they can embrace different institutional logics.

The Politics of Display

As the controversy over the *Sensations* show at the Brooklyn Museum of Art and previous controversies demonstrate, museum displays may have undeniable power.[51] While there has not, yet, been commotion about a self-taught art exhibit, such is not impossible. When the American Folk Art Museum installed the Henry Darger show, they consciously decided to add works that more fully demonstrated the range of Darger's violent and sexual images, showing images of young girls being killed, hanged, and disemboweled, works that had been excluded from the original display at the University of Iowa Art Museum.[52] The museum was prepared for and perhaps secretly welcomed controversy. No such controversy occurred; at one point only one of seven hundred visitors had requested his money back. For its part, the American Visionary Art Museum decided to change the name of its *Eros* show to *Love: Eros and Error*, noted that the curators were a married couple, and placed some of the more graphic work in a separate gallery that school tours could skip.

Controversial works are not the only issue of display. More important, given the idea of self-taught art as alternately "authentic" and "second-rate," is the context in which the art is placed. A work of art—any work, but particularly those that derive from outside of an art-historical tradition—requires contextualization. Or perhaps, re-contextualization. Where should an artwork be placed? How much is the meaning and impact of a work changed by being stripped from its original location and placed in a gallery?[53] Do these works demand their own space—their ghetto—or should they be interspersed with other artworks? Traditionally the assumption is that self-taught art constitutes a field. However, this can be seen, not as giving pride of place, but as marginalizing.

As a result, some museums—the High Museum in Atlanta is one American example—have incorporated self-taught art in their permanent collection,[54] either increasing its status or directing attention away from the work as constituting a field. One museum official noted: "We all see the walls as being soft and fluid and see the work from our collections or areas of focus seeping into and overlapping with and in some ways being absolutely continuous with one another" (Interview). How museum visitors and board members react to this erasure of artistic boundaries remains to be seen. Perhaps works can be viewed in several ways: some artists may be included in general collections and others treated as specialized. Certain works can be incorporated into the standard artistic canon, while also having peripheral canons for self-taught, African American, or southern art.

Displaying works together makes a statement about boundaries. While chronology and national origin are often used as the basis of museum display, such as rooms of seventeenth-century Dutch paintings, other models of organization are possible. Curators may present a theory of art or tell a story by their placement of thematically or stylistically similar works, creating interconnections that might not otherwise be noticed.[55]

In addition, consider the surroundings themselves. Like contemporary galleries, modern museums constitute white boxes—although much larger white boxes. Does self-taught art, produced by those who ignore the theories and justifications of modernist art, belong in such a space? As one museum director explained, "there is no such thing as a neutral installation. The moment we place something on the wall, we are interpreting it" (Field notes). One advocate for self-taught art criticized an argument by a curator to whom he was unsympathetic, whom he quoted as saying: "Oh, I love the work, but it would be irresponsible of we museum professionals to allow this work to go up on museum walls

where it doesn't belong. It was made for a specific site, which was not the museum walls. We should go out and photograph it and appreciate it where it comes from, but not try to put it on the museum walls" (Interview).[56]

There is a museum politics of display. One collector complained about the High Museum's installation of pieces from Howard Finster's Paradise Garden, objecting to "that awful gray installation of Paradise Garden. It's become minimalism." Another asked: "What happened to the exuberance? What happened to the essence of Howard?" (Field notes). In the eyes of these collectors the museum installation decontextualized the work with the dullness of the walls rubbing off on the experience of the otherwise bright pieces.

Even the choice at which museum a show should be exhibited has consequences. As noted, when the Bert Hemphill collection was touring, one of its first stops was the Indianapolis Children's Museum, where the director wrote, "We wanted something to appeal to both children and adults, to contribute to the Bicentennial celebration and to give a special feeling about America."[57] This location—and the associated rhetoric—represented for some a concrete indication of its low status. In contrast, the fact that it was the Corcoran Gallery of Art in the District of Columbia that sponsored the *Black Folk Art* show in 1982 indicated that African American vernacular art and the *artists* who produced it were legitimated. Granted, the Corcoran was not the National Gallery, but for this field it was close enough.

Museum Battles

A truism about traditional, high-status museums is that they are fundamentally conservative institutions, motivated to preserve the best in culture. They are run, some say, by "old money," whose aesthetic standards have long been set. They often seem to change at a glacial pace, searching for "works that have stood and will continue to stand the test of time"[58] and for which there is substantial scholarship and critical acceptance, criteria that pose problems for contemporary self-taught art and other institutionally marginal domains. Add the desire not to offend powerful supporters and to display what they know will be judged worthy by their established audience, and the problem for self-taught art in major museums is evident. While this is truer for some institutions than for others, it gives the supporters of self-taught art hope that in the future their preferred work will enter the "canon." In some cases, such as the work of William Edmondson, Horace Pippin, and Bill Traylor, all African American artists dead for half a century, that seems to be

occurring, as elite museums, including the Metropolitan Museum of Art in New York, are collecting their work.

Yet, despite this hopeful sign, resistance to self-taught art is evident among museum boards and acquisitions committees in generalist museums. Given the canon of art history, it is understandable that these establishments do not promote self-taught art, even storing pieces that they own (e.g., Traylors at the Met or Yoakums at the Art Institute of Chicago).

For smaller museums without encyclopedic collections, this is less of a problem, although for some the focus on self-taught art may indicate to the board that they remain a second-tier institution that no amount of discussion of this representing a "new model for the next century" can quite overcome (Interview). These organizations peer over their shoulders to see what other organizations—equals and role models—are doing. There is a strong push toward organizational sameness or isomorphism.[59] Curators must defend their choices of which object to obtain for the permanent collection, and in so doing they rely on communal conceptions of aesthetic value and connoisseurship. Curators explain, often with frustration, how their choices have been turned down by these committees, not "willing to go out on a limb," that the work is "not treated as fully legitimate," and that it was not "serious artmaking" (Field notes). One commented, "I've had some adversity from my fellow curators as to why I bother with this stuff over the years," including comments that the works are ugly and unimportant (Field notes). The board of the Montgomery Museum of Fine Arts actually discussed turning down a gift of a number of Bill Traylor drawings, wondering "whether they belonged in their museum of fine arts." They eventually accepted the gift, but only because they didn't wish to offend the donor (Interview).

Even price can be held against this art. One curator wanted to purchase a sculpture by the black stonecarver William Edmondson for $6,000. Some board members felt that was an excessive amount, while others felt that if the work was really significant it would be more expensive (Interview). Such remarks require a strong curator to continue in this stigmatized area.

It is a matter of some jubilation when, after criticism, a director or curator can gather sufficient support to persuade the board, such as at the Milwaukee Art Museum or the National Museum of American Art, to approve a major purchase. Such a decision, along with the commitment of money and space, permits the curator to feel, in the words of one,

"that we were really part of the collection" (Field notes) and to announce to other collectors and dealers that the field has been legitimated. As in so many social-movement domains, effective leadership and rhetorical frames are crucial to galvanize support, and this pressure should ideally come from other than the curator, who can be seen as advocating from self-interest.

The recognition of the importance of movement advocacy within a museum was explained by one curator:

> As this marginalized field, at least in the relationship to the museum world, begins to gain recognition, the problem is in finding some way to identify the work and the field for the purposes of advocacy. It's like the dilemma of identity politics, which in order for a marginal group to gain access to the forum, it's necessary to name oneself in one way that continues to distinguish oneself. In the 1970s any woman who created art created women's art. Now finally in the 1990s, women are suddenly creating just art. . . . But in order to gain that kind of recognition and become historically situated within that naturalized center, it was necessary for a long time to raise the banner of advocacy, by using a kind of adjective which qualifies the notion of art and art-making in an unfortunate way. . . . If you buy the idea that definitions of art are inherently political, which is hard to refute, it's logical to assume that there are certain kinds of socially defined individuals and certain kinds of socially recognized objects that qualify for the term art and for induction into the official institutions that maintain and establish the value of art. . . . There is a kind of constituency of collectors that serve as another kind of resource for the entry of this material into the museums. (Interview)

This perspective, with its distinctly sociological feel, recognizes that museums are political institutions. That the elite museum world currently assesses a subfield in a particular light doesn't mean that this will never change, but social actors—collectors, critics, donors—need to commit themselves to making that change happen. The curator, the inside agitator, is essential for the organizational case, but requires external support to overcome organizational inertia.

The Museum Nexus

No museum is an island. These organizations intersect with other players in the art world, notably with artists, dealers, and collectors. Institutions, like economic actors, are embedded in a set of social relations.

The Curator on the Front Line

Being a curator involves a mix between being an art historian—without the freedom, research time, and contemplation that this position implies—and being a bureaucrat, a functionary in a large, and often faceless, organization. As museums have changed, so has the role of curator. During the nineteenth and early twentieth centuries museums were dominated by the amateur collector; by the mid-decades of the twentieth century, the professional, technically trained curator became dominant; now in the new century, museums are increasingly controlled by the managerial expert, and curators have become part of a bureaucratic team, subservient to the growth and survival needs of the organization.[60]

Although museum audiences may know the names of the artists on display, few but the most active members know of the curators. This position, silent and invisible, is crucial for establishing the priorities of the museum, shaping what the public gets to see and what enters the art world canon.

Given this significance, it is notable that few curators specialize in self-taught art. Brooke Anderson at the Contemporary Center of the American Folk Art Museum and Lynne Spriggs at the High Museum of Art are currently the two most visible contemporary folk art curators. Few museums have curators who were hired to specialize in this area. Even museums, such as the Milwaukee Museum of Art or the Smithsonian National Museum of American Art, that have substantial collections, do not have folk art curators, although they have curators with expertise in the area. There is a very small niche for the art history graduate who hopes to work on self-taught art. While curators may begin as quasi-academics, interested in aesthetic principles, working in a museum with bureaucratic tasks limits this romantic illusion.

Curators often feel underpaid,[61] particularly as they socialize with art-world collectors and patrons who have dizzying wealth. One former curator was quoted as saying, "We're underpaid, overworked, and underappreciated" (Field notes), and yet many are passionate about their work, often spending vacations visiting artists, collectors, or museum exhibitions: a busman's holiday. One described her work as "a caring commitment. There's a love. It goes beyond academic interest. It is warm and caring, but also critical" (Field notes).

Because of the need to acquire art and the desire to publicize their area, some curators are accused by those more academic of being mercenary and in cahoots with dealers and collectors; in turn, by attempting to maintain distance from the world of commerce, dealers and collectors may find curators standoffish, snobby, or academic, a person to be

sniped at by those who want more personal attention than the curator can provide. Being a curator, in other words, is to be caught in the line of fire between those who are attuned to the market and those who wish to treat the object as pure and uncontaminated.

Just as in the theater, where visiting directors are hired, visiting curators organize shows. At some small museums, these are dealers or collectors, but at larger institutions, the visitors are typically academics, critics, or officials in other organizations. Because the American Visionary Art Museum has no curators on staff, each show is put together by a guest curator, making quality and style variable. The payment for this task is generally modest, and one academic comments that even though curating helps his career, it often costs money to accept an invitation. The curator who does not rely on a single collection must travel, begging and cadging pieces from collectors and other museums, a task occasionally exhilarating, but commonly wearying.[62] Depending on the budget, the search may be global, national, regional, or local.

Having a piece in a museum show may be an honor for the collector, while simultaneously increasing the value of the piece as a known and validated commodity, raising the likelihood of loans. Still, the reality is that museum shows depend on the largess of individuals who make a sacrifice. In some few cases, particularly with smaller museums, curators actually purchase the works themselves and then loan them to the show (Interview). The goal is to fill the space, and while the space may be elastic depending on the number of pieces to be had, space must be filled with *something* if the show is to go on.

CURATORS AND THE ETHICS OF COLLECTING. Curators are passionate about the art that they study. As a result, many desire to collect their objects of devotion. One wishes to live with what one has been thinking about so deeply and fervently. Bert Hemphill, for many years a curator at the American Folk Art Museum, admitted that he collected the objects in each show that he curated.[63] Another curator noted, "If I spent two years studying an artist and I'm still thinking about it, I would want to own some of those things" (Interview).

This practice, however, raises ethical issues in that these objects are not only objects of personal veneration, but of economic significance. I was told that one curator helped his museum purchase a major piece of an artist whose work he had "stockpiled" (Field notes). Even though this is a relatively minor artist and museum, the story, if true, raises concern. The Hemphill collection (sold for $1.4 million) might have included objects given to Hemphill or sold to him at reduced prices in order to curry favor with an important curator, albeit for a small,

struggling museum. I do not suggest that was a deliberate strategy on Hemphill's part (although the Hemphill files indicate he did receive gifts and special treatment), but there is clearly the *appearance* of such a conflict. If Hemphill were a stockbroker—or if he were curating today, not thirty years ago—we might complain about inside information and his power to sponsor artists with whom he had a personal relationship.

In the Hemphill files there is a copy of a three-page Code of Ethics for curators from the American Association of Museums, compiled in 1983, subsequently updated slightly in 1996 although with the same general themes.[64] This document claims that for a curator to be a dealer is unethical, although occasional sales are permissible. Otherwise, the code dispenses general advice: "Curators should never compete with their museum for an object. . . . Curators must give their institution first option to acquire an object that they have purchased before adding it to their personal collection. Curators must not purchase objects deaccessioned from their own institution or trade objects from their personal collection for objects from their museum's collection. If curators lend objects for an exhibition in their museum, they should lend them anonymously. . . . If curators decide to dispose of part or all of their personal collection, they should offer it first to their museum as a gift or at fair market value. . . . A curator should not negotiate personally with a dealer with whom the curator also does business on behalf of the museum."

This code of ethics led one curator to claim that she always brings any piece to the museum to find out if they were interested in purchasing it, avoiding a perceived conflict of interest (Interview). Another curator claimed that she would not collect self-taught art, because "I collect for the public trust. I think it's really impossible to collect for two people, for two entities. . . . There are curators who collect, and when they do . . . we need to be very careful not to violate a certain kind of code of conflict of interest, and that has to be checked very carefully" (Interview). A museum official actually gave all of the pieces of self-taught art in her personal collection to the museum, fearing a conflict of interest, and now no longer collects. What she loves she no longer lives with, but only works with (Field notes). While this is a somewhat extreme position, it avoids problems in that personal interests may conflict with organizational goals.

Artists and Their Museums

It is mundane to assert that were it not for artists, there would be no museums; artists, in turn, depend on museums for their reputations and market success. In the case of self-taught art, the issues are thornier.

Artists, if they are "authentic" outsiders, neither much know nor much care about the museum. The title of the essay in *The Artist Outsider* by Michel Thévoz, curator of the Collection de l'Art Brut in Lausanne, is "An Anti-Museum."[65] Several artists reject placing work in established museums, or, in the cases of Joe Barta or Rudy Rotter, establish their own, although most are flattered to have their works in museum collections.[66]

Other artists have close and positive relations with museums, even providing for these institutions in their wills. Georgia memory painter Mattie Lou O'Kelley left a trust of $1.5 million to be shared by the American Folk Art Museum and the High Museum of Art in Atlanta,[67] reminding us that to be self-taught doesn't mean that one need die poor. California artist Alex Maldonado included a provision in his will that 20 percent of the income from the sale of his work would be donated to the American Folk Art Museum. Aside from the generosity to the museum, this arrangement permitted each buyer to consider 20 percent of the sale as a charitable contribution, perhaps increasing interest in his work.[68] Baltimore artist Gerald Hawkes, closely associated with the American Visionary Art Museum, requested that his ashes be scattered in the wildflower garden of the museum.[69]

Some self-taught artists, not as close personally to a museum, find the idea of their work being displayed in a museum gratifying, and do what they can to encourage that inclusion. While most contacts do not result in a show, some do, making the strategy plausible. Through his own efforts self-taught artist Aaron Birnbaum was included in a show at the Brooklyn Museum of Art:

> Birnbaum recounts his first official recognition with great pleasure. "Some friends, they came over to my house and said, 'Why don't you have a show? They have a show at The Brooklyn Museum.' So I said, "How do you have a show?' I figure myself I am an amateur. But they said, 'Your pictures is nice.' And you know, I'll tell you, over there it is not so easy to get in at the Brooklyn Museum. You gotta first bring half a dozen pictures. And then they analyze your work. You gotta leave it there a long time. To my surprise I got a letter saying, 'You're admitted to a show and you can bring as many pictures as you want.' "[70]

While the perception of a museum is of an institution with more artworks than they could ever display, this is not always the case, and an artist can be in the right place at the right time, either because of the power of the work or because of the identity of the artist.

Museums are not only passive in their dealings with artists, but also

actively search out works. Artists are often asked to "contribute" their works to museums for which they will get a tax deduction. Robert Bishop invited Nounoufar Boghosian to donate one of her paintings to the museum's permanent collection, an honor, she felt.[71] Some curators don't feel that such strategies are quite proper, pressuring the artist in ways that a trained, established artist might not be pressured. One curator told me: "We do that to artists all the time I know, whether for the permanent collection or for an art auction . . . but I think knowing [the artist's] economic circumstances I just think that would be grossly unfair to do to him. . . . I really don't think it's fair to ask artists to give something, and also I think it doesn't show to me that the institution is really committed to it. When I read a label, I always feel the museum has worked a lot harder to get something when it's a museum purchase. I would rather see someone else [than the artist] donate the work" (Interview). She suggests that such a request suggests a lack of respect, even while the artist believes that such a request conveys respect.

Museums, with tight budgets, can supply stature and honor easier than cash. Self-taught artists often desire both. That these artists are not always aware of the market or the structure of the museum world can permit museum officials to play on their better nature in expanding the permanent collection.

Dealers and the Strategy of Placement

If one can consider many self-taught artists to be naive, the same cannot be said of dealers, often well versed in the machinations of museum politics. Indeed, dealers may at times serve as curators, particularly in smaller museums. The Paris show of Chicago self-taught art held at the Halle Saint Pierre was curated by a Chicago dealer, Judy Saslow, who included works from her collection, from the collections of friends and clients, and from artists she represented. While such a possible conflict of interest would be unlikely at major museums, it does occur at less established museums, and, given the nature of the venue, probably does little harm, and perhaps considerable short-term good for the museum, dealer, and artist.

Dealers and collectors of self-taught art consider themselves to be the frontline, feeling that the museums must strive to catch up;[72] while this is true, the museum provides the stamp of approval. Julia Ardery notes the role of the *Clarion*, the glossy magazine of the American Folk Art Museum, now renamed *Folk Art:* "Entering a folk art gallery today, one is likely to see the *Clarion* set out like an accent pillow. If the gallery owner

can't point you to a story about the artist he's trying to sell, then one of the handsome full-color ads does almost as well, if it touts another sales establishment. The *Clarion*, due to its link with the nation's premier folk art institution packs that much legitimation punch."[73] The inclusion of an artist in a museum collection can increase the standing of that work and can be used as a selling point, demonstrating art-world acceptance. With collectors often uncertain about the real value of the works they are considering and whether these values match the dealer prices, museum approval can persuade.

While dealers and museums are both major players in the art world, their interests do not coincide. Museums fret that dealers skew the art market toward available objects and those that they sell; dealers feel that museums do not recognize the central role of their galleries in keeping the arts alive and in generating support for museum programming.

During the first years of the Outsider Art Fair, the symposium organized by the American Folk Art Museum was held at nearby SoHo galleries (the Phyllis Kind Gallery, Cavin-Morris). A curator at the museum enthused, "I love this cooperation between the museum and galleries. There is that karma in the air" (Field notes), a statement that suggests that normally the relationship is difficult. After a few years the symposium moved to a larger lecture space at New York University, where the museum-sponsored folk art program is housed, rather than in gallery space.

Sometimes hostility is more evident as in the case of a museum official who describes a dealer (and implicitly other dealers) as being "this far from being a pimp," and a dealer who described a major curator as "having a bit of an attitude problem" (Field notes). Another dealer complained that a local museum with a show of self-taught art didn't direct anyone to her gallery; many employees were unaware of its existence. She notes, "museums don't think about this side of the market: sort of the dirty side. Museums are not in the business of promoting private dealers [although we promote them]" (Interview).

I do not suggest that a running battle exists between dealers and museums, but the tension is palpable in a way that it isn't with artists. Few dealers become museum curators and directors.[74] Yet some friendships do develop and these embedded relationships direct the flow of objects. As one dealer claimed, "You have to work with museums. You have to. I wouldn't work with a museum [if] I didn't establish a personal relationship with somebody. . . . There's museums I've sold things to, and I didn't like anybody there, so I never went back. [But at other museums]

I've been able to develop relationships because it was individuals that really care about the stuff" (Interview).

Although there are friendships between dealers and museum employees, there seem to be fewer of these ties than might be expected, perhaps because museum directors and curators feel self-interest undercutting these relations. The relations are relatively less embedded than those between dealers and collectors, where there is also self-interest, but perhaps less pressure in that a sale to any given collector means less than one to a museum, both in profit and prestige.

Ultimately the successful dealer must persuade museums to incorporate the work of their artists into the collection or to have a special show. This process is important for both dealers and museums, but is only occasionally successful.[75] One dealer commented about attempting to sell a piece to a major museum: "The curator kept my envelope on her desk for a year before she even opened it. The photos. I mean that was quite challenging to me not to lose my temper" (Interview). By not deciding—and museum bureaucracies can be slow—they prevent the dealer from approaching other museums or collectors, getting a quick return on his or her investment. There is considerable uncertainty about this process, as museums will often be close-lipped about their plans, and curators may not know what their Acquisitions Committee or the Board of Directors might decide.

Collectors as Donors

The relationship between the collector and the museum is structurally distinct from that between dealers and museums. It is true that, as always, each party desires something from the other, but the balance is different. While museum officials are routinely suspicious of the pecuniary motives of dealers, they cozy up to collectors, hoping for gifts, contributions, and other visible forms of support. One should not be cynical about this process: sincerity, after all, looks a lot like self-interest. We are often genuinely persuaded that what is right also is personally beneficial. A person without such a perspective would not have become involved in a social world. Still, observers sense a certain "ethical stretch," leading museum groups to issue ethical guidelines for proper behavior.[76]

One characteristic of major collectors—those who conceive of their objects as of "museum quality" and as belonging to art history—is the claim that they hold their collection "in trust." They are temporary curators, even while they enjoy the fruits of their efforts, financial and aesthetic. They protect their objects for future generations. If these comments appear self-serving, the emotion behind them is real and powerful:

I don't feel I own the collection. I don't believe that in theory any individual can or should own art. We as collectors are curators and conservators. Art belongs to history.[77]

* * *

[We] look at ourselves as curators, I really feel that. . . . I'm just somebody who's holding these pieces for the next generation. . . . Anything that can be done to further the artists and their work and their fame, I'm all for that.[78]

This emotion work is important for collectors with an antimarket mentality; collectors must be persuaded and must persuade themselves that they are not investors but benefactors.

COLLECTING RELATIONS. From the standpoint of museums, major collectors are targets. Everyone wants a piece of them, a tragedy of the rich. Just as dealers combine sociability with self-interest, so do curators. Major gifts are not given to strangers, but to friends, again emphasizing the embedded relationship as an economic engine. One major collector notes sarcastically: "All these museum curators are sophisticated con men and their craft is tricking the owners of the art they want into choosing them [for their gifts], and I see over and over, they'll do just about anything" (Interview). I was told that one museum director offered an artist a one-man show to gain access to his important collection; eventually another museum offered a full-career retrospective.

A collector with important works may be asked to serve on a museum's board of directors. In one case, a wealthy businessman pushed a museum to expand their collection of self-taught art, inviting the new director to dinner, vigorously reminding him of the "tremendous opportunity" and "untapped support available" (Interview). A person this benefactor admired and whom he had worked with was selected as curator, and this helped to cement his allegiance. As a result, the collector helped to raise a million dollar anonymous gift for the museum to build their collection. As he aged, he realized that he "couldn't take all this art with me," and so later gave the curator and the museum the bulk of his significant collection. The collector received a sizable tax deduction: in major gifts the nation's taxpayers are both givers and recipients. This collector's interest and wealth directly shaped the display of that museum, influencing what local citizens would be able to enjoy.

The High Museum of Art in Atlanta as part of their permanent display highlights the various gifts to the museum over the decades through sections devoted to particular collectors, reminding visitors how the strengths of the museum are intimately linked to choices of elites. How-

ever, investing in relationships has a downside; the investment can be lost if those relations sour. Further, in chasing the choices of collectors the museum may give up its professional authority. I was told that a benefactor decided not to make a large contribution because a museum did not select the curator that he thought best. Relationships can be productive, but give power to the emotions of the donor.

THE BLESSING OF LEGITIMATION. Although museums benefit from collectors, this is not the whole of the story. Museums confer status and through legitimating the collection in shows and gifts provide material benefits for collectors. Even if collectors see their effort as grounded in aesthetics, they benefit from the increasing economic value of their objects. As a result, some angle to have works from their collection included in shows (Interview). Particularly desirable is the one-source show—the museum exhibition and associated catalog of the objects of a particular collector.[79] Examples are shows of the Shelp collection, the Gordon collection, and the Gitter-Yelen collection. This is by no means limited to self-taught art; a notable recent example was the Brooklyn Museum's controversial 1999 *Sensations* show of objects from the Charles Saatchi collection.[80] Such an exhibit validates and often substantially raises the value of the collection; as such, it is a decision with consequences. A one-source show is a gray area for curators, even while these shows are still common in smaller venues. As one curator noted: "There is a kind of politics that goes well beyond the marketplace, because the marketplace is part of it that curators have to consider in dealing with works from any one source. It can act as a powerful sort of endorsement" (Interview).

This is particularly problematic if the collector serves as curator or heavily influences the organization of the show. In such cases, the perception of profit motive and conflict of interest rises. Non-profit institutions can benefit those they publicize. A curator who has organized one-source shows raises important questions: "Are collectors calling the shots? Are they making all the decisions? Is the institution just a front for their desires, promoting artists they want to promote? Are those valid curatorial decisions made or was it really collectors pulling the strings?" (Interview). Collectors may profit from the publicity if they sell their collection. Soon after the *O, Appalachia* show of the Lampell collection in the early 1990s the collection was sold. But even when the collection is not sold, the attention given to it and to the artists featured in the collection cause some museum officials to worry that they may have been used. Museum officials wish to convince others and themselves that their decisions have been made for the right, ethical reasons, but

often good and bad motives mesh together as when doing good allows one to do well.[81]

THE GIFT. The gift, combining emotion and commodity, aesthetics and economics, entails a relationship of trust and affiliation.[82] The gift is an offering, but an offering that may imply an obligation—a demand for status—and may result in other benefits. Museums, lacking the acquisitions budget to obtain all of the pieces they desire, depend on the largess of collectors—local and national. As one museum director echoed Blanche DuBois, "We are a collecting museum, but we are not a wealthy museum. Our collection is built on the kindness of friends and strangers" (Field notes).

In return they offer tax deductions and status markers, including engraved notation, just below the artist's name, of who donated the work. Some gifts, particularly major ones, are purchase-gifts. The museum pays the owner a portion of the appraised value of the collection and the giver contributes the rest. The acquisition in 1989 of the Michael and Julie Hall collection, 273 pieces, appraised at $2.3 million, by the Milwaukee Art Museum was such a purchase-gift. The museum, through individual, foundation, and corporate contributions, paid the Halls $1.55 million, and they contributed the rest.[83] The American Folk Art Museum paid Kiyoko Lerner $1 million for twenty-six paintings by the highly esteemed Chicago self-taught artist Henry Darger, and Lerner contributed the archive of Darger's writings with the understanding that the museum would preserve it for scholars.[84] Some museums auction off some of the lesser work, helping to pay for the purchase. The arrangement with the Milwaukee Art Museum benefited the Halls, the museum, and, presumably, the citizens of Milwaukee.

Museums frequently are offered gifts, and often these are unproblematic, readily accepted by the acquisitions committee.[85] The central problem for the museum is in deciding whether it really wishes to own those objects. There are expenses involved in being custodian of a collection, especially when those objects remain in storage.

Collectors may be motivated to give works to the museum either for prestige or for the tax relief involved. Because of the latter a powerful politics of appraisal exists. The works that are offered may not be what the museum wishes to own, but turning down a proffered gift may be awkward, creating ill will and diminishing the likelihood of a future gift. One museum director joked that a collector was once asked, "What do you do with your mistakes?" and answered: "I give them to museums." The director noted, "It's a problem, and we take them," although presumably they are more likely to accept those tax-deductible mistakes

from collectors with whom they have had and expect a long-term relationship. An accessions committee decides, supposedly based on quality, condition, and the fit with the museum collection. Yet, politics and strategy invariably affect decisions. Accepting second-rate work is akin to a loss-leader. One establishes a connection that hopefully will eventually bear fruit. Similarly, the museum might accept a large body of work of variable quality, obtaining both the wheat and the chaff.

The publicity value of gifts is such that some museums, including the American Folk Art Museum, organize shows in which the unifying theme is that the objects were recent gifts, suggesting that the generosity of donors is sufficient to connect otherwise disparate works, a model for other collectors. Some museums have special labels for recent donations and give special attention to the gift and the donor in their newsletter.

Major bequests are welcomed by institutions, but this is not always the case. William Arnett reports of his collection of African American vernacular art: "In the early nineties, I identified several institutions that, on paper, were the right ones at the time for the collection, and offered to donate my collection to them. Unfortunately, each had internal conflicts I wasn't aware of . . . so fate always intervened to prevent the gift from occurring." [86] While the details of the negotiation are not described—such as conditions of display or issues of appraisal—the fact that a gift may be declined suggests that there are institutional benefits and costs.

Negotiations are more complex if one is selling a collection, even if the arrangement involves a substantial gift. Herbert Waide Hemphill attempted to organize a purchase-gift arrangement for about a decade, approaching the Museum of International Folk Art in Santa Fe and the Milwaukee Art Museum, before consummating a deal in 1986 with the Smithsonian's National Museum of American Art, an acquisition of 378 works at a price of $1.4 million, plus a substantial gift. [87] Even though the cost to the museum was significantly reduced, it did involve allocation of resources for acquisition and display, a matter of organizational politics. The fact that the Halls approached the Milwaukee Art Museum soon after the negotiation with Hemphill had ended, may have impelled the museum to act with alacrity. [88] For these museums such arrangements connect to institutional impression management. Each museum must decide how it wishes to appear to its public and what art to emphasize. No museum has the resources to cover everything. Like universities, law firms, or hospitals, some departments will be stronger than others, and this reality affects the investment of resources. The opportunity for a purchase-gift like the Hemphill or Hall collections directs attention to

the museum among the supporters of that artistic arena, but simultaneously means that the museum may lack resources for other acquisitions, and may be stereotyped on the basis of their choice.

Russell Bowman, the former director of the Milwaukee Art Museum, commented that in the eight years since the purchase of the Hall collection, the museum had received three hundred gifts of self-taught art (Field notes), gifts that would have been less likely without the awareness that the institution had this interest. Just as collectors create their personal displays, so do museums. Yet gifts, out of the museum's hands, emphasize the importance of chance in the establishment of organizational reputation. While museums shape the interests of collectors, collectors do the same for museums.

Creating Institutions

Many activities within art worlds are based on personal interaction, reflecting the expression of an individual's interest. However, surrounding this interaction is a set of institutions—the state and the museum—that shape how art becomes institutionalized. No social world in contemporary society can survive without connections to powerful institutions.

As the discussion of state involvement emphasizes, these relationships can be helpful or malignant in building a social world; further, the art world, seemingly minor and insignificant, can help legitimate the state, constantly in need of bolstering in the face of claims of incompetence, dishonesty, and irrelevance. It is a dramatic realization that a state can dole out millions to art institutions and to artists, and can also, when it sees its own or other powerful interests attacked, destroy works of art, even in the face of opposition from art-world principals.

Museums, of course, are not in the business of destroying artworks, but their choices can be as controversial. The decision of what to purchase and what to exhibit affects how we come to understand the collective representation of our cultural heritage. In effect, the decisions of museum curators affect how we perceive the value and rarity of works and of a field of works. Of course, there are multiple institutions, each competing for public attention, so institutional hegemony is not as strong as it might otherwise be, but still proponents of self-taught art recognize that the bastions of high culture have had only a passing interest in this field. Whether this is because these are naturally conservative institutions, and the intense interest in contemporary self-taught art is barely three decades old, or whether the value of authenticity as opposed to credentialed competence is unpersuasive, remains to be seen.

The choices of displaying, purchasing, receiving, and requesting art-works gives museums considerable institutional heft, and artists, dealers, and collectors use museums, just as they are used by them. In the process, the museum creates a public image—a reputation—that affects its own standing in the art world. The reputation of the artist has its parallel in the reputation of the museum.

8

creating

art worlds

This is a book about everyday genius: about remarkable people who toil, sometimes in the face of indifference, sometimes in the face of impassioned fascination. I refer to self-taught artists, but I also refer to dealers, collectors, curators, critics, and art historians. These men and women claim that the lack of professional credentials, and the idea of authenticity constructed by this absence, might not serve as a barrier, but also might suggest, in its own right, that attention needs to be paid.

In concluding, I expand my argument from the local concerns addressed throughout the book, for, as I suggested in the introduction, my concerns are larger than to explain a particular social world, even if these details have a particular provenance. What can be said about this narrow sliver of the art world has implications for the larger part of art and beyond. I discuss core concepts that are helpful, not only for understanding this art world, but any art world, and indeed other social systems. Self-taught art

depends on a community and a market. In this, despite its manifest singularity, this world is like other communities and markets. The domain of self-taught art is a social system writ small, but it is a social system nonetheless.

Before turning to this set of concepts, I underline three broad concerns—embedded relations, multiple roles, and the politics of authenticity—that animate my analysis, allowing me to generalize from this detailed case. The examples presented throughout the text speak to these issues, but nowhere are they clearer than in the position—the problem—of Howard Finster. In my account, it becomes clear that the ability of dealers and collectors to be touched by Reverend Finster—to hear the blistering cadences of his brimstone sermons in his ramshackle chapel in Paradise Garden, contributed to the value of his productions. "Memories of Howard" were part of the worth of the object, and many collectors narrated dramatic or humorous anecdotes of their encounters with this country preacher, so different from urban ministers or rabbis and their cool and bleached liberal religion. So, too, we recognize that the Finster clan cannot be placed in any easy category. They—and particularly Finster's daughter Beverly—have gone to great lengths to become dealers of the work of the family, even setting up a 1–800 telephone number to the dismay of some. The gifts that Reverend Finster has received from artistic admirers over the years makes him a collector as well. Finally, and for many reasons, the issue of Reverend Finster's authenticity is a loud and lively debate, not for him, but for his market. Did his choice to use markers, rather than paint, change him; did the role of the family as helpers limit his vision; did his decision to paint rock album covers mean that he sold out? I do not have answers for these questions of authenticity, but the fact that they were asked and answered so frequently and with such passion suggested that the issues mattered deeply.

EMBEDDEDNESS. First, this market, like all markets, is embedded in social relations. The routine connections among people allow for economic transactions. In real worlds it is impossible to think of pricing strategies through a formal neoclassical supply and demand model of rational, isolated actors. The value of objects is linked to communal assessments that are based on social relations tied to reputations involving trust, morality, and esteem. Known and established reputations are essential in creating a location of a producer in the vertical hierarchy of the market. These collective images permit a *social cartography* of value. The expressive character of the work, the desire to use artistic objects for identity purposes, and the intersections among artists, collectors,

dealers, curators, and critics create a market, unstable as it sometimes appears.

MULTIPLE ROLES. Second, in many tightly networked social worlds with varied positions, roles are not so easily distinguished as they are often assumed. Individuals, here as elsewhere, often enact multiple roles, either sequentially or simultaneously. Involvement within a social world does not necessarily imply the persistence of a position within a division of labor. This case is impressive in emphasizing how many seemingly distinct roles one individual can enact. Few dealers are only dealers, as are relatively few curators, critics, and academics. While being a collector is often an entry point, many collectors eventually broaden their roles, curating, dealing, or writing critical commentary. It is in the detached position of the self-taught artist—spatially and socially—that this domain stands apart from other artistic realms. Unlike contemporary art, self-taught artists are often—although not always—locked in a role, often only ambivalently or passively relating to others in the art community.

AUTHENTICITY. Third, the politics of authenticity is central to this art world. In a domain characterized by an antimarket mentality, elites strive for objects that are not created for the purpose of economic transactions or for strategic investment. While this may be an illusion, it is important in creating the value of the object. Self-taught artists excel in displaying their authentic identity—either in fact or through the construction of their biographies. Such individuals are part of a market by virtue of their production decisions, but they must be defined as being external to it. The meetings of dealers and collectors with artists are themselves constructed as authentic, just as are their biographies and their productions. While this social world reveals a striking instance of the politics of authenticity, it is by no means the only such example, as is evident in other production and distribution markets, such as ethnic restaurants, blues clubs, musty antique shops, or vintage clothing stores. Within various social segments, and on particular occasions, there is a burning desire to find—and to purchase—the "real thing." These are objects that reveal heritage and reveal soul. The claimed authenticity of objects rubs off on the purchaser, particularly in a society that values diversity and an expansive tolerance as expressed through commodified markers of taste.

Boundary

For a system of organizations and persons to be seen as a social world, a label must stick. That is, this domain must be recognized—internally

and externally—as constituting a meaningful entity. Organizations rely on these social designations to legitimate their practices, even while the labels, and their implications, help to shape them. For instance, we do not find art-world categories of "crayon art," "yellow art," or "art of rural Alabama," even though some pieces are made with crayons, are yellow, or are from rural Alabama.[1] The naming—and the existence—of the adjoining fields of self-taught/contemporary folk/outsider is based in human choice. That these domains are now seen as "going together" is neither inevitable nor eternal. We collect what we decide belongs together. Even wild collectors such as Bert Hemphill who was said to collect "everything," did not in fact collect "everything," even if he could not easily describe the implicit aesthetic criteria on which his selections were made.

Over some thirty years, an image of an artistic field has developed, and with that image, we find an infrastructure and a politics. It is here that Pierre Bourdieu's concept of field of cultural production becomes relevant. A field for Bourdieu reflects a structured set of positions. The relationship among these positions is a function of the distribution of various forms of *capital*—human, economic, social, and cultural. As a result of these connections each field—self-taught art in this case—has a distinctive bounded authority.[2] In this, self-taught art mirrors other collecting domains within the arts and elsewhere.

As a historical matter, Julia Ardery argues that the Civil Rights movement and the radical politics of the 1960s helped to establish this field, but, to the extent that this argument is valid, it is valid because these movements altered the cognitive boundaries, forms of capital, and preferred identities for a set of social actors—both those who were inspired to make objects and those who were inspired to collect those objects under the rubric of "art" and not, say, craft, hobby, or personal decoration. The desire to collect and display objects made by people who know little about art is not an inevitable or unproblematic decision, but connects to what people feel are valuable and are suitable for display—what makes their homes beautiful and morally worthy. Even if such creators have existed throughout human history, the productions have not often been given the honorific title of art. Other fields have comparable historical backgrounds, such as the growth of documentary photography in the 1930s, pop art in the 1960s, and feminist art in the 1970s. Politics provided rhetoric that established the basis for claims that these domains should be treated as artistic and economic categories.

Following on the acceptance of cognitive claims comes the drawing of boundaries. Perhaps as central as defining what something is, is the

process of determining what something is not. Boundaries are often hazy and become social markers. How minimal does something have to be before it is "minimalist" and collectible as such? How self-taught must an artist be? Who decides? Put this way, it is clear that here, as elsewhere, boundary drawing is a social phenomenon, as often linked to the identity of the creator or the sponsor as it is to anything about the object itself. So, the minimal quality of minimal art is not on the canvas (or not entirely), but in the social relations of the artist and the theory ascribed to its creation.

There are no objective signposts for the edges of domains. Some self-taught artists have attended art schools, and some who have never attended would not be so labeled. Boundaries require border guards, and here critics, dealers, and academics stamp some passports, while rejecting others. That many artists do not much care how they are labeled gives the power to others, and the nature of self-taught art as an outsider domain makes this ideological, suggesting that if you claim to be an outsider (i.e., if you recognize the boundary), you are not.

Voluntary domains with social standing are particularly likely to have boundary concerns, as status goods are associated with belonging. Further, a social world requires a cognitive organization, as well as a social organization, to permit participants to choose courses of action.[3] As a result, boundaries provide structure, separating inside from outside, creating vertical hierarchies of value, and distinguishing one type of object from another. It is not only in the realm of aesthetics that boundaries operate to separate and to organize, but in nationality, race, or class. Categorical systems provide mental clarity.

Biography

We search for the real. Yet multiple strategies exist for determining the real: the art produced by experts can be felt to be real, as can the impulses of those who are untutored. Competing justifications for rarity and value can exist simultaneously, and these rationales emerge through interaction and through power relations among those with different amounts and types of resources.

In this art world—and, as a domain of activity, it is hardly unique— the character and standing of the producers matter. I speak of this domain as "identity art," not to diminish the aesthetic power of the art or the moral standing of participants, but because it is primarily defined through the characteristics of producers. Without this attention to identity, there would be no specialized galleries, museums, magazines, and

conferences. While every artistic domain engages in biographical work, within much of the rest of the art world identity is not perceived or discussed as salient. The domains of African American art or women's art remind us that self-taught art is not unique in its emphasis on identity. However, the fact that we speak of Dutch seventeenth-century art or Japanese ceramics suggests that even here artists are being characterized by their social placement. The emphasis on the characteristics of artists, naturalizing them and their art, is not inevitable, but is a part of a *strategy* in which members of marginalized and disenfranchised groups can become promoted to gain "a piece of the action." What sets self-taught art apart from other groups that play on the demography of the artists is that the self-taught typically do not speak; rather others presume to speak for them—ventriloquists of the muted virtuoso. In this, they have some similarity with the legions of artists now deceased—art-world players become their mouthpiece. Perhaps art-world elites are not so different from advocates for the homeless, the mentally ill, welfare recipients, children, fetuses, fish, trees, and so forth, where social movement activists claim the right to speak for those whose cause they so vigorously trumpet.

This case goes beyond identity politics, though, in that stigma is not dissolved, but venerated. The stigma validates the authenticity. It is the absence of training—the isolation of the artist from the art world, its visual culture, its network, and its ideology—that contributes to the perception of the work. Ignorance of art history and artistic politics constitutes its "value-added" quality. By its differentiation, identity art simultaneously elevates as authentic and denigrates as lacking expertise. It is easy to appreciate why some proponents of the work wish to erase the identity marker. This tactic could represent the final step of acceptance—*just becoming art*. The formal characteristics of the work would validate it, although even here, there is a value-added quality of reputation, linked to the public persona of that artist.[4]

For leading self-taught artists, such a strategy might be plausible. An altered justification would change the price structure of the field, linking it to higher-priced domains, and, equally important, it would shift the field's very justification. It could rend the field as artists become linked by their characteristic style, rather than on their outsider biography and public identities. Self-taught art is a field in which memory painters, whose works are detailed and precise, and blind assemblers of found objects are considered to belong to the same domain. There is no essential reason why that connection should remain, but an alteration would entail a restructuring of social relations within field. The linkage is tied to

the authority of authenticity. These artists are expected to speak "from the heart," rather than from specialized art-world knowledge, and their work is said to represent "art for art sake," rather than being driven by coarse market forces.

Art

Art is a dangerous word, a concept that claims both too much and too little. What is art, and, recalling the discussion of boundaries, what is not? The dilemma of drawing boundaries—the absence of formal criteria that effectively include and exclude—have led some, such as the philosopher George Dickie, to propose an institutional theory of art.[5] Put simply, this approach suggests that art is whatever is found on museum walls, or put another way, art is whatever experts in the art world claim that it is. This is reception theory grounded on privileged expertise. For some, including the critic and philosopher Arthur Danto, art is a function of what can be justified using a constructed aesthetic theory.[6] Changes in art worlds provide powerful support for the view that "eternal beauty" is not centrally implicated in aesthetic definitions.

Let us grant that Bill Traylor produces "drawings"—he draws on cardboard—but are these things art? Are the doodles of bored academics listening to unstimulating speakers to be considered art? What about the work of cartoonists? What about the crayoned efforts of four year olds at daycare? What about the sketches that professional artists make *in preparation* for creating? All are drawings, and so perhaps are art. Perhaps everything is art—or can be with the proper sponsor. To escape this troubling and promiscuous conclusion some suggest that art must appeal to audiences in particular ways, or that art needs to be motivated by a desire to express feelings or thoughts, but, alas, these approaches, attempting to set boundaries, seem little more definitive in practice than claims that what some expert thinks is art is art. Audiences can be swayed, change their minds, or be involved in identity politics. Creators can produce objects that others find appealing without the recognition that they are artists or that they are producing for an interested audience.

Self-taught art raises this issue precisely because art-world insiders create value and evaluate works using a vertical hierarchy.[7] Some works are judged better than others, just as some classes or genres of work are seen as having more artistic value. Visitors ignore some yards filled with stuff and stop at others. The attempt to develop a system that is based on "connoisseurship" depends on the existence of someone labeled a connoisseur, an evaluator: a person with the reputation (credentials and

an aesthetic theory) to persuade others to accept his or her assessments. The idea of quality ratifies a system of power. Power cannot be wished away in social systems; it is always present and is essential for social order. Systems of power are not inherently evil, but, like all social systems, they do give priority to some rather than others, creating hegemony.

Because of the desire for hierarchy, art refers to a set of objects, linked to ideas, ideologies, and symbols that have been ratified by those with power and with resources. In systems that are not heavily elitist, a chorus of divergent voices competes, and institutions grounded in varied social positions embrace dissimilar artists. Art in practice is not an anarchic scramble, but pluralist systems of connoisseurship that draw attention to a panoply of creative productions. Reputations depend on multiple criteria of judgment, making the establishment of esteem a contested tournament. Because self-taught art does not depend on the credentials of its maker, it requires alternative strategies to establish worth, such as claims of moral purity or psychic necessity. These alternative values permit this artistic domain to stand beside other artistic domains.

Collections

Art is not the only stuff that we collect, as the example of gathered and displayed crack vials revealed. Stamps, coins, erasers, jewelry, bottle caps, and leaves can make a collection, becoming durables in the process. Each set is seen as having collective or co-joint meaning, as cognitively and materially belonging together, and as revealing the interests of their gatherer. When these objects are defined by a segment of society as having worth—that they are "liquid" and can regularly be exchanged for other things—a market develops, often around a community.

Art represents an archetypal instance of a collectible, even if, unlike some collectibles, such as stamps and coins, there is no possibility of collecting all instances within in a domain. One must rely on a sample of the types of objects available, even if some collectors ("autograph collectors") strive to acquire works by each of the artists who is recognized to be a known figure in an artistic category. Unlike coins, stamps, books, and other mass-produced collectibles, art objects are unique goods, and so the quality of their characteristics—the process of their making—rather than the completeness of a set, is the criterion for evaluation.

The essence of collecting is not only that one collects "objects," but that in collecting objects, one also acquires memories and stories. Collections, as they are used, are built on talk. They are objects of narrative, and not only vision. Within self-taught art, particularly given the emphasis

on authenticity, many collect visits to artists—the "folk art adventure" or "road trip." The collection of experience parallels the collection of evanescent objects—mushrooms, bird sightings, and so forth. These are conceptual collections. Although in some regards the goal is to find objects to serve as souvenirs, equally important is to find artists, cross-class friends, and new experiences: a set of stories that one can share, revealing the authenticity of one's collection and one's intrepid skills. In the process the collector's life history may be transformed in ways that are subtle or dramatic.[8]

These stories—and their objects—remind us that collections are a status game, not necessarily a negative assessment, but in recognizing that they order a social group, fashioning a hierarchy. Collectors compete, as other collectors are the reference group by which a person judges his or her worth. That collectors enjoy visiting the displays of other collectors suggests that not only do they wish to see new objects and hear stories, but also that they wish to assess the collectors of these objects and stories. In a society that values commodities—where objects often provide a key into public identity and a private sense of self—the collection epitomizes this process. The identity in identity art refers not only to the creator but also to the person who displays the work.

Community

Throughout this analysis I have emphasized that the world of self-taught art constitutes a community of concern. Admittedly it is a divided community, a world with distinct, yet overlapping roles. However, the recognition of community implies that these individuals belong together. Even the image of the market is based on the community on which it stands.

As with all communities, this world is filled with friends, although the extent and the contours of these friendships vary from world to world. In social systems in which there is continual and motivated interaction, people become, at the least, friendly acquaintances, and this mutual adjustment smoothes interaction. This does not mean that every participant in the social system likes one another. This is not the case; still, for a social system to continue, there must be the assumption of colleagueship. One pretends to like and admire those who in their absence are the topic of critical gossip.

Like most social worlds, this is also an economic world. It is unjust to suggest that artists, collectors, and dealers are "in it for the money," but the money has causes and effects, and cannot be disentangled from choices of what to buy and sell. Some in the world—artists and deal-

ers, most particularly—depend on others for their livelihood. Since I observed during a period in which the field was growing and in which the economy was robust, the economic stress was not palpable, but a sudden downturn could easily alter the community. Indeed, even in these good times, some dealers failed, and many recognized that despite their dreams, representing self-taught artists alone was not a lucrative survival strategy. In hoping to specialize, but being unable to do so, they were not alone in recognizing the limits of their dreams.

In art worlds, the collector is at the heart of the economic system; the collector invests in art, and in so doing permits the continued activity of dealers and artists. The collector becomes the lynchpin. Particularly in artistic domains that do not rely on museum purchases, the largess of the collector is essential, and this means that dealers and, to some degree, artists and museums depend on the desires of collectors.

Even though the idea of community is important—and the institution of the folk art adventure underlines this—participation is bounded, not comprising the whole of any participant's life. For collectors, this domain is a voluntary, partial activity, one that can be exited or placed on hold when interests or financial conditions change. It is a supplement to other things that are considered to be of equal or greater importance. So, too, can it change with increased investment when the collector becomes a dealer, curator, or critic. The ability of participants to switch roles permits either an increased or decreased investment.

Market

While participants in art worlds often downplay the significance and the centrality of markets, the fact that art is a commodity is one of its most salient features. Art and money cannot—in western societies certainly—be divorced. However, art is a distinctive market. Central is the extent to which the market depends on embedded exchange relationships. That is, people deal with others with whom they have long-standing relations. This system has effects in that these long-standing ties build trust. Because one is likely to continue to see the person with whom one has traded, a strong pressure is felt to act in accord with community standards. Indeed, one reason that so many ethical issues exist between artists and collectors and between artists and dealers is not that they are from such different cultural worlds, but rather that they are unlikely to interact on a routine basis. The social control that develops from routine interaction is absent. Dealers and collectors can mistreat artists without suffering the consequences of trust being undercut. To

be sure, this does not explain the whole of the problem of ethics, but it suggests that trust is absent when routine relations are uncommon. In such circumstances, even a rubber check may have few consequences.

As an economic world, part of the problem of selling self-taught art is that alternate chains of connection exist between buyer and seller. In many cases—those that deal with living artists—collectors choose to bypass the gallery, negotiating directly with the artists, subverting the investment that the dealer has made in the artist and diminishing the dealer's motivation to promote the artist's career. In such a circumstance the dealer is competing directly against his or her supplier, and because these suppliers, the artists, do not have the dealer's overhead or have to pay the dealer's percentage, they can offer collectors better terms. The stability of the division of labor in worlds of contemporary art in which many artists are loath to compete with their dealers provides a more structured pricing system, or at least one in which the distributor has priority in price setting. In some instances, when artists and distributors compete, the latter are not disadvantaged. Some musicians sell their tapes and CDs at concerts for the same price (or more) than retailers, providing only convenience. Market relations between producers and distributors can be constructed in various ways. Here the relations are a function of the assumption of a personal relationship between the artist and the visiting collector.

The objects that are produced, even by artists with few luxuries themselves, are luxury goods, tied to the purchaser's sense of identity and belief that such objects will improve his or her quality of life. However, this realization destabilizes the market. Price can rise rapidly if some object—like tulips—becomes suddenly fashionable. But because these objects do not fulfill material needs, purchases can be deferred under economic strain. This reality places the needy artist and the dealer, a small and undercapitalized entrepreneur, at considerable risk from the vagaries of the market, no matter how embedded their relations.

Everyday Genius

As Howard Becker has pointed out in *Art Worlds*, art is a system of collective action suffused with conventions and expectations. This examination confirms his powerful insight. However, perhaps more than has been recognized, the fact that an art world is a community and a market affects relations among the parties, including institutions such as the state and museums. Having emphasized this point, such an approach, which downplays the creators' expressions and the viewers' responses,

may direct attention from the wonder, magic, and transcendence that some find in the work itself. Even if social scientists argue that such emotions are themselves collectively organized, they feel quite real to those who experience them. The numinous quality of art cannot be disentangled from its material qualities.

Perhaps our aesthetic response derives *directly* from the work or perhaps it emanates from our emotion work in capturing how we feel that we should feel. By playing an emotion, we may subsequently come to feel that emotion. By saying that a set of artworks are beautiful, in time we come to feel their beauty, and we cannot imagine how we might ever have felt otherwise. It is for this reason that being introduced to an artistic field by friends is particularly effective: it forces us to make the effort to pretend to like works that we might otherwise have passed by blindly. Aesthetic power becomes *real* because of such efforts at sociability.

As a formal aesthetic domain, self-taught art does not coalesce well: too many styles, media, forms, and contents jumble together—and no compelling, consensually held theories permit viewers to distinguish levels of quality. Collectors are told to rely on their own judgments—what moves them—but in a world in which elites are surprisingly insecure about their own taste, this forces a searching for other guarantors of quality. Often, here and elsewhere, we settle for collecting a list of names—a canon—that credentialed others have assured us reflect good taste. Still, unless these names are tied together aesthetically, their presence does not solve the problem of aesthetic unity.

What makes this a recognized sphere of work—a field that can be collected and sold—is the identity of the artists, not of their works, and, in this, the only thing that is common, given wide demographic differences, is their outsider, folk, and self-taught status—however those terms are defined. While one may wish to focus on the work itself, when considering the *field*, we have no choice but to focus on the artist. If self-taught artists lack the formal credentials of so many in art markets, they do not lack talent, vision, and wisdom. For all of their social marginality, these men and women are blessed with the gift of everyday genius.

Notes

INTRODUCTION

1. David Halle, *Inside Culture: Art and Class in the American Home* (Chicago: University of Chicago Press, 1993), 128–34.

2. Howard S. Becker, *Art Worlds* (Berkeley: University of California Press, 1982).

3. Arjun Appadurai, "Commodities and the Politics of Value," in *The Social Life of Things: Commodities in Cultural Perspective,* ed. Arjun Appadurai (Cambridge: Cambridge University Press, 1986), 6.

4. Gary Alan Fine, *Difficult Reputations: Collective Memories of the Evil, Inept, and Controversial* (Chicago: University of Chicago Press, 2001).

5. Howard S. Becker, "La Confusion de Valeurs," in *L'art de la Recherche: Melanges,* ed. Pierre-Michel Manger and Jean-Claude Passeron (Paris: La Documentation Francaise, 1994), 11–28, available in English ("Confusions of Value") at http://www.soc.ucsb.edu/faculty/hbecker/Confusion.html.

6. Pierre Bourdieu, *Distinction: A Social Critique of the Judgement of Taste* (Cambridge: Harvard University Press, 1984).

7. This is by definition. In practice, some self-taught artists, such as Malcolm McKesson, have had formal training in the arts. Whereas many "trained," mainstream artists lack that training.

8. With the integration of women into all domains of the contemporary art world, the category of "women's art" seems to have diminished.

9. Michael P. Farrell, *Collaborative Circles: Friendship Dynamics and Creative Work* (Chicago: University of Chicago Press, 2001).

10. Harrison White and Cynthia White, *Canvases and Careers: Institutional Change in the French Painting World* (New York: Wiley, 1965); see also Serge Guilbaut, *How New York Stole the Idea of Modern Art: Abstract Expressionism, Freedom, and the Cold War* (Chicago: University of Chicago Press, 1983).

11. Becker, *Art Worlds,* 258–69.

12. Admittedly there are numerous stylistic groups in the contemporary art world, and many, if not all, might consider themselves "out of the mainstream."

13. Personal communication, Lee Kogan, 2002.

14. Becker, *Art Worlds,* x.

15. In certain instances, worlds of activity and worlds of theory diverge in practice. See,

for example, Samuel Gilmore, "Schools of Activity and Innovation," *Sociological Quarterly* 29 (1988): 203–19.

16. Paul DiMaggio, "Market Structure, the Creative Process, and Popular Culture," *Journal of Popular Culture* 11 (1977): 436–52.

17. The numbering of the Beatles' White Album played upon this idea of producing a unique multiple, but of course that was designed to make a point about authenticity, rather than to create a collectible as such.

18. See Sally Price, *Primitive Art in Civilized Places* (Chicago: University of Chicago Press, 1989); Robert Goldwater, *Primitivism in Modern Art* (Cambridge: Harvard University Press, 1938); Shelly Errington, *The Death of Authentic Primitive Art and Other Tales of Progress* (Berkeley: University of California Press, 1998); Fred Myers, *Painting Culture: The Making of an Aboriginal High Art* (Durham: Duke University Press, 2002).

19. For a useful, episodic history of the development of American self-taught art, focusing on the South, see Lynda Roscoe Hartigan, "From the Sahara of the Bozart to the Shoe That Rode the Howling Tornado: Collecting Folk Art in the South," 43–61, in *Let It Shine: Self-Taught Art from the T. Marshall Hahn Collection,* ed. Susan Mitchell Crawley (Jackson: University Press of Mississippi, 2001).

20. John MacGregor, "Art Brut Chez Dubuffet," *Raw Vision* 7 (Summer 1993): 46.

21. Roger Cardinal, *Outsider Art* (London: Studio Vista, 1972).

22. John Michael Vlach, "The Wrong Stuff," *New Art Examiner* 19 (September 1991): 22.

23. Robert Bishop and Jacqueline M. Atkins, *Folk Art in American Life* (New York: Viking Studio, 1995), ix.

24. Vlach, "Wrong Stuff," 22.

25. Beatrix T. Rumford, "Uncommon Art of the Common People,"13–53, in *Perspectives in American Folk Art,* ed. Ian Quimby and Scott T. Swank (New York: Norton, 1980), 23–25; Daniel Robbins, "Folk Sculpture without Folk," 45–61, in *The Artist Outsider: Creativity and the Boundaries of Culture,* ed. Michael D. Hall and Eugene W. Metcalf Jr. (Washington, D.C.: Smithsonian Institution Press, 1994), 45.

26. Robert Bishop, preface to *Andy Warhol's "Folk and Funk,"* by Sandra Brant (New York: Museum of American Folk Art, 1977), 3.

27. See Jane S. Becker, *Selling Tradition: Appalachia and the Construction of an American Folk, 1930–1940* (Chapel Hill: University of North Carolina Press, 1998); and Robert Cantwell, *When We Were Good: The Folk Revival* (Cambridge: Harvard University Press, 1996).

28. Rosemary O. Joyce, " 'Fame Don't Make the Sun Any Cooler': Folk Artists and the Marketplace," 225–41, in *Folk Art and Art Worlds,* ed. John Michael Vlach and Simon J. Bronner (Logan: Utah State University Press, 1985), 238.

29. Sidney Janis, *They Taught Themselves: American Primitive Painters of the 20th Century* (New York: Dial Press, 1942).

30. See Julia S. Ardery, *The Temptation: Edgar Tolson and the Genesis of Twentieth-Century Folk Art* (Chapel Hill: University of North Carolina Press, 1998); and David Whisnant, *All That Is Native and Fine: The Politics of Culture in an American Region* (Chapel Hill: University of North Carolina Press, 1983).

31. Shows included important exhibitions in Minneapolis and Atlanta. Particularly notable in the period was the volume by Herbert W. Hemphill Jr. and Julia Weissman, *Twentieth Century Folk Art and Artists* (New York: E. P. Dutton, 1974), sometimes known

affectionately as "The Book." See Julia Weissman, "Bert," *Folk Art* 23, no. 3 (Fall 1998): 50.

32. Jane Livingston and John Beardsley, *Black Folk Art, 1930–1980* (Jackson: University Press of Mississippi, 1982).

33. Southernness and its images pervade the involvement of collectors, curators, and dealers. One southern academic described herself as "a creature of the South" (Interview), and the interests of a prominent New York collecting couple were attributed to their (long-ago) southern upbringing (Sandra Kraskin, preface and acknowledgments to *Wrestling with History: A Celebration of African American Self-Taught Artists* [New York: Sidney Miskin Gallery, Baruch College, 1996], 2). On the other hand, Northerners will attribute *their* interest to the otherness of the region, such as the enthusiastic Boston "born and bred" curator who had never been below the Mason-Dixon Line, and felt "the South was so . . . so foreign" (Cynthia Elyce Rubin, "Southern Exposure: One Curator in Search of an Exhibition," *Clarion* [Spring/Summer 1985]: 28–39).

34. Kenneth Dauber, "Pueblo Pottery and the Politics of Regional Identity," *Journal of the Southwest* 32 (1990): 576.

35. Interestingly it is not only region that serves as an organizing principle, but "state," an artificial political construction, is seen as a natural criteria for aesthetic organization, although one must admit that the organizational structure (museums being funded by *state governments* plays an important role). Thus, shows at secondary art museums will often focus on *Folk Arts of [state]*, even influential shows such as the *Spirited Journeys* show, organized by the Archer M. Huntington Art Gallery of the University of Texas at Austin, focused on folk artists of Texas, tied not to birth, but to adult residence. Even though these artists are highly varied, they are seen as "belonging together" as the image of states have a cognitive power (see Eviatar Zerubavel, *Social Mindscapes* [Cambridge: Harvard University Press, 1997]). Lynne Adele, the show's curator, responded when asked if there is something that makes these works "uniquely Texan," "I think there's such a strong sense of place that comes through their works that makes them very Texan" (Patricia C. Johnson, "Spiritual Journeys," *Texas*, 9 August 1998, 8). One informant in discussing why there are relatively fewer folk artists living in Tennessee than in Alabama or Georgia, expressed his belief that *Tennessee* folk artists tend to be hard living, hard drinking, and die young (Field notes). Dealers, particularly those from large states such as California, Texas, or Florida will often focus their inventory on artists from their state.

36. Wisconsin is seen as having a vibrant folk art tradition, perhaps because of the interest of the Kohler Arts Center and the Milwaukee Art Museum, while neighboring Minnesota does not (despite the jokes of one Wisconsin museum official that the it is a function of the cold, indoor winters [Field notes]). The same is true among collectors.

37. Barney Glaser and Anselm Strauss, *The Discovery of Grounded Theory: Strategies for Qualitative Research* (Chicago: Aldine, 1967).

38. For publication of all direct quotations from e-mails to this list I have obtained the approval of the authors. Some requested anonymity for publication in this volume.

CHAPTER ONE

1. The description in this section is a synthesis of events that I have witnessed and heard about Folk Fest.

2. Gerald L. Pocius, "Art," *Journal of American Folklore* 108 (1995): 413.

3. Larry Shiner, *The Invention of Art: A Cultural History* (Chicago: University of Chicago Press, 2001).

4. In this, I use "field" to refer to a community of interest, rather than the more specialized, theoretical meaning of Pierre Bourdieu.

5. Quoted in Robert T. Teske, "What Is Folk Art? An Opinion on the Controversy," *El Palacio,* 1982, 34.

6. A gallery in Atlanta is, oddly, named "Modern Primitive Gallery." A person associated with the gallery explained that, "The terminology behind the gallery . . . seems to be a good deal more significant to the critics and the academics than it is to us. We really want it to evoke a feeling for a large and vast and varied group of artists. . . . 'Modern Primitive' seemed to be ambiguous enough to sum it all up" (Interview).

7. Roger Cardinal, *Outsider Art* (London: Studio Vista, 1972).

8. Paul Arnett, "An Introduction to Other Rivers," xiii–xxii, in *Souls Grown Deep: African American Vernacular Art of the South,* vol. 1, *The Tree Gave the Dove a Leaf,* ed. Paul Arnett and William Arnett (Atlanta, Ga.: Tinwood Books, 2000), xv.

9. Some, such as critic Jerry Cullum ("From the Guest Editor," *Art Papers* 22, no. 1 [January/February 1998]: 7), suggest that the term is the most inclusive term for this unwieldy category.

10. For a discussion of contemporary term warfare, see Jenifer Penrose Borum, "Term Warfare," *Raw Vision* 8 (Winter 1993–1994): 24–31, and Charles Russell, "Finding a Place for the Self-Taught in the Art World(s)," in *Self-Taught Art: The Culture and Aesthetics of American Vernacular Art,* ed. Charles Russell (Jackson: University Press of Mississippi, 2001), 4. The debate dates back at least to the 1940s, when New York dealer Sidney Janis (*They Taught Themselves* [1942; reprint, Port Washington, N.Y.: Kennikat Press, 1965], 12–13) could list ten possible terms, preferring "self-taught artists."

11. One museum official joshed that, "We need a ten million dollar donor, then we can become the Smith Museum" (Field notes), allowing capitalist elites to solve the problem of naming.

12. Roger Cardinal, "Toward an Outsider Aesthetic," 20–43, in *The Artist Outsider: Creativity and the Boundaries of Culture,* ed. Michael D. Hall and Eugene W. Metcalf Jr. (Washington, D.C.: Smithsonian Institution Press, 1994), 22.

13. E-mail from Randall Morris, "Re: Nellie Mae Rowe article," to outsiderart@onelist. com, 4 January 1999.

14. Lynda Roscoe Hartigan, *Made with Passion* (Washington, D.C.: Smithsonian Institution Press, 1990), 1.

15. Shiner, *Invention of Art,* 317.

16. Gary Alan Fine, *Morel Tales: The Culture of Mushrooming* (Cambridge: Harvard University Press, 1998), chap. 2; Eleanor Rosch, "Principles of Categorization," 27–48, in *Cognition and Categorization,* ed. Eleanor Rosch and Barbara B. Lloyd (Hillsdale, N.J.: Lawrence Erlbaum Associates, 1978).

17. Ludwig Wittgenstein, *Philosophical Investigations,* 3rd ed., trans. G. E. M. Anscombe (New York: Macmillan, 1968).

18. Gene Epstein, "Who Are the Outsiders?" 4–7, in *Outsider Art Fair,* exhibition catalog (1991), 7.

19. Alan Sondheim, "Unnerving Questions Concerning the Critique and Presentation of Folk/Outsider Arts," *Art Papers* 13, no. 4 (July/August 1989): 35.

20. Russell Bowman, "Speakeasy," *New Art Examiner* 22, no. 1 (September 1994): 61.

21. Joan M. Benedetti, "Who Are the Folk in Folk Art? Inside and Outside the Cultural Context," *Art Documentation* 6, no. 1 (Spring 1987): 6.

22. Currently there is only one Ph.D.-granting department of folklore (at Indiana University). The department at the University of Pennsylvania, once a strong rival to Indiana, is no longer a department, only a degree-granting program.

23. Teske, "What Is Folk Art?" 35. See also Howard S. Becker, *Art Worlds* (Berkeley: University of California Press, 1982), for a similar view.

24. In general, the term folk art is more widely used in the South than in New York, perhaps for this reason.

25. Benedetti, "Who Are the Folk in Folk Art?" 4–5. Emphasis added.

26. Jane Kallir, *Grandma Moses: The Artist behind the Myth* (New York: Clarkson N. Potter, 1982), 32.

27. Holland Cotter, "A Life's Work in Word and Image, Secret until Death," *New York Times*, 24 January 1997, C27.

28. Judy Saslow, "What Is Outsider Art???" (Chicago), 1.

29. E-mail from Randall Morris, "Re: McCarthy's illness (was another point (White))," to outsiderart@onelist.com, 11 November 1998.

30. Roger Manley, "Separating the Folk from Their Art," *New Art Examiner* 19, no. 1 (September 1991): 28.

31. For a lively, and largely critical, discussion of the concept of outsider, see Hall and Metcalf, *The Artist Outsider.*

32. E-mail from Randall Morris, 11 November 1998, op. cit.

33. Tom Patterson, "Bandwagon Reactionaries & Barricade Defenders," *New Art Examiner* 22, no. 1 (September 1994): 23. This was written prior to the election of Governor Jesse Ventura, but perhaps the point still holds.

34. Mr. Imagination, "Voices," *New Art Examiner* 22, no. 1 (September 1994): 33.

35. Jenifer Penrose Borum, "Editorial," *New Art Examiner* 22, no. 1 (September 1994): 3.

36. Russell, *Self-Taught Art*, 24.

37. Jean Dubuffet (*Asphyxiating Culture and Other Writings* [New York: Four Walls Eight Windows, 1988], 109) in discussing art brut, notes, "We are seeing artistic works . . . owing nothing (or as little as possible) to the imitation of works of art seen in museums, salons, and galleries. On the contrary, these artistic works should put human originality to use, along with the most spontaneous and personal inventiveness, they should be productions which the creator drew . . . from deep within, the result of his own inclinations and moods, free from the habitual means of creation, and regardless of the conventions currently in use."

38. Black Alabama artist Thornton Dial early in his artmaking believed that his creations would be taxed and that making art required a license (William Arnett, "The Root Sculptures of Thornton Dial: A Network of Ideas," 172–189, in *Souls Grown Deep*, vol. 1, ed. Arnett and Arnett, 176). There are also reports that Dial buried his early assemblages for fear of retribution from Alabama authorities.

39. Patterson, "Bandwagon Reactionaries & Barricade Defenders," 23.

40. Ian Hacking, *The Social Construction of What?* (Cambridge: Harvard University Press, 1999).

41. Peter Berger and Thomas Luckmann, *The Social Construction of Reality: A Treatise in the Sociology of Knowledge* (Garden City, N.Y.: Anchor, 1967).

42. Malcolm Spector and John Kitsuse, *Constructing Social Problems* (New York: Aldine de Gruyter, 1987); Joseph Schneider, "Social Problems Theory: The Constructionist View," *Annual Review of Sociology* 11 (1985): 209–29; Donileen Loseke, *Thinking about Social Problems: An Introduction to Constructionist Perspectives* (New York: Aldine de Gruyter, 1999).

43. Joel Best, "But Seriously Folks: The Limitations of the Social Constructionist Interpretation of Social Problems," 129–47, in *Reconsidering Social Constructionism*, ed. James Holstein and Gale Miller (New York: Aldine de Gruyter, 1993); Jay Gubrium, "For a Cautious Naturalism," 89–101, in *Reconsidering Social Constructionism*, for criticism of this approach, and Steven Woolgar and Dorothy Pawluch, "Ontological Gerrymandering: The Anatomy of Social Problems," *Social Problems* 32 (1985): 214–27, and Peter R. Ibarra and John Kitsuse, "Vernacular Constituents of Moral Discourse," 25–58, in *Reconsidering Social Constructionism*, for support of this radical vision.

44. Gubrium, "For a Cautious Naturalism"; Gary Alan Fine, "Scandals, Social Conditions and the Creation of Public Attention: 'Fatty' Arbuckle and the 'Problem' of Hollywood," *Social Problems* 44 (1997): 297–323.

45. Marshall Sahlins, *Islands of History* (Chicago: University of Chicago Press, 1985), 147.

46. Shelly Errington, *The Death of Authentic Primitive Art and Other Tales of Progress* (Berkeley: University of California Press, 1998), 4.

47. Pierre Bourdieu, *Distinction: A Social Critique of the Judgement of Taste* (Cambridge: Harvard University Press, 1984), iii.

48. Sally Price, *Primitive Art in Civilized Places* (Chicago: University of Chicago Press, 1989), 7–22.

49. Michael Thompson, *Rubbish Theory: The Creation and Destruction of Value* (Oxford: Oxford University Press, 1979), 9.

50. Howard S. Becker, "Arts and Crafts," *American Journal of Sociology* 83 (1978): 862–89.

51. Raymonde Moulin, "La Genèse de la Rareté Artistique," 161–91, in *De La Valeur de L'Art: Recueil d'Articles* (Paris: Flammarion 1995), 179–82.

52. Michael D. Hall, "The Mythic Outsider," *New Art Examiner* (September 1991): 16. See also Donald Kuspit, "The Appropriation of Marginal Art in the 1980s," *American Art* 5, no. 1/2 (Winter/Spring 1991): 134.

53. Julia S. Ardery, "'Loser Wins': Outsider Art and the Salvaging of Disinterestedness," *Poetics* 24 (1997): 329–46.

54. We see this process in the enshrinement of self-taught artists by comparing them, favorably, with canonized artists. Thus, museum director Robert Bishop could say of Mose Tolliver's work at the Corcoran show: "I would say in comparing Tolliver's work to Picasso, it is of equal value—you can hang him beside a Picasso and you have the same kind of creativity and deep personal vision" (Anton Haardt, "Mose Tolliver Goes to Washington," *Raw Vision* 12 [Summer 1995]: 28). You could hang a Tolliver next to a Picasso, but how many curators would have the nerve to do so?

55. Randall Morris, "Self-Taught Ethics Regarding Culture," *New Art Examiner* (September 1994): 18.

56. Lynne Adele, *Spirited Journeys: Self-Taught Texas Artists of the Twentieth Century* (Austin, Tex.: Archer M. Huntington Art Gallery, 1997), 13.

57. Interview of Michael Hall by Julia Ardery, 14 August 1993, Kentucky Folk Art

Project, Oral History Program, Special Collections and Archives, University of Kentucky Libraries, transcript, 14–16.

58. Jack Hitt, "The Selling of Howard Finster," *Southern Magazine,* November 1987, 54–55.

59. Gary Alan Fine and Kent Sandstrom, "Ideology in Action," *Sociological Theory* 11 (1993): 21–38.

60. Chuck Rosenak and Jan Rosenak, *Contemporary American Folk Art: A Collector's Guide* (New York: Abbeville Press, 1996).

61. Herbert W. Hemphill and Julia Weissman, *Twentieth-Century Folk Art and Artists* (New York: E. P. Dutton, 1974), 9.

62. Stacy C. Hollander, "Self-Taught Artists of the 20th Century," *Folk Art* 23, no. 1 (Spring 1998): 46.

63. John Maizels, "no title," *Raw Vision* 11 (1995): 13.

64. Joe Adams, "Joe Adams Answers Questions from New Collectors about Building a Folk Art Collection," *20th Century Folk Art News* (July 1996): 10–11.

65. Roger Manley, "Robbing the Garden," *Folk Art Messenger* 7, no. 2 (Winter 1994): 5.

66. Cited by John Michael Vlach, "The Wrong Stuff," *New Art Examiner* 19 (September 1991): 23. See also Kenneth Ames, "Folk Art: The Challenge and the Promise," 293–324, in *Perspectives on American Folk Art,* ed. Ian Quimby and Scott T. Swank (New York: W. W. Norton, 1980), 312–13.

67. Alice Thorson, "The Temptation of 'O, Appalachia,'" *New Art Examiner* 18 (October 1990): 30, 28, respectively. Ironically the show contains the collection of Ramona and Millard Lampell, he formerly of the communist-affiliated Almanac Singers.

68. Personal communication, Steven Dubin, 2002.

69. James Yood, "Et in Arcadia Ego?" *New Art Examiner* 19 (April 1992): 26.

70. Eviatar Zerubavel, *Social Mindscapes* (Cambridge: Harvard University Press, 1997).

71. Andrew Abbott, *The System of Professions* (Chicago: University of Chicago Press, 1988).

72. There is also a boundary with folk craft, as utilitarian objects, such as pottery, quilts, or hooked rugs, have a marginal position in this world, not being sufficiently "arty" (see Becker, "Arts and Crafts"). One show organizer told me that although he allows pottery, he draws the line at hooked rugs, and likes the quilts to be older or African American (Interview). Many auctions include southern folk pottery and African American (but, rarely, white) quilts.

73. Prior to 2001, the museum was known as the Museum of American Folk Art. The new name legitimated the display of world folk art, rather than only American folk art. American can now be seen to modify "museum," rather than "folk art."

74. Interview of Jim and Beth Arient by Betty Blum, 27–29 April 1988, Smithsonian Archives of American Art transcript, 55.

75. Barry Newman, "Folk Art Finders," *Wall Street Journal,* 30 July 1974, 1.

76. Nora Howell Starr, "Perspective on American Folk Art," *Clarion* (Spring 1979): 29.

77. Rita Reif, "Presenting Folk Art's Greatest Hits," *New York Times,* 30 September 1990, 40; see Ardery, op.cit., 1998, 174–75. In the exhibit described in the article, Mrs. Lipman had—for the first time—selected twentieth-century works.

78. Robert Bishop, "Letter from the Director," *Clarion* 15, no. 5 (Winter 1990): 25.

See also Robert Bishop, "The Affects and Effects of Collecting: Artists and Objects," *Ohio Antique Review* (January 1984): 13–14.

79. So, as it happens, does the American Visionary Art Museum in Baltimore. One wonders whether this is due to the organizational culture or to the relatively modest value of what is being guarded.

80. E-mail from Wayne Cox to outsiderart@onelist.com, 14 November 1998.

81. Carter Ratcliff, "The Art of Innocence," *Elle*, February 1987, 238.

82. Stacy C. Hollander, "Self-Taught Artists of the 20th Century," *Folk Art* 23, no. 1 (Spring 1998): 51.

83. E-mail from Randall Morris, "It's over! and just begun," to outsiderart@onelist. com, 31 January 2000.

84. Robert Goldwater, *Primitivism in Modern Painting* (New York: Harper and Brothers, 1938).

85. Cardinal, *Outsider Art*, 36.

86. Herbert Gans, *Popular Culture and High Culture: An Analysis and Evaluation of Taste* (New York: Basic, 1974).

87. See George Ritzer, *The McDonaldization of Society*, New Century edition (Thousand Oaks, Calif.: Pine Forge Press, 2000); and Gary Alan Fine, "Art Centers: Southern Folk Art and the Splintering of a Hegemonic Market," 148–62, in *Resisting McDonaldization*, ed. Barry Smart (London: Sage, 1999).

88. Robert Adams, "Smithsonian Horizons," *Smithsonian*, June 1991, n.p.

89. Julia S. Ardery, *The Temptation: Edgar Tolson and the Genesis of Twentieth-Century Folk Art* (Chapel Hill: University of North Carolina Press, 1998), 212.

90. Howard Singerman, *Art Subjects: Making Artists in the American University* (Berkeley: University of California Press, 1999).

91. Adele, *Spirited Journeys*, 13; Kallir, *Grandma Moses*, 31.

92. Marsha MacDowell, "Folk Art Study in Higher Education," *Kentucky Folklore Record* 30, no. 1/2 (January–June 1984): 30.

93. Marie Proeller, "Fifteen Years of Folk Art Studies at New York University," *Folk Art Messenger* 9, no. 2 (Winter 1996): 10. See Ardery, *The Temptation*, 212, for another account of this "brilliant strategic alliance."

94. E-mail from Jeffrey Knapp, "Re: Purvis Young," to outsiderart@onelist.com, 13 May 1999.

95. E-mail from Randall Morris, "On Innovation," to outsiderart@onelist.com, 29 January 1999.

96. Scott T. Swank, "Introduction," 1–12, in *Perspectives in American Folk Art*, ed. Ian Quimby and Scott T. Swank (New York: W. W. Norton, 1980), 2–3.

97. This term, coined by Charles Keil, refers to jazzmen and aficionados who preferred classic musicians and styles, particularly those prior to World War I. Interestingly, Ames, "Folk Art: The Challenge and the Promise," 313, uses it to refer to the folklorists, who, he asserts are excessively interested in tradition and the elderly.

98. One folklorist, recognizing the contentiousness at the meeting, joked that, referring to the art historians, "I never crossed to the dark side."

99. Charles Flowers, "The Outsiders" (15 November 1979), 31.

100. Kallir, *Grandma Moses*, 9. She quotes critic Emily Genauer as noting, paradoxically: "Grandma Moses is a good painter, although few, if any, of the pictures she has done to date are, by the friendliest estimate . . . works of art" (p. 28).

101. Randall Morris, "The Gatekeepers of Culture: On Presenting the Works of African American Self-Taught Artists," *Folk Art* 22, no. 4 (Winter 1997/1998): 43.

102. Albert O. Hirschman, *Exit, Voice, and Loyalty: Responses to Decline in Firms, Organizations, and States* (Cambridge: Harvard University Press, 1970).

CHAPTER TWO

1. Interview of Hans Jorgensen by Willem Volkersz, 7 March 1975, Smithsonian Archives of American Art transcript, 25–26.

2. Russell Bowman, "Imagining the Academy: 'Naive' Art and the Mainstream," 81–94, in *Self-Taught Art: The Culture and Aesthetics of American Vernacular Art,* ed. Charles Russell (Jackson: University Press of Mississippi, 2001), 81.

3. Regina Bendix, *In Search of Authenticity: The Formation of Folklore Studies* (Madison: University of Wisconsin Press), 3–4.

4. Miles Orvell, *The Real Thing: Imitation and Authenticity in American Culture, 1880–1940* (Chapel Hill: University of North Carolina Press, 1989), xv.

5. Raymonde Moulin, "La Genèse de la Rareté Artisque," trans. Vanessa Gomez, 161–91, in *De la Valueur de l'Art: Recueil d'Articles* (Paris: Flammarion, 1995), 161, 167.

6. Ibid., 180–82.

7. Jean Baudrillard, *Simulacra and Simulation* (Ann Arbor: University of Michigan Press, 1994), 9.

8. Alan Sondheim, "Unnerving Questions Concerning the Critique and Presentation of Folk/Outsider Arts," *Art Papers* 13, no. 4 (July/August 1989): 34.

9. Shelly Errington, *The Death of Authentic Primitive Art and Other Tales of Progress* (Berkeley: University of California Press, 1998), 118, see also 3.

10. Judith McWillie, "From Ideology to Identity: Syncretism and the Art of the XXI Century," 4–6, in *Syncretism: The Art of the XXI Century* (New York: Alternative Museum, 1991), 5.

11. Richard A. Peterson, *Creating Country Music: Fabricating Authenticity* (Chicago: University of Chicago Press, 1997), 3.

12. David Grazian, *Blue Chicago: The Search for Authenticity in Urban Blues Clubs* (Chicago: University of Chicago Press, 2003).

13. Julia S. Ardery, *The Temptation: Edgar Tolson and the Genesis of Twentieth-Century Folk Art* (Chapel Hill: University of North Carolina Press, 1998), 277.

14. Theodor W. Adorno, *The Jargon of Authenticity,* trans. Knut Tarnowski and Frederic Will (Evanston, Ill.: Northwestern University Press, 1973.

15. Larissa MacFarquhar, "But Is It Art?" *New York,* 29 January 1996, 40.

16. E-mail from Lois Zetter, "re: Castle," to outsiderart@onelist.com, 19 January 1999.

17. E-mail from Randall Morris, "so anyway . . . ," to outsiderart@onelist.com, 23 March 1999.

18. Rosemary O. Joyce, " 'Fame Don't Make the Sun Any Cooler': Folk Artists and the Marketplace," 225–41, in *Folk Art and Art Worlds,* ed. John Michael Vlach and Simon J. Bronner (Logan: Utah State University Press, 1986), 226.

19. The recognition that artists over the past 150 years have been instrumental in establishing and organizing their own careers leads to what might be termed the *MBA theory of art history.*

20. Richard Blodgett, "Collectors Flock to Folk Art," *New York Times,* 12 September 1976.

21. John Windsor, "Catch 22: The Case of Albert Louden," *Raw Vision* 18 (Spring 1997): 50.

22. A prominent collector told me about her lunch with an established self-taught artist (although a boundary stretcher): "He's talking to me about his deals, and he wants to travel in Europe and he thinks it will affect his *oeuvre*. I said, don't ever use that word again. . . . I just said, don't use that word. Take it out of your vocabulary because it doesn't work" (Interview).

23. E-mail from Mike Smith, "Re: Collectors—Necessary evil?" to outsiderart@ onelist.com, 24 March 1999.

24. Betty-Carol Sellen with Cynthia J. Johanson, *Self Taught, Outsider, and Folk Art: A Guide to American Artists, Locations and Resources* (Jefferson, N.C.: McFarland and Company, 2000), 237.

25. Letter from Robert Manley to Chuck and Jan Rosenak, 11 May 1996, Smithsonian Archives of American Art, 2 pages.

26. David Levinson and Beverly Levinson, "A Long January Weekend in New York," *Folk Art Messenger* 12, no. 2 (Spring 1999): 23.

27. Lynne Adele, *Spirited Journeys: Self-Taught Texas Artists of the Twentieth Century* (Austin, Tex.: Archer M. Huntington Art Gallery, 1997), 14.

28. Allen S. Weiss, *Shattered Forms: Art Brut, Phantasms, Modernism* (Albany: State University of New York Press, 1992), 67; e-mail from Randall Morris, "A Solution perhaps," to outsiderart@onelist.com, 28 September 1999.

29. See John FitzMaurice Mills and John M. Mansfield, *The Genuine Article: The Making and Unmasking of Fakes and Forgeries* (New York: Universe, 1979); and Denis Dutton, ed., *The Forger's Art: Forgery and the Philosophy of Art* (Berkeley: University of California Press, 1983).

30. Moulin, "La Genèse de la Rareté Artisque," 166.

31. John E. Conklin, *Art Crime* (Westport, Conn.: Praeger, 1994), 47.

32. This informant suggested that several of Hawkins's dealers didn't like the picture, were afraid that it would not bring a high enough bid, and felt that it would decrease the value of other Hawkins works, which depend on the prices paid at auction. In other words, claims of forgery can be the cover for other concerns.

33. Gary Alan Fine, "Cheating History: Rhetorics and Art Forgery," *Empirical Studies in the Arts* 1 (1983): 75–93.

34. Hugh McLeave, *Rogues in the Gallery: The Modern Plague of Art Thefts* (Boston: D. R. Godine, 1981), chap. 1.

35. The debate as to how much and what kind of restoration is proper is a heated topic.

36. Howard S. Becker, *Art Worlds* (Berkeley: University of California Press, 1982), chap. 1.

37. E-mail from Randall Morris, "It's over! And just begun," to outsiderart@onelist. com, 31 January 2000.

38. However, some claim that this inability to distinguish is connected to the "eye" of a historical period. The forgery plays off how a generation views art; in the next generation, the forgery is said to be obvious.

39. Fine, "Cheating History."

40. Howard S. Becker, "La Confusion de Valeurs," 11–28, in *L'Art de la Recherche: Melanges,* ed. Pierre-Michel Menger and Jean-Claude Passeron (Paris: La Documentation Française, 1994), available in English ("Confusions of Value") at http://www.soc.ucsb.edu/faculty/hbecker/Confusion.html.

41. Sellen, *Self Taught, Outsider, and Folk Art,* 121–22.

42. It has been reported that his former dealer, Sherry Pardee, has met Angel.

43. Jeff Huebner, "Has Anyone Seen Clyde Angel?" *Chicago Reader* 29, no. 28 (14 April 2000): 1, 31–37.

44. Ibid., 37.

45. E-mail from geo, "Re: Clyde Angel," to outsiderart@onelist.com, 16 April 2000, emphasis added.

46. Laurent Danchin and Martine Lusardy, *Outsider and Folk Art: The Chicago Collections* (Paris: Halle Saint Pierre, 1998), 64–65.

47. Huebner, "Has Anyone Seen Clyde Angel?" 32.

48. Ibid.

49. E-mail from Randall Morris, "Clyde Angel," to outsiderart@onelist.com, 16 April 2000.

50. Butler Hancock, "The Designation of Indifference," *New Art Examiner* 20 (October 1992): 22, 25.

51. As with every claim there are a few exceptions to the rule: middle-class artists who are generally accepted within the canon, even in the absence of severe mental illness, because of characteristics of the work. The work of Ned Cartledge, Morton Bartlett, and Achilles Rizzoli seem to fall in this category. Cartledge was a carver, a recognized folk tradition, while Bartlett and Rizzoli were unknown until after their deaths. While there are some exceptions to the class-linked label of self-taught art, they are often exceptional cases.

52. Ardery, *The Temptation,* 254.

53. Ami Wallach, "The Thorny and Profitable Outsiders," *New York Newsday,* 28 January 1994.

54. E-mail from Randall Morris, "Troubled Waters," to outsiderart@onelist.com, 23 April 1999.

55. Sellen, *Self Taught, Outsider, and Folk Art,* 131. Robyn's brother, Shawn, "The Birdman," though legally blind, makes self-taught birdhouses, 132.

56. "In Memory of Our Most Precious Son Robyn Banks Beverland," *Folk Art* 23, no. 4 (Winter 1998/1999): 70.

57. Wendy Steiner, "In Love with the Myth of the 'Outsider,'" *New York Times,* 10 March 1996, 45, 48.

58. Thomas McGonigle, "Violated Privacy," *Arts Magazine* 55 (October 1980): 156.

59. Jack Cunningbury, "Correspondence," *Raw Vision* 15 (Summer 1996): 58.

60. "Review of Julia S. Ardery, *The Temptation: Edgar Tolson and the Genesis of Twentieth-Century Folk Art,*" *Folk Art Finder* 19, no. 3 (July–September 1998): 16.

61. Ardery, *The Temptaton,* 203.

62. Flora Rheta Schreiber, *Sybil* (New York: Warner, 1974).

63. E-mail from Randall Morris, "Sybil," to outsiderart@onelist.com, 22 December 1998.

64. Barbara Schreiber, "Notes from the Navel-Staring Department," *Art Papers* 22, no. 1 (January/February 1998): 16–17.

65. C. Wright Mills, *The Sociological Imagination* (New York: Oxford University Press, 1959), chap. 1.

66. I am indebted to Vera Zolberg for this insight (Personal communication, 2003).

67. Randall Morris, "Self-Taught Ethics Regarding Culture," *New Art Examiner* 22, no. 1 (September 1994): 19.

68. Gary Alan Fine, *Difficult Reputations: Collective Memories of the Evil, Inept, and Controversial* (Chicago: University of Chicago Press, 2001); Gladys Engel Lang and Kurt Lang, *Etched in Memory: The Building and Survival of Artistic Reputation* (Chapel Hill: University of North Carolina Press, 1990).

69. Ardery, *The Temptation*, esp. chap. 4.

70. Ross L. Peacock, Advertisement, "To the Memory of Anna Mary Robertson ("Grandma") Moses, N.A.," *New York Times*, 23 March 1980, 27.

71. Beverly Kaye, Advertisement, "Matt Sesow, Madman/Artist," *Folk Art Finder* 18, no. 1 (January–March 1997): 22.

72. Alex Freedman, "Art Being Her Bag, This Bag Lady Wins Acclaim in Chicago," *Wall Street Journal*, 1 April 1985, 1.

73. Steven C. Dubin, "The Centrality of Marginality: Naive Artists and Savvy Supporters," 37–52, in *Outsider Art: Contesting Boundaries in Contemporary Culture*, ed. Vera L. Zolberg and Joni Maya Cherbo (Cambridge: Cambridge University Press, 1997), 46.

74. Michael Bonesteel, "Lee Godie," *Raw Vision* 27 (Summer 1999): 41.

75. Michael Bonesteel, "Review of *Adolf Wölfli: Draftsman, Writer, Poet, Composer*," *Outsider* 3, no. 1 (Summer 1998): 6.

76. John Maizels, *Raw Creation: Outsider Art and Beyond* (London: Phaidon Press, 1996), 22–30.

77. Ibid., 29–30.

78. Bonesteel, "Review of *Adolf Wölfli*."

79. Sellen, *Self Taught, Outsider, and Folk Art*, 157. Some claim that Darger's art life lasted considerably longer than dates given.

80. Maizels, *Raw Creation*, 101, 104. See Michael Bonesteel, *Henry Darger: Art and Selected Writings* (New York: Rizzoli, 2000).

81. In Tessa DeCarlo, "The Bizarre Visions of a Reclusive Master," *New York Times*, 12 January 1997, 43.

82. Ibid.

83. Stephen Prokopoff, *Henry Darger: The Unreality of Being* (Iowa City: University of Iowa Museum of Art, 1996), 6.

84. "What's Happenin' at Intuit," *Outsider* 1, no. 1 (Winter 1996): 2.

85. Wesley M. Shrum Jr., *Fringe and Fortune: The Role of Critics in High and Popular Art* (Princeton: Princeton University Press, 1996), 113.

86. Related are stories of purchasing art at astonishingly low prices: a Frank Jones work for $.25 (now several thousand dollars) or a Jimmy Lee Sudduth for $.50 (now several hundred). Some stories involve the purchase of an enormous number of self-taught art objects at remarkably low prices, such as the Woolsey bottlecap sculptures at a farm auction, where one dealer paid $37 for 158 pieces, each of which now brings thousands (Don Johnson, "Bottle-Cap Fever," *Maine Antique Digest* [October 1993]: 12E–13E), or the sale of the nearly seventy Possum Trot dolls, found in a rundown tourist attraction in the Mojave Desert for a modest price. A single doll, a year later, was selling for over $12,000 (Susan L. Brown, "Possum Trot," *Connoisseur* 211 [September 1982]: 8).

87. Sellen, *Self Taught, Outsider, and Folk Art*, 245.

88. Ann Jarmusch, "Mysterious Stranger," *ARTnews* 85, no. 7 (September 1986): 166.

89. Interview of John Ollman by Liza Kirwin, 15 March 1990, Smithsonian Archives of American Art, 62–66.

90. Jarmusch, "Mysterious Stranger," 166.

91. Of course, British historian Hugh Trevor-Roper once authenticated the "Hitler diaries."

92. E-mail from Randall Morris, "The Philadelphia Wireman," to outsiderart@onelist. com, 15 December 1999.

93. Michael Bonesteel, "Review of *Charles A. A. Dellschau, 1830–1923: Aeronautical Notebooks*," *Outsider* 3, no. 1 (Summer 1998): 7–8.

94. Bonnie Grossman, "Amplifying Achilles," 11–13, in Jo Farb Hernandez, John Beardsley, and Roger Cardinal, *A. G. Rizzoli: Architect of Magnificent Visions* (New York: Harry N. Abrams, 1997), 11.

95. Roger Manley, "Outsider Art (and) Who Needs It?" 11–14, in *Unsigned, Unsung, Whereabouts Unknown: Make-Do Art of the American Outlands*, ed. Jim Roche (Tallahassee: Florida State University Gallery and Museum, 1993), 12.

96. See Gary Alan Fine, *Morel Tales: The Culture of Mushrooming* (Cambridge: Harvard University Press, 1998), chap. 3.

97. Roger Manley, "Robbing the Garden," *Folk Art Messenger* 7, no. 2 (Winter 1994): 4–7, 9.

98. Lynda Hartigan, while interviewing John Ollman, 10 August 1989, Smithsonian Archives of American Art transcript, 57.

99. Interview of Bert Hemphill by Julia Ardery, 1 February 1993, Kentucky Folk Art Project, Oral History Program, Special Collections and Archives, University of Kentucky Libraries, transcript, 52.

100. Adele, *Spirited Journeys*, 61–62.

101. David Maclagan, "Silence, Exile, and Cunning: The Art of Martin Ramirez," *Raw Vision* 6 (Summer 1992): 40.

102. Eviatar Zerubavel, *Terra Cognita* (New Brunswick, N.J.: Rutgers University Press, 1992).

103. One collector made it a point to note that they were the *third* people to have visited Howard Finster.

104. Charles Shannon, "Bill Traylor's Triumph," *Art & Antiques*, February 1988, 88.

105. Personal communication, Steven Dubin, 2002.

CHAPTER THREE

1. Stuart Plattner, *High Art Down Home: An Economic Ethnography of a Local Art Market* (Chicago: University of Chicago Press, 1996), 37.

2. Henry C. Finney, "Art Production and Artists' Careers: The Transition from 'Outside' to 'Inside,'" 73–84, in *Outsider Art: Contesting Boundaries in Contemporary Culture*, ed. Vera L. Zolberg and Joni Maya Cherbo (Cambridge: Cambridge University Press, 1997), 76.

3. Diana Crane, *The Transformation of the Avant-Garde: The New York Art World, 1940–1985* (Chicago: University of Chicago Press, 1987), 9–10.

4. John Russell, "A Remarkable Exhibition of Black Folk Art in America," *New York Times*, 14 February 1982.

5. Florence Laffal and Jules Laffal, "Just the Facts, Ma'am: Statistics and Their Implication about Women Self-Taught Artists," *Outsider* 3, no. 3 (Winter 1999): 18–21. See also Jules Laffal and Florence Laffal, "Aspects of American Folk Art," *Folk Art Finder* 16, no. 2 (April–June 1995): 4–7. They also find that men are more likely to begin to create after retirement than are women (41 percent to 20 percent), and that as compared to men,

women create memory paintings, scenes of rural life, and depictions of everyday life, while men are more likely to emphasize vehicles, buildings, history, and fantasy. According to the Laffals, gender typifies the content of work.

6. Laffal and Laffal, "Aspects of American Folk Art," 4.

7. Jules Laffal and Florence Laffal, "Geographic Distribution of American Folk Artists," *Folk Art Finder* 5, no. 4 (November/December 1984): 2, 3, 19.

8. For discussion of Holley's art see Paul Arnett, "Lonnie Holley: Pulling on the Root," 190–95, in *Souls Grown Deep: African American Vernacular Art of the South*, vol. 1, *The Tree Gave the Dove a Leaf*, ed. Paul Arnett and William Arnett (Atlanta, Ga.: Tinwood Books, 2000); Jay Murphy, "Cultural Recycling: The Work of Lonnie Holley," *Raw Vision* 7 (Summer 1993): 20–23; and Judith McWillie, "Another Face of the Diamond," *Clarion* 12, no. 4 (1987): 42–53.

9. Betty-Carol Sellen with Cynthia J. Johanson, *Self Taught, Outsider, and Folk Art: A Guide to American Artists, Locations and Resources* (Jefferson, N.C.: McFarland and Company, 2000), 190–91.

10. Interview with Lonnie Holley, August 1993, quoted in Babatunde Lawal, "African Roots, American Branches: Tradition and Transformation in African American Self-Taught Art," 30–49, in *Souls Grown Deep*, vol. 1, ed. Arnett and Arnett, 43.

11. Not all agree with this assessment. One collector told me that she thought Holley was "a phony." She explains, pungently, "He gets up and he tells this big long story about, 'Oh, I put this together, and I put that together, and it means this, and it's symbolic of thus and so' and you've got exegesis here, and you've got a philosophical statement that's about five paragraphs. That goes with this piece of crap that he has wired together. . . . I go look in that gallery space with all this Lonnie Holley, and, you know, it's like none of it means anything to me at all without all this philosophical write-up. It's the analysis, the written analysis . . . it's like, give me a break! I've been through this with all the abstract expressionists and all the minimalists, this art of the mind stuff, you know, intellectualized" (Interview). Perhaps it is the formal quality of the work that is unappealing, but more likely it is the "theoretical infrastructure," particularly as given by a self-taught artist. Whether she would have preferred these same pieces ("From the Slippery Elm I Hang" or "The Sadness of the Professor") if they were labeled "Untitled" cannot be known.

12. Material for this discussion comes from a four-part story, published in March 1999: Jim Auchmutey, "Sandman's Blues: Lonnie Holley's Life of Art and Troubles," *Atlanta Journal-Constitution,* and placed on the newspaper's Web site: www.accessatlanta.com/ajc/bigstory/031499.

13. Ibid., part 2.

14. Paul Arnett et al., "The Hidden Charms of the Deep South," 66–105, in *Souls Grown Deep,* vol. 1, ed. Arnett and Arnett, 83–84.

15. Jane Livingston, "The Gentle People Who Make Folk Art," *Washington Post,* 16 March 1983.

16. Dealers and collectors have problems as well, but those are discussed later.

17. Michel Thévoz, "An Anti-Museum," 63–74, in *The Artist Outsider: Creativity and the Boundaries of Culture,* ed. Michael D. Hall and Eugene W. Metcalf Jr. (Washington, D.C.: Smithsonian Institution Press, 1994), 67–68; John MacGregor, "Art Brut Chez Dubuffet," *Raw Vision* 7 (Summer 1993): 42–43.

18. In Larissa MacFarquhar, "But Is It Art?" *New York,* 23 January 1996, 41.

19. Jews make up a substantial portion of the major dealers and collectors in the field (Plattner, *High Art Down Home,* 167), so much so that when one Jewish dealer first met

a Christian dealer, he reports that her first comment was, "My God, you're so young and Waspy!" (Interview). A Jewish dealer worried to me that Jews in the art world might be perceived as cheap, and referred in particular to a Jewish show promoter, who in her estimation did not provide sufficient food at his show's opening in contrast to a Christian promoter (Field notes).

20. Jennifer Schuessler, "The Visionary Company," *Lingua Franca* (December 1998/January 1999): 51.

21. Julia S. Ardery, *The Temptation: Edgar Tolson and the Genesis of Twentieth Century Folk Art* (Chapel Hill: University of North Carolina Press, 1998), 280.

22. Ibid., 268.

23. Lee Kogan, "Review of *Revelations: Alabama's Visionary Folk Artists*," *Folk Art* 19, no. 4 (Winter 1994/1995): 32; emphasis added.

24. Interview of Jesse Howard by Willem Volkersz, 21 March 1977, Smithsonian Archives of American Art transcript, 19.

25. Jerry Cullum, "Vernacular Art in the Age of Globalization," *Art Papers* 22, no. 1 (January/February 1998): 13.

26. Tom Patterson, "Bandwagon Reactionaries & Barricade Defenders," *New Art Examiner* 22, no. 1 (September 1994): 24.

27. Quoted in Ardery, *The Temptation*, 261.

28. John Hood, "Jimmy Lee Sudduth," *Folk Art* 18, no. 4 (Winter 1993/1994): 49.

29. Some white artists feel that they are discriminated against because of their skin color. I was told that one potter was warned by a museum curator that they would no longer display any of his works if he continued to make some works with black figures that the museum felt were offensive (Field notes). I know of at least two southern white artists who feel ignored because of their race.

30. Some tolerance, at least the way it is phrased in interviews, can be read as patronizing, a hard call, as in remarks by these dealers: "I have always enjoyed myself more around black people than [with] white people. And I always grew up in the city schools and always was in the remedial classes with the black kids. And I always found myself enjoying myself with them more than the white kids from the neighborhood. . . . We had a black lady who lived with us, and she raised us. So a lot of my appreciation comes from her. . . . She was married at fourteen and had seven kids, but she spent all her time at our house" (Interview), or "I went to high school here with blacks and when I was growing up there was a man who worked for my daddy for awhile who was black and who came in and sat at our kitchen table. . . . I just see them as people, and I like most all of them, too" (Interview). I have similar stories myself, stories that can be read as patronizing as these. Fortunately no one interviews me. I do not dismiss the good nature of these informants.

31. Richard A. Peterson, *Creating Country Music: Fabricating Authenticity* (Chicago: University of Chicago Press, 1997), 4.

32. Interview of William Dawson by Betty J. Blum, 11 and 23 April 1990, Smithsonian Archives of American Art transcript, 154.

33. Cornel West, "Horace Pippin's Challenge to Art Criticism," 44–53, in *I Tell My Heart*, ed. Judith Stein (Philadelphia: Pennsylvania Academy of the Fine Arts, 1993), 46–48.

34. E-mail from collector to outsiderart@onelist.com.

35. Marvin Scott and Stanford Lyman, "Accounts," *American Sociological Review* 33 (1968): 46–62.

36. "The Folk Artists Speak," *Folk Art Messenger* 1, no. 1 (Fall 1987): n.p.

37. Ibid.

38. Simon J. Bronner, *Chain Carvers: Old Men Crafting Meaning* (Lexington: University Press of Kentucky, 1985).

39. Paul S. D'Ambrosio, "The Making of a Working-Class Artist," *Folk Art* 20, no. 2 (Summer 1995): 28–29.

40. A survey by Jules Laffal and Florence Laffal ("Aspects of American Folk Art," 4) found that of 318 individuals, death or illness in the family led to the beginning of artwork in thirty-four cases; illness, injury, or depression led to art for seventy-four individuals, and retirement was the stimulus for another 118 individuals, together a clear majority of the sample. A vision was said to lead forty-one individuals to creative activity.

41. Stephen Flinn Young with D. C. Young, *Earl's Art Shop: Building Art with Earl Simmons* (Jackson: University Press of Mississippi, 1995), 17.

42. J. F. Turner, "Howard Finster: Man of Visions," *Clarion* 12, no. 3 (Fall 1987): 39.

43. "The Folk Artists Speak," *Folk Art Messenger* 2, no. 1 (Fall 1988): 6; see also Lucy R. Lippard, *Mixed Blessings: New Art in a Multicultural America* (New York: Pantheon, 1990), 66.

44. Maridean Hutton, "Dialogues with Stone: William Edmondson, Ernest 'Popeye' Reed, and Ted Ludwiczak," *Folk Art* 21, no. 1 (Spring 1996): 48.

45. While most of his secular collectors respect his beliefs, not all of those with whom he has had contact have similar respect. Consider journalist Jack Hitt ("The Selling of Howard Finster," *Southern Magazine*, November 1987, 91), who writes unkindly: "Finster stands up, hovering over me. One hand brandishes his container of Raisin Bran, the other is poking at me. . . . 'The world is filled with terrorists! Terrorists could be shooting needles through the sealed bag in this cereal box!' . . . He's in full rage now. . . . The phrases roll out in perfect evangelical cadences. Spittle and specks of Raisin Bran fly across the room. 'The world is wicked! And God ain't going to put up with it any more! He's going to rain down plagues! New ones! Plagues like radiation and leukemia and AIDS! People are wickeder than they were in Noah's time! I'm like a second Noah! I'm warning against a world of plagues! . . . These ain't paintings!' He sweeps his arm to encompass all the bizarre works leaning against the wall. . . . 'They're preaching! And if you don't listen and if the world gets any wickeder, then God's just going to destroy the whole thing.'" While Hitt is smugly unsympathetic, the words are Finster's as anyone who has heard him sermonize can attest.

46. Jane Kallir, *Grandma Moses: The Artist behind the Myth* (New York: Clarkson N. Potter, 1982), 43.

47. Lee Kogan, "Mose Tolliver: Picture Maker," *Folk Art* 18, no. 3 (Fall 1993): 48.

48. Cullum, "Vernacular Art in the Age of Globalization," 12.

49. Howard S. Becker, *Writing for Social Scientists* (Chicago: University of Chicago Press, 1986), chap. 1.

50. Interview of Howard Finster by Liza Kirwin, 1 June 1984, Smithsonian Archives of American Art transcript, 10.

51. Eleanor E. Gaver, "Inside the Outsiders," *Art & Antiques*, Summer 1990, 76.

52. Andrew Van Sickle, "Howard Finster: God's Artist," *Dialogue* 11, no. 4 (July/August 1988): 19.

53. Ardery, *The Temptation*, 133.

54. Roger Manley, "Separating the Folk from Their Art," *New Art Examiner* 19 (September 1991): 26.

55. J. F. Turner, "Howard Finster: Man of Vision." *Clarion* 14, no. 3 (Fall 1989): 42.

56. Anton Haardt, "Mose Tolliver Goes to Washington," *Raw Vision* 12 (Summer 1995): 23, 28.

57. Joanne Cubbs and Eugene W. Metcalf Jr., "William Hawkins and the Art of Astonishment," *Folk Art* 22, no. 3 (Fall 1997): 60.

58. JM, "Review of *Original Sin: The Visionary Art of Joe Coleman*," *Raw Vision* 21 (Winter 1997/1998): 72.

59. Shelly Errington, *The Death of Authentic Primitive Art and Other Tales of Progress* (Berkeley: University of California Press, 1998), 156.

60. Cullum, "Vernacular Art in the Age of Globalization," 11.

61. Roger Cardinal, "Private Worlds." 10–13, in *Private Worlds: Classic Outsider Art from Europe*, ed. John Beardsley and Roger Cardinal (Katonah, N.Y.: Katonah Museum of Art, 1999), 10.

62. Howard S. Becker, *Art Worlds* (Berkeley: University of California Press, 1982), 4.

63. Charlene Cerny and Suzanne Serif, eds., *Recycled Re-Seen: Folk Art from the Global Scrap Heap* (New York: Harry N. Abrams, 1996).

64. James L. Foy, "The Book and Its Reception," xiii–xvi, in Hans Prinzhorn, *Artistry of the Mentally Ill* (1922; reprint, New York: Springer-Verlag, 1995), xiii.

65. Nancy Karlins, "Bill Traylor," *Raw Vision* 15 (Summer 1996): 30–31.

66. Mary Padgelek, "In the Hand of the Holy Spirit: The Life and Art of J. B. Murray," University of Georgia Department of Art, 1996, n.p. The standard art-world spelling of the artist's name is "Murry."

67. Interview of Jim and Beth Arient by Betty J. Blum, 27–29 April 1988, Smithsonian Archives of American Art, transcript, 201–2.

68. The fact that an artist makes a choice does not mean that others will agree with that choice. Perhaps the most notable example is Howard Finster's decision in the late 1980s to use markers instead of tractor enamel paint. In the words of one dealer: "They were decent markers, but what happened is, you know, he was using paint. He was using tractor enamels, it was just oil-based paint. When you put down a blue and a white and mix them together, there was depth and there was 'painting.' And then all of a sudden, he started using nothing but markers. You put down one color, and it dries, and you put down another color and it's just a different color. So, the work started getting, for lack of a better word, worse" (Interview).

69. John Hood, "Jimmy Lee Sudduth," *Folk Art* 18, no. 4 (Winter 1993/1994): 48–49.

70. Wilfrid Wood, "Where That Good Mud's At," *Raw Vision* 19 (Summer 1997): 44.

71. Karin Pendley Koser, "Folk Art with Extra Texture," *Atlanta Constitution*, n.d.

72. Jack Lindsey, "William Edmondson," *Folk Art* 20, no. 1 (Spring 1995): 44.

73. Robert Farris Thompson, William Edmondson, and Judith McWillie, *The Art of William Edmondson* (Jackson: University Press of Mississippi, 2000).

74. "Sybil Gibson," *Folk Art Finder* 6, no. 3 (September/October 1985): 16.

75. Robert Draper, "Plunder or Patronage?" *American Way*, n.d., 16.

76. Roz Chast, "Folk Art of Midtown" (cartoon), *The New Yorker*, 10 January 2000, 94.

77. Michael D. Hall, "The Problem of Martin Ramirez," *Clarion* 11, no. 4 (Winter 1986): 60–61.

78. Patterson, "Bandwagon Reactionaries & Barricade Defenders," 25.

79. Interview of John Ollman by Liza Kirwin, 15 March 1990, Smithsonian Archives of American Art transcript, 23–24.

80. Samuel Gilmore, "Schools of Activity and Innovation," *Sociological Quarterly* 29

(1988): 203–19. Self-taught artists are more likely to be involved in schools of activity, rather than schools of thought, as aesthetic choices are assumed to be highly personal and idiosyncratic.

81. Julia Ardery, *The Temptation,* 123.

82. Ibid., 126.

83. Lippard, *Mixed Blessings,* 77.

84. Andy Nasisse, "Aspects of Visionary Art," 8–27, in *Baking in the Sun: Visionary Images from the South* (Lafayette: University Art Museum of the University of Southwest Louisiana, 1987), 16.

85. Michael Kimmelman, "By Whatever Name, Easier to Like," *New York Times,* 17 February 1997.

86. Susie Mee, "Folk and Family: George and Benny Andrews," *Clarion* 15, no. 3 (Fall 1990): 34–36.

87. Advertisement, *Folk Art* 23, no. 1 (Spring 1998): 86.

88. John Foster, "The Colorful, Complex and Chaotic World of Robert Eugene Smith," *Envision* 3, no. 1 (January 1998): 1–3.

89. Roberta Smith, "Born in a Dancer's Therapy, The Definition of Outsider," *New York Times,* 9 January 1998, E38.

90. Joanna Taylor, "Reader Exchange," *Folk Art Finder* 8, no. 4 (October–December 1987): 2.

91. Thomas McEvilley, "The Missing Tradition," *Art in America,* May 1997, 78–85.

92. Nancy Karlins, "Four from Coal Country: Friendships and the Contemporary Folk Artist," *Clarion* 12, no. 2/3 (Spring/Summer 1987): 56.

93. Jay Murphy, "Cultural Recycling: The Work of Lonnie Holley," *Raw Vision* 7 (1993): 22.

94. Cullum, "Vernacular Art in the Age of Globalization," 15.

95. Interview of Adrian Swain by Julia Ardery, 10 June 1993, Kentucky Folk Art Project, Oral History Program, Special Collections and Archives, University of Kentucky Libraries, transcript, 25–26.

96. There are instances in which other members of a family produce "their own" work, as opposed to collaborating with a relative. Charlie Lucas's wife Annie produced art in her own style, as do Malcah Zeldis's son David, Felipe Archuleta's son Leroy, and several members of the New Mexico Navajo Willeto family.

97. Arient interview, 127–28.

98. See also "Raw News," *Raw Vision* 11 (1995): 18–19.

99. Haardt, "Mose Tolliver Goes to Washington," 27.

100. Rosemary O. Joyce, " 'Fame Don't Make the Sun Any Cooler': Folk Artists and the Marketplace," 225–41, in *Folk Art and Art Worlds,* ed. John Michael Vlach and Simon J. Bronner (Logan: Utah State University Press, 1986), 225, 240.

101. James Alexander, "Review of Mose T show," *Art Papers* 6, no. 2 (March/April 1982): 19.

102. Regenia Perry, "Sam Doyle: St. Helena Island's Native Son," *Raw Vision* 23 (Summer 1998): 34.

103. Paul S. D'Ambrosio, "Ralph Fasanella: Artist of American Labor," *Folk Art Messenger* 8, no. 3 (Spring 1995): 1, 3–4.

104. Didi Barrett, "A Time to Reap: Late Blooming Folk Artists," *Clarion* 10, no. 3 (Fall 1985): 40.

CHAPTER FOUR

1. Walter Benjamin, "Unpacking My Library: A Talk about Book Collecting," 59–67, in *Illuminations,* ed. Hannah Arendt (New York: Harcourt Brace and World, 1968), 60.

2. Arjun Appadurai, "Commodities and the Politics of Value," in *The Social Life of Things: Commodities in Cultural Perspective,* ed. Arjun Appadurai (Cambridge: Cambridge University Press, 1986), 17; Igor Kopytoff, "The Cultural Biography of Things: Commodification as Process" (ibid., 66–67).

3. David Halle, *Inside Culture: Art and Class in the American Home* (Chicago: University of Chicago Press, 1993).

4. Mihaly Csikszentmihalyi and Eugene Rochberg-Halton, *The Meaning of Things: Domestic Symbols and the Self* (Cambridge: Cambridge University Press, 1981), 53.

5. Brenda Danet and Tamar Katriel, "No Two Alive: Play and Aesthetics in Collecting," *Play and Culture* 2 (1989): 253–77.

6. Paul Sheehan, "My Habit," *The New Yorker,* 12 February 1996, 58, 61.

7. Werner Muensterberger, *Collecting: An Unruly Passion* (Princeton: Princeton University Press, 1994).

8. Susan Pearce, "Objects as Meaning, or Narrating the Past," 25–140, in *Objects of Knowledge* (London: Athlone Press, 1990), 138; Marianne Hirsch, *Family Frames: Photography, Narrative, and Postmemory* (Cambridge: Harvard University Press, 1997).

9. Russell W. Belk, *Collecting in a Consumer Society* (London: Routledge, 1995).

10. Brenda Danet and Tamar Katriel, "Glorious Obsessions, Passionate Lovers, and Hidden Treasures: Collecting, Metaphor, and the Romantic Ethic," in *The Socialness of Things,* ed. S. H. Riggins (Berlin: Mouton de Gruyter, 1994).

11. Collectors also make it a point to comment about how open-minded and accepting they are as a group, explaining their satisfaction in crossing class boundaries and collecting work that others would dismiss. Given the absence of a systematic survey, I cannot judge whether this claim has validity.

12. Hemphill himself agreed, describing it as a "fix," noting "You find yourself lethargic or depressed. . . . I can expend love on objects without a fear of loss or rejection" (Lynda Roscoe Hartigan, *Made with Passion* [Washington, D.C.: Smithsonian Institution Press, 1990], 55).

13. Ben Apfelbaum, "On Becoming and Being a Collector: Thoughts but No Conclusions," 1996, 7.

14. Joe Adams, "Joe Adams Answers Questions from New Collectors about Building a Folk Art Collection," *20th Century Folk Art News* 1, no. 3 (July 1996): 10.

15. Danet and Katriel, "No Two Alive: Play and Aesthetics in Collecting."

16. Howard S. Becker, "La Confusion de Valeurs," 11–28, in *L'art de la Recherche: Melanges,* ed. Pierre-Michel Menger and Jean-Claude Passeron (Paris: La Documentation Française, 1994), available in English ("Confusions of Value") at http://www.soc.ucsb.edu/faculty/hbecker/Confusion.html.

17. Parents, of course, do make money off their children, encouraging them to take jobs after school to contribute to the family budget. Many parents, particularly prior to Social Security, expected their children to provide for them in old age, just as happens when an aging collector sells the objects amassed when younger.

18. Thorstein Veblen, *The Theory of the Leisure Class* (New York: Macmillan, 1899).

19. D. Angus Vail ("The Commodification of Time in Two Art Worlds," *Symbolic*

Interaction 22, no. 4 [1999]: 325–44) argues that time can serve a similar end: the commodification of time in art worlds (in his cases, opera and tattooing) can serve as a status marker of expertise.

20. Erving Goffman, "Symbols of Class Status," *British Journal of Sociology* 11 (1951): 294–304; Paul Fussell, *Class: A Guide through the American Status System* (New York: Simon and Schuster, 1983).

21. Interview of Jim and Beth Arient by Betty J. Blum, 27–29 April 1988, Smithsonian Archives of American Art transcript, 137.

22. Gary Alan Fine, *Morel Tales: The Culture of Mushrooming* (Cambridge: Harvard University Press, 1998), chap. 3.

23. Arient interview, 29.

24. E-mail from Randall Morris, "Re: First Experience," to outsiderart@onelist.com, 16 February 1999.

25. A santo is a saint figure, in this case made in Hispanic communities in the American Southwest.

26. Thomas F. Pettigrew, "Social Evaluation Theory: Convergences and Applications," 241–311, in *Nebraska Symposium on Motivation*, ed. David Levine (Lincoln: University of Nebraska Press, 1967).

27. E-mail from Lynne Browne, "Fwd: The Temptation," to folkpot@abts.net, 16 August 1999.

28. Richard Price and Sally Price, *On the Mall: Presenting Maroon Tradition Bearers at the 1992 Festival of American Folklife* (Bloomington: Special Publications of the Folklore Institute #4, Indiana University, 1994), 1–2.

29. Julia S. Ardery, *The Temptation: Edgar Tolson and the Genesis of Twentieth Century Folk Art* (Chapel Hill: University of North Carolina Press, 1998), 245–46.

30. Bill Ellis, "Legend-Tripping in Ohio: A Behavioral Survey," *Papers in Comparative Studies* 2 (1982/1983): 52–69.

31. Kenneth Dauber, "Pueblo Pottery and the Politics of Regional Identity," *Journal of the Southwest* 32 (1990): 579.

32. John Hood, "Jimmy Lee Sudduth," *Folk Art* 18, no. 4 (Winter 1993/1994): 51.

33. In Ardery, *The Temptation*, 266.

34. Jerry Cullum, "Vernacular Art in the Age of Globalization," *Art Papers* 22, no. 1 (January/February 1998): 13.

35. Love of the mud: the romanticism of elites for lower-class people and culture. Tom Wolfe, *Radical Chic and Mau-Mauing the Flak Catchers* (New York: Bantam, 1971), 38.

36. Hartigan, *Made with Passion*, 37.

37. Larissa MacFarquhar, "But Is It Art?" *New York*, 29 January 1996, 43.

38. Ardery, *The Temptation*, 244.

39. Ibid.

40. Ibid., 252.

41. Arient interview, 52.

42. I found determining the proper relationship difficult. It seemed awkward when one younger white woman joked with an older black man about all his girl friends, although, from what I could tell, the artist didn't seem to mind. After commenting that she could barely understand him, she noted, "Bless his heart, he wanted to hug me" (Field notes).

43. Beverly Gordon, "The Souvenir: Messenger of the Extraordinary," *Journal of Popular Culture* 20, no. 3 (Winter 1986): 135; Susan Stewart, *On Longing: Narratives of the*

Miniature, the Gigantic, the Souvenir, the Collection (Baltimore: Johns Hopkins University Press, 1984); Dean McCannell, *The Tourist* (New York: Schocken, 1986).

44. Roger Manley, "Robbing the Garden," *Folk Art Messenger* 7, no. 2 (Winter 1994): 7.

45. Some collectors will pay more than what an artist asks, but these visitors are rare.

46. Manley, "Robbing the Garden."

47. Arient interview, 105.

48. Interview of Chuck and Jan Rosenak by Liza Kirwin, 10 December 1998, Smithsonian Archives of American Art transcript, 2.

49. Rosemary O. Joyce, " 'Fame Don't Make the Sun Any Cooler': Folk Artists and the Marketplace," 225–41, in *Folk Art and Art Worlds,* ed. John Michael Vlach and Simon J. Bronner (Logan: Utah State University Press, 1986), 240.

50. Stephen Flinn Young and D. C. Young, *Earl's Art Shop: Building Art with Earl Simmons* (Jackson: University Press of Mississippi, 1995), 19.

51. Letters in Howard Finster file, Smithsonian Archives of American Art.

52. Lee Kogan (Personal communication, 2002) points out that the traditional folk portrait painter always painted on commission. Painting for these artisans was a business enterprise.

53. Wilfrid Wood, "Jungle Cats, African Queens, and Cold Beer: A Visit with Richard Burnside," *Raw Vision* 9 (1994): 23.

54. One savvy self-taught artist apparently offended a collecting couple when he asked them to sign a sales agreement. The artist is abashed, writing to the collectors, "I certainly hope we have not indelibly tainted your opinion of us. . . . We especially do not wish to offend or alienate collectors of your stature" (Letter from Raymond Materson to Chuck and Jan Rosenak, 29 July 1993, Rosenak file, Smithsonian Archives of American Art). Sales agreements are unheard of in this domain, although they are increasingly common elsewhere.

55. Chuck and Jan Rosenak, both attorneys, once wrote a letter on behalf of inmate Henry Ray Clark, who was up for parole from a Texas prison (Rosenak file, Smithsonian Archives of American Art).

56. Charles Briggs, "The Role of *Mexicano* Artists and the Anglo Elite in the Emergence of a Contemporary Folk Art," 195–224, in *Folk Art and Art Worlds,* ed. Vlach and Bronner, 217.

57. Ibid., 218–19.

58. Hartigan, *Made with Passion,* 41.

59. Jane Kallir, *Grandma Moses: The Artist behind the Myth* (New York: Clarkson N. Potter, 1982), 12–13.

60. Harrison White and Cynthia White, *Canvases and Careers: Institutional Change in the French Painting World* (New York: Wiley: 1965), 111.

61. Tom Wolfe, *The Painted Word* (New York: Bantam, 1976), 47–50.

62. Elaine Wintman, "Seymour Rosen and SPACES: Saving Our Sites," *Clarion* 13, no. 1 (Winter 1988): 47.

63. Diane Bartel, *Historic Preservation: Collective Memory and Historical Identity* (New Brunswick, N.J.: Rutgers University Press, 1996).

64. Nancy Raabe, "Deep Roots," *Birmingham News,* n.d., F8.

65. John Lewis, "In Pursuit of New Freedoms," 8–9, in *Souls Grown Deep: African American Vernacular Art of the South,* vol. 1, *The Tree Gave the Dove a Leaf,* ed. Paul Arnett and William Arnett (Atlanta, Ga.: Tinwood Press, 2000), 8.

66. Vincent Harding, " 'I Always Wanted to Be Free,' " 16–23, in *Souls Grown Deep,* ed. Arnett and Arnett, 16.

67. The relationship between Arnett and the Michael Carlos Museum became so toxic that when I interviewed museum officials, they refused to refer to him by name but labeled him the "collector." When it became time to rehang the show under the auspices of the City of Atlanta the photographs and wall texts had been lost by the museum—or so they claimed.

68. The second volume, subtitled "Once That River Starts to Flow," appeared in 2001, equally remarkable, is almost six hundred pages in length.

69. Michael Mulkay and Elizabeth Chaplin, "Aesthetics and the Artistic Career: A Study of Anomie in Fine-Art Painting," *Sociological Quarterly* 23 (Winter 1982): 117–38.

70. Wolfe, *Painted Word.*

71. John Forrest, "Why Do Duck Decoys Have Eyes?" *North Carolina Folklore Journal* 31, no. 1 (Spring/Summer 1983): 24.

72. Leslie Prosterman, *Ordinary Life, Festival Days: Aesthetics in the Midwestern Country Fair* (Washington, D.C.: Smithsonian Institution Press, 1995), 163.

73. Ludwig Wittgenstein, *Philosophical Investigations,* 3rd ed., trans. G. E. M. Anscombe (New York: Macmillan, 1968), 33–36; Gary Alan Fine, "Wittgenstein's Kitchen: Sharing Meaning in Restaurant Work," *Theory and Society* 24 (1995): 245–69.

74. Chuck Rosenak, "Folk Art Is Alien to Cultural Aesthetics," *Folk Art Messenger* 5, no. 3 (Spring 1992): 8.

75. Rebecca Dimling Cochran, "Fresh Perspective: An Interview with Lynne Spriggs, the High Museum's New Curator of Folk Art," *Art Papers* 22, no. 1 (January/February 1998): 25.

76. Gabriella Boston, "For the People, By the People," *Creative Loafing,* 15 August 1998, 40.

77. Allen S. Weiss, *Shattered Forms: Art Brut, Phantasms, Modernism* (Albany: State University of New York Press, 1992), 68.

78. In MacFarquhar, "But Is It Art?" 43.

79. Only in a few marriages are both parties equally committed to the collection. Sometimes it is his, sometimes hers. Sometimes it is a cause of divorce, as one resents the money being wasted. Often, too, there is a divergence of aesthetics, as one prefers memory paintings, and the other more difficult works.

80. Apfelbaum, "On Becoming and Being a Collector," 7.

81. Suzanne Slesin, "Outsider Art Comes In," *New York Times,* 26 January 1995, C6.

82. Arient interview, 206.

83. A central division is between those collectors who insist that all works be displayed as opposed to those willing to keep their works in storage. As one of the former told me, "If I can't see it, I don't want it" (Interview), even if some of these recognize that because of the clutter things cannot be seen to their best advantage with the home becoming a warehouse. One of the latter, a collector with a rather small urban apartment, knows that much of what he will purchase will go directly to storage, but comments, "These days I know most stuff I buy is going to go in storage . . . but I buy it. I have to want it so much that I want it in storage. . . . I'm afraid I'll never get the chance again" (Interview). Put this way both groups seem a little neurotic, but most collectors understand both perspectives whichever they select.

84. Quotation from Lynda Hartigan in an interview with John Ollman, 10 August 1989, Smithsonian Archives of American Art transcript, 50–51.

85. Tanya Heinrich, "Herbert Waide Hemphill, Jr., 1929–1998," *Folk Art* 23, no. 3 (Fall 1998): 52.

86. Letter from Jane D. Connolly to Myron Altschuler, 29 September 1982, Hemphill file, Smithsonian Archives of American Art.

87. Framing can be an issue as well. Some collectors feel that many of the works, particularly those on board and other found objects, should not be framed, while other collectors spend considerable effort selecting high quality frames. One collector commented, "I wanted the frames on the art to be more finished than a lot of people frame their art—very roughly—and that just didn't fit in with my house and my furniture" (Interview).

88. Richard Burns, " 'You Might as Well Throw It Away If You Don't Get Paid for It': The Folk Art of Nathaniel Barrow," paper presented at the Annual Meeting of the American Folklore Society, Austin, Texas, October 1997, 9.

89. In American homes there is a tendency to place erotic works in the master bedroom or bath, where, perhaps, the content of the work might inspire private activities. While these works are not often used as sexual aids, their content is seen as appropriate for intimate places.

90. Arient interview, 156.

CHAPTER FIVE

1. Robert D. Putnam, *Bowling Alone: The Collapse and Revival of American Community* (New York: Simon and Schuster, 2000).

2. Philip Nusbaum, "Spear Fishing and Spear Fishing Decoy Collecting," *New York Folklore* 19, no. 3/4 (1993): 24.

3. One of the skills of the effective auctioneer is to create this sense of community, even in its absence, given that the audience members are largely strangers. As Charles Smith notes of country auctions (*Auctions* [Berkeley: University of California Press, 1989], 73), "the auctioneer must create the ambience of a community. Without this sense of community, there is unlikely to be either the sense of trust or the social dynamics of mutual contagion which are necessary for a successful country auction."

4. Gary Alan Fine and Ralph L. Rosnow, "Gossip, Gossiper, Gossiping," *Personality and Social Psychology Bulletin* 4 (1978): 161–68; Jörg R. Bergmann, *Discreet Indiscretions: The Social Organization of Gossip* (New York: Aldine de Gruyter, 1993).

5. Ralph L. Rosnow and Gary Alan Fine, *Rumor and Gossip: The Social Psychology of Hearsay* (New York: Elsevier, 1976).

6. Jack Levin and Arnold Arluke, "An Explanatory Analysis of Sex Differences in Gossip," *Sex Roles* 12 (1985): 281–86.

7. In Julia S. Ardery, *The Temptation: Edgar Tolson and the Genesis of Twentieth-Century Folk Art* (Chapel Hill: University of North Carolina Press, 1998), 206–7.

8. Malcolm Gladwell, *The Tipping Point: How Little Things Can Make a Big Difference* (Boston: Little Brown, 2000).

9. Interview of Michael Hall by Julia Ardery, 14 August 1993, Kentucky Folk Art Project, Oral History Program, Special Collections and Archives, University of Kentucky Libraries, transcript, 28.

10. It is a marker of the racial composition of the field that aside from the Jazz Band, only three of the nearly thirty attendees were African American.

11. Letter from Wilma Lambert to Jan Rosenak, n.d., Rosenak file, Smithsonian Archives of American Art.

12. "Reader Exchange," *Folk Art Finder* 12, no. 3 (July–September 1991): 2.

13. Interview of Florence Laffal and Jules Laffal by Julia Ardery, 31 January 1993, Kentucky Folk Art Project, Oral History Program, Special Collections and Archives, University of Kentucky Libraries.

14. In Ardery, *The Temptation*, 276.

15. Jack Haas, "Binging: Educational Control among High-Steel Ironworkers," *American Behavioral Scientist* 16 (1972): 27–34; Gary Alan Fine and Lori Holyfield, "Secrecy, Trust, and Dangerous Leisure: Generating Group Cohesion in Voluntary Organizations," *Social Psychology Quarterly* 59 (1996): 22–38; Lori Holyfield and Gary Alan Fine, "Adventure as Character Work: The Collective Taming of Fear," *Symbolic Interaction* 20 (1997): 343–63.

16. The first: Kind is a dealer; the second: Hemphill is a collector; the last two: Tolliver and Finster are artists. Of course, the somewhat unusual names help make the point: John, Michael, David, and Mary would not be recognizable outside a local conversational context.

17. Erving Goffman, *Presentation of Self in Everyday Life* (New York: Anchor, 1959).

18. Interview of Ruth Ellsworth Wells by Willem Volkersz, 9 November 1983, Smithsonian Archives of American Art transcript, 13.

19. Ardery, *The Temptation*, 223–24.

20. Communities differ in the extent of multiple roles; other studies are necessary to determine the extent to which this applies to other art worlds outside this domain.

21. In Peter Watson, *From Manet to Manhattan: The Rise of the Modern Art Market* (New York: Random House, 1992), 385.

22. E-mail from Randall Morris, "Re: L.A. Gallery," to outsiderart@onelist.com, 6 December 1998.

23. The informality has led to claims of theft and other economic impropriety by co-owners and employees, including one infamous case in Chicago.

24. This reality helped my interviewing in that I could often interview dealers during their gallery hours without being interrupted.

25. Betty-Carol Sellen with Cynthia J. Johanson, *Self Taught, Outsider, and Folk Art: A Guide to American Artists, Locations and Resources* (Jefferson, N.C.: McFarland and Company, 2000), 3–48.

26. Sharon Zukin, *Loft Living: Culture and Capital in Urban Change* (New Brunswick, N.J.: Rutgers University Press, 1982).

27. Harrison White, "Where Do Markets Come From?" *American Journal of Sociology* 87 (1981): 517.

28. Paul Hirsch, "Processing Fads and Fashions: An Organization-Set Analysis of Cultural Work," *American Journal of Sociology* 77 (1972): 639–59.

29. What that condition should be raises issues of impression management. Pieces from rural, impoverished artists need a requisite patina—dirt provides the "look of folk art," as opposed to contemporary art that needs to be fresh. For collectors a folk art patina seems to suggest that the piece is "authentic," not restored, even though dirt can be added more easily than it can be cleaned (Personal communication, Tony Rajer, 2002).

30. One story told about Chicago artist William Dawson is that when Dawson was apprized early in his career that his works were insured for $25,000 at a show, far higher than he could imagine, he reports his wife as saying, "I hope that somebody will break in there tonight and steal every piece of it" (Interview of William Dawson by Betty J. Blum, 1990, Smithsonian Archives of American Art transcript, 102).

31. Aarne Anton, "Reader Exchange," *Folk Art Finder* 17, no. 1 (January–March 1996): 2.

32. Victor Faccinto, *Howard Finster, Man of Visions: The Garden and Other Creations* (Philadelphia, Pa.: Philadelphia Art Alliance, 1984), 9.

33. Stephanie Grace, "Memorial Plays Tribute to Artist," *New Orleans Times & Picayune*, 8 April 1997, B2.

34. E-mail from Randall Morris, "Dealing," to outsiderart@onelist.com, 16 March 1999.

35. Some dealers, like publishers, will take on creators of which they are not confident that they can profit, but do so either because they believe the work is sufficiently powerful or because it can be seen as a "prestige good," revealing to others their taste—a form of "conspicuous merchandising."

36. David Smith, "Conversation [with Albert Louden]," *The Bottlecap* 1, no. 1 (Spring 1998): 10.

37. Wendy Steiner, "In Love with the Myth of the 'Outsider,'" *New York Times*, 10 March 1996.

38. Encouraging artists to produce more "complex" or "bigger" works seems common. See Jeffrey R. Hayes on dealer Larry Hackley and carver Carl McKenzie ("Obituary," *The Bottlecap* 1, no. 1 [Spring 1998]: 9).

39. Roger Manley, "Separating the Folk from Their Art," *New Art Examiner* 19 (September 1991): 26.

40. Eleanor E. Gaver, "Inside the Outsiders," *Art & Antiques*, Summer 1990, 73.

41. William Arnett, "The Herod Paradigm," *Art Papers* 22, no. 1 (January/February 1998): 27.

42. Several smaller dealers have shared "horror stories" about how larger galleries would not return the works they had placed on consignment, but they didn't feel that they could sue because of the legal cost involved.

43. Robert Ellickson, *Order without Law: How Neighbors Settle Disputes* (Cambridge: Harvard University Press, 1991).

44. Stuart Plattner, *High Art Down Home: An Economic Ethnography of a Local Art Market* (Chicago: University of Chicago Press, 1997), 17.

45. Dealers also have strengths and weaknesses: some are known for having a good eye, others for being efficient, others for being flamboyant and theatrical, others for being conscientious in their business dealings, and still others for treating customers and/or artists well.

46. Mark Granovetter, "Economic Action and Social Structure: The Problem of Embeddedness," *American Journal of Sociology* 91 (1985): 481–510; Sharon Zukin and Paul DiMaggio, "Introduction," in *Structures of Capital: The Social Organization of the Economy* (Cambridge: Cambridge University Press, 1990), 14–15; Paul DiMaggio and Hugh Louch, "Socially Embedded Consumer Transactions: For What Kind of Purchases Do People Most Often Use Networks," *American Sociological Review* 63 (1998): 619–37.

47. Brian Uzzi, "Embeddedness in the Making of Financial Capital: How Social Relations and Networks Benefit Firms Seeking Financing," *American Sociological Review* 64 (1999): 481–505.

48. Peter Kollock, "The Emergence of Exchange Structures: An Experimental Study of Uncertainty, Commitment, and Trust," *American Journal of Sociology* 100 (1994): 313–45.

49. Oliver Williamson, "The Economics of Organization: The Transaction Cost Approach," *American Journal of Sociology* 87 (1981): 548–77.

50. Kathy Kaplan, "Show Room," *Chicago Tribune Magazine,* 10 May 1998, 24.

51. Jay Jacobs, *Winning the Restaurant Game* (New York: McGraw-Hill, 1980), 9. Needless to say, collectors not so favored who hear such stories can resent the dealer or be angry at the collector for "bragging."

52. Plattner, *High Art Down Home,* 201.

53. Ibid., 17.

54. Joe Adams, "Joe Adams Answers Questions from New Collectors about Building a Folk Art Collection," *20th Century Folk Art News* 1, no. 3 (July 1996): 11.

55. E-mail from Randall Morris, "Re: Dealers/non dealers," to outsiderart@onelist.com, 17 November 1998.

56. E-mail from Jim Linderman, "Re: Dealers," to outsiderart@onelist.com, 30 March 1999.

57. E-mail from collector to outsiderart@onelist.com.

58. Bozart is a term lifted from H. L. Mencken's essay, "The Sahara of the Bozart," in *Prejudices: Second Series* (New York: Knopf, 1920), in which he inveighed against the cultural provincialism of the South, which he described as a "gargantuan paradise of the fourth-rate."

59. Jim Roche, "Jim Roche on the Artists and Unsigned, Unsung . . . ," 57–73, in *Unsigned, Unsung, Whereabouts Unknown: Make-Do Art of the American Outlands* (Tallahassee: Florida State University Gallery and Museum, 1993), 57.

60. I have also heard a rumor that Butler was forced to move by a dealer who didn't want collectors to be able to purchase from Butler directly.

61. Robert Draper, "Plunder or Patronage?" *American Way,* n.d., 18. One has to assume that there is more to the story in that the story as presented opens the North Carolina dealer to serious legal charges.

62. Interview of Ken Fadeley by Julia Ardery, 17 March 1993, Kentucky Folk Art Project, Oral History Program, Special Collections and Archives, University of Kentucky Libraries, transcript, 46–47.

63. Florence Laffal, "Traylor Art in Court," *Folk Art Finder* 14, no. 1 (January–March 1993): 2.

64. Catherine Fox, "Traylor Folk Art Suit Settled: Lesson Is Open-Mindedness," *Atlanta Journal-Constitution,* 31 October 1993, N4.

65. Interview of Herbert W. Hemphill by Julia Ardery, 1993, Kentucky Folk Art Project, Oral History Program, Special Collections and Archives, University of Kentucky Libraries, transcript, 57.

66. A more recent case in Australia concerns the auctioning of a work of the aboriginal painter Johnny Warangkula Tjuppurrula, whose work was paid for in food. The painting, *Water Dreaming at Kalipinya,* sold for Australian $206,000 at auction. Tjupurrula, living in poverty, asked for a 4 percent commission, which was rejected ("Raw News," *Raw Vision* 20 [Fall 1997]: 6).

67. Ed Park, "The Outsiders," *Village Voice Education Supplement,* 23 April 2002, 92.

68. "Jack Savitsky," *Folk Art Finder* 2, no. 5 (November/December 1981): 6.

69. Plattner, *High Art Down Home,* 150–51.

70. John Ollman, quoted in Gaver, "Inside the Outsiders," 80.

71. There are borderline instances of this, such as a possibly apocryphal tale, "One artist tells the story of selling a major piece to a teacher for a very modest sum, since the purchaser assured it was to be used for instructional purposes, and later finding out

that it had been sold almost immediately for an impressive profit" (Charlotte G. Morgan, "Skinners: An Editorial," *Folk Art Messenger* 1, no. 4 [Summer 1988]: 2).

72. Both of these letters are included in the Finster files at the Smithsonian Archives of American Art. The names of the authors are available upon request. I have no evidence that the claims in the passages I have quoted—or the rest of the letters—are true or false. For one published account of the Finster/Camp relationship that presents both sides, see Jack Hitt, "The Selling of Howard Finster," *Southern Magazine*, November 1987, 52–59, 91.

73. Gary Alan Fine and Sherryl Kleinman, "Rethinking Subcultures: An Interactionist Approach," *American Journal of Sociology* 85 (1979): 1–20; Gary Alan Fine, "Small Groups and Cultural Creation: The Idioculture of Little League Baseball Teams," *American Sociological Review* 44 (1979): 733–45.

74. Erving Goffman, *Frame Analysis* (Cambridge: Harvard University Press, 1974), 83–123.

75. Erving Goffman, "On Cooling the Mark Out: Some Aspects of Adaptation to Failure," *Psychiatry* 15 (1952): 451–63.

CHAPTER SIX

1. A show promoter noted that work by South Carolina artist Sam Doyle is selling for tens of thousands of dollars, and a decade ago, it "could be traded for a six-pack" (Gabriella Boston, "For the People, By the People," *Creative Loafing*, 15 August 1998, 40).

2. Peter Watson, *From Manet to Manhattan: The Rise of the Modern Art Market* (New York: Random House, 1992); William D. Grampp, *Pricing the Priceless: Art, Artists, and Economics* (New York: Basic, 1989).

3. Howard S. Becker, "La Confusion de Valeurs," in *L'Art de la Recherche: Melanges*, ed. Pierre-Michel Menger and Jean-Claude Passeron (Paris: La Documentation Française, 1994), 11–28, available in English ("Confusions of Value") at http://www.soc.ucsb.edu/faculty/hbecker/Confusion.html.

4. Raymonde Moulin, "La Genèse de la Rareté Artistique," trans. Vanessa Gomez, 161–91, in *De la Valeur de L'Art: Recueil d'Articles* (Paris: Flammarion, 1995), 173.

5. E-mail from Jim Linderman to outsiderart@onelist.com, 16 April 1999. See also Shelly Errington, *The Death of Authentic Primitive Art and Other Tales of Progress* (Berkeley: University of California Press, 1998), 10.

6. For the most complete analysis of an art market, see Raymonde Moulin, *The French Art Market: A Sociological View*, trans. Arthur Goldhammer (New Brunswick, N.J.: Rutgers University Press, 1987).

7. Stuart Plattner, *High Art Down Home: An Economic Ethnography of a Local Art Market* (Chicago: University of Chicago Press, 1997), 23.

8. Randall Morris, "Self-Taught Art Ethics Regarding Culture," *New Art Examiner* 22, no. 1 (September 1994): 20.

9. Interview of John Ollman by Lynda Hartigan, 10 August 1989, Smithsonian Archives of American Art transcript, 62–64.

10. "Folk Fest '96," *20th Century Folk Art News* 1, no. 3 (July 1996), 1.

11. Wendy Espeland and Mitchell Stevens, "Commensuration as a Social Process," *Annual Review of Sociology* 24 (1998): 313–43.

12. In Lynda Roscoe Hartigan, *Made with Passion* (Washington, D.C.: Smithsonian Institution Press, 1990), 63.

13. Norman Girardot, "Cave Man: A Review Essay," *Folk Art Messenger* 5 (Spring 1992): 6–7.

14. Egle Victoria Zygas, "Who Will Market the Folk Arts?" *New York Folklore* 12 (1986): 73; Robert T. Teske, "'Crafts Assistance Programs' and Traditional Crafts," *New York Folklore* 12 (1986): 75–83; Julia S. Ardery, *The Temptation: Edgar Tolson and the Genesis of Twentieth Century Folk Art* (Chapel Hill: University of North Carolina Press, 1998), 45–99; Jane Becker, *Selling Tradition: Appalachia and the Construction of an American Folk, 1930–1940* (Chapel Hill: University of North Carolina Press, 1998).

15. Deirdre Evans-Pritchard, "The Portal Case: Authenticity, Tourism, Tradition, and the Law," *Journal of American Folklore* 100 (1987): 287–96; Kenneth Dauber, "Pueblo Pottery and the Politics of Regional Identity," *Journal of the Southwest* 32 (1990): 576–96; Charles Briggs, *The Wood Carvers of Córdova, New Mexico: Social Dimensions of an Artistic Revival* (Knoxville: University of Tennessee Press), 1980.

16. Michel Thévoz, "An Anti-Museum," 63–74, in *The Artist Outsider: Creativity and the Boundaries of Culture*, ed. Michael D. Hall and Eugene W. Metcalf Jr. (Washington, D.C.: Smithsonian Institution Press, 1994), 72.

17. Plattner, *High Art Down Home*, 3.

18. One dealer told me of a collector who will not buy from Atlanta dealers—"she feels better when she buys it in Manhattan"—and so some of the works that are sold to her are shipped from Atlanta to New York dealers with a premium added (Interview).

19. Moulin, "La Genèse de la Rareté Artistique," 163.

20. Ibid., 171.

21. Interview of John Ollman by Liza Kirwin, 15 March 1990, Smithsonian Archives of American Art transcript, 80–81.

22. Harrison White, "Where Do Markets Come From?" *American Journal of Sociology* 87 (1981): 517.

23. Plattner, *High Art Down Home*, 12.

24. Ibid., 196.

25. In *Accounting for Tastes* (Cambridge: Harvard University Press, 1996), 4, Gary S. Becker argues that preferences (a topic rarely examined by neoclassical economics) are a function of past experiences and social pressures.

26. Consider the following dialog:

Willem Volkersz: What kind of figure are you thinking of [for your handmade bicycle]? Just in case I run into a rich person or a museum director. . . .

John Martin: Well, $50,000. Now, of course, that's a lot of money for a bicycle.

Volkersz: It sure is. But it's a *very* special bicycle.

Martin: It's *very* special. . . . It's something that you won't find no place else. . . . Because it's a rare thing. It's really rare. There's nothing else in the world like it.

(Interview of John Martin by Willem Volkersz, March 1984, Smithsonian Archives of American Art transcript, 13–14).

27. One dealer predicted that much of the recent work of Howard Finster, some sold for over $1,000, will within five years be found at yard sales (Interview).

28. This was made evident in the case of one collector who saw southern pottery jugs on sale for $800. He went to the potter and bought several for $100. When he tried to sell them, he found "no one wanted them, even for a hundred dollars" (Interview). Their use value was little, and their exchange value was not much more.

29. Art is among the rare commodities in which there is virtually no connection between production cost and price (Plattner, *High Art Down Home*, 20).

30. In Mort Winthrop, "American Folk Art: Hanging Money on Your Wall," *The Robb Report,* January 1984, 92.

31. Jenifer Penrose Borum, "Spinning in a Lonely Orbit: The Work of Drossos P. Skyllas," *Folk Art* 19, no. 4 (Winter 1994/1995): 38.

32. In Ken Wells, " 'Outsider Art' is Suddenly the Rage among Art Insiders," *Wall Street Journal,* 25 February 1992, 1.

33. Jena McGregor, "The Outside Edge," *Smart Money,* January 2000, 143.

34. Julia S. Ardery, " 'Loser Wins': Outsider Art and the Salvaging of Disinterestedness," *Poetics* 24 (1997): 342.

35. E-mail from Randall Morris, "so anyway," to outsiderart@onelist.com, 23 March 1999.

36. Plattner, *High Art Down Home,* 15.

37. Julia Weissman, "Bert," *Folk Art* 23, no. 3 (Fall 1998): 52.

38. Philip Nusbaum, "Spear Fishing and Spear Fishing Decoy Collecting," *New York Folklore* 19, no. 3/4 (1993): 32.

39. Often these transactions involve considerable amounts of money. When they involve strangers, the buyer paying by check, some awkwardness may result, as trust has not been established. One informant who purchased a relatively expensive work from a gallery that she had never dealt with told me that the dealer seemed relieved that she asked the piece to be sent. This would permit the dealer to make sure the check was good without embarrassment (Field notes). Next time, that presumably won't be necessary.

40. Some note should be made of corporate art purchases (see Roseanne Martorella, *Corporate Art* [New Brunswick, N.J.: Rutgers University Press, 1990]), which, while private, typically do not have this personal, idiosyncratic aspect. Many corporate collections include self-taught art, notably the Atlanta law firm King & Spalding and Chase Manhattan Bank. These firms when purchasing for their public spaces invariably select works that do not offend clients and workers, which fits many folk artists well, although some businesses find self-taught art "too childlike, too toylike" (Interview). Corporations like memory paintings, but not edgy or visionary work. Often employees with little art training have a large say in selecting which works are purchased and where they are displayed. During years in the 1990s when the House of Blues (a chain of music clubs with a southern blues theme) was expanding, it would buy large amounts of southern folk art: museum quality pieces for their corporate collections and celebrity VIP rooms, and cheaper and nonoffensive ones for their clubs (Field notes). When purchasing for a new club, their buyer could spend over $100,000, and, according to a knowledgeable informant, in the early years when the original owner was involved in selecting art, dealers took advantage of his largess, significantly raising their price (Interview). Finally, corporations also affect self-taught art through their museum sponsorship. Coca-Cola, Philip Morris, Pfizer, AOL Time-Warner, and the Ford Motor Company have all supported the American Folk Art Museum, gaining accolades by helping to fund what is felt to be a patriotic, populist institution.

41. As noted, negotiation is considered not quite proper when dealing with artists, but is sometimes practiced, especially when buying several items.

42. Interview of Jim and Beth Arient by Betty J. Blum, 27–29 April 1988, Smithsonian Archives of American Art transcript, 17–19.

43. Brenda Danet and Tamar Katriel, "No Two Alike: Play and Aesthetics in Collecting," *Play and Culture* 2 (1989): 253–77.

44. "News from Summerville," *Folk Art Finder* 9, no. 3 (July–September 1988): 10–11.

45. With the interest of certain Hollywood and music business personalities, such as Tim Robbins, Robin Williams, Jonathan Demme, and David Byrne in this market, the ability to demonstrate that ownership of this art reveals artistic discernment may become more crucial.

46. Didi Barrett, "Rev. Howard Finster: Painting By Numbers," unpublished manuscript, 1984.

47. Michael Bonesteel, "Lee Godie," *Raw Vision* 27 (Summer 1999): 43.

48. Gene Epstein, "What Kind of Art Is This?: Justin McCarthy and the Age of Outsiderism," *Folk Art* 17 (Winter 1992/1993): 56.

49. Jack Hitt, "The Selling of Howard Finster," *Southern Magazine*, November 1987, 52-55.

50. Steven C. Dubin, "The Centrality of Marginality: Naive Artists and Savvy Supporters," 37-52, in *Outsider Art: Contesting Boundaries in Contemporary Culture*, ed. Vera L. Zolberg and Joni Maya Cherbo (Cambridge: Cambridge University Press, 1997).

51. Michèle de la Pradelle, remarks on a Provencal market, conference on "Fieldwork in Contemporary Society," University of California, Los Angeles, 2002.

52. Larissa MacFarquhar, "But Is It Art?" *New York*, 29 January 1996, 41.

53. Interview material and Julia S. Ardery, *The Temptation: Edgar Tolson and the Genesis of Twentieth Century Folk Art* (Chapel Hill: University of North Carolina Press, 1998), 195.

54. E-mail from collector to outsiderart@onelist.com.

55. E-mail from Randall Morris, "Open Note to Colin Smith and the Fair," to outsiderart@onelist.com, 20 April 1999.

56. E-mail from collector to outsiderart@onelist.com.

57. Charles Smith, *Auctions* (Berkeley: University of California Press, 1989).

58. Ibid., x.

59. Ibid., 38.

60. Ibid., 132.

61. Ibid., 173.

62. "Terms and Conditions," in the catalog of the Kimball M. Sterling Gitter-Yelen auction (29 July 2000), 2.

63. Koenraad Kuiper, *Smooth Talkers: The Linguistic Performance of Auctioneers and Sportscasters* (Mahwah, N.J.: Lawrence Erlbaum Associates, 1996), 44-47.

64. Lindsey Churchill and Susan H. Gray, "Number Sequences in Auction Bidding," n.d.; Susan H. Gray, "Power in the Auction Setting" (Ph.D. diss., City University of New York Graduate Center, 1976).

65. R. E. Turner and K. Stuart, "The Negotiation of Role Conflict: A Study of Sales Behavior at the Auction," *Rocky Mountain Social Science Journal* 11 (1974): 85-96.

66. As discussed in Erving Goffman, *Forms of Talk* (Philadelphia: University of Pennsylvania Press, 1981).

67. Smith, *Auctions*, 108.

CHAPTER SEVEN

1. Howard Singerman, *Art Subjects: Making Artists in the American University* (Berkeley: University of California Press, 1999).

2. Julia S. Ardery, *The Temptation: Edgar Tolson and the Genesis of Twentieth-Century Folk Art* (Chapel Hill: University of North Carolina Press, 1998), 152.

3. William Arnett, "The Herod Paradigm," *Art Papers* 22, no. 1 (January/February 1998): 31.

4. Not always. Reactions to a Howard Finster painted bicycle at the High Museum of Art included, among many positive comments: "Howard Finster had way too much time on his hands," "It's a joke on the curator," and "people will spend good money on any crap that's called ART."

5. Steven C. Dubin, "The Centrality of Marginality: Naive Artists and Savvy Supporters," 37–52, in *Outsider Art: Contesting Boundaries in Contemporary Culture*, ed. Vera L. Zolberg and Joni Maya Cherbo (Cambridge: Cambridge University Press, 1997), 43, and Interviews.

6. Thomas Scheff, *Being Mentally Ill: A Sociological Theory*, 2nd ed. (New York: Aldine de Gruyter, 1984), 36–48.

7. Debra Brehmer, "Mary Nohl of North Beach Drive," *Raw Vision* 26 (Spring 1999): 52–55.

8. Lee Kogan, *The Art of Nellie Mae Rowe: Ninety-Nine and a Half Won't Do* (Jackson: University Press of Mississippi, 1998), 18.

9. "Vollis Simpson Arrested!" *Raw Vision* 24 (Fall 1998): 12.

10. Dinitia Smith, "Bits and Pieces and an Artist's Drive," *New York Times*, 5 February 1997, B2.

11. Interview of Cleve Warren by Willem Volkersz, 9 June 1981, Smithsonian Archives of American Art transcript, 13–14.

12. In fact, some seriously handicapped people, such as Laura McNellis, a severely developmentally delayed adult, have been included in museum shows and are represented by the best galleries.

13. Maria Henson, "This Time and Place: Outsider Art," *Folk Art Messenger* (reprinted from *Charlotte Observer*, 24 June 1995) 8, no. 4 (Summer 1995): 11.

14. Jann Malone, "Couple Learns Fine Art of Buying Folk Works," *Richmond Times-Dispatch*, 15 September 1974, C2.

15. Dick Netzer, *The Subsidized Muse: Public Support for the Arts in the United States* (Cambridge: Cambridge University Press, 1978).

16. Edward C. Banfield, *The Democratic Muse: Visual Arts and the Public Interest* (New York: Basic, 1984).

17. "$1,000,000 for Watts Towers Preservation," *Spaces: Notes on America's Folk Art Environments* 1, no. 1 (n.d.): 1–2.

18. Riccardo Salmona, "New York City Pledges $2.5 Million to the Museum of American Folk Art's Building Project," *Folk Art* 24, no. 3 (Fall 1999): 12.

19. David Levinson, "News from Kentucky," *Folk Art Messenger* 11, no. 4 (Fall 1998): 17.

20. Tamara H. Shackelford, "Rescue Mission: Anderson Johnson Receives Grant," *Folk Art Messenger* 8, no. 4 (Summer 1995): 10.

21. "Director Belittles Garden," *Kansas Grassroots Art Association News* 5, no. 3 (1985): 7.

22. Lynne Adele, *Spirited Journeys: Self-Taught Texas Artists of the Twentieth Century* (Austin, Tex.: Archer M. Huntington Art Gallery, 1997), 123, 174.

23. See Judith McWillie, "(Inter) Cultural, (Inter) Connections," *Public Art Review* 4, no. 1 (Summer/Fall 1992): 14; "Heidelberg Project Loses Long Battle for Survival," *Raw Vision* 26 (Spring 1999): 16; and http://www.heidelberg.org.

24. Holly Metz, "The Ark of the Broken Covenant: How the City of Newark Sunk

Kea Tawana's Dreams," *Public Art Review* 4, no. 1 (Summer/Fall 1992): 22–23; "Kea's Ark: The Last Chapter," *Folk Art Finder* 9, no. 4 (October–December 1988): 2.

25. "Constitutional Questions about Government & Art," *Kansas Grassroots Art Association News* 7, no. 2 (1987): 5.

26. Larry Yust, "Salvation Mountain," *Raw Vision* 16 (Fall 1996): 40–41.

27. Anton Haardt, "Mose Tolliver Goes to Washington," *Raw Vision* 12 (Summer 1995): 27.

28. Susan A. Niles, *Dickeyville Grotto: The Vision of Father Mathias Wernerus* (Jackson: University Press of Mississippi, 1997), 22.

29. Ardery, *The Temptation*, 37.

30. Tamara H. Shackelford, "Visionary Museum a Reality," *Folk Art Messenger* 8, no. 4 (Summer 1995): 3.

31. "Raw News," *Raw Vision* 10 (Winter 1994/1995): 16.

32. Jeff Cory, "Intuit Celebrates Five Years," *Outsider* 1, no. 1 (Summer 1996): 6–10.

33. Francie Ostrower, *Why the Wealthy Give: The Culture of Elite Philanthropy* (Princeton: Princeton University Press, 1995).

34. Alice Goldfarb Marquis, *The Art Biz: The Covert World of Collectors, Dealers, Auction Houses, Museums, and Critics* (Chicago: Contemporary Books, 1991), 275, cited in Stuart Plattner, *High Art Down Home: An Economic Ethnography of a Local Art Market* (Chicago: University of Chicago Press, 1997), 38.

35. Diana Crane, *The Transformation of the Avant-Garde* (Chicago: University of Chicago Press, 1987), cited in Plattner, *High Art Down Home*, 38.

36. Vera L. Zolberg, "Conflicting Visions in American Art Museums," *Theory and Society* 10 (1981): 104.

37. There is also the Museum of International Folk Art in Santa Fe, and several museums that focus on traditional folk arts, notably the Abby Aldrich Rockefeller Folk Art Museum in Williamsburg.

38. It had been previously chartered in 1961. The museum was originally named the "Museum of Early American Folk Art," but changed its name in 1966 to the Museum of American Folk Art (Alice Hoffman, "The History of the Museum of American Folk Art," *Clarion* 14, no. 1 [Winter 1989]: 36–63).

39. See, for example, Peter Schjeldahl, "Folks," *The New Yorker*, 14 January 2002, 88–89. Schjeldahl concludes, "Our contemporary artists can learn a lot from a visit to this provocative new museum, starting with the indispensability of joy" (p. 89).

40. There is some competition between the two organizations. MOMA would very much have liked to expand into AFAM's space, but AFAM was able to mobilize support to build their new building.

41. The fact that the Hemphill, Hall, Hahn, and Rosenak collections went to other institutions is taken by some to indicate that there is much work that needs to be done for the museum to enter the first rank of institutions. Yet, that, everyone agrees, is the goal.

42. Lynda Roscoe Hartigan, *Made with Passion* (Washington, D.C.: Smithsonian Institution Press, 1990), 29.

43. Didi Barrett, "Survey Results Reflect an Enthusiastic Museum Membership," *Clarion* 14, no. 3 (Summer 1989): 9.

44. In Tessa DeCarlo, "The Bizarre Visions of a Reclusive Master," *New York Times*, 12 January 1997, 43.

45. For more about the museum, see *Link: A Critical Journal of the Arts in Baltimore*

and the World 3 (Summer 1998), a publication of the Department of Visual Art, University of Maryland, Baltimore County.

46. Stephanie Mansfield, "The New Populism: Rebecca's World of Visionary Art and Big, Splashy Parties," *New York Times,* 19 April 2000, H22.

47. John Maizels, "AVAM: John Maizels Interviews Anita Roddick," *Raw Vision* 14 (Spring 1996): 46–49.

48. Mansfield, "The New Populism."

49. E-mail from Randall Morris, "Re: AVAM," to outsiderart@onelist.com, 29 April 2000.

50. In Mansfield, "The New Populism."

51. Steven C. Dubin, *Displays of Power: Memory and Amnesia in the American Museum* (New York: New York University Press, 1999).

52. DeCarlo, "The Bizarre Visions of a Reclusive Master."

53. Alan Sondheim, "Unnerving Questions Concerning the Critique and Presentation of Folk/Outsider Arts," *Art Papers* (July/August 1989): 13, 33–35.

54. For a Dutch example, see Nico van der Endt, "A Palace for Outsiders," *Raw Vision* 15 (Summer 1996): 50.

55. Randall Morris, "Self-Taught Ethics Regarding Culture," *New Art Examiner* 22, no. 1 (September 1994): 21.

56. A similar argument could—but rarely is—be made about ecclesiastical art—now found in secular museum spaces (Personal communication, Steven Dubin, 2002).

57. In Ardery, *The Temptation,* 178.

58. Michael Watts, "Acquiring the 'Questionable,'" *Dialogue* 11, no. 4 (1988): 16.

59. Paul DiMaggio and Walter W. Powell, "The Iron Cage Revisited: Institutional Isomorphism and Collective Rationality in Organizational Fields," *American Sociological Review* 48 (1983): 147–60.

60. Zolberg, "Conflicting Visions in American Art Museums," 103–25.

61. McCandlish Phillips, "Curators' Wages Scored in Report," *New York Times,* 21 Nov. 1972, 55.

62. Cynthia Elyce Rubin, "Southern Exposure: One Curator in Search of an Exhibition," *Clarion* 10 (Spring/Summer 1985): 33.

63. In Ardery, *The Temptation,* 207.

64. Code of Ethics, 1983, American Association of Museums, Hemphill file, Smithsonian Archives of American Art. The 1996 version is available from the American Association of Museums.

65. Michel Thévoz, "An Anti-Museum," 62–74, in *The Artist Outsider: Creativity and the Boundaries of Culture,* ed. Michael D. Hall and Eugene W. Metcalf Jr. (Washington, D.C.: Smithsonian Institution Press, 1994).

66. "Joe Barta," *Folk Art Finder* 1, no. 5 (November/December 1980): 14. Barta, a carver, rejected an offer from the Ford Foundation for $500,000 for his life-size carving, *The Last Supper.* The Museum of Woodcutting remains open in Shell Lake, Wisconsin. Rotter, recently deceased, who did not reject inclusion of his work in larger museums, has his Rudy Rotter's Manitowoc Museum of Sculpture.

67. Gerard C. Wertkin, "Mattie Lou O'Kelley: Reflections on the Artist and Her Work," *Folk Art* 22, no. 4 (Winter 1997/1998): 50.

68. Tanya Heinrich, "An Artist's Generosity Benefits the Museum," *Folk Art* 24, no. 4 (Winter 1999/2000): 88.

69. "Gerald Hawkes, 1943–1998," *Raw Vision* 23 (Summer 1998): 16.

70. Anne Mai, "A Little Pepper, A Little Salt: Aaron Birnbaum," *Folk Art* 20, no. 3 (Fall 1995): 51.

71. "Reader Exchange," *Folk Art Finder* 2, no. 1 (March/April 1981): 2–3. She had previously donated a work to the Smithsonian's National Museum of American Art.

72. E-mail from Randall Morris, "It's over! and just begun," to outsiderart@onelist. com, 31 January 2000.

73. Julia S. Ardery, "The Designation of Difference," *New Art Examiner* 19, no. 1 (September 1991): 29.

74. The Museum of American Folk Art's long-time director Robert Bishop, an antique dealer, was a notable exception.

75. Interview of John Ollman with Liza Kirwin, 15 March 1990, Smithsonian Archives of American Art transcript, 42.

76. As does the American Association of Museums in the 2000 Code of Ethics.

77. Quoting Herbert W. Hemphill. Hartigan, *Made with Passion*, 58.

78. Interview of Jim and Beth Arient by Betty J. Blum, 27–29 April 1988, Smithsonian Archives of American Art transcript, 198–99.

79. One critic described the catalog of one such exhibit—a catalog he admired—as "something of a 'vanity' publication" (Michael Bonesteel, "Review of *Pictured in My Mind: Contemporary American Self-Taught Art from the Collection of Dr. Kurt Gitter and Alice Rae Yelen*," *Outsider* 1, no. 1 [Summer 1996]: 3–4).

80. Steven C. Dubin, *Displays of Power: Controversy in the American Museum from Enola Gay to Sensation* (New York: New York University Press, 2001).

81. Howard S. Becker, "La Confusion de Valeurs," 11–28, in *L'Art de la Recherche: Melanges*, ed. Pierre-Michel Menger and Jean-Claude Passeron (Paris: La Documentation Française, 1994), available in English ("Confusions of Value") at http://www.soc.ucsb.edu/faculty/hbecker/Confusion.html.

82. Marcel Mauss, *The Gift: Forms and Functions of Exchange in Archaic Societies* (New York: Norton, 1967); David Cheal, *The Gift Economy* (London: Routledge, 1988).

83. Lita Solis-Cohen, "Three Academics Sell Their Folk Art," *Maine Antiques Digest* 18, no. 2 (February 1990): A34.

84. Ed Park, "The Outsiders," *Village Voice Education Supplement*, 23 April 2002, 96.

85. Some collectors prefer to give works to several museums, such as one couple who has given five hundred pieces to various museums (Warren Lowe and Sylvia Lowe, "Warren and Sylvia Lowe's Collection to be Auctioned," *Folk Art Messenger* 11, no. 3 [Summer 1998]: 25).

86. William Arnett, "The Herod Paradigm," *Art Papers* 22, no. 1 (January/February 1998): 27.

87. Didi Barrett, "Folk Art of the Twentieth Century," *Clarion* 12, no. 2/3 (Spring/Summer 1987): 32.

88. Russell Bowman, "Speakeasy," *New Art Examiner* 22, no. 1 (September 1994): 15.

CHAPTER EIGHT

1. Julia S. Ardery, *The Temptation: Edgar Tolson and the Genesis of Twentieth Century Folk Art* (Chapel Hill: University of North Carolina Press), 1998.

2. Pierre Bourdieu, *The Field of Cultural Production: Essays on Art and Literature* (New York: Columbia University Press, 1993).

3. Eviatar Zerubavel, *Social Mindscapes: An Invitation to Cognitive Sociology* (Cambridge: Harvard University Press, 1997).

4. Sarah Burns, *Inventing the Modern Artist: Art and Culture in Gilded Age America* (New Haven, Conn.: Yale University Press, 1996).

5. George Dickie, *Art and the Aesthetic: An Institutional Analysis* (Ithaca, N.Y.: Cornell University Press, 1974).

6. Arthur C. Danto, "The Artworld," *Journal of Philosophy* 61 (1964): 571–84; Arthur C. Danto, *The Transfiguration of the Commonplace* (Cambridge: Harvard University Press, 1981).

7. Richard E. Caves, *Creative Industries: Contracts between Art and Commerce* (Cambridge: Harvard University Press, 2000), 7.

8. Personal communication, Lee Kogan, 2002.

Index

FROM THE ELABORATE DRAWINGS OF HENRY DARGER to the sacred paintings of the Reverend Howard Finster, the work of outsider artists has achieved unique status in the art world. Celebrated for their lack of traditional training and their position on the fringes of society, outsider artists nonetheless participate in a traditional network of value, status, and money. After spending years immersed in the world of self-taught artists, Gary Alan Fine presents *Everyday Genius*, an insightful look at this network and how it confers artistic value.

Fine considers the differences among folk art, outsider art, and self-taught art, and then explains the economics of this distinctive market. Interviewing curators and critics and venturing into the homes of self-taught artists, Fine describes how "authenticity" is central to the system in which artists—often poor, elderly, or mentally ill—are seen as having an unfettered form of expression highly valued in the art world. Revealing the inner workings of a prestigious world in which money, personalities, and values are deeply intertwined, Fine speaks eloquently to both experts and general readers.

"Indispensable for an understanding of this world and its workings. . . . Fine's book is not an attack on the Outsider Art phenomenon. But it is masterful in its anatomization of some of its contradictions, conflicts, pressures, and absurdities."
ERIC GIBSON, *Washington Times*

"Sociology's best ethnographer of his generation, Gary Fine, is back in from the field. . . . [*Everyday Genius*] is based on extensive participant detail and judiciously draws on the available archival material. . . . [All] presented in delightfully cant-free prose."
RICHARD A. PETERSON, *Contemporary Sociology*

Gary Alan Fine is the John Evans Professor of Sociology at Northwestern University and the author of numerous books, including *Difficult Reputations: Collective Memories of the Evil, Inept, and Controversial; With the Boys: Little League Baseball and Preadolescent Culture;* and *Shared Fantasy: Role-Playing Games as Social Worlds,* all published by the University of Chicago Press.

Cover image: *Figures and Construction with Blue Border,* Bill Traylor (1852/56–1949), Montgomery, Alabama, ca. 1941. Poster paint and pencil on cardboard, 15.5 × 8 in., Collection American Folk Art Museum, New York, Gift of Charles and Eugenia Shannon, 1991.34.1. Photo by John Parnell, New York. Photo courtesy of the American Folk Art Museum, Shirley K. Schlafer Library.

THE UNIVERSITY OF CHICAGO PRESS
WWW.PRESS.UCHICAGO.EDU